THE
LANGUAGES
OF
LANDSCAPE

65

THE LANGUAGES OF LANDSCAPE

Mark Roskill

The Pennsylvania State University Press
University Park, Pennsylvania

Library of Congress Cataloging-in-Publication Data

Roskill, Mark W., 1933–
 The languages of landscape / Mark Roskill.

 p. cm.
 Includes bibliographical references and index.
 ISBN 0-271-01553-5 (alk. paper)
 1. Landscape in art. 2. Art—Language. 3. Semiotics. I. Title.
 N8213.R58 1997
 760'.04436—dc20 95-36306
 CIP

It is the policy of The Pennsylvania State University Press to use acid-free
paper for the first printing of all clothbound books. Publications on uncoated
stock satisfy the minimum requirements of American National Standard for
Information Sciences—Permanence of Paper for Printed Library Materials,
ANSI Z39.48-1992.

To Nancy,
WHO HAS SEEN
MANY LANDSCAPES WITH ME

CONTENTS

List of Illustrations

PHOTOGRAPHIC SOURCES AND ACKNOWLEDGMENTS

Lichtbildwerkstätte Alpenland, Vienna, Fig. 57
Jorg B. Anders, Berlin, Figs. 27 and 29
British Library, Oriental and India Office, Fig. 48
Geoffrey Clements, Fig. 73
Courtauld Institute of Art, Witt Library, Figs. 10, 12, and 42
Deutsche Archäologische Institut, Rome, Figs. 14 and 15
Dienst Gemeentelijke Musea, Rotterdam, Fig. 26
George Holmes, Fig. 41
Institut Royal du Patrimoine Artistique, Brussels, Fig. 18
Istituto Centrale per il catalogo e la documentazione, Rome, Fig. 28
Sachiko Kimura, Paris, Fig. 76
Kapellenflege Stuppacher Madonna, Stuppach-Bad Mergentheim, Bildarchiv, Fig. 21
J. Lathion, Fig. 40
Ministry of Culture, Hellenic Republic, Fig. 5
Carl Nardiello, New York, Fig. 72
Ernani Orcorte, Turin, Fig. 36
Photothèque des musées de la ville de Paris, Fig. 52
Réunion des Musées Nationaux, Paris, Figs. 17, 24, 53, 56, and 63
Sotheby's, London, Victorian Picture Department, Fig. 55

The following illustrations were made after reproductions in books or catalogues: Figs. 2, 49, 50, and 78.

All other illustrations were supplied by the museums, institutions, or private owners to whom the works belong, and are reproduced with their kind permission.

INTRODUCTION

Landscape is an extraordinarily important component of our concrete physical experiences in the world, the apprehension of things deriving from these experiences and our accompanying sense of place. It represents a shaping term in our conceptualization of what is "out there," and of human relationships as they intertwine and interact with that. It also constitutes a root aspect of our social consciousness that can be brought to the fore according to how it is addressed. It calls up impulses, moods, and regulative or controlling patterns of awareness, which in turn affiliate the varying verbal and visual forms of expression that we use as admissible means of response.[1]

Landscape represents traditionally the domain of nature as opposed to culture. It also represents what human understanding and skill have done over time to improve and embellish nature. As a subject for art it includes at one extreme the vastness and terror of forest and ocean; at the other, the artificial park carefully ordered for human use. In the Renaissance people looking out had the sense of an uncharted, untamed world. Wherever living or working spaces gave way to forest and wild, there formed an open terrain of undefined and potentially limitless extension. Prior to the Renaissance, the concept of landscape had corresponded (without there being a generic name for it) to specific types of outdoor environment to which culture gave a form—garden, grove, vineyard, harbor, estuary—affording the idea of their being places of physical or spiritual refuge. Later, the concept became associated with socially and intellectually conditioned forms of response

to nature. Possessing it and shaping it, recording it so as to give substance to its scope and strangeness, coming to terms with its immensity and grandeur corresponded to distinctive ways of "seeing" it. Still later, it came to represent a territory of the mind and spirit in need of reclamation and protection, in consequence of pressures of urbanization and technology. Whichever of those paradigms one accepts and foregrounds constitutes a "politics" of landscape: a scheme of understanding from which hierarchies of importance and value derive. Nature in its ongoing organic life and richness of display is suborned to the needs of culture, from which it then takes its meaning, or at least gets reconciled with those needs.

Landscape correspondingly comes to play specific roles in our lives. It actualizes for us webs of memories and emotions associated with particular conjunctions and confrontations, distributed over space and over time. Whatever is special and persists in the mind about this kind of experience must, basically, be *seen* rather than *said*. We pass through a place in a particular season, or time of life or frame of mind about being there, alone or accompanied. What can be put into words is what we subsequently recall. We naturalize remembered sensations—wind on our cheeks, the smell of grass and herbs, a glimpse of sky—that can keep the experience fresh. Using words for the act of remembrance, we return those sensations to their original source.

John Constable, in a letter to Maria Bicknell describing in this spirit the views that they had shared when they were young, and at a time when the prospect of their being able to marry seemed remote, wrote of seeing from his window at East Bergholt "those sweet fields where we passed so many happy hours together." "It is with melancholy pleasure," he went on, "that I revisit those scenes that once saw us so happy—yet it is gratifying to me to think that the scenes of my boyish days should have witnessed by far the most affecting event of my life [namely, their courtship]."[2] And the Danish writer Isak Dinesen (Baroness Karen Blixen) opened her memoir of her seventeen years in Kenya with the words:

> I had a farm in Africa, at the foot of the Ngong Hills. . . . The geographical position, and the height of the land combined to create a landscape that had not its like in all of the world. . . . It was Africa distilled up through six thousand feet, like the strong and refined essence of a continent. The colours were dry and burnt, like the colours in pottery. The trees had a light delicate foliage, the structure of which was different from that of the trees of Europe; it did not grow in bows or cupolas, but in horizontal layers, and the formation gave to the tall solitary trees a likeness to the palms . . . and to the edge of a wood a strange appearance as if the whole wood were faintly vibrating. Upon the grass of the great plains the crooked bare old thorn-trees were scattered, and the grass was spiced like thyme and bog-myrtle. All the flowers that you found on the plains, or upon the creepers and liana in the native forest, were diminutive like flowers of the downs. . . . The views were immensely wide. Everything that you saw made for greatness and freedom, and unequalled nobility.
>
> The chief feature of the landscape, and of your life in it, was the air. . . . The

sky was rarely more than pale blue or violet, with a profusion of mighty, weight-less, ever-changing clouds towering up and sailing on it.[3]

Beyond the sensory immediacy of a recollection like this, landscape also provides us with a series of discrete categories that can fit like templates onto our exposure to nature. Typically—moving from city outward—they consist of park, suburb, wood, lakeland, coast, mountainside, desert, ad infinitum.[4] These categories enable our sense of progression and change to be marked off in sequential stages. We move from civilization to its opposite, or back to beginnings and forward to ends. Components of meaning attaching to landscape can be encapsulated and called up accordingly. In Charles Dickens's *The Old Curiosity Shop* Little Nell and her aged grandfather journey away from the city and its oppressive atmosphere of crime and terror, in a quest for renewed health and well-being that can only satisfy itself when it finds pure air and open country; the ultimate destination of their pilgrimage proves to be a rural churchyard. Resting in that green setting,

> they admired everything—the old grey porch, the mullioned windows, the venera-ble gravestones . . . the ancient tower, the very weathercock; the brown thatched roofs of cottage, farm and homestead, peeping from among the trees; the stream that rippled by the distant watermill; the blue Welsh mountains far away. It was for such a spot the child had wearied in the dense, dark, miserable haunts of labour . . . amidst the squalid horrors through which they had forced their way, visions of such scenes—beautiful indeed, but not more beautiful than this sweet reality—had been always present in her mind. They had seemed to melt into a dim and airy distance, as the prospect of ever beholding them again grew fainter; but, as they receded, she had loved and panted for them more.[5]

Equally landscape presents us with a set of basic polarities for organizing frameworks of apperception and the psychological affects (such as wonder or revulsion) that they invoke: polarities that include particularly tended/untended, intact/spoiled, vast/diminutive, solid/evanescent, open/closed. In a famous passage in *The Great Gatsby* F. Scott Fitzgerald describes an area of land "about halfway between West Egg and New York" where the railroad runs alongside the motorway for a quarter of a mile, and passengers on trains that are halted while the drawbridge on an adjacent river is up have an opportunity to look out onto the scene:

> This is a valley of ashes—a fantastic farm where ashes grow like wheat into ridges and hills and grotesque gardens; where ashes take the form of houses and chimneys and rising smoke and, finally, with a transcendent effort, of ash-grey men, who move dimly and already crumbling through the powdery air. . . .
> But above the grey land and the spasms of bleak dust which drift endlessly over it . . . the eyes of Doctor T. J. Eckleburg are blue and gigantic—their retinas are one yard high . . . dimmed a little by many paintless days [they] brood on over the solemn dumping ground.[6]

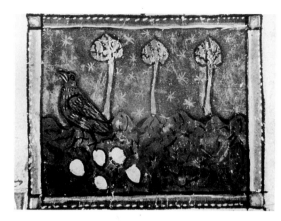

Fig. 1. *Bestiaire d'amour*, Partridge and Eggs, c. 1310. Bodleian Library, Oxford, Ms Douce 308, fol. 102r, miniature, c. 2 × 2½ inches

In the stirring of reactions such as the foregoing, landscape establishes a ground for the extended sharing of social attitudes and patterns of social behavior (as in tourism or the environmental protection movement). It represents a continuously contested territory over which private and public interests meet or diverge, as to what is done to its appearance and with the aid of whom, and to whom it belongs in respect to both use and enjoyment. It constitutes a habitat in which the behavior patterns and rituals of the animal kingdom take their place as subjects of curiosity and vitalistic interrogation. It provides a setting for stories and staged performances (usually fantastic). Interests, individual and communal, deriving from these considerations have gained purchase on the intellect and imagination from antiquity on, and since the Renaissance remain a constant in Western civilization.

The two most fundamental features of landscape art, over time and across different cultures, are that it works by dint of compression and distillation, and that it sets up a quality of resonance in the viewer's mind.[7] Compression and distillation entail singling out from a vast expanse or range of possibilities in nature those elements that effectively bring into focus key aspects of experience. Resonance causes the viewer to search in the memory, through the personally charged associations and paths of recollection that are evocatively set up. These operative principles are ones that extend equally to the literature and poetry of landscape, given that the visualizing capacities of the reader are channelled and made alert to emotive overtones along similar lines there.

In the case of painting and prints, such terms of operation are germane to other genres equally, and the constructions of appearance found in them. But they have particular application and force in the case of landscape. As in other arts, distinctive idioms of presentation, associated pictorially with the workings of compression and distillation and the achievement of resonance, impart the sense of being governed by underlying principles of construction, without being narrowly bound by them.

Thus a medieval miniature from the fourteenth century, which forms one of the illuminations to Richard de Fournival's Bestiary from a century earlier (Fig. 1), shows in compressed fashion a number of concrete elements from the world of nature and the relation between them: mother bird, representing a female partridge; five eggs together, in a formation of irregular white shapes; a brown ground, for the earth on which they rest;

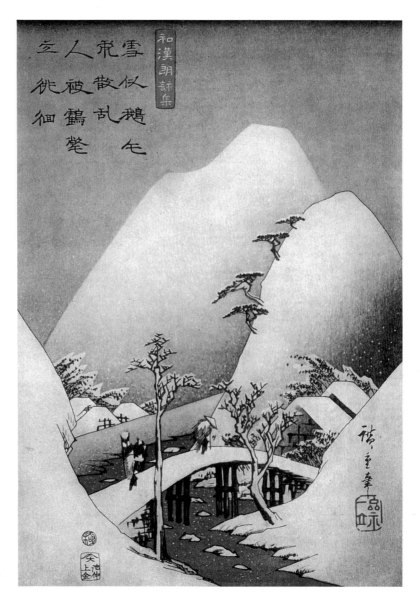

Fig. 2. Ando Hiroshige, *Snow Scene with Chinese verse*, from *Japanese and Chinese Poems for Recitation* [*Waken roei-shu*], 1840–41. Color woodcut, 14¾ × 10⅛ inches.

and three blue-white trees, set against a similarly blue-white area of sky. The adjoining manuscript passage (into which the image is inset with a framing border) explains how the female partridge allows the eggs she has laid to be stolen by another partridge, which hatches them and rears the young birds. The analogy here to the patterns of courtly love represents a running theme of the text. It is, however, brought to attention in the miniature only in visually encoded form: these are birds that recognize the call of their mother and follow her for the rest of their days.

In Ando Hiroshige's *Snow Scene* of 1840–41 (Fig. 2), from a set of woodblock prints that each contain a Chinese or Japanese poem for recitation, distillation takes the form of showing two farmers, quite diminutive in scale compared to the mountains and flying cranes, crossing a bridge in falling snow toward what is evidently their home. The

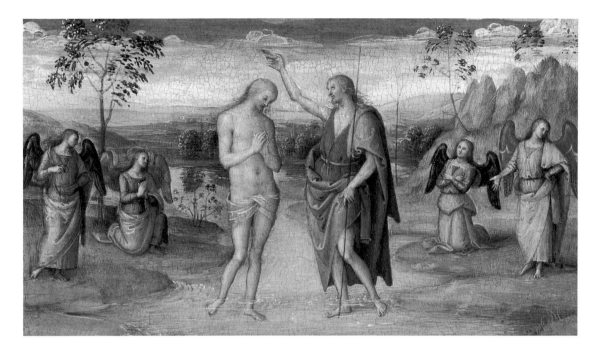

Fig. 3. Perugino, *Baptism of Christ*, predella of altarpiece for San Agostino, Siena, c. 1502–6. Tempera on panel, transferred to canvas, 10¾ × 8¼ inches. Art Institute of Chicago, Mr. and Mrs. Martin A. Ryerson Collection, 1933

coloring of the print is limited almost entirely to tones of black, white, and gray, with a resulting rarefied and refined quality to the spare use of a clear, limpid blue for the stretch of river, and to the touches of red, yellow, and blue that appear on the figures with their loads. Included in the sky area, in formal Chinese script, are the first two lines of a poem by Po-Chui from the Tang dynasty (772–846), referring to snow flying and scattering like goose feathers and to figures loitering in grass coats, like cranes. Significantly, these lines are not illustrated. Rather, they are visually analogized, in the suspended animation of the patterned snowflakes and the inclusion of the birds themselves.

To illustrate more specifically the workings of resonance, a painted landscape of the Italian Renaissance and a more modern example may serve. Pietro Perugino's *Baptism of Christ* (Fig. 3) forms one of four predella panels for an altarpiece that was originally in the Church of San Agostino, Siena, painted for the Chigi family between 1502 and 1506; while Frederic Edwin Church's *Morning, Looking East over the Hudson Valley from the Catskill Mountains* of 1848 (Fig. 4) represents a subject of a kind that this artist showed regularly from 1845 on, at the National Academy of Design in New York and in other group exhibitions. The musical quality given to the rhythms in the rocks, water, and trees of the Perugino landscape and their fine-tuned coloring help convey, through the sensations they impart, an overall tenor of sweet-tempered and delicate harmony. In Church's painting, even though its dimensions are quite modest, the dramatic lighting and the expansiveness of sky and framing mountains serve as conduits for feelings of a grandly spiritual or metaphysical order: ones of awe and reverence especially.

These four works have in common an apparent seamlessness in the ordering and

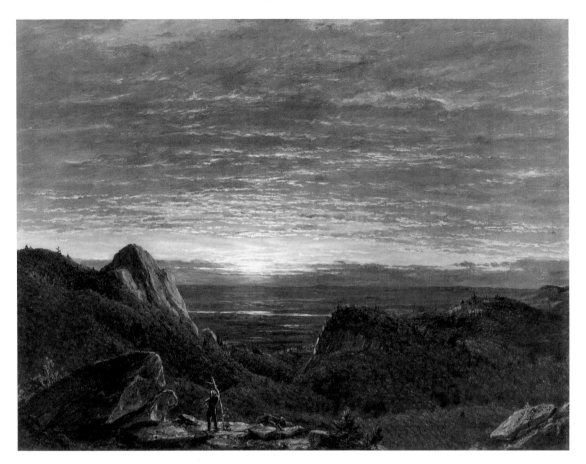

Fig. 4. Frederic Edwin Church, *Morning, Looking East over the Hudson Valley from the Catskill Mountains*, 1848. Oil on canvas, 18 × 24 inches. Albany Institute of History and Art, Gift of Catherine Gansevoort Lansing

putting together of their component elements. A sense of appropriacy links the scenic presentation to the particular subject-matter taken up, then binds it more broadly to material and spiritual aspects of the viewer's receptive engagement with the work (bringing into account here context of display). But in the great majority of cases such a sense of seamlessness in landscape art is in fact replaced by its contrary. Junctures appear within the ordering process and yield to being seen that way, even as a forced overriding of disconnections. Rival or conflicting contexts of apprehension collide with one another, and claims linking presentation to subject require indemnification in the form of appended words. What is brought into focus or evoked is also linked inevitably to omissions or exclusions, of expected characteristics of the subject. By the application of inference or through interposed commentary, response must be extended to bring out in some parallel fashion what is not actually there in the work, yet is indirectly present. The very idea of a hard and fast "subject" drawn from the domain of nature may itself come to seem thematically elusive and conceptually ambivalent.[8]

The means of analysis that are available for understanding such antinomies in the pictorial rendering of nature form the basis for the sequence of chapters following. Chapter

1 addresses the question of how the representation of outdoor settings can provide, or support, an equivalence to the unfolding of stories, where settings shift in time and change from one place to another. The implications of the relationship between verbal linear narration and nonlinear but spatiotemporally coordinated visual presentation bring up directly the roles, in connection with painting, of allied texts or supporting discourse. Chapter 2 takes up relationships to the viewer that landscape images promote, and the consequent terms of access to the scene depicted. Chapter 3 moves to considering how the types of reference that weight landscape art generally become engaged with issues of social and political moment in which nature and culture interact, with culture always dominant. Chapter 4 treats the way in which regimens of outdoor practice and the application of the paint itself, the force of social commentary and the cult of spectacle expand upon the meaning of being a landscape artist, amplifying the imaginative and figurative ways in which the import of this activity can be grasped by a public audience. Chapter 5 is concerned with the modern loss of faith in the scope of an integrative vision. The Conclusion returns once more to the hypostatized viewer and the processing on his or her part of salient features offered by the representation, and the associations attaching to them.[9]

To expand, then, on the title of the book: the subject of study is not so much what is intrinsically appealing in landscape art, considered conceptually and historically, but rather the different kinds of "language" that are entailed in the creation and apprehension of it. This is an inquiry into varieties of syntactical construction and the ways they work upon the viewer, setting up forms of commentary and acting as vehicles of inter-communication. The risk of interpretative subjectivity is inevitable here, as is reductionism, when in fact multiple threads or layers of reference may accrue to any work over time. But it is important to make the attempt at an overview, if critical insight is what is sought; and texts of the time can provide some guidelines, if used inductively, rather than simply as documentation.

In art history, until quite recently, landscape has been treated for the most part as a container or surround for actions and events; or as a source of information regarding actual or possible "worlds" that the artist has experienced. Those concerns put a strong limitation on the kind of characterization that is made, and how it is set out. In contrast, the elements of language (which need not be verbal) are deployed and amplified for discursive purposes by those who use and understand it. They are manipulated to resonate across a range of relations to description and discourse—whether or not the thematic material brought into focus in that way possesses a narrative coherence. They can be made to carry associations and allusions, and in that way become charged with imaginative or poetic import. They can be given figurative accentuation, or be endowed with a symbolic power of affect.

Representations of landscape, in having these varied and sometimes overlapping properties and potentials, become in their operation like a series or succession of languages. While the basic tasks of attribution and dating, grouping by period and categorization by subject continue, it becomes timely at this stage in art-historical scholarship to develop an approach based upon attention to selected examples, and the kinds of analysis that they invite. Both rhetorical theory, in its long-standing concerns with the empowering of

language, and recent conceptual developments in the field of linguistics can be adapted suitably to the field of the visual.

My previous books evince, across a number of fields or subfields, a long-standing concern with the differing ways of contextualizing a work of art, and with the question of how the doing of this most effectively supports analysis of the work itself. If, against that background, I identify the approach that links the chapters of this book together as broadly semiotic in its thrust, I do this with a strong sense of what lies beyond the limits of my coverage.[10] Some of the topics that I take up fall quite specifically within the scope of those branches of semiotic inquiry now dignified with labels: narratology, tropology, and discourse analysis. These entail, in the last case particularly, the consideration of how issues of race, gender, nationality, and class have impacted on the formulation of interpretative discourse about and around visual images. Other topics again, such as the part played in visual communication by prints and forms of popular imagery, as distinguished from painting, cannot possibly in this format receive the kind of sustained attention they deserve in their own right.

A full-scale semiotic study would also focus more specifically on the overlap and differences among mediums, as they bear on the enframing and distribution of landscape imagery in a variety of guises, and their use for communicative purposes. But my own seasoned inclination is to use theory, which looms large in this connection, only lightly and as a supporting framework. At one time theory could be given the role of relating art to ideas within their historical contexts, with the aid of an intensive critical scrutiny of the links and parallels discovered. But today, in its demandingness and tendency toward self-duplication, as it pores over and seeks to situate ideologically what has previously been said, it can have the effect of blotting out all else that is germane to the works in question. Or it can fail to integrate a sufficient range of individual cases, along with the terms that persuasively fit them, into its ongoing trajectory of discussion.

For these reasons I have preferred a polyphonic arrangement, in which different perceptions of landscape are put into dialogue with one another, through both synchronic and diachronic comparisons. I am also more comfortable with a critical contextualism: one that seeks to elucidate artistic practice in terms appropriate to its period. At the same time, however, I draw upon critical and theoretical perspectives of the present, as a wedge or lever to foreground key issues.

All words about art, including the artists' own, are instruments for gaining purchase on the visual, serving from their own direction or helping in their fashion to articulate how the object of study is to be perceived. Key to my own approach is the re-creation of the viewer's processes of gaining perceptual access to works of art ("prospecting" may be a better term, finally, than the more familiar "reading," borrowed or carried over from literature, for conveying what is at stake).[11] The aim attending this approach is not to impose or attach meanings as if they had to be "there," in the work, concretized as it were in the present moment and conditions of perception. I mean, rather, to suggest a variety of ways in which the bridging of image and words in respect to landscape may occur, to expand upon the semiotic implications of each in turn (as art history does not normally do), and to suggest how they fit together.

To make my text as accessible as possible, I have kept the explanation of theoretical concepts concise and reduced the discussion of those concepts to a level that does not call for extensive cross-reference to other fields (such as literature or anthropology). Where necessary explanation is given, in what I trust is a reasonably straightforward and untechnical fashion, I have couched it to indicate how the terms in question are to be transposed from the area or body of writing in which they originated to the field of visual imagery. The same applies equally to the Glossary I have included of terms from other fields, summarizing their relevance and suggesting how such transposition should occur.

1 | Landscape and Language, Landscape and Literature

The Making of a Genre

Space and time enter inevitably into the way that landscape is perceived. Things are taken as set apart from one another, in a fashion that entails both distribution and extension. But because of the parts played by imagination and recall here, in piecing together how the key features in question take up their places, and what sort of ordering they imply, it is not at all clear that what happens spatially and temporally within the representation of an outdoor scene can be identified and responded to, independently of acquiring a language in which to do this.

Semiotically, the issue can be put in a way that brings up the activity of reading (see page 9), as it applies to visual images. We look at or scan a page of writing, and similarly a surface like that of a picture, which has on it a variety of signs or symbols; we read *in* a language, which presupposes already having some command of being able to do this. Effectively to "read" in the latter sense is to explore the image in question, so as to derive something from it, or to register what may be found there: which is an activity of consciousness.

Being in a position to do what is in question here is not simply a matter of exposure to artistic practice. It has to do, more fundamentally, with the terms of *transposability* between a visual image, as it asks to be read across its span, and the structuring of a verbal language.[1] Because a visual image with multiple components requires attention to their internal distribution and a focused sense of their importance—but not more than that initially—it need not embrace the capacity to shift from one land to another, as Egyptian storytelling does, or proceed through intervals of time that are marked out in such

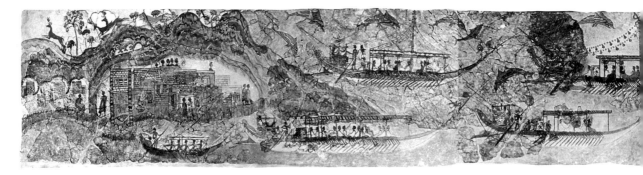

Fig. 5. "Flotilla" fresco from Akrotiri (Thera), c. 1500 B.C. (West House, Room 5, south wall), 17 inches high. National Archaeological Museum, Athens

narration by the supplying of calendar dates. It can offer, as Egyptian wall painting consistently does, a "tract" of land and water, without limit or transition to it, in which different units of representation, such as trees, fishes, and figures grouped in an activity, are put together to form a scenic ensemble.

The earliest pictorial representation known today, which includes in its scope people, birds, animals, and common objects in use, and also flora in the form of lilies and papyrus plants, along with garlands and rosettes, is the series of painted frescoes from the West House of Akrotiri (Thera), discovered in 1972 (Fig. 5). These examples of Minoan art date from the late Bronze Age, around 1500 B.C. Among them, the so-called flotilla fresco (now in the National Museum, Athens) is remarkable for showing a fleet of ships spaced out in two rows in a stretch of sea with dolphins leaping, harbor towns either side, and wild animals and birds in movement beside the banks of a winding river.[2]

Sea, harbor and buildings, river and countryside are shown here in what may be called—using the term loosely—cartographic fashion: with extension to the representation, as in Egyptian art, but without any specific indication of depth. The figures and animals may overlap and appear as if interacting with one another; but in the same sense, in both cases, as is true of more purely decorative motifs in other parts of the total fresco scheme. More particularly, the depiction of people, objects, animals, birds, fish, and materials in nature is of a kind that can specify familiar shape or form; number and gender; occupation (as with the rowers shown in the ships); and location, in a manner analogous to the relationship of place expressed by a governing preposition; but not—however naturally a modern viewer of the fresco may wish to read this in—order of succession in time. Thus a description that was worded in an appropriate verbal counterpart to this representation, like the written language of Linear B contemporary with it (a Mycenaean version of Greek, used in its commonest functions for documentary recording) would run correspondingly:

> [The] ship [with] five rowers [and] two steersmen is in [the] harbor; six [more] ships [with] garlands [and] inlaid decoration are in [the] dolphin-[infested] sea . . . [a] lion [hunts] antelope . . . men [and/or women] of [the] town are on rooftops . . . etc.[3]

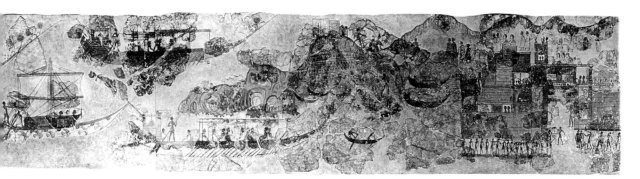

Such a hypostatized Linear B–type language would be one that came into existence prehistorically and lent itself to a variety of enumerative purposes without effectively needing to incorporate, or even intimate, any form of narrative sequencing. Recognition and identification in front of the flotilla fresco could consist simply of naming its contents in succession, without needing to imply any more than this, in the way of a causal and chronological explanation for their being presented in this manner, in order to justify a sufficient and working apprehension of the nature of the arrangement.

Contrastingly, it was in classical antiquity that a discursive language first made itself available for the purpose of describing an outdoor scene (with or without figures) in its coordinates of space and time. After the contributions of Homer and Hesiod, in their extended descriptions of narrative representations in visual form and their settings (as on the shield of Achilles in the *Iliad*), the development of such a language, for different forms of visual representation—including still life—seems to have happened independently of poetic or dramatic literature and without help from them. There are occasional Hellenistic epigrams that, in making reference to the painting of mythological subjects, specify a key element of the setting (Marsyas suspended from a pine, Andromeda loosing her foot from the crag to which she is bound).[4] But the way in which language could be applied to tasks of visual description and characterization became a form of literature in itself. Known rhetorically in later antiquity as *ekphrasis*, it entailed imaginative accounts, of potentially existent or fictive artistic creations.

That the genre or category of artwork which came to be known, in the Renaissance and later, as landscape had any existence prior to Roman times has been denied by many writers on the subject, on the grounds that direct evidence to this effect is simply lacking. Others have argued, with good reason, that those Roman examples that do exist imply some kind of earlier precedent, or a series of such precedents: ones that would then locate themselves in terms of origin in the Hellenistic world, at the point of confluence of different cultural forces, Greek, Alexandrian, and Southern Italian.[5]

What would the defining characteristics of pre-Roman landscape be, if it were thought of in this way? It seems that the premise for the use of the term would lie in there being complete scenes with two governing features to them. Nature would have predominated

in them over the representation of human action, and there would have been a technique of rendition that conveyed a consistency of mood throughout; so that on those twin bases one could speak of landscape per se, set up to play both a scenic and an atmospheric role. This must be what Vitruvius had in mind when he referred, in his account of the evolution of wall painting, to the propensity of the ancients for choosing to depict "the wanderings of Ulysses over the countryside" (per topia, a term designating known and familiar place settings), along with other subjects "taken on similar principles from nature."[6] The first of these phrases suggests several distinct scenic locales with a linking extension of space between them; the second, a technique for transposing onto a two-dimensional surface in paint effects of airiness and volatility such as were to be associated with the outdoors.

In the Greek world of the fifth to third centuries B.C., painted settings were limited in their imagery of nature—as in vase painting and equally in relief sculpture over the same time period—to the showing of trees and plants placed between and behind the human figures, or rocks and stones underfoot. Such was the case already in a scheme of decoration by Polygnotus from the fifth century, as it remained known to Pausanias in the second century A.D. in a version at Delphi; and a surviving example of such inclusions is provided by the mid- to late fourth-century wall paintings of Vergina in Macedonia. A schematic vocabulary of natural detail of this sort served to make the setting plausible in its spatial readability and appropriate to the subject. Vitruvius was aware that, by the later Hellenistic period, there was theatrical scenery decorated in a similarly schematic kind of way, in the form of what were called periaktoi. These were triangular wooden prisms set into openings in the walls that fronted the stage, which could be revolved to suggest a change of scene, including an arrival from the countryside. But what he describes as the choice of subjects from nature (varietates topiorum) to decorate the long walls of covered promenades was of a different order of creation.[7] It offered—inasmuch as he writes of "finding subjects in the characteristics of particular places"—something more like a "code," that entailed the viewer's participation. Such participation, characteristic in general of Hellenistic as opposed to classical Greek art, meant in effect, for extensive outdoor scenery, that the viewer was engaged in responding to and reading from an associatively charged ordering of content and layout.

That basic idea of a "code" has affected landscape painting ever since. In its premise of an intelligible set of principles at work, regulating the disposition and sequencing of natural elements according to an inherent system, it forms the basis of the "ideal" tradition in landscape from the Renaissance on. But what might underlie this in the way of a cohesive attitude toward nature—to form a basis of communication, as in the case of lyric and bucolic poetry from the third century B.C.—remains, for the Greek world down into Hellenistic times, entirely moot.

To understand why this should be so, one must turn back to the data themselves about Greek life and experience. Knowledge and recollection of the countryside on the part of the Greeks might embrace farming and hunting activities that took place there; travel between localities, and over unfamiliar or less charted territory; and the ongoing cult of sacred places such as mountains and springs. But this did not add up to a larger view of the

outdoors, or had no need to move the mind that way, either in physical or in empathic terms—unless in a form commensurate with the experience of nature's ultimate forces, such as storms and whipped-up seas. No ancient texts have come down to us in which descriptive and interpretative language is harnessed to produce (or reproduce) a concrete sense of the way in which the artist's imaging of nature, on a smaller scale, was experienced, and the emotions that were appealed to or called up in this connection. Instead, there are only biographical encomia giving the themes associated with a few selected figures, who are recorded thereby as singular in their achievement: like Apelles' depiction of the "unpaintable" in the form of lightning and thunderbolts.[8] And then there are also evocations of the character of imaginary paintings, which were undertaken as an exercise of the sensibility in their own right.

Given this constraint on the nature of the evidence, what was invested in a Greek painter's earning of the label *topographos*—a term that was used for the second-century B.C. Alexandrian artist Demetrios—and the kinds of discussion that attended such art are matters conducive to speculation, but there is no way in which they can find real purchase.[9] The archaeological data here, such as they are, suggest only a plurality of distinct typologies, adapted to specific functions over several centuries, and certain core ingredients that made for continuity, either in narrative source material or in the favoring of particular motifs. How those materials were handled can be tackled only on a comparative and largely hypothetical basis, which assumes there to be points of distinction between Greek and Roman, or public and private examples on which to build an art-historical argument.

Yet the imaginary descriptions referred to also imply that the component elements making for a particular genre or category in ancient painting are, so far as visual conception and viewing experience are concerned, inseparable from the way in which its character as a genre and its ingredients are verbalized. Those descriptions are addressed to one who wishes to know in principle and to embrace imaginatively all of the elements that can serve as a source of pleasure, in their combinative usage and in the operations of recollection that they induce. That person must also grasp the basic conjunctions of elements that offer themselves as a matter of "rule." So understood, those elements correspond to what is termed in linguistics a "lexicon." A form of discourse through images is mapped out. It mixes expectable inclusions with more complex dispositional features; in doing so it caters to a viewer's sense of competence in being able to handle the genre through words.

The *Eikones* or *Imagines* of Philostratus the Elder, a sophist of the third century A.D., represent a set of such imaginary descriptions in the form of "addresses" through which, according to the author's introduction, "the young may learn to interpret paintings and to appreciate what is esteemed in them." They purport to be inspired by the panel paintings belonging to a Campanian collection or group of collections, set within the walls of a portico on the sea. Goethe, whose artistic circle in Weimar admired the descriptions greatly, published an essay on them in 1818 in which he was responsible for the arrangement under nine headings that has been taken over by modern editors; one of these headings consists of "Landscape, including pictures of the sea." Among the eleven descrip-

tions brought together in this way (immediately preceding the two on still-life subjects, titled *xenia*), the three that come closest to conveying a sense of landscape per se, as it was defined above, are titled respectively "Bosphorus," "Marsh," and "The Islands," to which may be joined the marine subject of "Dionysus and the Tyrrhenian Pirates," which concentrates on the appearance of two ships about to engage with each other, rather than the people in them.[10]

"Bosphorus" extends its description from women on the banks of the river and youths crossing it in a boat to their destination: a house on the sea with a circular stoa and its situation on a lofty promontory, above the dark blue of the sea. It goes on to encompass flocks and herds of cattle, "hunters and farmers and rivers and pools and springs" in other parts of the painting, and ends with a columned temple that serves as a marker, in that it has hung at its entrance a warning beacon light for ships. The continuation that follows focuses on the sea and the activity there of the fishermen and their catches.

"Marsh" begins with the reeds, rushes, and plants growing there. It moves to the surround of mountains and trees, and the springs breaking forth from the mountainside to form a directed alluvial stream with a winding path of its own, "abounding in parsley and suited for the voyaging of the waterfowl," including ducks and a tribe of geese. In the swimming pool formed by the marshwaters swans are ridden by cupids, while others sing on the banks. A broad stream "also issues from the marsh" and there are goatherds with skipping goats and shepherds with their more sedentary flocks crossing a bridge that is made of date palms.

In "The Islands," which are small ones "herding together," different topographic formations are sketched out for each in turn. One builds up to a peak with its sheer cliffs forming a "natural wall"; a second is contrastingly "flat and covered with deep soil," so that it is cultivated by both farmers and fishermen; a third consists of two severed portions that were once joined, so that they correspond inversely to one another in their configurations. Ships sail under their linking bridge; wagons travel over it. There follows a volcanic island, and one "canopied with ivy and bryony and grape vines" that claims dedication to Dionysus, and is peopled with herds and animals, hunters and woodsmen. At the point where the description ends—the landing place for this island—a small palace and bubbling springs herald the appearance of a miniature city, "fair and splendid [but] no larger than a house," with a theater and hippodrome attaching to it.

All of these descriptions include narrative elements, involving the actions of identifiable figures: in "Marsh," the cupids riding on the swans, the zephyrs giving the keynote for their song and the goatherds and shepherds. They are described alongside the natural elements, including birds and plants, and in association with them. But what tends to distinguish the subjects in question from the "megalographic" subjects of myth and heroism, as these are described in other places in the same collection, is the establishment of an implied point of sight for the scene as a whole, while at the same time the exercise of imagination is invited. This is most explicit in the opening sentence of "Islands," addressed to the young boy of ten who in the introduction is invoked as the son of the writer's host, "an ardent listener and eager to learn," who "kept watching and asking for guidance" as the narrator went from one painting to another. "Would you like, my boy, to

have us discourse about those islands just as if from a ship, as though we were sailing in and out amongst them in the springtime [?] . . . but you must be willing to forget the land and accept this as the sea . . . a sea fit for sailing and as it were alive and breathing."

In semiotic terms, relations, processes, and qualities all come up directly within the terms of description, with the capacity for reference attaching to them. Relations are called up in such a way that ones involving time and ones involving space are kept distinct (as also in the still-life descriptions) *except* when it is a matter of continuous narration, with the same figure or figures appearing in more than one scene. "Bosphorus" closes with the words: "the painting gives the very image of things that are, of things taking place, and in some cases of the way they take place, not slighting the truth by reason of the number of objects shown, but defining the real nature of each thing just as if the painter were representing one thing alone." This corresponds in its phrasing to the Aristotelian conception of matter as made up of distinct physical units, such as rocks and trees, with unoccupied space filling up the interstices.

Processes are described in terms of their being intended features of the rendition. Thus in the "Tyrrhenian Pirates" the pirate ship "in order that it may strike terror into those they meet and may look to them like some sort of monster . . . is painted with bright colors, and it seems to see with grim eyes set in its prow." Equally, qualities of a referring sort are brought in as if cleverness and a sense of fitness were the most important elements of art—as opposed to insignificant features, like the puckered lips of pipe-blowers and of the pipes themselves, that have to do "solely with imitation," which is to say, the imitation of related passages in classical literature. In "Marsh," the bridge of date palms thrown across the river is explained in terms of its reference to the way in which palms of opposite sex marry by bending over and, unable to reach the full way, form a "safe bridge for men to cross."

That the viewer should be taken here as responding to the scope of reference on more than one front forms a point of congruence with what can be inferred about the most important series of frescoes surviving from antiquity, in which successive incidents of a story unfold in a continuous outdoor setting: the Odyssey Landscapes now housed in the Vatican Library (Fig. 6). Discovered in 1848 in the excavation of a house on the Esquiline, these frescoes depict episodes from books 10 and 11 of the *Odyssey* including the battle with the Laestrygonian giants (which occupies only a few lines in the poem), the stay on the island of Circe, and the descent into the Underworld. Those particular episodes may have been singled out because they offered an opportunity for the settings to provide a continuity extending by implication from section to section, across all eight sections of the frieze as it survived, together with a patterned repetition of the motifs of cliff, rocks, plants, and trees from one section to the next.

The viewer's sense of pictorial sequencing is appealed to imaginatively in the inclusion of painted pilasters giving the effect of a portico, so that the assimilation of the individual sections framed in this way recalls the experience of a person pausing successively at different viewing points, in a walk in which a consistent distance from the works on display is maintained. The height of the horizon is somewhat higher than would, in that case, be expected and it is not clear how to explain this, unless it be a sign of adaptation

Fig. 6. *The Arrival of Ulysses in the Land of the Laestrygonians*, section 2 of the Odyssey Landscapes, late first century B.C., c. 60 inches high. Vatican Library, Rome (photo: Biblioteca Vaticana)

to Roman conventions of a frieze that was differently located in its original form, so as to afford the viewer a more comfortable kind of access. Small-scale figures in successive zones of space blend in with the setting, and there is a strong intimation of temporality in the handling of light and shade. In this fashion, for one who knows the story—which is most directly echoed in the details of the harbor—episodes involving heroic fortitude, escape by guile and confrontation with the mythical dead populate a larger vista that, without more than a limited material credibility in the various kinds of building it includes, evokes strange lands and forbidding shores.

The term "Greco-Roman" for these creations, insofar as it implies more than simply the possible origins of the artist or artists responsible, consorts with their being an adaptation of story materials and pictorial vocabulary to a specific viewing context. In that context the readability of the narrative—based on key figures it would be hard to pick out without help from the accompanying inscriptions, and this available only to those who could read Greek—becomes less important overall than the relations between elements and their articulation across a continuous space: one that embraces both sea and land, with the appropriate marks of human presence and possession attaching to each. The role of the visual language that does all this is not to link up with the verbal and complement it by making visible what is only described in the Homeric presentation of the story, the gaps or

differences in this respect being too obvious and, indeed, foregrounded. It is rather to supply an imaginative locus for the recall of that story—those parts of it that appealed to the instigators of the commission—and to do this in a way that was transformative of past experience on the viewer's part, and yet at the same time based on a "code" of organization and placement, that discourse could pleasurably expand upon.

To do this with and in front of pictures is, initially, to work within the dictates of a taste. For Vitruvius, writing as an architect and engineer under Augustus in the second half of the first century B.C., the device of ornamenting covered promenades with varieties of imagery taken from nature represented such a taste, to be described in terms of a consistent and characteristic vocabulary of motifs: "harbors, headlands, shores, rivers, springs, straits, temples, groves, hills, cattle, shepherds."[11] But in the perspective of Philostratus the Elder two to three centuries later, the aim of discourse in front of such images was to help the young to interpret and appreciate pictures by giving them a controlling sense of what was "fit" and "significant" in the rendition. In the framing of what was said with respect to relations, processes, and qualities, the setting up of a movement of thought and feeling in the viewer had become inherently more prescriptive. And the way in which this worked was by treating the image that was to be written about as itself a form of text. Whether or not it corresponded to an actually existent painting becomes ultimately immaterial; what mattered was the instructional value that could be given to it on the analogy of a written text, and the way in which that value emerged of its own accord, as it were, from a sensitive adaptation of terms of description to subject.

To work with the "code" in question was not just to advance one's taste, but to promote one's ability to perform with it, putting its application and its controls over judgment into operation on one's own behalf. Such a condition of viewing, encouraging a reading of the ensemble along already familiar lines, rather than a more particularized scrutiny of its details, is by no means unique in Greco-Roman art: witness, for instance, the cycle of episodes in the Trojan War depicted high up around three walls in the House of the Cryptoporticus in Pompeii. But the Odyssey frieze is unique among surviving mural paintings in the role that is given to natural setting in this regard.

INTERTEXTUALITY

In the High Renaissance a shift can be charted along similar lines, from the suggestive play of taste to a more prescriptive framework of description and interpretation. The best way to illustrate it with respect to landscape (for which a generic term, *paese*, has now been called into being) may be through the appeal, in Venice and Northern Italy more generally, of the Ovidian subject-matter of satyrs and nymphs, and the kind of setting that accommodates their presence and their sexual interaction with one another. As in the case of Homeric subject-matter, it was one thing to echo classical passages of text and to supply an appropriate setting for the general tenor of the narrative; it was a distinctive

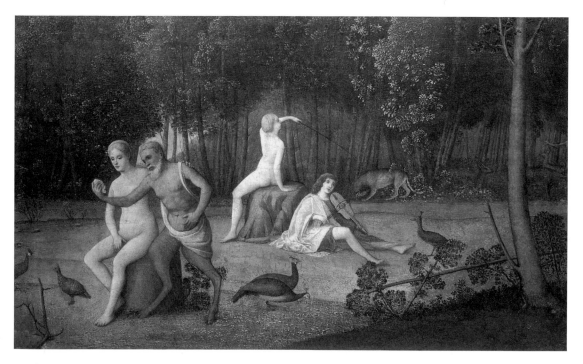

Fig. 7. Giovanni Bellini, *Orpheus*, c. 1515. Oil on canvas, transferred from panel, 15⅝ × 32 inches. National Gallery of Art, Washington, D.C., Widener Collection

step beyond that to solicit the viewer into being able to fill out imaginatively the ambience of those stories.

In literature, nymphs and satyrs become part of the general decor of the pastoral world of Arcadia with the appearance of the long poem by Jacopo Sannazaro, who was attached as a prominent literary figure to the court of Naples, hymning its pleasures and activities. The terms of description there chimed with a taste in humanist circles that was already fueled by Petrarch's poetry of nature, and by the imaginative evocation of antiquity in Francesco Colonna's *Hypnerontomachia Poliphili,* published in Venice in 1499 with woodcut illustrations. But the fact that Sannazaro's poem was in Italian and was printed in unauthorized fashion in 1502, followed by its official and integral publication two years later, instigated a wider currency.

The nature of the taste in question, as it affected painting, is signalled by a small panel painting of Lorenzo Lotto's from about 1505, known as the *Maiden's Dream* (National Gallery, Washington, D.C.), and by the *Orpheus* of Giovanni Bellini (Fig. 7) from a decade later. In the latter case the taming of wild life is included in the imagery; a pure, untroubled stream of blue water flows alongside the rocks and grass on which the figures repose; to complete the conjuring up of tranquillity and harmony, the setting is bounded further back by a grove of trees that are dappled by the play of light and shade. The curvature of trunks and branches there, and the adaptation of one such branch to make a primitive kind of fence at the edge of the bank in the right foreground add an intimation, for the figures sharing the center of the field and the birds as well, of protection and enclosure.

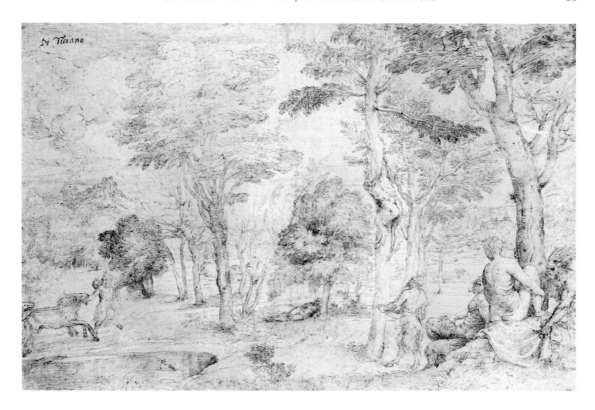

Fig. 8. Titian, *Landscape with Nymphs and Satyrs*, c. 1535. Pen and brown ink on paper, 10¾ × 16⅛ inches. Musée Bonnat, Bayonne

When Titian takes up this subject-matter of nymphs and satyrs in the 1520s and 1530s, in drawings from which prints were to be made, the setting becomes more open, with mountains visible and floating clouds overhead (see Fig. 8). Light and atmosphere are also more diffused, as if they were inspiring in themselves the behavior shown in the center, where a nymph sleeps in the shade of a tree. One satyr has climbed a tree to spy on her, another holds a sheet below ready to catch falling fruit, a third approaches at the left with a flock of gambling goats, and still another pair are already engaged with a nymph who looks away from their grinning faces, as if to gain a fuller sense thereby of what she should do in response.[12]

If this image is compared to a Northern (South Netherlandish) print of mid-century (Fig. 9) that includes similar kinds of detailing to the landscape—mountains and clouds, rustic buildings and animals, winding paths, and a patch of water—the sense of a panorama with a wide stretch to it, in which the human actions find purchase for their purposiveness, stands to the fore in that case also. But there is a more incremental sense of passage via the paths from one component of the setting to the next—in keeping with this being the subject of the Road to Emmaus, with Christ accompanying the two pilgrims and their dog in the foreground—and a more specific quotation of preceding images. In particular, the view of Jerusalem at the back left is derived from a large woodcut of the city, after drawings done by Jan van Scorel in the Holy Land, that was published in

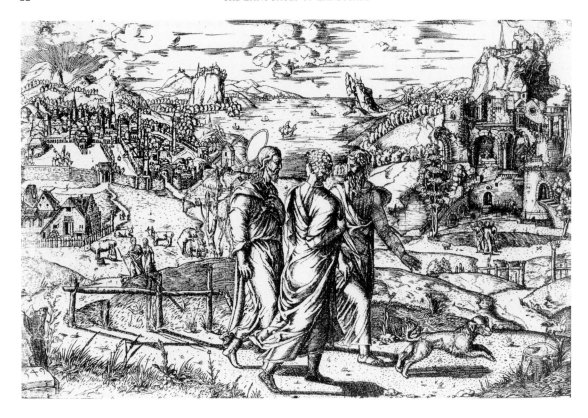

Fig. 9. Attributed to Theodor de Bry, *Christ on the Road to Emmaus*, 1549. Engraving, 4 ×6 inches. The Harvard University Art Museums, Susan and Richard Bennett Fund

Utrecht in 1538; the round palace matching it at the back right, with its Romanesque architectural detail, probably has a similar source.[13]

Neither image depends, apart from the cast of characters, on a literary text for what is shown, and what they have in common, correspondingly, is a putting of the distinct components of the outdoor scene into a counterpoint with one another, which the viewer can be brought to read as if it were a text, in keeping with the tenor of the subject at large. In recent literary theory, the term *intertextuality* designates what is in question here: a relationship between different "texts" of the same time period, in which one is read in the light of, or in terms established by the other.[14] In the *Emmaus* print shipping out on the water, windmills at work and copulating cattle form parts of the scene that the pilgrims have passed. All of these are included as pointing up the temptations of the everyday world, and thus as profane in their role of textual evocation, in contrast to the mission of promised salvation that the pilgrims have assumed. A rationale for the stages of the journey is provided in this way, with another pair of travelers on their way to the same high-up point, from which the whole landscape in its multiplicity and strangeness can be taken in at once.

In the Titian drawing, the landscape serves as a source of pleasure through the hedonistic (which is to say, totally unspiritualized) associations that it carries; it becomes in this fashion akin to a text in its own right. Here a specific *intertext*—playing a mediating role

without serving as exact source—is to be found in fact in Sannazaro's *Arcadia*, in a brief passage in which shepherds climb to a temple and find painted above its entrance a pastoral scene that shows, alongside herds and shepherds, naked nymphs who are standing "half-hidden as it were behind the trunk of a chestnut tree" and satyrs in pursuit of them, "stealing very softly through a thicket . . . to seize them from behind."

That early viewers and appreciators of Titian's paintings with satyrs in them, such as the *Pardo Venus* (in the Louvre) were aware of such a line of connection is brought out by the humanist Lodovico Dolce's comments, in his 1565 *Dialogue on Color,* on a painting of nymphs spied on by satyrs. This, he wrote, might constitute an allusion to the temple painting in *Arcadia* (which Dolce had edited in 1556); if so, it served to indicate "that this was intended to be the Land of Lasciviousness."[15] Titian's painterly procedure was not simply one that served to "light up and gladden the whole landscape," as Dolce had put it in a formal description he wrote about 1554 of the *Venus and Adonis* sent to Philip II of Spain;[16] it could be taken prescriptively as a conduit for conveying those effects, of light and texturing especially, that incarnated the release of libido, for viewers of the picture guided by their sensibility to respond in those terms.

ASSOCIATIONISM

In the cult of the picturesque in the eighteenth century and the movement of thought that developed out of this toward the end of the century—in Britain especially, but also in France and Central Europe—the principles so far discussed, involving the viewer's capacity to respond discursively to a "lexicon" of pictorial elements, received a firm semiotic foundation. This was a function of the fact that, as commentary on the picturesque took shape, the leading protagonists wrote theoretically on the subject, to a greater extent than their classical or Renaissance predecessors; and they engaged in active debate as to whether the play of association that images of nature set up in the viewer's mind should be of a controlled sort, or inherently freer in character.

The term *picturesque* came to be applied in the eighteenth century to landscape gardening, estate design, and related architecture (especially the creation of artificial ruins and follies), and in addition to a range of pictorial media, with varying functions and uses: drawing and watercolor, printmaking and book illustration, as well as oil painting itself.[17] Originally it had meant simply "graphic" or "pictorial," but it came to be linked in the first half of the century with the appeal of subjects suited to pictorial representation, and with the kind of viewing activity in front of landscape in which contemplation brought to mind a specific structuring of perception, associated with the landscape painters who were most in demand among collectors at the time: Claude Lorrain, Salvator Rosa, and Gaspard Dughet, known by the surname he adopted from his brother-in-law Nicolas Poussin. This larger meaning and the discourse of appreciation associated with it form the basis for the definition that William Gilpin gave, when he first used the term *picturesque*

in his 1768 *Essay on Prints:* it represented "that peculiar kind of beauty, which is agreeable in a picture."

The principle of selection at work here was one that could be applied equally to the sites and scenery visited by tourists, as travel for this purpose, into Wales and to the Lake District, and also through France and Switzerland into Italy, became increasingly popular from the 1770s on. Gilpin himself contributed to this trend. The successive "tours" that he published from 1782 on guided the visitor to the picturesque beauties of the River Wye, the Lake District, and the Highlands, and helped to train the very way in which nature was perceived on the spot through the illustrations provided from watercolors of his. The picturesque became accordingly a vogue word, mediating between man and nature through the formulaic way of seeing that it imposed.

What that way of seeing entailed, as the creation of a poetry of place on the analogy of literary evocation, is shown very effectively in a painting by Michael "Angelo" Rooker (Fig. 10).[18] Rooker had studied under Paul Sandby and would make sketching tours of Britain from the late 1780s on, trying rather unsuccessfully to find a market for his watercolors; at the same time he worked as an engraver for magazines and other illustrated publications. There is an obvious recollection of Claude in the high-up panoramic viewpoint and framing pair of trees on the left, with smaller clumps serving like stage flats to introduce the middle distance, and the country house that forms the subject, Temple Newsam outside Leeds, set atop a gently rising slope against a large expanse of sky. Between the foreground staffage of figures and bushes and the house itself the eye is invited to travel along a series of extended diagonals and gentle bends—those of the lake especially—and in so doing to become caught up in a mood of studied calm and reflectiveness.

The establishment here of a commanding viewpoint, and the controlled and graduated passage of vision forward and back it affords correspond to the way in which the term *prospect* had begun to be used for landscape in the sixteenth century. This usage of the word was extended in the mid-seventeenth century to pictorial representations of such scenic views, and also to landscape planning. In James Thomson's poem *The Seasons* of 1730, in the section devoted to the estate of Lord Lyttleton at Hagley Park, where the poem was expanded in the early 1740s, there is a specific celebration of the opportunity for Thomson's patron to enjoy such views:

> Meantime you gain the Height, from whose fair Brow
> The bursting Prospect spreads immense around . . .
> And snatch'd o'er Hill and Dale, and Wood and Lawn
> And verdant Field . . . your Eye discursive roams . . .
> To Where the broken Landskip, by Degrees,
> Ascending, roughens into ridgy Hills.[19]

At Temple Newsam, the improvement of nature's beauties by means of Art that Thomson had celebrated was the work of Capability Brown, beginning in 1765. It included the large artificial lake that appears in the painting and an assemblage of natural features that artfully intermixed light and shade across diversified combinations of scen-

Fig. 10. Attributed to Michael "Angelo" Rooker, *View of Temple Newsam, Yorkshire*, c. 1767. Oil on canvas, 39¾ × 52 inches. Collection of the Earl of Halifax, Garrowby, Yorkshire

ery: hilly slopes and lawns, rocks and water, groves and glades. A Salvator Rosa–like wildness and the scenic placement of waterfalls and lakes in Jacob van Ruisdael's art were thereby called to mind, as well as Claude Lorrain's pastoralism of mood; and this became a source of pleasure in its enlivening felicitousness.

William Gilpin's "lexicon" of the makeup of picturesque views, as he developed it in his writings of the 1780s and 1790s, subdivided itself to include mountains and lakes in the background or middle distance; valleys, woods, and rivers, which he termed "off-skip"; and in the foreground rocks, cascades, broken grounds, and ruins, as well as figures and animals. He also specified trees of differing character and forest scenery. But while in park scenery he expected lawns and their appendages to be arranged in a fashion that provided both artificial variety and depth of vista, he also advocated that there should be a graded transition through the park, from the neatness and elegance of the house itself to greater roughness and "wild scenes of nature," which he named as including wood and copse, the "glen" and the "open grove."[20]

Sir Uvedale Price, a wealthy landowner and Whig member of Parliament who entered the debate on the essential desiderata of the picturesque in the 1790s, was in agreement

on the importance of flexibility and neatness as one approached the house—to judge from the records of his own estate garden at Foxley (Herefordshire)—and he continued to evoke, at least initially, the example of the great landscape painters, Claude especially. But he also sought, in his 1794 *Essay on the Picturesque,* to define more prescriptively what separated the picturesque from the "beautiful" and the "sublime." For this purpose—with the example of Thomas Gainsborough, who had worked at Foxley, to draw upon—he invoked the qualities of roughness, irregularity, and sudden variation. He also stressed the importance of intricacy, which he explained as "that disposition of objects which by a partial and uncertain concealment, excites and nourishes curiosity," and of movement imparted to the eye as an antidote to monotony.[21] Richard Payne Knight, whose "didactic poem" *The Landscape* (1794; Fig. 11) had appeared a few months earlier, dedicated and addressed to his friend Price, illustrated his objection to "shaven lawns" and "trimmed hedges" such as Brown had favored, and the lack of variety in tone and shading, which Price termed "baldness," with a pair of contrasting plates: the lower one resembling Rooker's painting in its point of view and layout, while the upper one aims to bring out the advantages of variety and informality of arrangement.

Knight is equally prescriptive, in his advocacy of "just proportions" and the consistent use of woodland "to outline [the] scene" in bolder fashion than "unbroken turf's smooth even green" would permit. His "lexicon" is one which

> wood, water, lawn in just gradation joins,
> and each with artful negligence combines,[22]

so that the "natural" is encoded, as in Gainsborough's drawings, on the model of Hobbema and Ruisdael and the "intertext" that they provided, together with Rosa, rather than on the model of Claude.

As to how the picturesque served as a source of pleasure in its elements of surprise and contrast, the argument of the Scottish philosopher Archibald Alison about the nature of response on the part of the viewer provided the basis for a specific disagreement with Price, which Knight went on to articulate. In the first of his *Essays on the Nature and Principles of Taste* (1790), discussing the role of the emotions to which painting and poetry give rise, Alison held up landscape painting as an art form in which—compared to gardening—the artist was relatively free to use an imaginative selectivity in both the materials and their disposition, so as to "improve the expression of the real scenery." In particular, the inspiration of the momentary and the seemingly accidental could be used to create a heightened effect of strength and unity. Here Alison had in mind a more "improved" taste than for the "mere assemblage of picturesque incidents": to wit,

> Some general principle is universally demanded, some decided expression, to which the meaning of the several parts may be referred, and which, by affording us, as it were, the key of the scene, may lead us to feel, from the whole of the composition, that full and undisturbed emotion which we are prepared to indulge.

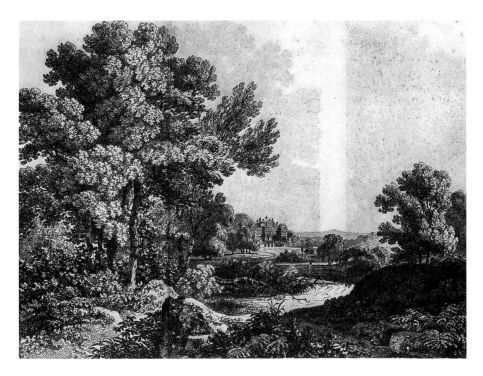

Fig. 11. Thomas Hearne and Benjamin Thomas Pouncy, pair of contrasting etchings, each plate 11 × 9 inches, for Richard Payne Knight, *The Landscape*, 1794. By permission of the Houghton Library, Harvard University

The masters of landscape that Alison invoked to exemplify "purity and simplicity of composition" of this order were still Salvator Rosa and Claude. But he went on to propose that fuller or deeper acquaintance with such art could bring about a change in sensibility. A realization of the degree to which the artist departed from reality could lead from a sense of "some degree of surprise" at first to "an emotion rather of wonder than of delight," and so progressively as "we begin to connect expression with such views of nature," to a form of understanding in which "it is not for imitation we look, but for character." In that spirit, it then becomes possible to consider the landscape as the artist presents it as "a creation of fancy in which only the greater expressions of nature are retained, and where more interesting emotions are awakened, than those which we experience, from the usual tameness of common scenery."

In this way to discover the "object of painting"—as an imaginative process of selection and construction—was to come to feel at one and the same time how "unity of expression" represented "the great secret of its power." What was "vivid" and "striking" in the character of the picturesque, as it metamorphosed toward the end of the century, was thereby linked to the exercise of a trained appreciation for painted landscape; in poetry, in Alison's view, the opportunity for "bestowing on the inanimate objects of [the] scenery the character and affections of mind," to produce "an expression which every capacity may understand, and every heart may feel," was even more pronounced.[23]

Alison went to suggest in his Second Essay, dealing with response to the material world, that material objects—whether they be works of nature or of art—signify not in themselves, through their component properties, but in virtue of qualities possessed by them that generate an emotional response in the viewer. The associations that affect the imagination in this way prove expressive because

> in works of art, particular forms are the signs of dexterity, of taste, of convenience, of utility. In the works of nature, particular sounds and colours, &c. are the signs of peace, or danger, or plenty, or desolation, &c. In such cases, the constant connexion we discover between the sign and the thing signified, between the material quality and the quality productive of emotion, renders at last the one expressive to us of the other, and very often disposes us to attribute to the sign, that effect which is produced only by the quality signified.[24]

When Knight came to argue with Price in his *Analytical Enquiry into the Principles of Taste,* it was in similarly prescriptive terms: the relation to painting expressed by the word "picturesque," he now wrote,

> is that, which affords the whole pleasure derived from association; which can, therefore, only be felt by persons, who have correspondent ideas to associate; that is, by persons in a certain degree conversant with [such] art. Such persons being in the habit of viewing, and receiving pleasure from fine pictures . . . [25]

In the earlier phase of the picturesque toward mid-century, the viewer had been invited to participate in a certain taste—for temples, ruins, and other ornaments artfully disposed

within the scenery of the park or garden—picking up the associations that were encoded in the choice and arrangement of particular features recalling paintings. Such had been the case in Lord Cobham's garden at Stowe, with its Elysian Fields and Grecian Valley as completed by William Kent after 1738, and in Henry Hoare's layout of Stourhead in the 1740s so that lake, grotto, and cave evoked specific episodes in Virgil's *Aeneid,* and perhaps also paintings and sculptures represented in the house itself, as part of Hoare's collection displayed there: like the choice of an easy or a hard way, based on Nicolas Poussin's *Choice of Hercules.* [26] Response was directed in the sense that positional relations among the elements were open to discovery, rather than being locked into a grid system, as with the statuary, hedges, and paths of sixteenth-century French gardens or the park at Versailles. The material and physical experience of the visitor followed a path of revelation, in the sense of opening up successive views that could both surprise and enlighten, according to an underlying scheme. (In the Renaissance garden, surprise tended to be more crudely humorous.) There was also an association to politics as well as painting: to the public world of civic responsibility and its ideals of liberty and concord modeled upon antiquity.

Knight, in contrast, advocated that the "skilful painter" should concentrate exclusively on those "parts of his subject" that are inherently picturesque: "those which nature has formed in the style and manner appropriate to painting," so that they are available for him to "adorn and embellish." The pathway for the sensibility that is charted, with the support of Alison's thinking, entails "comparing nature and art" so that eye and intellect "acquire a higher relish for the productions of each"; contrast as well as association invigorates the "ideas" that are thereby "excited." This is more narrowly prescriptive in the sense that it brings the workings of association back into the realm of art, in an intertwining of discursive interchange between art, literature, and the natural landscape that is controlled by prior conversancy. As Knight put it: "The spectator, having his mind enriched with the embellishments of the painter and the poet, applies them, by the spontaneous association of ideas, to the natural objects presented to his eye, which thus acquire ideal and imaginary beauties: that is, beauties which are not felt by the organic sense of vision; but by the intellect and imagination through that sense."[27]

LANDSCAPE ENGENDERED

So one comes to a scheme of wall painting that—in respect to the deployment of a "lexicon" of elements, the role of intertext, and the play of associations—sums up all of the subthemes of this chapter. This is the decoration of the main drawing room at Norbury Park, Surrey (Fig. 12), undertaken for the collector and artistic enthusiast William Lock around 1775–86 by a team of artists, so that three of the walls were covered in scenic views down to the floor. The attraction here to visitors—unique to the period, though there is a comparable painted room of the 1790s, from Drakelow, attributed to Paul Sandby—lay in a choice and arrangement of features that recalled directly all of the

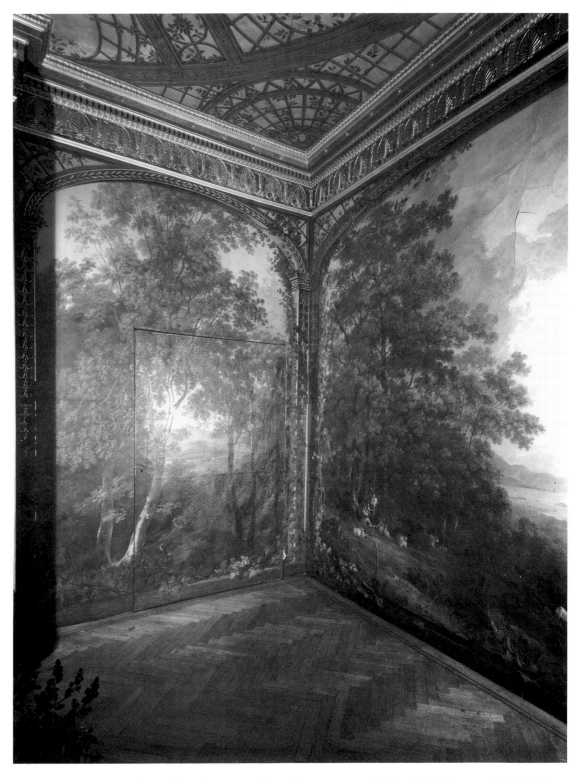

Fig. 12. George Barret and co-workers, decoration of main drawing room at Norbury Park, Surrey, c. 1775–76. View toward the northwest corner, showing two sections, oil on canvas, c. 15½ feet high, and portion of ceiling

favorite components informing the taste for the picturesque, and in the seeming continuity thereby provided with the views of vale and hill and outlying parkland obtained through the windows in the fourth wall of the room.

The framing device for this scheme, which was the contribution of an Italian artist, Pastorini, consisted of a painted trellis above and below the cornice of the room, with its supports enclosing distinct views corresponding to the shape of the room (which had doors set flat into the walls and one wall broken forward where the mantel and chimney came), and its circular top treated as if open to a sky of pale blue with white clouds in it. A carpet of green, imitating mown lawn, originally covered the floor. The surround of the protruding chimney, with a pier glass set into it, was painted to suggest an arbor with honeysuckle, roses, grapevines, and convolvulus growing over it, which reappeared in the trellis on the adjoining walls and ceiling. Within the views themselves, which were done by the Irish artist George Barret, rocks and hillside, trees with different kinds of foliage, and expanses of water were most prominent.[28]

Such were the relations governing the scheme, and the way in which it offered an anthology of picturesque motifs is best expressed by John Timbs, an early nineteenth-century author who, when the taste in question had become increasingly popularized, began his *Picturesque Promenade around Dorking* (1822) at this house. The west wall, as described by Timbs, "introduced an assemblage of the lakes and mountains of Cumberland and Westmoreland blended together . . . expressive of the most majestic idea of rural grandeur." The "rude crags and distant summit of Skiddaw" were contrasted here with the "placid expanse of water below," lit by a setting sun and enlivened by the "tints of a retiring storm, shadowing the mountain's side." To the right of the mantel with its arbor and in continuation to its left, there was a more gloomy "view of immense rocks," and then contrasting with that, a "placid effect of evening serenity," with a shepherd talking to his love. On the third wall, bounded on one side by hills and rocks, came a view of the ocean, with a "variety of characteristic accompaniments."[29] Lock, who had bought the house in 1775, was a friend and admirer of William Gilpin, who began his *Western Tour* a short while after with Norbury; while still another Italian, Giovanni Battista Cipriani from Pistoia, was responsible for the figures in the landscape, Gilpin's brother Sawrey is recorded as having painted the cattle.

In Gilpin's description of the scheme—which, being in oil on stucco, has faded considerably or lost its original surface as one sees it today—it was the plausible and skillfully created sense of illusion that was particularly stressed as a unifying factor. This sense extended to tones of autumn shown throughout, to the inclusion of rainclouds more and less heavily massed, and to the sun breaking through; and, as in the Odyssey frieze, there was a unidirectional lighting corresponding overall to a particular time of day (here, shortly before sunset). Gilpin also brought out in some detail the processes by which, as in Titian's landscapes (pages 21–23), rough and distinct elements or surfaces in the nearground and the judicious placement of figures and buildings harmonized with the varying depths of recession, to endow the scenery as a whole with an enhanced richness. So that the "prospects" should not compete with one another, variety and extension are both in principle treated as important. And to the general concerns of the picturesque—

as articulated for the visitor through the intertext of Gilpin's writings—is added an inviting atmosphericity and a spatiotemporal focus that is primed to link up the artificial with the real.[30]

But what kind of a responsive "seeing" is the viewer invited to engage in here, that endorses and upholds qualitatively the ingenuity and attractiveness of the scheme? In his *Unconnected Thoughts on Gardening* (1764), William Shenstone—best known from mid-century on for the poetry of associations embodied in the garden that he brought into being for his house in Shropshire, The Leasowes—offered a distinction between "landskip" and "prospect": "the former expressive of home scenes, the latter of distant images." Shenstone's discontinuous musings and prescriptions as to how the mind should be engaged in the exploration of a garden offer no further key as to what "home scenes" should contain. Instead, he harps on those aesthetic considerations that would become standard in the theory of the picturesque: the gratification introduced by a variety of "pleasing objects" (among which he includes cottages), and the kind of balancing contrast that is maintained by keeping art and nature distinct.

But where Shenstone turns most specifically from suggestions to rules imposed upon the exercise of the picturesque sensibility and what it takes in, is in his insistence as to how the eye and the imagination should operate. "[The Eye] should always look . . . down upon water"; objects should be "less calculated to strike the immediate eye than the judgment or well-formed imagination: as in painting"; and in a further extension of the analogy between "prospects" seen from a distance and their pictorial representation, "a plain space near the eye gives it a kind of liberty that it loves [and one which "home scenes" presumably do not allow]. And then the picture, whether you chuse the grand or beautiful, should be held up at its proper distance."[31]

What Shenstone advocates in these prescriptions of his—in precedence over alternatives—is essentially a masculine way of seeing landscape: one that seeks to impose control on the viewing of nature by the promotion of a commanding point of sight, and to empower a sense of freely taking hold of it from afar. It was not that this kind of viewing experience was excluded, either physically or emotionally, in the faculties that female viewers brought to bear, but rather that social and cultural forces at work tended to polarize response to landscape. The affections and concerns to which a feminine sensibility would be drawn were correspondingly subordinated, in what could amount to a peremptory way. And the cult of the picturesque could, in its public and prescriptive aspects, draw powerfully—as its accompanying discourse shows—on that kind of gendered preference.[32]

In the Odyssey Landscapes the governing thread in the story of Odysseus's resourcefulness and sustained initiative is matched—appropriately for a male audience—in the placement of his heroic encounter with the enchantress Circe at the center of the scheme, and in Titian's satyric landscapes a strongly masculine ethos is implied in the theme itself. At Norbury Park, the painted trellis is adapted, either directly or via later Italian examples of such a scheme, from the ceiling decoration for the garden loggia of the Villa Farnesina in Rome, created by Raphael and his assistants, and from Parmigianino's use of this device to frame the story of Diana and Actaeon, in his decorative scheme for the Rocca at Fontanellata (near Parma).[33] But in place of the representation on those High Renaissance

ceilings of the desiring gaze and what it fastens upon—while amorous cupids, singly or in pairs, watch over the scene—here the dissolution of boundaries between the painted and the actual is more absolute. What invites capture by the gaze is the illusory appeal of landscape itself, compounded as masculine construct in the forceful play of associations that is set up.

In a period marked by the engendering of literature, especially the novel and the educational tract, in virtue of the development of a specifically female readership, it was still difficult for a differentiated version of the experience of landscape to emerge, except in the private sphere (as in later eighteenth-century women settlers' accounts of the kind of garden they would like to establish in the New World).[34] An adequate vocabulary for this purpose was lacking—and perhaps, with a few notable exceptions, still is. But that there could be a different order of visual language, with correspondences of a different sort to literature, is evident in the later landscapes of Jean-Honoré Fragonard, done after his return to France from his second stay in Italy in 1773–75.

Fragonard's *Blindman's Bluff* (Fig. 13 and Color Plate I), in the National Gallery, Washington, D.C., forms a pendant in its dimensions to his painting in the same gallery of *The Swing* and may originally have been joined to it. Both of these canvases and the so-called *Fête de Saint-Cloud* (Banque de Paris) may together have belonged, according to one suggestion, to the scheme of decoration of a house of Fragonard's outside Paris; at all events, the patron for whom they were done is not known.[35] Fragonard would have been familiar by this date with the British theory of the picturesque as transposed for French readers by Charles-Nicolas Cochin *fils* in his *Voyage d'Italie* of 1758 and by Claude-Henri Watelet in his *Essai sur les jardins* of 1774. He would have been encouraged thereby to improve on actual landscape sites; to make up landscapes that were informed by the aesthetics of the *pittoresque*; and particularly to draw for this purpose on his experience of the gardens of the Villa d'Este at Tivoli, to which he had been introduced in 1760 by his early patron the Abbé de Saint-Non, who was a known enthusiast for the *pittoresque* landscape. He would also probably have been familiar with the philosopher Condillac's development, from 1746 on, of the concept of the "natural" sign, determined in respect to what it signifies by natural law or necessity, as distinct from the "instituted" sign, which is socially determined, in virtue of an agreed universality of purpose pertaining to its selection (as in the example of words). The former kind of sign was of interest to Condillac insofar as it could be used at will to represent feelings. The key difference from the non-natural sign then lay in its capacity for spontaneous generation, wherever the reference embodied in it caused this to be the case, independent of choice or reason.[36]

In *Blindman's Bluff* the women are in active roles, the men less so compared to Fragonard's earlier art.[37] They engage in play and conversation under the aegis of the goddess Minerva, whose statue (transposed from the Villa d'Este) stands on the terrace at the upper right; children are also included, attached in one case to a woman who is carrying out a domestic task. On the base of the fountain at the left women also appear, as sculpted figures with hands joined in meditation. The landscape has no "female" forms in it, that harp associatively on the role of a possessive, capturing kind of vision; it defeats that sort of association through its irregular shapes and flattened profiles. Texturing especially gives

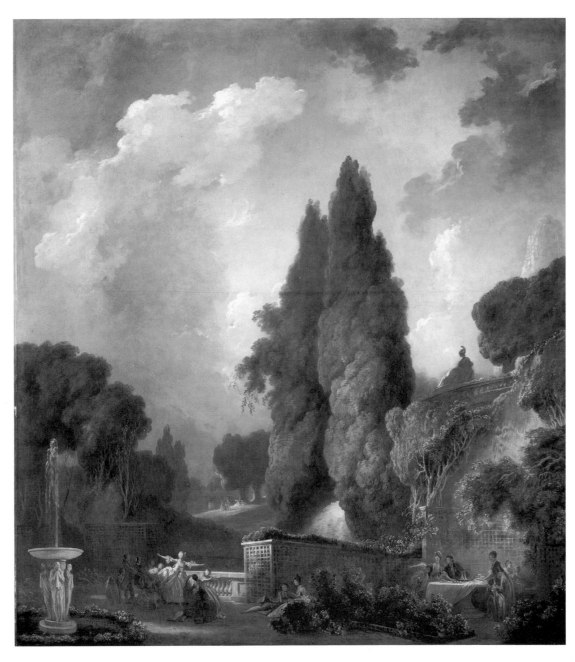

Fig. 13. Jean-Honoré Fragonard, *Blindman's Bluff*, c. 1775–80. Oil on canvas, 85⅛ × 77⅞ inches. National Gallery of Art, Washington, D.C., Samuel H. Kress Collection

rise to a sense of fantasy without specific focus or organization throughout the setting, so that a visionary sense of beauty is in the dominance, and art and nature appear as combined rather than competing.

The values projected in this way are ones reflected in the language of the time, without their invocation being polarized according to physical gender. They refer to a socially constructed version of reality that, in its behavioral emphases and sensitivity to the psychological conditioning of personality, draws attention to the importance of the education of the senses, and to the kind of intimacy that, in the sphere of art, involves women now in the mediums of needlework and tapestry. As there, so also in the case of landscape the values in point can play a determining role in the appreciation of images that are close-textured and softly or subtly colored.

To understand the contrast being made here between "masculine" and "feminine" types of image (which are in both cases by male artists), a further point of history needs to be brought in: the limited scope for women's art to be produced that could be related—other than privately—to those values, and the terms of its subsequent reinstatement. Because the decorative arts were taken away from women, from the later eighteenth century on, as a public forum for the demonstration of interests and skills, the terminology that lends itself to describing the particular aspects of the rococo that are in question here, in terms of their engenderment, has to be taken from French craftswomen's reclamation of the "intimate" and the "domestic" at the end of the nineteenth century, linking them to forms of pictorial representation that are at once "organic" and "suggestive" in the kinds of exploration they invite.[38]

This is not to say, then, that such a landscape of Fragonard courted female viewers, through the way in which it represents what is taken here as being a strongly feminine side to his art; but that nature, in the intimacy and playfulness of the scene depicted, defines itself here in opposition to the receptive and bountiful nature that is mastered by masculine force, to the point of being implicitly under the control or dominance of the male gaze. In particular, the sense of a specific time and of a governing viewpoint is displaced by the role given to memory; if there is an invitation here to enter the landscape, it is not a landscape altered to make it comply with a dream of possession, but one that is appropriate in its scenic resonances to an idealized intimacy and domesticity. In these ways, in contrast to more constrained dependencies on an intertext, the "feminine" qualities of Fragonard's park setting take on a seemingly "natural" signification.

2

Pragmatics of the Creative Process

Production: Output and Outlook

The production of landscape art comprises both the bringing into being of images with a particular cast to their subject-matter, and the putting of those images into circulation. However one makes the separation here between the artist's own active responsibility, and what devolves from the discriminations and decisions of others, putting on a signature and mounting a work are extensions of what went into its generation; they overlap into, and contribute to, making the work known. In an artist's lifetime, display and availability for purchase, whether arrived at consciously or by force of circumstance, turn the work that is so offered into an item of commerce. A name becomes associated with a particular kind of perception. In what does that "perception" consist, to which viewers respond in a shared or potentially shareable fashion?

It may be hard for us today to think ourselves back into a context of creation for landscape painting, in which its ultimate purpose and value are not tied to working outdoors directly from nature, or at least observing and sketching there, as a source of conversancy with particular features, topographic or botanical. Communing with the forces of nature in this fashion, grasping the moment and making direct notations of effects of color and light have become the criteria of a focused response to the subject-matter of landscape, that communicates itself both efficiently and succinctly. One speaks

accordingly of being returned to nature as to a primal state of being; of being brought to
know one's environment in specific seasons and points of time; of being put into touch
with organic processes of growth and change.

Down through history, however, the vast majority of landscape paintings have been
produced to satisfy needs of a more practical, workaday sort. "Nature" is not only con-
ceived of in a great variety of ways; in the background of altarpieces, on the walls of
private houses, in the stock owned by art dealers, it represents an amenable construct.
Like a syntax in the case of a spoken or written language, it could be made to function
synthetically in particular cases and contexts, in parallel to current perceptions and
intersubjectively held values. The sense of tradition in the representation and framing of
nature could itself be adapted, so that, as well as licensing fresh variations, it matched a
particular set of inventions to the ideological outlook of consumers belonging to a particu-
lar social class and economic background.

Evidence attaching to the works in question or to the context of their display some-
times allows one to infer what the practical needs and requirements of production were
like, and how they corresponded to attitudes and experiences belonging to a particular
cultural group and social milieu. A contract of 1485, for the frescoing of the Tornabuoni
Chapel in Santa Maria Novella, Florence, assigns to the painter, Domenico Ghirlandaio,
responsibility for putting in not only figures and costumes, but also "buildings, castles,
cities, mountains, hills, plains, rocks . . . animals, birds and beasts of every kind."[1] A
specific skillfulness on the artist's part was to be exercised in all of those forms. In the
inventory of Jan Vermeer's estate in Delft taken in February 1676, a "small seascape" and
a landscape are listed as hanging in the front hall of his residence, and in the great hall a
painting "representing a peasant house."[2] These works that Vermeer owned are not
identified any further, but they correspond to types of picture that already filled private
houses in Delft by the first decades of the seventeenth century. An archival historian has
recently estimated that there were some 15,000 such landscapes in that city by 1620 and
22,500 by 1660, with seascapes and river scenes rising steadily in proportion during that
time period, and with beach scenes and cityscapes coming to join the subdivisions that
were significantly represented by the time that Vermeer produced his *View of Delft* and
Little Street, the only such paintings of his now known.[3]

Canaletto in 1727, according to the agent acting in Venice for the duke of Richmond,
was so much in demand that he had to be bribed to complete what British collectors
wanted from him; and if that expedient worked, he could then produce a "view of the
Rialto Bridge . . . in twenty days."[4] And Joseph Vernet, the French painter of "wild"
subjects, wrote by the mid-1760s of wanting to be left free to give of his best with only the
"dimensions and general subject" specified. Nevertheless he took responsibility over his
lifetime for permutations on the imagery of cascades, torrents, rocks, high mountains,
tree trunks, and ruins that fulfilled what was requested of him.[5]

Implied in all of these cases is not just a repertoire of landscape elements and a syntax
for their arrangement, but a practice built up progressively with particular patrons and
admirers (and latterly, dealers) in mind. "Nature," as a generative force behind the
production of paintings, gives rise to a set or range of subjects comprising details linked to

one another that can both distract, in their contribution to a mood of leisurely enjoyment, and embellish the physical context in which they are to be installed. Such a form of production, comprising what will be termed here both modalities and specializations, goes back to Roman times.

The concept of "modes" or "modalities" was not applied to painting until Nicolas Poussin attempted this, rather tamely, in a letter of 1647 to his patron Chantelou, drawing for that purpose on a mid-sixteenth-century musical treatise written and published in Italy. But the application to music itself goes back to antiquity, where it served to indicate how differences in sequence of intervals and in tonality could have differing ethical affects attributed to them. Plato and Aristotle assigned ethnic names (Ionian, Lydian, Dorian, Phrygian) to the "harmonies" in question.[6] If "mode" is taken as signifying, in the case of painting, a relationship between structure and affect that can be adopted by choice and applied to particular tasks of rendition (as with the bird's-eye view, which, in Roman art, is related to the conventions of mapping), then the Romans certainly operated workshops on the principle that particular schemes of arrangement, involving natural and architectural elements, could be used recurrently in wall decoration.

What links these recurrences—to constitute a modality—is the presence of an informing concept by which invention and execution are constrained, without thereby becoming delimited. They are not delimited because different frameworks of creation will provide differing incentives for what is done: for magnification and miniaturization, the floating of the landscape imagery on a continuous ground of a single color, or its aggregation around a "core" that is dictated by the subject. Pliny the Elder in his *Natural History* of the first century A.D. attributes to one Studius or Ludius the invention of painting walls with representations of "gardens, groves, woods, hills, fish-ponds, canals, rivers, coasts," and he would appear to be syncopating together here the spread of a fashion and a named figure who had become legendary in that connection.[7] Whatever his historical status, no single artistic personality could have originated the several and overlapping frameworks of invention in question here; rather, they evolved over time, in a manner that permitted the governing modality in each case to bring under its overlay the satisfying of current and newly topical requirements.

Thus a mode of working or modality entails an organizational concept that proves adaptable to a variety of frameworks. A specialization in turn differs from a mode in being a more purely artisanal term. It posits an expertise practiced in particular workshops. The patterns of combination and juxtaposition that it imposes, adjusted to specific locations, are recognizable by their geographical distribution.

Among the Romans, the creation of stage designs, and of tablets that were left at cemeteries with paintings or epigrams on them, offered the opportunity for marketing and disseminating such an expertise. Presumably the same applied to landscapes in such a typical form as the "sacro-idyllic" vignette, comprising a shrine with worshiper or offerings, materializing against the background of a sacred grove. But this said, there is no way of specifying just how a modality evolved into becoming the basis for one or more specializations. The sacro-idyllic landscape is itself, in its extant forms, most often a medley of received and familiar elements, such as the framed panel or window and the

vignette, to which new motifs may be conjoined. The most one can say is that competing combinations and thematic subdivisions, coupled with the task of adaptation to specific sites and patrons, generated a proliferation of alternatives as to how the sacred and the profane, rustic detail and otherworldly atmosphere, spatial continuity and its denial in favor of flatness, could be melded or juxtaposed.[8]

The Campanian villa owner of the first century B.C. and later could opt for architectural constructions reaching out seawards over iridescent water; shrines treated like artificial islands; trees, plants, and shrubs particularized; figures, larger and smaller; fruits, animals, and birds, along with a great variety of framing devices or overall schemes of coloration. And similar conditions of choice apply to the various specializations of the Dutch seventeenth century in landscape: dunes, country roads, woods, water, the beach, the sea, and the townscape.[9] The result could be stereotyped, in the sense of drawing upon conventionalized subject-matter and on mimetic skills for specialized purposes that were learned and passed on, and yet be adapted structurally in its particulars for the sake of a specific, interpersonal kind of sociability on the viewer's part: a sociability that was directed to appreciating in a certain key, and bringing indoors, the pleasures and pursuits of country life (*rus et otium*) as if they were vicariously possessable in this fashion.

Production was then, with Roman landscape, a matter of multiplication and diversification within limits keyed to the relationship of workshop and client. Small-scale models, sketches done in the form of underdrawing or the temporary exhibition of works already in progress served as the vehicles of choice and decision, as to what suited and what could be afforded. Style represented a way of putting things together rather than an ultimate artistic goal, the highest praise being given to the painter who drew attention to his skill and knowledge by including details of a readily recognizable and thoroughly plausible sort. And all of this fell within the framework—as again in seventeenth-century Holland—of the obsession of an urban elite, busy and prosperous, with the countryside, its most familiar occupants and the religious and historical resonances of the buildings to be found there.

The two Roman wallpaintings illustrated here (Figs. 14 and 15) use specific structural devices and expressive means to body forth in one case shimmering light and airiness; and in the other the cultivated ordering of nature's variety and bounty. In both examples— one cut out of its original setting, the other decorating a pair of rooms that remain as they were found—a particular idiom of relationship to the wall surface is put to work. The term *idiom* in the domain of language designates a dialect or whole style of speaking that links hearers in their consciousness and understanding to what is being spoken. It represents in words a particular view or expressive interpretation of reality, with which its users wish to be associated. In Roman villa construction, the provision of windows in which scenic views of nature were framed provides an example of an idiom affiliated to what happens in painting. Desires stemming from the natural world are thereby served; what was wished for in the way of a knowing relationship to that world was articulated in respect to how the viewer stood and saw.

But the term *idiom* can also be extended to a language that gives access to a special "voice," such as that of a creative writer or artist, conveying in relation to the natural

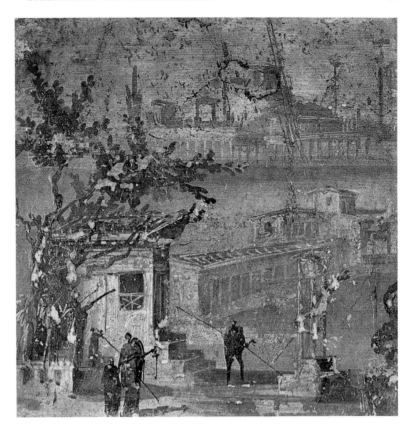

Fig. 14. Detail of Roman fresco, cut from its wall, mid-first century A.D., 15¼ × 15¼ inches. Museo Archeologico, Naples, no. 9414

world a particular spirit of perception.[10] Without knowing then for Roman wall painting, as one does for Roman poetry, the patterns of attachment that link such a "voice" to individual patrons or to prescribed channels of expression, one still posits a concept of representation at work:[11] an approach and attitude in creation that engages response, without being causally separable from the structural and expressive means that take effect in the work's reception. "Pragmatics" as a branch of study links production to conditions of response, for the visual as for the verbal. And such remains broadly the case for all of the examples following.

Protocols: Disposition as Datum

Representation of nature in the Middle Ages subdivides itself conceptually into two major strands, which may be called for convenience the *encyclopedic* and the *emblematic*.[12] The encyclopedic tradition, relating as it does to the illustrations provided for such major compilations of lore and observation as Isidore of Seville's *Liber Etymologiarum* and Vincent of Beauvais's *Speculum Historiae*, is concerned basically with obtaining control of the world around by ordered classification and description, so that it encompasses botanically accurate renderings of plants (as in Herbals); particular zoological species in their

Fig. 15. View of the fresco decoration of the House of the Fruit Orchard, Pompeii, early first century A.D. (Region 1, Insula 9, no. 5), c. 14 feet high

natural environment (as in the content of Bestiaries); fabulous trees and forms of vegetation (as in the *Marvels of the East*); and by the later fourteenth century the distinctive geographical features of particular regions and provinces.

The emblematic tradition by comparison takes natural elements as a vehicle for reflection and moralistic elaboration on the workings of the cosmos and the order of creation at large, as seen for instance in the cycle of the months and seasons and in the movement of the spheres. It deals most commonly in personification of one kind or another, as of the winds or the Fountain of Life; its underlying impulses are mystical and in some cases (as with the sensibility to nature associated with the cult of Saint Francis) poetic in character. Complete landscape settings without such didactic components are relatively rare before the fourteenth century, and are linked mainly with the depiction of the pleasures and pursuits of the court, such as the hunt, which were themselves open to being allegorized.

As these traditions, overlapping but distinct in character, pass down in line of succession into Northern European art of the late Gothic period and the early Renaissance, they come to invoke alternative forms of engagement on the viewer's part, which will be termed here *protocols*. There is, in effect, a mental preparation or preinclination in the viewer that is called upon. Assumptions that a person of the time is disposed to bring to bear before a painting or other work of art, about the relation of the "world" portrayed to experience, organize themselves as a basis for performative response so that the subject is read accordingly.

The protocol governing the encyclopedic type of landscape was, it may be said, to give all of its manifold particulars—whether they were plants, flowers, rocks, niches such as those made in caves, or buildings more generally—the sense of having a basis (rather than an equivalence) in actuality, so that as much as possible of what could be expected or known about in the natural world comes to be pieced together in this way. Viewers' responses could then fasten on the sense of there being a specific and concretely grounded defining of features and properties at work, for all of the elements included. Organizationally, the piecing together took place in an expansive and ordered fashion that appeared as being framed, from the point of view of access to it, by the main scene represented, and as owing its inexhaustible richness of details and texturing to that scheme of framing. After the salient contributions of Jan van Eyck, this tendency in the treatment of landscape is carried forward by Hans Memling later in the fifteenth century; after Flemish influences reach Italy, through the work of those two artists especially, it appears in Ghirlandaio and in Leonardo da Vinci.

In the emblematic tradition, settings are of a more generalized sort, and the individual elements tend to carry a stronger or more specific weight of reference: not in terms of a preconceived order to what is shown, or a puzzlement set up as to why this or that should be included, but more simply as a set of relations between the elements in question with which the viewer must engage, opening himself or herself to apprehension in a larger sense through the contribution made here. This is what is found in the work of Dieric Bouts, who is said to have made Haarlem into a renowned center for landscape art, and in that of Hugo van der Goes. It appears comparably in the Venetians Antonello da Messina

and Giovanni Bellini. Rather than the "emblem" being reduced to a single entity with a self-sufficient meaning to it—like Jean Pucelle's group of bare trees in the *Belleville Breviary*, comparable to a zodiacal symbol in being called upon to stand for the season of winter—all four of these artists tend in the reverse direction, toward enriching and qualitatively increasing local detail whenever it has a concrete topographic or otherwise functionally explicit role to play.

The nature of this antinomy between the encyclopedic and the emblematic in landscape, as it presented itself to viewers of the time, can be brought out more fully by a comparison of two works from early in the fifteenth century that are not much more than a decade apart in date: the Master of Flémalle's *Nativity* (Fig. 16) and Jan van Eyck's *Madonna and Child with Chancellor Nicolas Rolin* (Fig. 17).[13] Like all of the Master of Flémalle's extant landscape and cityscape images, and especially the left wing of his *Entombment* triptych (Courtauld Galleries, London, c. 1415–20) showing the two thieves on the crosses, the setting of the *Nativity* has a pared-down character, as though detail were intrinsically lacking, but added or superimposed. The outline shapes and individual elements that one does have, and the importance given to roadways coming through create the effect of imprints on the sensibility, or more generally records, of a journeying. It is as if stages or successive moments of travel were being emblematically reconstituted, to correspond to a pilgrimage of the eye in its devotional role up to and into the main scene, which stands accordingly as climax to the visual progression from back to front of the altarpiece. Like the sun appearing behind the mountain peaks just above the horizon, its halo-like rays conveying in starkly recognizable or recollected form the short days of the winter solstice, so too what is passed and what is left behind in the *Nativity* landscape—including castle, inn, and other figures in transit passed along the way— inflects the sense of journeying to devotional ends.[14] It does so potentially, it may be suggested, for a broader spectrum of worshipers than the wealthy merchant class and prelates at the courts of Flanders and France who constituted a select clientele for van Eyck's devotional imagery.

In the *Madonna with Chancellor Rolin*, the interrelation of what is inside to what is outside, of experience to idea and of the temporal present to eternity is far more complex in terms of what is invoked, and yet all is contained—as in van Eyck's unfinished *Saint Barbara* panel (Koninklijk Museum, Antwerp)—within a continuously receding spatial structure that includes seemingly endless diversity of detail. Commerce and travel, the church that Rolin served and the vineyards that he owned are all comprehended within the imagery in miniaturized and yet crystalline form. The enclosed garden this side of the rampart forms an extension of an entrance hall that could belong to either church or palace—or to both—and from that eminence one takes in the comprehensive richness of a "beyond" that is also attached to the "here and now." The two little figures seen from the rear who are depicted looking out and down serve as stand-ins in this respect for the artist's positioning of himself so as to have a framed and at the same time comprehensive vantage point; whereas the representative bystanders on the bend in the middle ground of the Dijon *Nativity* are more obliquely positioned in relation to what the eye takes in overall, and less actively engaged.

Fig. 16. Master of Flémalle (Robert Campin?), *The Nativity*, c. 1425. Oil and tempera on panel, 34¼ × 27⅝ inches. Musée des Beaux Arts de Dijon

Fig. 17. Jan van Eyck, *Madonna and Child with Chancellor Nicolas Rolin*, c. 1436. Oil on panel, 26 × 24½ inches. Musée du Louvre, Paris

Later in the fifteenth century the growth and expansion of a more personal kind of devotional imagery—for a clientele that is still an upper echelon of civic and ecclesiastical wealth and power, but more eclectic in its interests and concerns—leads to landscape settings that are increasingly toylike or miniaturistic in character, as in the work of Petrus Christus done in Bruges.[15] Dutch manuscript illumination and panel painting, which prized small-scale illusionistic effects—like the inclusion of flies and other insects as if they had happened to alight on the scene—may be partly responsible for this. But there is also an evident relationship with devotional practice and liturgical ritual of the time. It promoted particularly, as far as settings are concerned, the inclusion of buildings and portions of cityviews (as in Rogier van der Weyden's *Bladelin Altarpiece* and Petrus Christus's *Exeter Madonna*, both from around mid-century), that constituted a specific link with the worshiper's own life and on-the-spot experience, and correspondingly invited the eye in more directly.[16]

This more knowing and often isolated kind of reference, still in the Eyckian tradition but shifted in its scope so as to embrace other concerns of a socially diversified and more broadly accessible sort, contrasts with the relative abundance and at the same time mystically charged detail of the landscape settings devised by Hugo van der Goes and Geertgen tot Sint Jans. The latter invite a more subjective participation on the viewer's part, through their direct display of blossoms and flowers that have a very precise symbolic reason for their inclusion in the scene, and for their internal positioning also.

The alternative "protocols" for the reading of landscape imagery that have been suggested in these observations on Northern European fifteenth-century art entail as that century moves forward an appeal to distinct, and sometimes competing, audiences or communities. In the past study of those developments, the idea of Flemish artists in line of succession egging one another on to greater naturalistic verisimilitude has found a fertile field in which to advance a corresponding reading of what takes place. A teleologically oriented conception of history is made to coincide with, and effectively underwrite, a particular view of how these artists thought of themselves and their endeavors.

According to that argument, art that has a limited attention to the visible world built into it finds itself displaced by a new incursion or newer waves of "naturalism." The will to work from direct observation, and thereby achieve convincingness, brings about a superseding of the kind of compositional frameworks that had imposed themselves when that concern remained secondary, or its application was disguised in favor of looking back to the past for models.[17] One mode of proceeding drives out another, assigning it implicitly to an outdistanced artistic past when the key impulse or priority was to draw upon preexisting structural formulas.

But what is "naturalistic" in those terms of reference may also be artificial, acting like a stage set sufficiently spread to include subsidiary incidents or (to put it another way) like the representation in paint of a representative scene of a larger sort, within which the narrative subject in its separate parts is acted out. What matters then is whether the setting offers a physical or spiritual linkage with the main scene; or whether alternatively such linkage is denied or obfuscated, as happens in the art of Dieric Bouts (Fig. 18). Bouts's settings, whether filling up the whole background or seen through an aperture,

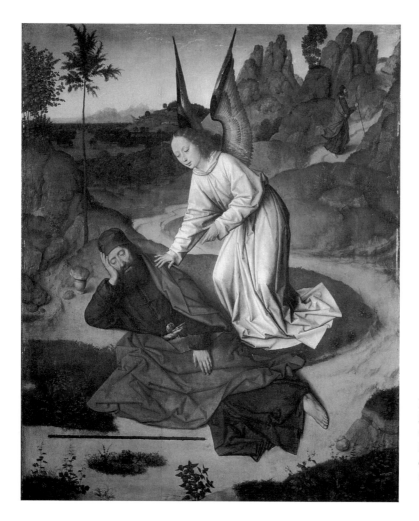

Fig. 18. Dieric Bouts, *Elijah in the Desert*, wing from triptych for the Collegiate Church of St.-Pierre, Louvain, c. 1464–67. Oil on panel, 34¾ × 28¼ inches (Copyright IRPA-KIK Brussels)

and however replete with detail they may be, are essentially tokens: of his and the viewer's capacity—according to this later extension of the "emblematic" tradition—to make what is shown stand in a generalizing fashion for the presence and role of landscape, and serve thereby as a suffix to the main activity.

This, and not the degree of innovation in pursuit of "naturalism" is what makes for distinction from the landscapes of Memling and Gerard David, which are graduated intrinsically to form unfolding extensions of the main scene. Where Bouts produces, correspondingly, the embryo of a future development involving the representative inclusion of the outdoors is in his creation of landscape elements that can function, for portraits set in closed rooms, as tokens of a further and outlying space, which serves as a view in itself in the manner of an inset picture. This particular device, as used in Bouts's *Portrait of a Man* of 1462 (National Gallery, London) will be taken up in the 1520s and 1530s by the Northern Italian painters Lotto and Savoldo and by Titian, all of them making the framing of landscape within portraits of theirs more specifically picturelike, as it was already made to seem in the role given to it in Giovanni Bellini's Pesaro *Coronation*

of about 1475, centralized within the surround of the throne there. The device will also be used by Lucas Cranach in the North for a genre subject: the so-called *Payment* of 1532 (Nationalmuseum, Stockholm).

A second pair of alternative protocols, becoming important in the North by the end of the fifteenth century and increasingly so after 1520, in the atmosphere of the Reformation, set the "landscape of knowledge," as it may be called, in opposition to the "landscape of belief." Basically the landscape of knowledge traded, like the "encyclopedic" type of landscape, on a propensity to value concreteness and inclusiveness as controlling elements in dealing with the world. More specifically it was constituted so as to enforce the sense in the viewer that direct study as well as technical skill had been expended in the depiction of natural elements. That study may have located itself wholly or partly in the studio—with the objects in question, such as animals and plants, brought back there for this purpose—but the choice of objects and their rendition together attested to its having taken place. They showed, and in turn contributed to the achievement of, a desired intimacy with the character and function of the natural elements in question, brought about by empirical, observational means.[18]

The landscape backgrounds of fifteenth-century altarpieces were replete with such elements. The sense they gave accordingly of how their presentation was arrived at was reason and justification enough for their presence, quite apart from symbolic meanings that they might be taken to include. In this perspective, then, the relationship between looking and imaging was one in which the artist showed publicly that he knew how to do certain things and distinguish himself in doing this—like a successful public speaker or speechwriter in the case of language—on the basis of a prior activity of a private order, in which he addressed his eye and intelligence to the tasks in question and how they were to be brought to fruition. To use "signs" for such a purpose—as a medieval philosopher such as Saint Augustine had conceived them, namely, as the distinguishing marks or features by which objects are recognized—was necessarily to add to them, or to supplement them inventively. To the bare or merely schematic approximation was added what would give the things in question life, and in that way, for the viewer entering into the availability and uses of that visual language, what would otherwise be trivial, inert, or dead became infused with signification.

Joachim Patinir, working in Antwerp, drew on that fifteenth-century tradition of aggregated natural elements for his landscapes with religious scenes inset. Most often the Rest on the Flight into Egypt (Fig. 19) or the hermit saints Anthony and Jerome in their caves were chosen for depiction, because those subjects could be fitted into the foreground so that they concorded thematically with great expanses of natural scenery around. Besides rock formations, wood and trees, valley and water, winding paths and undulating streams and buildings in cluster formations, Patinir included on occasion, as filling elements incidental to the story (*staffage*), village scenery and fields with workers in them, along with the animals and birds associated with rustic life. What he created in this way is not quite comprehended within a single modality (any more than the landscapes of Bosch), there being many variations to the way that the story elements and accompanying props are situated in relation to the viewer. But the bird's-eye view of Roman art returns in force,

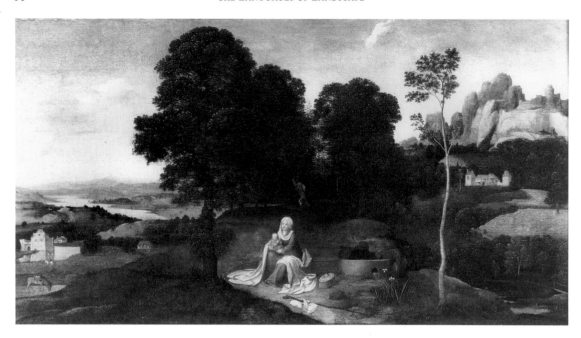

Fig. 19. Joachim Patinir, *Landscape with the Rest on the Flight into Egypt*, c. 1515–16. Oil on panel, 12½ × 22¾ inches. Museo Thyssen-Bornemisza, Madrid (All rights reserved: Fundación Colección Thyssen-Bornemisza)

along with the related features of shifting angles and vistas to the perspective and subtly modulated tones of blue and green that extend far back to a high horizon.

Patinir was adhering here to fifteenth-century frameworks of assemblage for natural elements. But he was also setting on foot the kind of panoramic expansion of landscape motifs that made Antwerp by the 1520s into a busy commercial center, that was successfully marketing such painting in several other countries of Europe.[19] It was on this dual basis that Albrecht Dürer designated Patinir, whom he met in Antwerp in 1521 and one of whose works he owned, as the "good landscape painter" (*der gut landschafft mahler*). In this understanding of a now specialized activity, the painting of landscape is akin to the bringing of knowledge to bear in the making of maps and utilitarian plans of towns and provinces. These serve to demonstrate accordingly, in their schematic layout, how configurations such as those of mountain and valley are constructed, and how those features in turn are linked by routes and waterways to a spread of terrain that reaches across vast tracts of space, and back into the recesses of the unknown.[20]

Dürer's artistic training in the later 1480s in Nuremberg exposed him to the altarpieces painted there by Hans Pleydenwurff, between mid-century and his death in 1472. Pleydenwurff's most notable assistant and the inheritor of his workshop after his death was Michael Wolgemut, with whom Dürer apprenticed. That exposure made Dürer familiar with the direct ways in which the example of Netherlandish art, stemming from both Haarlem and the Flemish centers of export and training, had impacted on the treatment of landscape in Southern German altarpieces. Dürer's watercolors and drawings of the next five years, after his apprenticeship had ended, link up with fifteenth-century artists' concern with such aspects of nature as tree specimens, reflections, and sky movements.

Dürer was familiar with the exemplary stories (*topoi*) about famous artists of antiquity, told by Pliny and others, which were retailed over and over in the Renaissance and showed observation and descriptive skill brought into perfect tandem with one another. Those topoi could be extended from still-life or animal and bird subjects to landscape, insofar as they dealt with stationary objects brought under close-up scrutiny; in his famous brush drawings of the *Hare* and *Great Piece of Turf* (1502 and 1503, both in the Albertina collection, Vienna) Dürer treated those subjects in a precise observational sense that served as affidavit for knowledge on his part. On his travels, he conceived of himself equally as a recorder and witness, contributing to knowledge by his gains in visual exposure: as when he drew the *Siege of Huhenasperg* on a visit to Zurich in 1519, and, visiting the Netherlands the following year, wrote on a drawing "this is the deer garden and its pleasure ground at Brussels," and made the connected note in his *Diary* "Behind the King's House [I saw] the fountains, labyrinth and Beast-garden; anything more beautiful and pleasing to me and more like Paradise, I have never seen."[21]

In that way Dürer worked to authenticate, as a source of knowledge, what experience and exposure brought into sight for him. But it was also possible for the concrete to be invested with a spiritual or visionary potentiality, so that the way in which it was apprehended spoke to the imagination, impelling a believing acceptance in the viewer who was disposed to respond in those terms. Such was the concern with Dürer when particular sites became a source for the backgrounds of prints on religious themes: *Saint Jerome, Saint Anthony, The Virgin with a Monkey, The Prodigal Son*. For the overwhelming and the terrifying in nature, a context of understanding and appreciation had to be created, lest the impact on the senses and the soul should appear as a purely private response. Thus on the watercolor known today as his *Dream Vision* (Fig. 20), Dürer wrote in detail of how on the night of 7–8 June 1525 he had such a vivid dream of a rainstorm that he woke up horrified: "Many great waters fell from the heaven. And they came down from so great a height that they all seemed to fall with an equal slowness. I was so sore afraid that when I rose in the morning, I painted it above here, as I saw it. God turns all things to the best."[22] The page as a whole becomes the surface for performing this humbly submissive gesture. And only when the stormclouds are read in relation to the trees and buildings—as if they were like stalactites hanging above, with a dark threateningness to them—does this depiction take on the character of a landscape. At which juncture belief and knowledge intersect.

Martin Luther, describing the consequences of the Flood in his first lectures of 1535 on the Book of Genesis, wrote that "the earth, which is innocent and committed no sin, is nevertheless compelled to endure a curse," and he went on to refer to the effect of this on mountains, trees, and the course of rivers.[23] Both aberrancies in nature's forces and grossly abnormal patterns of growth were then marked existentially with a message of origins that had its positive counterpart in the signs of divine beneficence, like the rainbow in the sky after the Flood. As an explanation for the oddities and deformities of nature, as they were currently made manifest, the relationship of causality put forward here had to be taken on trust. In Matthias Grünewald's *Madonna and Child in a Garden* (Fig. 21) in the parish church of Stuppach (c. 1518–20, brought there from the

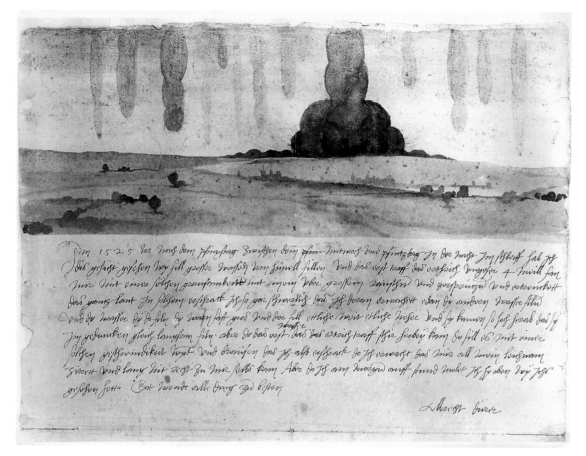

Fig. 20. Albrecht Dürer, *Dream Vision*, 1525. Watercolor on paper, c. 12 × 16 inches. Kunsthistorisches Museum, Vienna

Ashaffenburg Chapel of "Maria Schnee"), a pond and mill and a view of the village of Seiligenstadt abut on the large pink church in the background. Specific plants appear in the foreground and the artist himself in painter's blouse stands on the church steps. But there is also a huge and ethereally colored rainbow that links the Madonna and Child with the vision of the New Covenant offered to man, which appears in the sky at the upper left. On the same basic principle as with the "emblematic" type of landscape, devotional faith is charged here with mediating between a specific earthly location and the evocation of hope and promise. Within the altarpiece, the illumination made active beneath the arc of the rainbow performs that kind of a mediating role: on the same basic lines as with the "emblematic" type of landscape, but with attention given now to qualitative effect in the choice and intensity of colors, rather than their sequencing.

Equally in Gerard David's landscapes done after 1500 delight that is taken in specific, natural detail allows for an openness to association, making for a link with devotional texts that are recalled in the viewer's mind. Or it allows, as with Patinir, for an imaginative response founded in experience, as opposed to the reading in of a single insistent meaning. The viewer's movement of attention, from left to right or front to

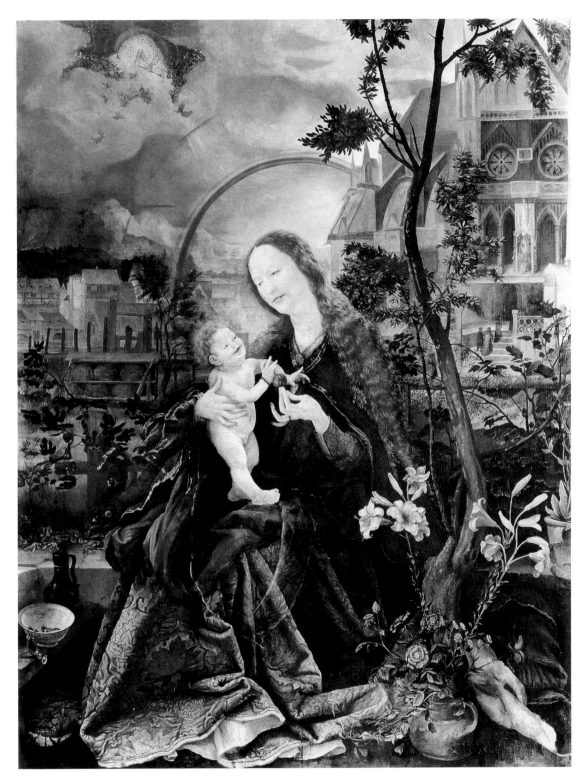

Fig. 21. Matthias Grünewald, *Madonna and Child in a Garden*, c. 1518–20. Oil on canvas, transferred from wood, 73¾ × 57½ inches. Parish Church, Stuppach

back within the picture, itself becomes consequential in this way for the forms that response takes.[24]

In the so-called world landscapes created by a second generation of artists, active in Antwerp between 1520 and 1540, including Herri met de Bles, Cornelis Massys, and Lucas Gassel, mining scenes are in some cases introduced into the foreground, taking place around pitted quarries. The buildings in the middle ground are extended to include larger clusters or groupings, and also the suburbs of cities. These buildings are represented from a high viewpoint that emphasizes city walls and tall towers standing against the sky or mountains behind, according to a convention also used in cartography at this time. The treatment of the mountains themselves becomes thinner and more transparent in its pictorial substance, so that the effect of suspension in the far distance and merger with it is enhanced.[25]

The expansion of the workshops producing this type of landscape, and also the interest it held for humanists of the time are factors helping to account for the impact that it exerted concurrently in Italy, where Patinir's paintings had earlier been collected. In the landscapes of Benvenutó Garofalo and Battista Dossi, done in Ferrara, both religious and mythological scenes could be enlivened in their settings by the inclusion of bizarre rock formations and winding paths that created a looping circuit of progression back into space for the viewer's eye. The same applies to the work of Niccolò dell'Abbate done after he moved from Bologna to France, to work at Fontainebleau.

Pieter Bruegel's earliest extant landscapes take the form of drawings of mountain scenery, which on internal evidence can be presumed to date from soon after 1550 and to have been done outdoors. A year or two later come his earliest dated drawings, from 1552 and 1553, on the basis of which a trip over the Alps to Italy can be roughly dated, to be followed by a stay in Italy during which he visited Rome and Naples, before his return to Antwerp where he was back by 1555. Some of his compositional schemes of those years suggest in the placement of trees and inclusion of clouds that he responded while in the South to landscape prints he had seen by the Italian artists Domenico Campagnola and Girolamo Muziano, who worked in the vein with which Titian especially is associated (see page 21). Forest scenes are also included in his repertoire, and from this combination derives a set of twelve prints published after his return by Hieronymus Cock in Antwerp. For this purpose Bruegel certainly refined and amplified what had originally been taken from nature, as an expression of both his wonderment and his learning process. In fact what he had learned in traveling can be accounted largely as a matter of self-education, in terms of the complexity of elements brought under scrutiny, and the variegation of tones and textures achieved.

Particularly important for Bruegel's self-positioning here, both in relation to the world-landscape tradition and in relation to his immediate experiences that the drawings served to record is the inclusion on some of these sheets of a solitary figure or group of figures in the foreground. Their presence is established in terms that connect them with other figures who are traveling or standing in the landscape. The placement of the latter, below and smaller in scale, presents them as being under the gaze or potential gaze of the foreground figures, which can take in the whole scene more comprehensively than they.

And that comprehensive viewpoint is in turn assimilated or analogized to that of the artist himself, who engages in bringing this "view as a whole" into being. In one case the figure in point, with pack on his back, seems to be pausing to ask the way of a younger trio who are in colloquy together, and one of whom points with an orienting gesture that takes in the entire vista to the right of him. In another case (known only from a copy in Besançon) the stand-in, as we can call him, after the case of van Eyck (see page 44), has a younger companion with him and both are already at work drawing, overlooking a river. But they do not have the whole atmospheric extension of scene in their view quite so commandingly and so completely as we do, from somewhat higher up.

There follows, in 1560, an engraving in which a panoramic landscape includes in its foreground a pair of rabbit hunters and their dog moving around a tree; and then, dated between 1562 and 1564, landscapes in oil in which equally expansive vistas are occupied in the foreground by traditional religious subjects: both the *Rest on the Flight into Egypt*, with only two figures as in the *Rabbit-Hunters*; and also themes involving a great number of separate but interrelated incidents and episodes, such as the *Suicide of Saul*, the *Tower of Babel*, and *Christ Carrying the Cross*, in each of which the biblical subject-matter serves as point of departure for a vast population of figures. Their role is improvised out of and around the story in question. More directly, however, it is conceived in terms of the spatial layout of the scene and the various participatory activities it takes in. What is made credible is thus a particular kind of spatiotemporal animation, extending to areas where the detail is sparse or seemingly inconsequential to the main action portrayed. The landscape not only provides a locus and conduit for those patterns of activity; its very expansiveness seems to pull and stretch them, into an equivalently organized configuration and sequencing.

The series of the *Seasons*, or perhaps the *Months*—since the imagery is related to medieval and Renaissance calendar pictures of the labors and other activities associated with each month of the year—that Bruegel went on to paint in 1565 for the Antwerp merchant and art collector Nicholas Jongelinck brings knowledge and the force of credence together in another way again. These paintings belong with those of his, such as the *Fall of Icarus* (Musées Royaux, Brussels) and the *Hireling Shepherd* (Philadelphia Museum, either a good copy or much restored) in which natural forms join together as if they were participating characters in the playing out of a mundane event, and in so doing raise it to a mythic dimension.

In those Italian landscapes of mid-century that have the most in common here in their panoramic treatment of nature, including some by Titian, such as the *Pardo Venus* (in the Louvre) in its revised form of around 1560, landscape serves as site for the playing out of desire or sensual longing.[26] The elements of nature are distilled, atmospherically dilated and bracketed by framing elements in such a way that the trajectory and strength of the desire, extending into the landscape, is in effect eternalized. Having already found its subject quiescent and waiting, desire is arrested for presentational purposes in expectation of its attaining fulfillment, and in a seeming permanence of light conditions and atmosphere. In the North, the mediating role of other adjunct figures is already anticipated in Patinir; in Bruegel, however, they are subject in their appointed tasks, like the shepherd

in the *Fall of Icarus* who looks to where the falling boy has come from, while the plowman does not see him at all, to an overarching providence that seems to regulate, paradoxically, the informality and spontaneity seen to be vested in what they are doing.

The *Seasons* were commissioned for Jongelinck's villa at 't Goet ter Beke, and so along with two cycles by Frans Floris the Younger, on the themes of the Labors of Hercules and the Seven Liberal Arts, they formed part of a collection that early in 1566 would be deeded to the city of Antwerp.[27] Originally the series may have comprised six paintings, with one now missing, each corresponding to two months put together, but there is also the possible alternative of a cycle of twelve panels, one for each month; or four panels, one for each season, in which case the *Haymaking* (Prague, National Gallery) could be the one that is disjunct from the rest of the series. Whatever the original number and order of the paintings, the *Hunters in the Snow (Winter)* (Fig. 22) would in any case have closed the series, and it is marked by the inclusion of an Alpine mountain view at the back right, like a sign-off feature toward which a flying bird is pointed.

It is a view recalling Bruegel's own encounter with mountain scenery on his way to Italy and back, and the knowledge and experience thereby gained; topographically, of course, it is impossible for the Netherlands. Its importation here becomes congruent with the rest of the winter scene, nonetheless, if viewers coming to it at the end of the cycle see it as the nearest foreground figures do not see it; for they look down and toward the village, into which they know their way. The third of the group, whose head and expression are lost against a line of branches is closest to the edge of the slope, beyond which that potential of seeing the view that he has will be lost; there is a bird perched on a branch and further trees that line themselves up with this proffered trajectory of vision. What he has in sight is associated in this way with a particular conditioning of experience, and at the same time offers a pregnant glimpse of how that conditioning is open to being transcended. This figure stands in for the artist, then, in the form of a pattern of engaged activity: one suspended in place and time so that it bridges what is known to be true of ordinary life in nature, and what can be believed to lie beyond. And it does this retroactively for the set of paintings as a whole.

A generation earlier, a cycle for a private house with landscape settings as a fixed ingredient from scene to scene would have taken the form of tapestries, with stylized borders of foliage and flower decoration. There are cartoons dating from 1526 to 1533 by Bernaert van Orley for a series of twelve such tapestries on the theme of the Hunt of Maximilian, set in the forest of Soignies in different seasons. The treatment of the bush in the foreground of Bruegel's *Hunters*, its stems flattened up against the picture surface, may be taken as recalling that kind of framing expedient and the forces of increasing secularization within the representational arts that valorized it.

Here the question of who is to be master, in relation to nature's changeability and its numbing extremes of bareness and cold—those who exert themselves through all this to complete their appointed tasks, or those who take time out to amuse themselves on the frozen pond—is conceived in fatalistic terms, of dependence rather than dominance. Those terms link back to the world-landscape tradition, in which human existence and persistence within nature amount to little more than a typologically patterned response.

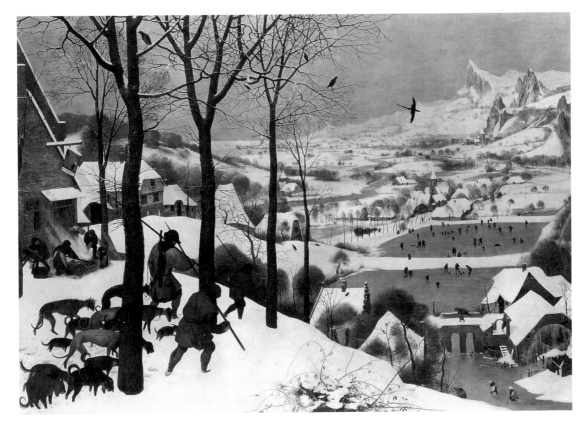

Fig. 22. Pieter Bruegel the Elder, *Hunters in the Snow (Winter)*, 1565. Oil on wood, c. 46 × 64 inches. Kunsthistorisches Museum, Vienna

What the returning hunters have to look out for, as markers of the season as they experience it most directly, is encapsulated in the twin motifs of ice and fire, including a burning cottage.

But the near foreground of the *Hunters* does not fit into that conspectus of the ordering of man's place in nature, or at least not without resistance. Close to the picture plane and minimally tilted away from it, it reminds us of the surface on which a painting—as opposed to a tapestry—is made. And so in turn it brings up those forms of constriction and comprehension that govern the activity of picture-making itself.

By virtue of the kind of comprehensive vision that can furnish release, when it is used from such a vantage point to open up the further scene, the artist is freed from the constriction that adheres to being servant to a patron. He is free as an artist to identify himself with a vision that is sufficiently transcendent to escape those governing conditions of service, that press also on seeing as a socially conditioned act. He cannot avoid having his work appropriated, within the terms of conventional patronage. But he can engage with how that appropriation has its equivalence within the domain of nature, and the kinds of knowledge that it imposes.[28]

The pictorial schemes previously established by Jongelinck in his villa, going back to a decade earlier when he first took up occupancy there, had for their respective themes

labor and the arts: more specifically, the mythical playing out of heroic struggles, set in distinct topographical locations, and the regimen of the liberal arts as it related to patronage and to humanism. Bruegel's cycle effectively collapsed together the protocols associated with viewing according to those kinds of dispensation. His own mandate in contrast was to bring labor into relationship with nature, and to project an enduring prospect for it, according to the dispensation of his own pictorial vision.

PSYCHOLOGY: AFFECTIVITY IN ACTION

Psychology enters into the depiction of landscape through the conveying of a particular mind-state. The viewer is introduced affectively to that mind-state. To participate in this way in the character of the depiction entails the adoption of a suitable point of sight for this purpose, and the use of the framing borders as a means of entry, into what appears as an independently existent and self-sufficient "world." It implies correspondingly a syntactical combination and construction of the elements of landscape, in which the viewer can find himself or herself, in the sense of achieving an imaginative engagement of the self there.

Thus the use of the term *psychology* at this point has to do not so much, as in the preceding section, with terms of seeing imposed on the viewer's consciousness in front of the work, in the same sort of fashion as terms of persuasion are imposed on the hearer in rhetoric. Rather, it has to do with qualities of mind and feeling conveyed, as in a speaker's mode of delivery, and the way in which they impart a sense of invitingness in the case of landscape, emanating from what is presented and how its implications and intimations are put across.

It appears impossible to determine in any precise historical sense how the production of "independent" landscapes—basically, ones that are freed in regard to readability and accessibility from the constraints of having a specific line or tenor of narrative subject-matter to them—came into being soon after 1500, both in Northern Italy and north of the Alps. The question of when and why this happened remains elusive, both in terms of conceptual motivation and in terms of a set of developments that can be attached to a particular milieu of production.[29]

The problem here is, first, one of definition. What had existed previously in painting as the expression of knowledge—according to the terms of reference set up in the preceding section—shifted now to becoming a vehicle that impelled belief in its very substance and tissue, rather than as a matter of appropriacy to a particular kind of rendition of the known world and its contents. In 1456 an Italian humanist, Bartolommeo Fazio, described a lost painting by Jan van Eyck of *Women Bathing*, which was in Urbino at the time (or less probably in Genoa). It included, in his words "mountains, groves and castles carried out with such skill that you would believe one was fifty miles distant from another." In this account of a Flemish painting that was greatly celebrated at the time, the degree to which credibility was achieved belongs, intrinsically, in company with the

other constituents of the picture described and their appropriacy to a genre subject, which was related in turn to a standard mythological theme. We are told of a lantern lighting up the bathchamber convincingly, an "old woman seemingly sweating, a puppy lapping up water and also horses [and] minute figures of men."[30] The extent to which landscape elements contributed on this larger front takes its place in the description after the singling out of those genre elements, which were presumably in the forefront. It serves as a supplement to them, in terms of representing a specific kind of believability that merits citation: one appropriate to the encompassment, on the same picture surface as shows the main scene, of what lies around and beyond.

For its institution half a century later, an "independent" landscape required that the rendition of the natural world should be brought forward, from the background or margins of painting, so that it made a prime contribution in itself to the mood or atmosphere of the whole. There could be genre figures included, or participants in the scene dressed and acting in such a way as to bring mythological or religious subject-matter to mind; but they would no longer have primacy in the sense that Fazio's descriptive sequencing entails. In narrative terms, the relationship of the figures to one another and to the setting would be marked, relatively speaking, by an absence of the kind of clarity and specificity that fifteenth-century accounts of painting insist upon, in their naming of the subjects part by part. Describing Giorgione's famous *Tempest* (Venice, Accademia) in one of a series of journal entries inventorying works that were in private hands in Venice in the second quarter of the new century, an anonymous author (most probably Marcantonio Michiel) labeled it "a small landscape on canvas comprising a tempest, a gypsy woman and soldier." Other paintings listed there, including Giovanni Bellini's *Saint Francis* (Frick Collection, New York) and a *Tower of Babel* and a *Saint Catherine* by Patinir, are identified as having a component of landscape to them; and in another Giorgione, the role of *paese* is placed descriptively before the accompanying mythological subject, of the Birth of Paris in sight of two shepherds.[31] But with the *Tempest* we find acknowledgment made of how the role of landscape has come to the fore, and the identity of the figures and the raison d'être for their presence is taken as incidental to their association with those particular effects of light and weather that make the painting, according to its modern title, essentially and integrally "about" a storm. The appeal of those effects, as they act and interact over the canvas surface, has shifted to the point of coming to appear as the work's center or core.

At the same time the invitingness of rustic and pastoral subject-matter in painting was, in its later fifteenth- and early sixteenth-century forms, predicated on suitability to particular formats of production and contexts of display. The technical term adopted in Northern Italy by 1500 to describe the activity in question, and simultaneously its appeal, was *parerga*, painting done "on the side." This use of the term derived from the account given by Pliny of the small warships added by Protogenes, in the late fourth century B.C., to his wall paintings in Athens.[32] The term offered a license in this way to improvise "in the margins," as a supplement to the main subject, and to take and give pleasure in doing this—as was already true of the accessory details of the natural world that had been added for variegation's sake in the borders of late Gothic manuscripts. But as the term came to be used by Paolo Giovio soon after 1527, in his biographical encomium of the work of

Dosso Dossi of Ferrara, it referred to the imagery belonging to a particular area or sector of the work, in which diverting detail—rocks, groves, riverbanks, peasants at work, and figures out hunting, as well as "far distant prospects of land and sea [including] fleets"— could be picked up by the eye and enjoyed in virtue of the relish (*voluptuarius labor*) with which it was carried out, in a "lavish and festive" (*luxurianti ac festiva*) style.[33]

Precedents for the deployment of rural scenery to provide supplemental and pleasing detail in an independently framed attachment to the main work are to be found in the predella of mountainside that forms part of Lorenzo Lotto's 1506 altarpiece of the Assumption of the Virgin (in the Cathedral of Asolo, near Treviso) and his *Allegory* of 1505 (National Gallery, Washington), serving as cover for his portrait of Bishop Bernardo de' Rossi. The latter could qualify as "independent" landscapes in virtue of how they were physically constituted, and the same holds for a pair of portrait covers of Dürer's, showing rustic and woodland scenes with hunting taking place in them, which are known about from a seventeenth-century inventory. That paintings done in such a spirit should serve as a relief from religious and heroizing subject-matter was an idea that found its day when there was a spreading market for such productions. In the case of Venice and nearby Padua and Ferrara, this meant a clientele of interested humanists and their sense that, as in Pietro Bembo's *Gli Asolani* of 1505 celebrating the court of Caterina Cornaro at Asolo, the territories of garden and grove could win attention in their own right, in a fictional form that accompanied and conveyed a gracious and elegant lifestyle.

This humanist enthusiasm appears to correlate directly with the creation in Venice and its environs of a whole series of small-scale paintings in oils, intended to serve as room decorations, or bespoken in order to be fitted into and onto pieces of furniture. But to say that the attractions of such an idea required a formalized and governing theory to set it going may be too restrictive as a reason for the rise of "independent" landscape. Fortification would have come from the possibility of referring to ancient precedent. But a simpler and more instinctual motivation is to be traced in the psychological investment of the artist, and comparably of the patron, in what such imagery had to offer.

In Italian painting of the fifteenth century the tendency from Masaccio and Fra Angelico, and especially from Piero della Francesca on, was to mold a landscape setting from the principles of perspective, giving it a gently modulated color scheme and a graded luminosity throughout. Even when the incidental detail was of the kind that the Italians admired in Jan van Eyck, there was on the one hand an organic quality attaching to the marks and splotches made with the paint, and the kind of perceptual processing that they called for. Conjoined to this, on the other hand, was an effect of distancing and self-containedness that was imposed, as in looking through a window, by the rational construction of space in relation to the framing borders, and expressed in the relative salience and proportioning of the main subject.[34] This allowed for a response to rhythms and tonal harmonies in landscape; but it also tended to make the detail most directly understandable in terms of its supporting contribution to what was placed closest to the picture surface.

In Giorgionesque panel paintings by comparison, of the kind illustrated here with the *Idyll*, a work that has been attributed since its cleaning to the young Titian (Fig. 23), the

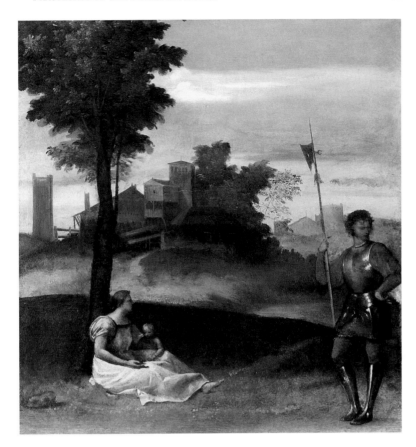

Fig. 23. Attributed to Titian, *Idyll: A Young Mother and a Halberdier in a Wooded Landscape*, c. 1510. Oil on panel, 18¼ × 17¼ inches. Courtesy of Fogg Art Museum, The Harvard University Art Museums, Loan from Vermeer Associates Ltd.

sense of bounded pockets of space that the figures occupy, individually and as a group, is much stronger. This is a small painting, about two-thirds the size of the *Tempest* and very much in the spirit of that work, so that it can be taken to belong near to the time when Titian was assisting Giorgione and then working independently alongside him, in a closely related spirit; that is, shortly before or around 1510, the year of Giorgione's death. Like other paintings attributable to the young Titian that are equally on wood, but in horizontal format—which allows for the inclusion of additional generic figures, treated so that they appear as indirect participants, attached to some imprecisely characterized event—it provides in its cast of halberdier and mother with infant child the implication of faraway states, of dream or pensiveness.[35] The diffusion and reflection of light, impregnating everything that it touches with a warmth and opalescence suggestive of early evening, inducts the viewer into responding to the mood of the landscape, and listening abstractedly to its "music" as these nameless participants seem to do.[36] By such invitingness the qualities of containedness belonging to fifteenth-century Italian landscape are broken, or one might say spiritually infringed upon.

That such an imagery of the outdoors, at peace and sensually charged, had to be fashioned to stand as a distillation of experience on its own is brought out by the contrasting case of Dürer's watercolors. Whereas Dürer's brush drawings of animals and plants referred to earlier were avidly imitated by followers and collected later in the

sixteenth century, his watercolors of landscape subjects were created for their own intrinsic interest and satisfaction. They bear no signatures, are without framing borders of any kind, and—though some of them were stored for a long space of time in the imperial collection in Vienna, having presumably come there as a group, and one belonging to Philip II of Spain was mounted in the company of flower and animal studies of the artist's—do not seem to have been individually prized by collectors until the eighteenth and more especially the early nineteenth century.

There are more than thirty of them known today, the majority done in a combination of watercolor and body color. With the exception of one on parchment, they are on paper, the discovery and manufacture of which advanced and encouraged the development of a watercolor technique, since it provided a clear, smooth surface that absorbed the wet pigment and allowed it to dry rapidly. In their time of execution they begin around 1494, with studies made in and around Nuremberg. They continue with a group done in the course of Dürer's first Italian journey, which took him over the Alps to Venice in October 1494 and back the following spring, passing in one case or the other through the Tyrol and the Adige region. And along with five studies of rock formations in varying techniques, assignable to 1495–96, there is a further group of sheets depicting Nuremberg and its environs that belong some time between the months succeeding Dürer's return from Italy and 1501–2.[37]

What was entailed procedurally and technically in the making of these watercolors was twofold. In the first place, nature had to be *seen*, in its most contingent or informal aspects. In contrast to the landscape of knowledge, based on materials brought back to the studio and studied there (page 49), working outdoors as Dürer chose to do meant confronting—in the shape of a tree trunk, the pattern of a rock face, or the spread of a forest clearing—aspects of nature that took on relationally the appearance of being fragmented, or even incoherent. This was the factor of contingency that had to be dealt with: namely, that connective order would appear present only incidentally, or as if by chance. Along with that there was the sense of informality, or radical "unshapedness," which came from there being no narrative elements or factors that tied the different components of the scene in question together. In some of the views from around Nuremberg figures are included going about their business within the expanse of foreground or middle ground. But they are quite small and rendered so that they blend in to the point of being inconspicuous, or visible only on very close inspection.

To deal with what was at stake here meant choosing a position and finding a motif that was not relationally intractable. In addition, a notation had to be devised with which to record what was seen. There was no controlling sequence, in the use of watercolor for more transparent areas and body color for opaque passages, that would answer to the requirements here. Rather, Dürer's progression in the use of the two media, side by side and in combination together, stands as a "trace," or physical record in itself, of the investigation of particular areas within the subject. Such investigation opened up those areas to scrutiny, and in so doing "discovered" on paper—sometimes partially or in a fashion making allowance for seams and junctures, which remain visible—a syntax for their rendition.[38]

Fig. 24. Albrecht Dürer, *View of Arco*, 1494–95. Watercolor on paper, with body color and pen and ink, 8¾ × 8¾ inches. Musée du Louvre, Paris, Cabinet des dessins inv. 18,579

The German word *Landschaft* had at this time the sense of open terrain, lying beyond the outer confines of a city or town, or outside the limits of a village or group of country dwellings and their dependent territory of common space and cultivated fields. What Dürer sketched on his Italian journey correspondingly separates hillside fortifications and the dense aggregation of town buildings from the rest of the landscape, within a kind of visual precinct. Cultivated fields and the roadways and waterways providing passage through them or down to them have descriptively an intermediate and a transitional status.

In the *View of Arco* (Fig. 24), what lies beyond the sphere of habitation and the olive grove, mulberry trees, and vineyards attaching to it, together with the river that irrigates them, is treated in one of two ways. Either the ongoing flow and transparency of the wash eliminates detail in favor of a continuity without specification, appropriate to what is effectively *terra incognita:* as in the right background here. Or, on the other hand—as happens along the bottom and at the left edge of the sheet—a graphic syntax is improvised in added pen-strokes, to correspond to the variety and impacted density of the rock formations in question. Where body color is added, in what is most probably a secondary stage of amplification, as in the rocks that expose themselves on the left of the main hillside, it is used to convey further how human or animal shapes (most prominently a large head in profile) can be read into such configurations, as a way of giving them a more focused character, such as adheres to them in the memory. And Dürer's own inscription,

dispensing in retrospect with the need to recover or attach a specific name to the site, labels it simply "Venetian fortress," to encapsulate its strategic placement as he has brought it into focus in relation to the landscape at large.

The landscape drawings of the Florentine Fra Bartolommeo, who entered the Dominican order in 1499, were, like Dürer's watercolors, not brought into a gathering reflecting the interest of a collector until much later. A large group of them, acquired in the eighteenth century from what the artist had left behind and assembled soon after into an album (broken up in 1957) represents the main reason for the survival of more than fifty. As well as including one sheet in which landscape elements are transcribed from a print of Dürer's, this production parallels Dürer's outdoor practice, in the media described, in two other ways. It extends over a time period that runs from about 1495 into the new century—in this case down to 1508 or thereabout. And it was equally brought into being for the artist's personal satisfaction, as an informal or nonofficial side to his creativity.[39]

Like the term *Landschaft* north of the Alps, *paese* in Italy took on a double use, for the landscape itself and for a pictorial rendering of it. And while Fra Bartolommeo's subjects are, following ancient precedent, concerned with human uses of the landscape and with the records of this in the forms of buildings devoted to labor and common dwellings, they cover a range comparable to Dürer's, drawing equally on what was seen by the artist on his travels. Besides farm landscapes and convents that the Frate visited, pen and ink is used for studies of trees and cliffs, and also for townscapes.

As Dürer's watercolors served in general, along with his drawings, as source material for the backgrounds of his prints, so too did Fra Bartolommeo use his landscape drawings, or allow members of his school to use them, for the backgrounds of painted altarpieces. And analogously, drawings of the Frate's that seem to have been added to, or worked up subsequently from annotations made on the spot, contrast, as in Dürer's watercolor landscapes, with sheets that have a stronger immediacy of feeling. The procedural consequences of this, particularly as they concern lighting and texture, can be read into the two drawings of hillside towns illustrated, which are combined on a single sheet (Fig. 25). Although Fra Bartolommeo almost always leaves the sky blank and never includes clouds—which is true only of Dürer's earliest ventures into watercolor, and is indeed one index to their dating—his elaborated hatching and shading of the nearer trees serves, in the upper drawing here, as the record of an emergent process in which, as with Dürer, technique is correlated with the bringing of the natural subject-matter, in its diverse parts, into focus. As Dürer would put it in an appendix of 1528 to the third of his *Four Books of Human Proportion*, "in truth art lies in nature, and he who would wrest it from her [rather than seeking to compete with the power of God's creation], possesses it."[40]

More like the Italian creation of "independent" landscapes, in contrast, are those done by artists of the Danube School in Southern Germany, beginning some ten to fifteen years later than their counterparts in Venice and its environs. Albrecht Altdorfer (born around 1485 and active in Regensburg) is the most indicative figure here in terms of procedures and the motivations of circumstance. Works by Lucas Cranach the Elder from soon after 1500 that give a prominent role to landscape settings, using them as mood-enhancing backgrounds for portraits, and for images of hermits and visionary saints (Jerome, Francis)

Fig. 25. Fra Bartolommeo, *Farm Buildings on the Crest of a Hill and View of a Fortified Town in a River Valley*, c. 1500–1508. Pen and brown ink on paper, c. 11 × 9½ inches. Statens Museum før Kunst, Copenhagen, Køngelige Kobberstiksamling

seem to have played the same sort of preparatory role here as the works of Giovanni Bellini and Giorgione did for the young Titian. Wolf Huber (born around 1490 and working in Passau), usually counted as a follower of Altdorfer's, had produced landscape drawings by 1510 of windblown trees and of the mountains and lakeshore of the Danube region, in which no figures appear. Delicate outlining supports a pellucid concentration on the shapes of tree trunks and the tufted tops in which they terminate; an atmospheric openness is given to the empty sky. These features may have helped establish a regional tradition of topographical drawing; behind both them and Altdorfer's panel paintings and pen drawings heightened with white of 1507–15 lies the example of Dürer's prints.[41]

Works of Altdorfer's from those years characteristically use forest in the foreground and mountain and sky behind as a suggestive venue for scenes of heroism (Samson crushing the lion, Saint George charging, a knight in combat) as well as hermits and holy men. The accessory material of landscape is played with and ornamentally elaborated so that it reverberates with the sense of a sequestered and inhospitable environment, suitable for

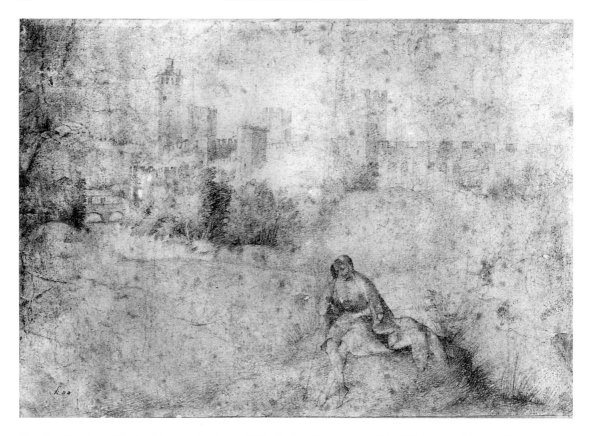

Fig. 26. Giorgione, *Shepherd in a Landscape*, c. 1502. Red chalk on paper, 8 × 11½ inches. Museum Boymans–van Beuningen, Rotterdam

the tryst of lovers or as habitat for the naked family of a "wild man." But Altdorfer had also produced by 1511 two drawings in pen and ink on paper, one bearing that date, which feature like Huber's the delicate silhouettes of mountainside and strange configurations of trees; castles and hillocks are also included in the imagery here.

This choice of features forms a parallel to the one drawing generally taken as being Giorgione's (Fig. 26), the sheet in red chalk from around 1502 (Boymans Museum, Rotterdam), which is now identified as showing San Zeno di Montagnana, rather than, as had previously been supposed, Giorgione's hometown of Castelfranco.[42] But the topographical focus that makes that identification possible goes with a pastoral subject-matter that has been put together here, in the form of a shepherd resting on a rock in the foreground, to provide a concordance of hatching and shading that felicitously links figure to setting. Altdorfer depends upon a more uneven kind of hatching and more extended rhythms.

In the group of nine etchings linked together in subject-matter that were done between 1517 and 1522, a horizontal format is used by Altdorfer to allow more space for sky and cloud formations. Sharpness and atmospheric clarity go with a quietening down of the tempo of linear energy. The short, repeated rhythms in the settings of Mantegna's engravings, which Altdorfer had drawn upon for his earliest figure compositions, are returned to

Fig. 27. Albrecht Altdorfer, *Landscape with Wood-cutter*, 1522. Brown ink, watercolor, and gouache on paper, c. 8 × 5¼ inches. Kupferstichkabinett, Berlin

here; but within the framework of a Germanic cast of feeling, based on the cult of the forest and the wild, common to all of the Danube School.

A stabilization of the same order is found in Altdorfer's remarkable painted landscapes of 1522 done in a combination of ink, watercolor, and body color on paper, or on parchment mounted on wood paneling. Both the figures and the buildings function as seemingly casual or purely scenic inclusions, quite incidental to the telling of any "story." In the example illustrated here (Fig. 27), a tiny woodcutter rests by the side of the track, with his jug and his axe on the ground beside him. A wooden casing, probably housing a sacred image, hangs from the central fir tree, and a pair of rustic structures join with the tree itself to create an effect of atmospheric merger. The lingering presence of Dürer-like touches—as in the treatment of the branches—and the fashion in which they empower the rest of the scenery, through the traces of the working process that they leave apparent, save the image from becoming pure fantasy. They invoke the authority of a knowledge that is empirically gained, extending to the boscage and to the lighting of the sky over the mountains.

Since neither the resonances of a residual subject-matter nor the technical scope of the

medium fully account for the independence of "story" that is gained here, it is necessary to come back to the pragmatics of creation, both as an activity of the brush and pen and as a gearing of what is done to the finding, or the potential engagement, of a responsive clientele. In Italy at that time independent drawings were becoming prized, but their distribution depended—in contrast to prints such as the Campagnolas'—on personal gifts of them that their artist chose to make. Size and format indicate that Altdorfer chose to perform in the medium of watercolor as he had with etching, putting himself in so doing into competition with the reputation of Dürer for small-scale graphic works. The framing border placed around and the inclusion of the artist's monogram as signature also link up with the etchings, to imply the quest for a market that could be formed and expanded through the appeal of the watercolors, as a probationary excursion that need no intellectual grounding for appreciation of it to burgeon.

Altdorfer's attempt at uniting modality and specialization, as these were defined in the first section of this chapter, had some impact on the treatment of landscape among followers of his and on the Danube School more generally. In Italy, by comparison, the convincingness and credibility that belong to the treatment of landscape cannot be separated as a focus of interest from the other material and compositional coordinates that go to the making of a believable "world" on the further side of the picture surface. Already in Mantegna's decoration of the Camera degli Sposi in the Ducal Palace at Mantua, completed in 1474, landscape views are included as one form of opulent illusionism among others. They continue behind the fictive architecture, are joined above to medallions of the Caesars and putti bearing the look of sculpture, and terminate below in the ledge-tops of marbleized dadoes. Clusters of buildings in the landscape make the same kind of appeal to regional familiarity as they will do, more generically, in the paintings of Giovanni Bellini and in the prints of Giulio and Domenico Campagnola. Latterly they are brought up closer to the surface for this purpose, and put into rhythmically accented association with shepherds and animals.

Sophistication in the form of a playful intermixing or crossing of media equally continues in Central Italy through most of the sixteenth century. Devices of perspective keyed to a fictive painted architecture open up the walls of a painted room on all sides to provide vistas of city and country, as in Peruzzi's Sala delle Perspettive (c. 1516) for the Villa Farnesina in Rome. Battle scenes are made to seem like hanging tapestries, in a fashion that extends to their vastly expansive landscape settings, as in Giulio Romano's *Battle of Constantine* fresco from 1521 (Sala di Costantino, Vatican). By mid-century and later, different kinds of illusionism may be mixed, so that for instance inset landscape scenes are made to appear as if they were on painted screens, reminiscent of Far Eastern scroll paintings, in Francesco Salviati's fresco decoration from the early 1550s for the Palazzo Sacchetti in Rome.[43]

In those cases the use of narrative, or the showing of rustic occupations in an idealized bucolic form that has diversified strands of activity to it, continues to predominate over the presentation of nature as an unoccupied or unalloyed domain. But by the 1580s the interrelation of narrative, or quasi-narrative, and nature increasingly takes on a new form in Central Italian painting. The cast of figures shown in landscape settings comes to

Fig. 28. Jacopo Bassano, *The Garden of Eden*, c. 1560. Oil on canvas, 29½ × 42½ inches. Galleria Doria Pamphili, Rome

include peasants and their accompanying herds of sheep or cattle, brought more strongly into descriptive focus along with humble peasant dwellings.

There is precedent for this in Venetian drawings and prints from earlier in the century, including ones by or after Titian that go back to around 1520; and also in the choice of peasant imagery that is found in Jacopo Bassano's art by 1560 or soon after (see Fig. 28). The woodcut of a *Landscape with Ploughman* from close to mid-century (attributed to Giuseppe Porta) recalls, in its focus on plow, oxen, and costume, Flemish prints of country activities of a kind that were by now in wide circulation.[44] Probably, then, this increasingly popular focus in Italy built on a consciousness of Northern precedents, going all the way back to the International style of the fifteenth century in manuscript illumination. The treatment of landscape there had tended to set up its own bounded areas and assigned spaces for the peasantry, implying social separation as well as exclusion from courtly pleasures, as in the *Très Riches Heures* of the Limbourg brothers (1413–16, Musée Conde, Chantilly).

The development was further motivated by the growth of concern in sixteenth-century Italy with social conditions in the countryside, where wealthy patricians had elected to settle (as on the terra firma around Venice). The agricultural land belonging to aristocratic villas and estates was coming at this time to be more thoughtfully and productively

tended, with a regard for those who subsisted on this soil. Perhaps also there was a linked interest in using a focus on such figures to make the presentation of landscapes in which they were included more accessible. In the frescoes of Matthew and Paul Bril, done in Rome in the 1580s after they moved there independently from Antwerp, peasant costumes and dwellings are contrasted with aristocratic castles and villas: not just for variety's sake, and to give a more encompassing view of the state of the countryside, but perhaps also so that those proletarian elements could call attention to themselves, amid the uniform rhythmic continuities and smooth tonal transitions of the natural settings. The very greenness of the landscape, whether occupied by hermits or by peasants, brings to notice, as a place of implied spiritual refreshment, what had previously been looked upon as hostile or threatening wilderness.[45]

In the early landscapes of Annibale Carracci, done in Bologna in the 1580s after he had visited Venice and North Italy, country figures and their actions provide a point of entry into the landscape; particularly when they are engaged in an overt display of energy in moving boats along (see Fig. 29). These figures imply an antidote to meditative tranquillity and a spirit in which awareness of where one is heading in nature, for what purpose, chimes with the specifics of a mundane routine. It is a routine in which hunting and fishing have their allotted time-span during the day—directed by the light and weather, which the scenery as a whole distils—and the way home must be found in good time, in order to escape those darkening shadows that appear already to be taking occupancy of the foreground. Human concentration and the overwhelming scale of the domain or tract of nature in which it needs to find purchase—that of moving water for those still at their pursuits—come together in this way, so that they appear charged with a sense of melancholy.[46]

In seventeenth-century Italian landscape, from Annibale Carracci to Gaspard Dughet and beyond, the viewer is characteristically prompted to follow a particular pathway into the landscape, as opposed to being invited to participate sensually and imaginatively in its character (as is still true of the early works of Poussin's, from the 1620s and 1630s, which draw on the example of Titian). Rather than entering into the spirit of the landscape accordingly, viewers are given access to what it holds in strong emotional terms. The figures within the scene are linked to "story," yet detached from it so that they comment through their actions and gestures on the full extent of the emotionally charged implications belonging to the scene. Traditional narrative concerns are thereby replaced with a form of psychological involvement, between figures and landscape, that is internal to the scene, and at the same time capable of eliciting spatial extension, in the viewer's behalf, through the way in which it is contained and controlled.

In Poussin's *Landscape with the Gathering of the Ashes of Phocion* (1648, Walker Art Gallery, Liverpool) there is an opposition between city and country, going back to the Renaissance already, in which the country features as a place to be buried, outside of the enclosing and protective city walls. Here that opposition is charged with an extreme poignancy as part of the story, inasmuch as the Athenian general Phocion had been falsely sentenced to death for treason by his fellow citizens, and condemned to be interred outside the city; in the companion scene (National Museum of Wales, Cardiff)—painted

Fig. 29. Annibale Carracci, *River Scene*, c. 1580–90. Oil on canvas, 31½ × 56¼ inches. Staatlichen Museen, Berlin, Preussischen Kulturbesitz, Gemäldegalerie Dahlem

along with this one for the wealthy Lyons merchant Jacques Cérisier—his body is shown in the foreground, being transported on a bier for cremation outside Megara.

The gathering up of Phocion's ashes is the work of his widow. She is excluded as a woman from the male ethic, of strenuously assertive physical presence and the mastering of circumstance, that is represented in the figures of slaves who are carrying the bier. She can participate in that ethic, in the cause of duty and honor, only vicariously, by putting herself at risk, inasmuch as she is being spied upon, and with the aid of a vigilante who takes the form of a female servant beside her. The connecting thread, linking her action with the city to which the ashes will eventually be returned, is natural rather than narrative in essence, since it hinges on the figures from the city—not excluded from it, but free to return there—who form part of the scene. They occupy the middle ground (in the companion picture their equivalents are further back, beyond scenes of the country and right outside the Athenian walls), and the actions they perform are those of enjoying and making use of the landscape, in the unbroken continuity of their lives.

There are other late paintings of Poussin's in which a strongly directed pattern of gaze and movement, on the part of a male figure, is associated with the finding of a way into the landscape setting that is not there as yet, but potentially there. In the *Blind Orion Searching for the Rising Sun* (Fig. 30; Metropolitan Museum, New York), painted in 1658 for Michel Passart, adviser to Louis XIV on administration and finance and another of Poussin's wealthy patrons, the giant hunter is shown, following an imaginary depiction described in antiquity by Lucian, seeking the sunlight that will heal his blindness. He does this with the aid of Cedalion, who stands on his shoulders, and Hephaistos who acts

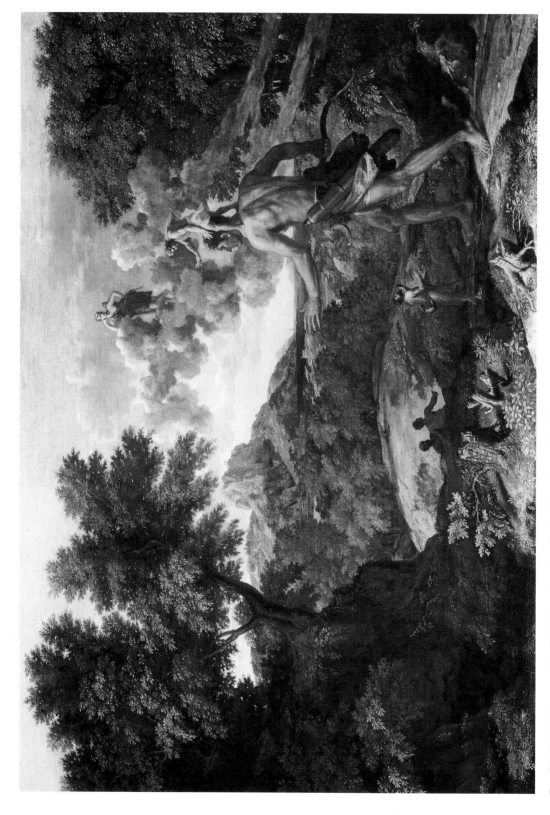

Fig. 30. Nicolas Poussin, *The Blind Orion Searching for the Rising Sun*, 1658. Oil on canvas, 46⅞ × 72 inches. The Metropolitan Museum of Art, New York, Fletcher Fund 1924

as guide at his feet. In keeping with an allegorical version of the story supplied by Natale Conti, a sixteenth-century writer on mythology, Diana, who had blinded Orion for having assaulted a nymph of hers, watches from the heavens and she is responsible for the clouds coming down earthward to bring rain; while it is Apollo as Orion's third father who offers the cure of the sun.

This cure is to come to pass when Orion's travel eastward brings him to the sea. In the painting a glimpse of it in the further distance appears between trees; and not only do the edges of dark cloud relieved by sunlight confirm that direction of journey, in their angle and ordered placement: two bystanders also, with sunlight touching the ground before them, which Orion cannot see but is about to reach, serve along with tiny figures in the distance, next to Orion's head, to connect the near and the far. This form of storytelling and structuring entails suspense: the delaying of a proffered outcome to a search, or in other instances an escape; at the same time that outcome is made clear syntactically to the viewer, who is put in the position of addressing here what Orion's guided travel entails, and intuiting thereby the fulfillment of an overmastering purpose.[47]

After completing his *Landscape with Pyramus and Thisbe* of 1651 (Städelsches Kunstinstitut, Frankfurt) for Cassiano del Pozzo in Rome, Poussin sent to his friend and colleague Jacques Stella a letter with a detailed description, which is known from the publication of the segment in question in 1688 by his biographer André Félibien. In this account of the picture Poussin wrote of having "tried to represent a storm on the ground," in such a fashion that "every figure seen there acts in accordance with the weather."[48] This concern of his with the release of emotions in the context of landscape goes back earlier, as does his concern with the terms on which women are subject to the will and demands of men. The latter replaces, in effect, his early, Titianesque presentation of women in outdoor settings as objects of desire and longing. The *Landscape with a Man killed by a Snake* of about 1648–49 (National Gallery, London) done for the banker Jacques Pointel in Paris, was explained, in a dialogue given to Poussin, as depicting the emotion of fear.[49] It includes not only a man in violent flight from the scene, but also a kneeling woman who responds with an emotional engagement that the men fishing in the boat beyond her do not have. Together, these concerns form the basis for what came to be seen (as on the part of Félibien) as a "tragic" modality in Poussin's art, as distinct from a "pastoral" or a "heroic" one. But the situation here as far as landscape is concerned is of some internal complexity.

Poussin's theory of the modes, as enunciated in his letter of 1647 to Chantelou, derived from antique theory of music where it referred to harmonic scales (see page 39), differing from one another in sequence of intervals and tonality. It seems that he adapted the theory to suggest performances of inner passions and feelings—such as those adduced in the letter to Stella—that are of an attuned kind. Guiding features of structure are thereby provided, along with a distancing from the present in terms of concrete detail and the psychological charging of the event in question. Thus the scars on his architecture, besides helping to set the scene historically and giving credence to the state or character of the buildings, establish for subjects such as the *Massacre of the Innocents* (Musée Condé,

Chantilly) the psychological tenor of a lapsarian world. Modality serves in this way as a means of orchestration.

The landscape paintings do not fit in here with the modes that Poussin named, in any direct way. Those that do not have biblical, mythological, or heroic events taking place within them are sometimes called Poussin's "pure" landscapes, to relate them to the inspiration of his drawings from nature, or even classed as "miscellaneous."[50] But the fact that the figures are smaller in them, and the role of the setting more expansive, as it accommodates all of the actions, goes with there being no specific "story" to them with a known textual source. It also goes with their sequencing and pairing over two decades, from the mid-1630s on: *Landscape with a Boy drinking from a Stream* and *Landscape with Travellers Resting* from the mid- or later 1630s (both National Gallery, London, from the Del Pozzo collection); *Landscape with a Man Washing his Feet at a Fountain* (also National Gallery, London), which may be a pendant in a loose sense to the *Landscape with a Roman Road* (Dulwich Picture Gallery), dated 1648 by Félibien; *Landscape with Three Men* of about 1650–51 (Fig. 31; Museo del Prado, Madrid) with a horseman, bathers, travelers being shown the way by a youth in the rough foreground and conversing figures; and the *Storm* (Musée de Rouen) and its rediscovered companion *Landscape with Calm* (Studeley Castle, Gloucestershire), said to have been created for Pointel in 1651.

Poussin's seeming lack of interest in "pure" landscape, when not linked in this way to some kind of participating activity on the part of male and female figures—including sensually charged pairings of the same, such as a young man peering out of the bushes at a woman washing her feet (c. 1650; National Gallery of Canada, Ottawa)—might well suggest his being more of a thinker than a feeling person: as Bernini surmised when he saw the *Landscape with the Gathering of the Ashes of Phocion* and tapped his head, saying, "[This] is a painter who works from up here."[51] But the activation of pathways and the associative pairing of contrasting actions and reactions with virtual nonactivity establish a transmission of feeling, from the protagonists back into the landscape as a whole. The suppression of brushwork essentializes, in turn, a strategy of presentation that could be read back into the ancient landscapes that Poussin knew. It is a strategy serving to conceptualize what belongs already to the past and will remain ineluctably so: fixed thereby for the perception of viewers and their prospective entry, on psychologically controlled terms.

In Claude Lorrain's art there is also the question of how gesture and visual responses that are shown within the picture relate to landscape, independent of narrative considerations. The harmonization of those ingredients on Claude's part has been consistently stressed; but the role of the tiny background figures in his landscapes in terms of action and vision has largely been passed up. These figures seem in fact to propose, or inject into the presentation, a particular mode of participation in the main scene that is relevant to defining, and indeed crystallizing, the attitude of viewers in front of the painting itself.

For the Netherlandish stages of a journey (page 21) and for the idea in Bruegel's *Hunters in the Snow* of the view that becomes available at the edge of a hillside, with the potential of taking everything in (page 56), Claude's landscape art substitutes prospects of nature as if they were capable of synthesizing, in a golden moment, different and succes-

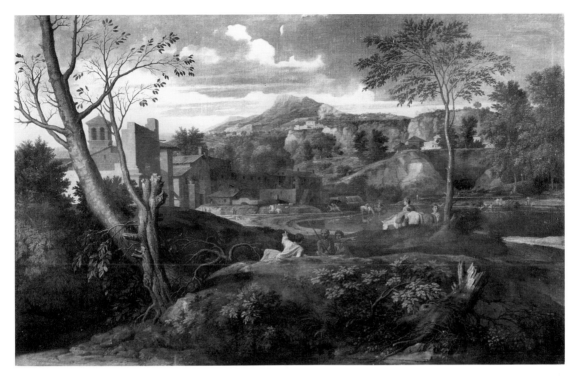

Fig. 31. Nicolas Poussin, *Landscape with Three Men*, c. 1650–51. Oil on canvas, 47¼ × 73½ inches. Museo del Prado, Madrid

sive experiences of seeing, making them seem continuous with one another and thereby giving a stable, and even implicitly eternalized, quality to the act of vision. When the theme is explicitly one of journeying, Claude's travelers have such prospects spread out before them and offered to their vision, even while they are tied up with concerns of the moment, such as boarding a boat; other figures who represent disengaged participants will be shown in the vicinity enjoying the view, or its possibility, as they converse.[52] In the *Landscape with Apollo, Muses and a River God* (National Gallery, Edinburgh) a small figure at the upper left prays for admission to the hilltop temple from a figure standing at its entrance, with scepter and outstretched arm; and from that prominence, as an approach to the left of the temple conveys, a view over the rearward landscape can be obtained in its entirety. In the later subject of *Aeneas's Departure from Dido in Carthage* (c. 1675–76; Kunsthalle, Hamburg), a figure similarly goes up the temple steps, as if asking for admission and being received; around the bend there are unoccupied figures. Contrasting with those who have tasks to complete, they are engaged in looking at the view.

The *Sermon on the Mount* (Fig. 32; Frick Collection, New York) done for Bishop Bosquel of Montpellier in 1656, is most interesting in this connection, one reason being that it formed the companion to a subject of travel: *Queen Esther Approaching the Palace of Ahasuerus*, a canvas that was virtually destroyed by fire when it belonged early in the nineteenth century to William Beckford of Fonthill. Access to the central mountain here, as a site of refreshment (based on Mount Tabor on the Dead Sea), and equally

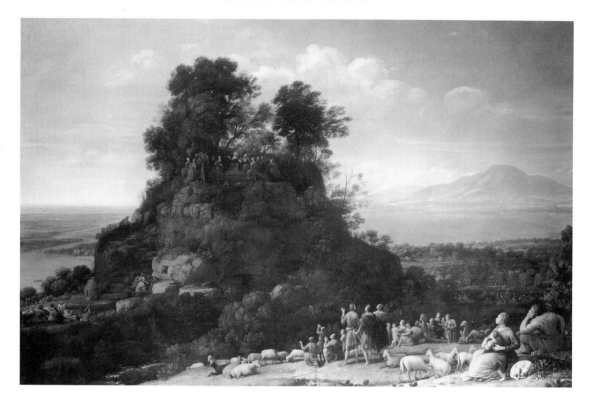

Fig. 32. Claude Lorrain, *Sermon on the Mount*, 1656. Oil on canvas, 67½ × 102¼ inches. The Frick Collection, New York

descent from it, is provided by a stairway cut into the rock, with climbing figures on it, and also by the path of a river.[53] At the back right, in a hollow of the landscape, a small circle of figures is to be found in what appears to be an outdoor theater (Fig. 33). If so, there is a drama with a death scene (which could be either heroic or religious in tenor) taking place before them. Their kind of engagement in a theatrical experience is analogized to the visual and emotional engagement of the circle at the front right, men, women and children, with the preaching of Christ as a source of wonder to them, imaginatively drawing the gaze. These latter figures are attending to and at the biblical event in the same manner as spectators attend the performance of a play. And the landscape setting invokes, in both cases equally, access to an accompanying, and universally available, expansion of insight.

Whereas Poussin and Claude invite the viewer, in the terms described, to identify with a single figure or group of figures within the landscape, Rembrandt is more concerned with seeing itself, as a process. The exercise of vision is posited as bridging, rather than juxtaposing as with Dürer, the terms of access to the natural world provided by knowledge on the one hand and belief on the other; but it is on the latter side that the emphasis falls in Rembrandt's painted landscapes, because he is interested psychologically in the role of light, mysterious and expansive, and especially in what it does to substance and atmosphere. There is a contrast here to his landscape drawings, in which there is a precise

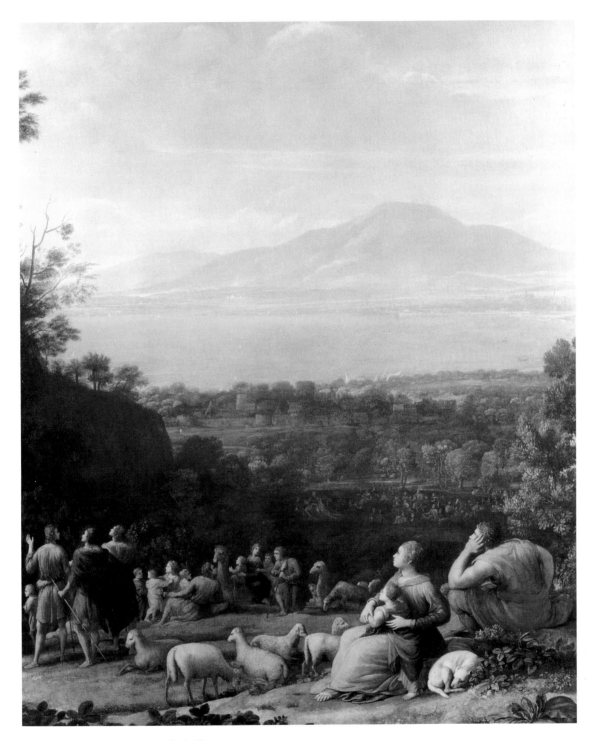

Fig. 33. Detail of Figure 32, right half

interest made evident in reporting and recording natural phenomena, such as the surface of snow or the vibrancy of sunlight, as well as in affirming the traditional pleasures of the Dutch countryside.[54] His oils have more in common with the prints of his predecessor Hercules Seghers, insofar as they appeal to the imagination; but they implicate the viewer even more directly in filling up what is missing, or supplying what is left unspecified.

Rembrandt's extant painted landscapes are in fact too few in number—between nine and nineteen in all, depending on one's inclusions and exclusions—and from too short a time span, the mid-1630s to the mid- to later 1640s, to permit classification according to type and treatment. Any such classification becomes a superimposition of one's own. And as with his graphics, their making suggests an experimental combination of motifs and techniques, corresponding to the following of those models that he admired the most: Jan Porcellis, six of whose seascapes he owned, and Hercules Seghers, some of whose landscapes in oil he evidently retouched, as well as more obviously reworking prints of Seghers's.[55]

A good number of Rembrandt's landscapes were left unsold, twelve being included in the 1656 inventory of his possessions; the only one that implies a more pragmatic orientation, toward a specific clientele, is the small *Winter Landscape* of 1646 (Kassel, Gemäldegalerie). It is singular in character in being based upon the work of Esaias van de Velde, from some twenty to twenty-five years before, almost as if Rembrandt had been asked to match a painting by that artist showing the seasons and activities associated with them, or to add to an incomplete set of subjects by him. Rembrandt must also have given recommendations and technical help to studio assistants of his, guiding their production of landscape, as with Govaert Flinck and Ferdinand Bol especially, from the 1640s on; hence the difficulty of separating out what represents unquestionably his own work.

Amongst the strongest candidates for being so regarded, the *Stormy Landscape* (Fig. 34; Herzog Anton Ulrich Museum, Braunschweig) has in common with the 1637 *Landscape with a Coach* (Wallace Collection, London) and the 1638 *Landscape with the Good Samaritan* (Nationalmuseum, Krakow) a beaded, almost phosphorescent quality to the paint, in the trees and other areas picked out by light; and buildings of different architectural types, only readable in general terms, are closely juxtaposed. Rembrandt deals here with the emergence, into the viewer's cognitive grasp, of ruins and fantasy buildings. What happens is comparable in its order of imaginative understanding to Leonardo da Vinci's interest in the way in which recognizable forms and images come into sight, when one stares intently for a long time at a rough wall surface. But Rembrandt is more concerned with images irrationally materializing, and certainly not in an ordered succession of elements reaching back to the horizon.

Most of the Dutch seventeenth-century landscapists are concerned, in contrast, with accepting the landscape as it is: its proportions, its structuring, as apprehended either from within or from a more external viewpoint, and its particular landmarks. Keeping observation and memory in balance, they engage the viewer in specific ways, by appealing to common experiences up and down the social scale, such as walking in nature and the appreciation of rustic farmlife, and also by including specific features, such as castles and ruins, that are of topographical, national, or historical interest.[56] It is on this dual basis

Fig. 34. Rembrandt van Rijn, *Stormy Landscape*, c. 1637. Oil on canvas, 20½ × 28¼ inches. Herzog Anton Ulrich Museum, Braunschweig

that the English writer Henry Peacham could define *landskip* in his *The Art of Drawing* from 1606 as a term of Dutch origin entailing "hills, woods, castles, seas, rivers, valleys, hanging rocks, cities, towns," and also "prospects" in the form of sweeping views from high places; and another Englishman, Edward Norgate in his *Miniatura, or The Art of Limning* from around mid-century could call the creation and appreciation of landscape art a "harmless and honest recreation" that diverts and lightens the mind.[57]

Jacob van Ruisdael's work can stand representatively for those Dutch painters who, in the middle and later decades of the seventeenth century, effectively democratized the experience of landscape and the social forces that contribute to it, by invoking a more diversified range of ways of responding to it, based on association, and by bringing into focus particular visual pleasures and excitements.[58] It is not figures, singly or in groups, that stand in here for a way of seeing and responding, but elements of landscape that serve as signposts aiding the viewer to find his or her way through, in an unassuming and essentially isocratic fashion. Ruisdael's *Hilly Landscape with a Great Oak* (Fig. 35; c. 1650–55; Herzog Anton Ulrich Museum, Braunschweig) is named for its tree, the wood of which is a rich orange where the trunk has been opened up. The eye also encounters a cottage at the far left, with figures coming down the road; a cut-down tree and a peasant woman seated nearby; to the right a man with a dog, and beyond a grain field a church and town hall under darkened stormclouds. These are key sights of the countryside, in the sense of being representative, but also appealing to specific capacities of recognition, with an appropriate show of variety, or transitions of scale and emphasis. Some have argued for a specific philosophical viewpoint or concept of nature at work here; but if so, as with Roman landscape, it is left implied.

PROJECTION: INVESTMENT IN ILLUSION

The use of one-point perspective as a method of structuring for landscape entails recognition on the viewer's part, and identification with, the position of a single "seeing eye," placed at the same height as the vanishing point toward which the lines of recession set up within the pictorial representation converge. The *camera oscura* or dark chamber, as a convenient mechanical device that came to be used for the drawing and painting of landscape from the early 1600s on, produces correspondingly a visual projection into the landscape or cityscape that is chosen for depiction, as from the exact position of the artist studying the scene. But beyond that its effect on the way in which the subject is viewed carries important shades of difference.

Perspective sets up on a two-dimensional surface a relational plausibility such that, in the words of Samuel van Hoogstraaten in the section on landscape included in his 1678 treatise on painting, perfection in the mirroring of nature can cause "things that are not there to appear," and can deceive in an "acceptable, pleasing and praiseworthy way."[59] With the *camera oscura,* in contrast, the image that is created on the screen contained within a darkened room, or a shuttered box, by the entry of light through a hole in one of

Fig. 35. Jacob van Ruisdael, *Hilly Landscape with a Great Oak*, c. 1650–55. Oil on canvas, 41¾ × 54¼ inches. Herzog Anton Ulrich Museum, Braunschweig

its sides, models a way of seeing the outside world that brings in temporality and move-
ment, prior to and independently of the decision to represent in frozen form what appears
on the screen. It is a way of seeing in which an effectively disembodied individual has
sovereign power of command over a section of the world that is physically separated from
him and made subject to its own autonomous principles of structuring. From that vantage
point a trajectory is provided for the comprehension as well as the apprehension of the
portion of the world, or "cut" of reality that is in question.

This is the species of projection that finds its apogee in the early to mid-eighteenth
century, in the *vedute* or topographical views of Antonio Canaletto.[60] Vermeer may have
used the *camera oscura* for his views of Delft from the 1650s, which include diminutive
figures participating incidentally in the scene.[61] But in Canaletto's work from the 1720s
on there are figures included who, as if in a frozen tableau, observe the view of buildings,
water, and human activities from positions and angles that implicitly contrast with the
posited position of the artist himself. That viewing point onto the scene is higher up and
centralized, so that from it the recession of the architecture and landscape is given an
overarching, synoptic reach back to the further horizon, under a sky that takes up
approximately half of the composition. This form of *veduta* was brought to England
through the patronage of the merchant Joseph Smith, who became the British consul in
Venice in 1744 and acquired Canaletto's work in quantity, and through Canaletto's own
stay in England, which began in 1746. It was carried to some of the major cities of Eastern
Europe by Canaletto's nephew Bernardo Bellotto, who rose from being a pupil and
assistant to an independent practice: one in which shadows, clouds, and sunlight are
distinctively emphasized (see Fig. 36).[62]

But in the last decades of the eighteenth century a fundamental change in the authority
of that kind of view is set on foot, and this change can be associated specifically with the
development of the panorama. How this development differs from the unfreezing of the
two-dimensional tableau, to include actual movement of figures or objects and changes of
light, is made clear by accounts of the *Eidophusikon* created by the painter and stage
designer Philippe de Loutherbourg in the 1780s, and offered as a performance to the
public in successive versions, from the 1780s through to the end of the century.[63]

De Loutherbourg, who had come from France to England in 1771, had had experience
of the stage productions of the Paris Opera using mechanical contrivances and sources of
colored light that were movable to spectacular effect. For a series of dramatic and panto-
mime productions mounted for the Drury Lane Theatre in London over the next ten
years, he used three-dimensional models, along with flat pasteboard cutouts, for the
display of ships and boats in motion. He also opened up the back and sides of the
proscenium stage so that flats and wings could be angled; above all he experimented with
the distribution and control of light, using transparencies especially.

All of this De Loutherbourg drew upon and distilled in his *Eidophusikon*, advertised as
consisting of "Various Imitations of Natural Phenomena, represented by Moving Pic-
tures." In a box eight feet deep, with a vertical picture area of sixty square feet or less,
those same devices were used to offer a spectacle that included initially a perspective of
Greenwich Park, with the "Effects of the Dawn" changing to those of midday, and then
fading to dusk; "Noon [in] the Port of Tangier, with [a] distant View of the Rock of

Color Plate I. Jean-Honoré Fragonard, *Blindman's Bluff*, c. 1775–80. Oil on canvas, 85⅛ × 77⅞ inches. National Gallery of Art, Washington, D.C., Samuel H. Kress Collection

Color Plate II. Hendrik Willem Mesdag. *Panorama of Scheveningen*, 1881, c. 46 feet high. Detail: the village and the "Haringkade" canal. Archives Mesdag Panorama, The Hague

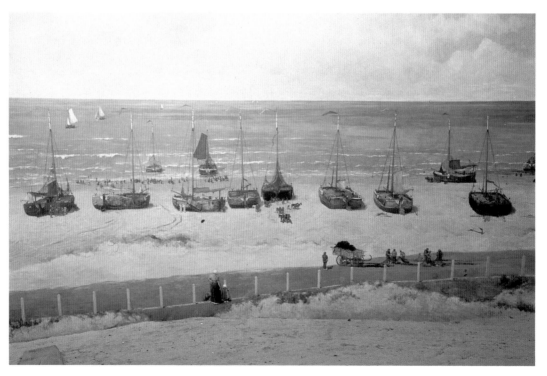

Color Plate III. Mesdag, *Panorama of Scheveningen*, 1881. Detail: the fishing port. Archives Mesdag Panorama, The Hague

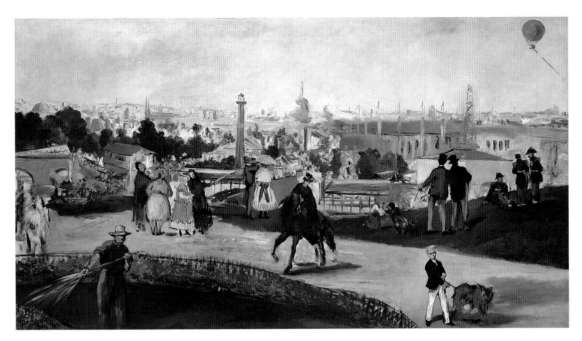

Color Plate IV. Edouard Manet, *View of the Universal Exhibition,* 1867. Oil on canvas, 42½ × 77¼ inches. Nasjonal-
gallerier, Oslo

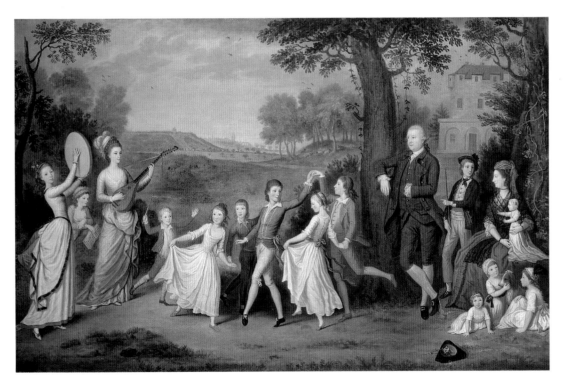

Color Plate V. David Allan, *The Family of Sir John Halkett of Pitfirrane,* 1781. Oil on canvas, 60¼ × 94 inches.
National Gallery of Scotland, Edinburgh

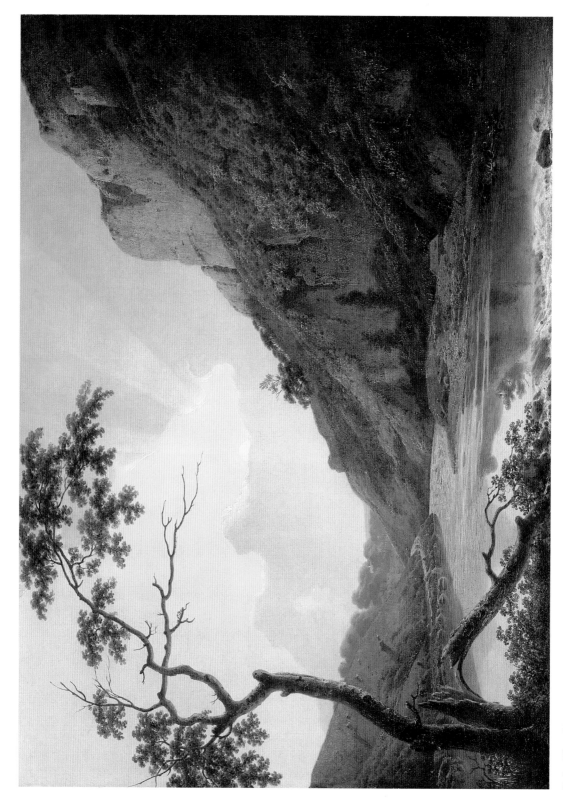

Color Plate VI. Joseph Wright of Derby, *Matlock Tor, Daylight*, c. 1785. Oil on canvas, 28½ × 38½ inches. Fitzwilliam Museum, University of Cambridge

Color Plate VII. Théodore Géricault, *Landscape with a Roman Tomb,* 1818. Oil on canvas, 98½ × 86¼ inches. Musée du Petit Palais, Paris. Copyright 1996 SPADEM, Paris

Color Plate VIII. John Brett, *Val d'Aosta*,
1858. Oil on canvas, 34½ × 26⅞ inches.
Private collection, England

Color Plate IX. Berthe Morisot, *Forest of Compiègne*,
1885. Oil on canvas, 21¼ ×
25½ inches. Art Institute of
Chicago, Bequest of Estelle
McCormick, 1978

Color Plate X. Richard Wilson, *Dinas Bran from Llangollen,* 1770–71. Oil on canvas, 69 × 93 inches. Yale Center for British Art, Paul Mellon Collection

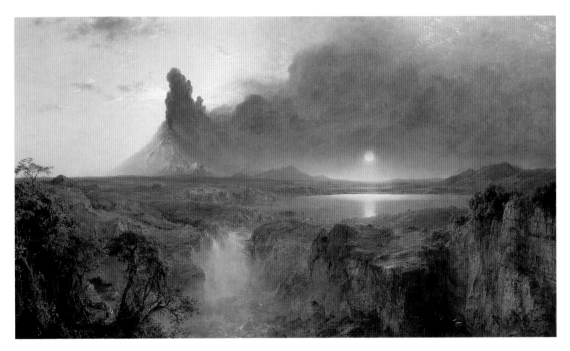

Color Plate XI. Frederic Edwin Church, *Cotopaxi,* 1862. Oil on canvas, 48 × 85 inches. Detroit Institute of Arts, Founders Purchase Fund

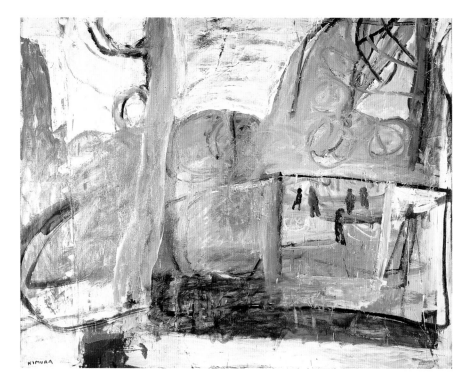

Color Plate XII. Chuta Kimura, *People Taking a Walk*, 1982. Oil on canvas, 57⅛ × 63¼ inches. Collection of Numura Securities Co., Tokyo

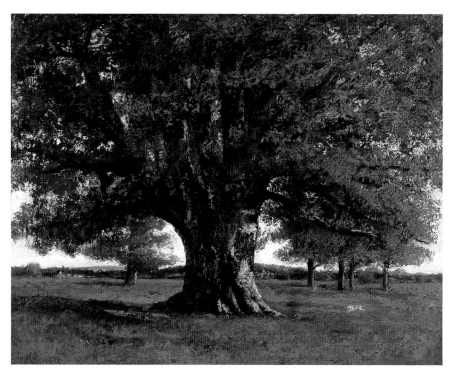

Color Plate XIII. Gustave Courbet, *The Oak at Flagey*, 1864. Oil on canvas, 35 × 43⅜ inches. Murauchi Art Museum, Tokyo

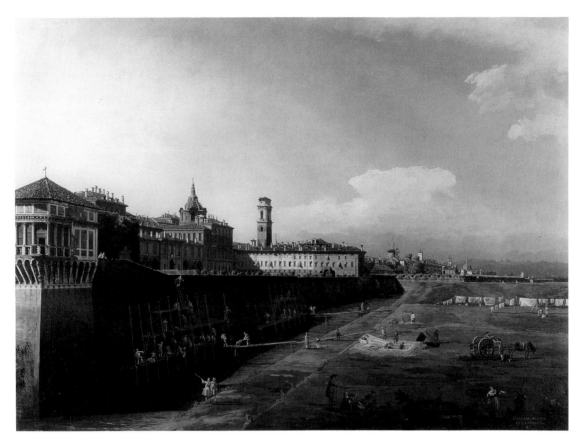

Fig. 36. Bernardo Bellotto, *The Royal Palace of Turin from the East*, 1745. Oil on canvas, 50 × 64½ inches. Galeria Sabauda, Turin

Gibraltar; "Sunset . . . near Naples" and "Moonlight . . . in the Mediterranean . . . contrasted with [an] Effect of Fire," as well as a concluding scene of storm and shipwreck, of a kind that was becoming exceedingly popular in oil painting of the time.

But however De Loutherbourg amplified his display in successive seasons, with subjects of war at sea or a scene of Satan on the Banks of the Fiery Lake from Milton, the audience sat in fixed places throughout, on benches or seats in the public rooms that he used. The panorama, in contrast, offered a different kind of viewing experience.[64] As patented in 1787 by an Irish painter in Edinburgh, Robert Barker, it entailed "an entire new Contrivance or Apparatus . . . for the Purpose of displaying Views of Nature at large, by Oil-Painting, Fresco, Watercolours, Crayons or any other Mode of painting or drawing": to wit, the construction of a circular building, or rotunda, lit exclusively from the top. The rotunda that Barker opened in London in 1793, offering views of London and Scotland, correspondingly had visitors enter and pass along a darkened corridor to a viewing platform. Once there, they could move and turn at will to view the panorama, which was painted on the inside of the rotunda so that it stretched through 360° all around them.

In France, Robert Fulton, inventor of steamships and submarines, obtained in 1791 an exclusive ten-year license to show panoramas over the country. By the early nineteenth century there were four such cityscapes on display in Paris, of London, Lyons, Naples,

and Rome, made under the direction of Pierre Prévost. The commune of Thun in Switzerland offered from 1814 an overview of its own streets and squares. In London, Barker's successors ran into competition with the Colosseum in Regent's Park, which opened in 1829 a "pleasure dome" in which visitors ascended by a staircase or elevator to viewing galleries from which they could explore a "panorama of London": the work of Thomas Hornor, draftsman, surveyor, and garden designer, done from the scaffolding mounted on the dome of Saint Paul's Cathedral while it was being restored in 1823.

By that time Louis Jacques Mandé Daguerre, one of the inventors of photography, had opened his "London Diorama" next door, following a great success in Paris with this invention of his, based on his experience as a stage designer. Besides going much further than De Loutherbourg had with spectacular lighting and scene changes, the diorama differed from the *Eidophusikon* in rotating the viewing room between two frames, each of which in turn offered a fifteen-minute exposure to a picture located at the further end of an "invisible" tunnel, so that it formed part of the illusion that size and distance could at best only be estimated. Its subjects from 1823 to 1830 were mainly drawn from the field of landscape, with particular emphasis on scenes of Switzerland and the interiors and ruins of famous cathedrals. Transparencies and other devices were used to create dreamlike effects of weather and lighting, such as fog and fire.[65]

John Constable, invited by his Paris dealer to a private viewing of the Diorama, wrote complainingly in a letter that "[though] it is very pleasing and has great illusion—it is without the pale of Art because its object is deception—Claude's never was—or any other great landscape painter's."[66] In associating pleasure with the degree of deception, Constable was in effect controverting van Hoogstraaten's terms of discussion for landscape art, which were familiar to him. He was turning them in a negative direction by positing that where nothing was left for the viewer to supply—everything being done to make the illusion perfect—the achievement of pictorial illusion became pointless; or perhaps one should say it became redundant, in its impressions of movement and artificial transformations of nature.

Amid this panoply of spectacles and performances, with landscape as a key ingredient, to which the public was exposed through the later nineteenth century and in some cases on into this century, Hendrik Willem Mesdag's panorama, of Scheveningen as it was in 1880 (Fig. 37 and Color Plate II), stands out particularly. It was not the first, certainly, to focus primarily on landscape for its subject-matter; but it is the one in which human activity is seemingly least stressed. As in photographs of the time taken from a raised viewing point or prominence, the figures here take on their own intrinsic patterning. This is because no one activity stands to the fore, amid several different kinds that are shown, and the tones are generally kept close to one another. The artist's wife Sientje, who is not generally given sufficient credit for her role in directing the whole project as well as helping to paint the dunes and village, with George Hendrik Breitner as a main assistant in the latter case, appears within the painting. Fittingly in view of her role, she is shown on the beach, at work under a white umbrella; the viewer can thereby project into her situation, and gain a concrete sense of what she is seeing, as well as doing (Fig. 38 and Color Plate III).

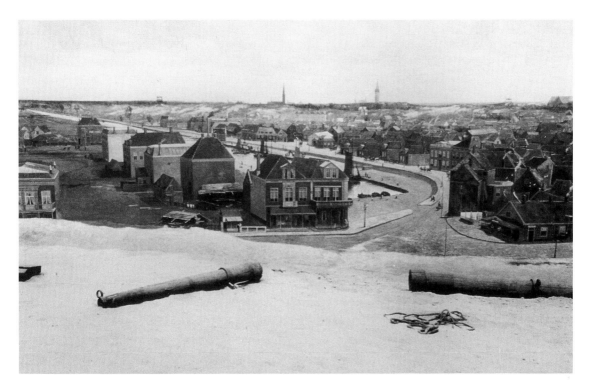

Fig. 37. Hendrik Willem Mesdag, *Panorama of Scheveningen*, 1881, c. 46 feet high. Detail: the village and the "Haringkade" canal. Archives Mesdag Panorama, The Hague

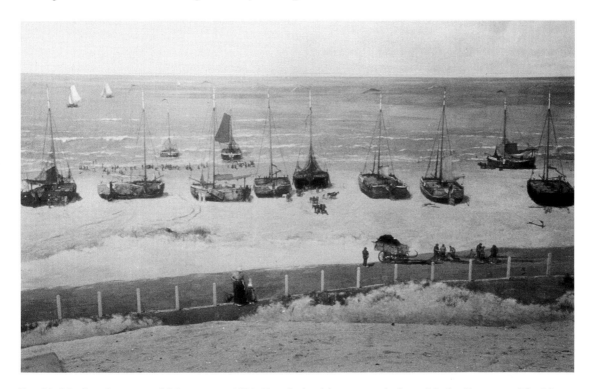

Fig. 38. Mesdag, *Panorama of Scheveningen*, 1881. Detail: the fishing port. Archives Mesdag Panorama, The Hague

This panorama had also a commemorative function; the building that houses it, still intact today, displaced at its creation the actual dune from which the view as a whole was taken. Correspondingly, the terms on which the illusion operates depend upon a practice of enlargement from sketches by the use of squaring, which was made to fit onto a curved surface, with the right projection and proportions for this degree of curvature, by the use of a glass cylinder mounted on legs. This cylinder had the contours of the main landmarks drawn upon it in white paint, so that their positioning could then be pinpointed and marked out in advance, under Mesdag's central direction.[67]

In accordance with what was specified in Barker's original patent, an umbrella-like roof overhead prevents the viewer looking up from going beyond the limits of the painting; what lies beneath the lower edge of the painting is similarly blocked from view, by an intervention of a material kind. In Mesdag's case, however, this role is performed by a *faux terrain* of actual sand, with beachgrass and fisherman's tackle on it, to which the viewing platform effectively denies access. (In Robert Altman's 1990 film *Vincent and Theo,* the young daughter of van Gogh's companion and model in The Hague, Sien, is shown as being drawn into the naive response of going out and relieving herself on the sand.) The representation, including the sky above, in this way embraces the viewer, and has one turn the body through a full rotation, back to one's starting point, to take it in.

When attention is drawn in this fashion to the processes of illusion themselves (rather than simply the potentialities afforded by a monocular viewing instrument, as with the *camera oscura*), the result is a form of theater, in which recognition of the source and mechanics of what takes place only enhances the magical effect.[68] What it means, in resistance to that kind of spectatorial absorption and acceptance, truly to take possession of one's vision, so as to be able to use it opportunely and constructively, is suggested in turn in the account of the world and its representation (*Vorstellen*) offered early in the nineteenth century by the philosopher Arthur Schopenhauer. Schopenhauer advocates that

> further we do not let abstract thought, the concepts of reason, take possession of our consciousness, but instead of all this devote the whole power of one's mind to perception, sink ourselves completely therein, and let our whole consciousness be filled by the calm contemplation of the object actually present, whether it be a landscape, a tree, a rock, a crag, a building or anything else. We lose ourselves entirely in this object; to use a pregnant expression, [on the model suggested by a passage from Spinoza, we conceive of it] *sub specie aeternitatis.*[69]

In anticipation of much later attitudes toward the imaging of landscape, such as those of Paul Cézanne in the 1880s and 1890s, we are invited here to disengage ourselves from the fixed positioning of the eye, or the whole upper body, as source and point of origin of perception, in order to project our perceiving awareness *into* the character of the individual object, including the very circumstance of its coming to be perceived (in shape, extension, solidity) the way it is. We internalize the act of perception for this purpose,

and at the same time make ourselves aware of how the shifts we make in the relative positioning of ourselves impact upon what we come to see, and especially the relation between successive images.

What kind of pressure did spectatorial absorption and acceptance, of the kind that Schopenhauer saw the need to resist, place on an artist who still chose to use the two-dimensional mediums—oil painting, watercolor, printmaking—for views that in the context of nineteenth-century urban development, coupled architecture with the natural scenery of the city, such as park or riverside? How response on the part of such artists should be detected and evaluated is suggested by a passage in Charles Baudelaire's review of the Salon of 1859, dealing with the representation of landscape subjects there. "I long," Baudelaire wrote,

> for the return of the dioramas whose enormous, crude magic subjects me to the spell of a useful illusion. I prefer looking at the backdrop paintings of the stage where I find my favorite dreams treated with consummate skill and tragic concision. These things, so completely false, are for that reason much closer to the truth, whereas the majority of our landscape painters are liars, precisely because they fail to lie.[70]

Baudelaire was interested in landscape as a critic because of his concern, more generally, with *who* is to enter into a pictorial image, in what social and spiritual state of mind or being; and how the viewer is to respond to what is desirably to be found there, in the way of inspiring sentiments serving as incentives to the imagination.[71] If the tide was to be turned in landscape subject-matter—in relation now to the development of photography, with its atmospheric and spatially redolent ways of structuring landscape and cityscape—it was to be in virtue of a dramatic input that was generated from within the scene itself, as an offshoot of structural incongruities or discordances there, and that registered as such in the imaginative piecing together of the viewer. To single out here views of Paris by Charles Meryon from the 1850s and Edouard Manet from the next decade is to bring up artists to whom Baudelaire responded admiringly.

In Meryon's print from 1854 of the *Morgue* (Fig. 39), on the Ile de la Cité, which was accompanied in its fourth state by a poem of the artist's, "The Hostelry of Death," there is a compacting of space and architecture that draws the eye in, as if with an intense sucking movement at the center of the plate. And yet it gives it no place of rest, because of the black or closed windows blankly returning one's stare, and the denial of entrance and exit points. The critic Philippe Burty, cataloguing the artist's graphic work in 1863, found this entirely remarkable:

> It would be impossible to extract a more moving treatment of a corner of houses, which, in reality, were far from producing a similar impression on the soul. These bizarre, superimposed roofs, these colliding angles, this blinding light which renders the contrasts of the masses of shadow so striking, this monument which

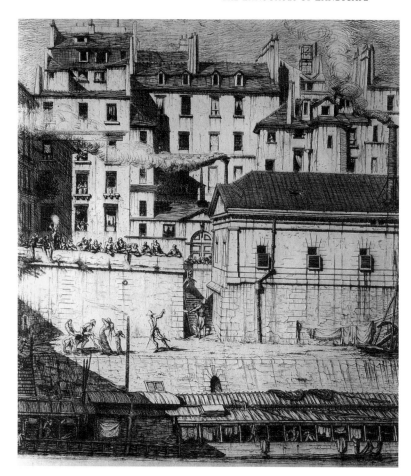

Fig. 39. Charles Meryon, *La Morgue*, 1854, Etching, first state, plate 9⅛ × 8⅛ inches. National Gallery of Art, Washington, D.C., Rosenwald Collection

acquires a vague resemblance to an antique tomb under the burin of the artist, offers to the spirit some unknown enigma about which the characters speak a sinister word; the massed crowds hanging on the parapet of the quai look upon a drama which unfolds on the bank: a corpse has just been dragged from the Seine; a little girl sobs; a woman turns her back, distraught, choked by despair; the police-man gives the order to the sailors to carry this derelict of misery or debauchery to the Morgue.[72]

A very different kind of drama, representative of Paris and its denizens in an intrinsi-cally prouder, more self-conscious moment, is provided by Manet's *View of the Universal Exhibition*, from 1867 (Fig. 40 and Color Plate IV). But it is one in which, analogously, the spaces and the actions of the foreground figures appear as not fully interconnecting. Here also there is a claim entailed to spectatorial attention, and a situation of excitement, but it is in this case a presumed excitement, based on the character of the occasion and the lead-up to it.[73]

Working on a large scale, Manet manages at the same time to give a provisional and extemporaneous character to his way of painting the scene, as if in correspondence to the

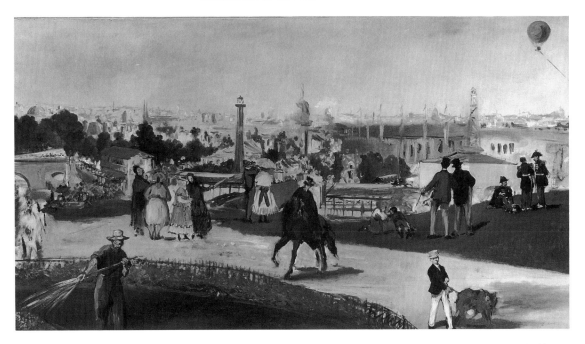

Fig. 40. Edouard Manet, *View of the Universal Exhibition*, 1867. Oil on canvas, 42½ × 77¼ inches. Nasjonalgalleriet, Oslo

improvised character of the view itself. It is a view that could be gained by descending from the Trocadéro to a hill that had been specially constructed for the occasion, and indeed just completed in time. On it there appear from left to right, in distinctly isolated patterns of action that function like condensed glimpses of what typically went on there, a gardener standing in a bed of flowers to water them; a group of ladies, in what appears to be animated conversation together; an "Amazon" on horseback; a boy being pulled along by a large dog. Groups of two or three enjoying the view in the middle ground include a woman under a parasol, next to a man who looks through binoculars at the balloon in flight; children; a pair of men in fashionable dress, with their backs turned; and a trio of seated and standing soldiers in their uniforms. There are also more sketchily painted figures, here and further back, which make the transition to buildings treated so that—as in photographs of the time showing the parks and gardens of Paris—their artificial character as designed creations is stressed, evoking a particular kind of social participation. Here this is done in "backdrop" form, but with the summariness and incompleteness of the markings in paint left distinctly visible as such.

This painting belongs only nominally to a definable mode, insofar as it undermines or undercuts basic premises of response that attach to the panoramic view in its publicly offered forms; and it is also at the furthest possible remove, pragmatically, from representing a specialization on the part of its maker. Projection into Manet's landscape calls—if it is possible at all—for a wry and even satiric attitude toward the proceedings that have resulted in this show. It means getting past socially conditioned and psychologically stereotyped ways of responding—as resident, visitor, tourist—to what is on display. And

it means putting one's detachment at risk because certain elements here, like the flowers and the towers, are so sensually inviting to the eye, only to be asked to summon back that detachment again. One's degree of participatory investment in this panorama is, finally, a matter of Baudelairean acknowledgment that, while commitment to diagnostic truth should have a paramount claim on the creative sensibility, illusion can also be "useful."

3

The Developing Appeal of Landscape, 1750–1830

Property and Possession

The extraordinary rise in the appreciation of natural scenery that took place in the course of the eighteenth century is linked, philosophically, to a growing cult of the wild and of nature in all of its variety, which visual images helped to propagate.[1] It is linked, socially, to the expansion of travel that improved means of transportation made possible. Intellectually, it draws upon the growth of natural science, as it encompassed the directly relevant fields of botany, geology, and zoology. It is also related to growing improvements in the use and cultivation of land.

This strength of interest was predicated at the same time, as a movement of taste, on prior exposure to the traditions of European art that took landscape as a prime ingredient of their subject-matter: especially the imaginatively charged vistas of Claude Lorrain, and Dutch landscape of the seventeenth century. Claude's art came to embody a particular vein of sentiment, having to do with tranquillity in landscape and change entering in only by slow transmogrification. The Dutch masters most notably admired then, such as Nicolaes Berchem and Meindert Hobbema, betokened for their part a concern with coming to know a particular terrain or tract of land as one's own, in terms of regional and national interests attaching to it.[2]

All of those developments and their conceptual background rendered it inevitable that the production of estate views, topographical landscapes, and rustic scenes complete with

local types and animals, should multiply in the course of this century, so as to encompass a whole activity of production: one that proliferated to include engravings, book illustrations, and such specially favored genres as the sporting picture. Britain in all of these respects took a lead, throughout the century, in promoting the patterns of appreciation for landscape that are in question.[3] Those patterns were in turn taken up and paralleled across Europe—in France, Italy, and Germany especially—with matching manifestations of a "pre-Romantic" sensibility toward nature: one that becomes fully Romantic when it has, in the early nineteenth century, a poetry of place and an internalized spiritual framework of perception to accompany it and give it focus.

What happened in this growing trend—reaching its apogee in a succession of manuals of instruction in landscape drawing—may be likened to a spreading pattern of language usage, in which models of practice and the rationalization of the practices themselves are discursively tied together. The models from the past frame a set of features singled out for approbation. The designation of those features has what is termed in language a *constative* dimension to it, describing and evidencing as it does the benefits that adoption brings. At the same time there is a *performative* dimension at work, declaring a commitment or stamping a purposiveness onto the use of the features in question, in what is now a formalized fashion.[4]

The topic of this chapter is not, however, the way in which previously existent categories of landscape and representations of specific types of scene were annexed to serve the mandates of the ever more widespread taste for putting oneself into touch with nature: a form of projection in which present interests are read back into preceding art, as a self-fulfilling way of addressing its character. The concern is, rather, the annexation of nature now, in the service of the self and as a site of self-realization. Here, to whom the landscape belongs and the interests of commerce and industry that is equipped to serve— rather than its long-standing identification as a place of relaxation and self-enjoyment— becomes crucial.

Again, British art has a key role to play in the showing forth of what is in question: both because there is a use of the visual image in Britain, from the mid-eighteenth century on, that chimes with the new importance and social awareness of the landowner; and because British colonialism marks out the sites of territorial and commercial expansion abroad at this period, as a means of bringing home what is and is not capable of being made subject to comparably enlightened forms of control. What evades that control encompasses in turn—as part of the same larger picture—both what is displaced, in the way of a native population and pattern of life with its own particular ties of intimacy with the land; and the will of the imagination to read into the uncharted and unpopulated realms of landscape an expression of its own larger fears and anxieties. These impulses are ones that, however suppressed, will come back in force, to form a substitute or compensating means of giving relief to the psyche.

It is not that the imagery of cultivated and conquered landscape is new at this point in art, as an expression of how governance over nature is thought of, and what it implicitly excludes. In Gentile da Fabriano's *Adoration of the Magi* from 1423 (Uffizi) the delineation of the setting focuses on ordered plantings of bushes and trees, with cultivated flowers and

nesting birds both emphasized, and on city gates and the trajectories of passage established by the roadways that run through and between them. In the fresco in the Palazzo Pubblico of Siena of Giudoriccio da Fogliano riding between captured fortresses (attributed to Simone Martini, but dating from later than the inscribed year 1328 if this whole section of the wall surface was, as now appears, substantially reworked), and equally in Piero della Francesca's pendant portraits of the duke and duchess of Urbino (c. 1460; Uffizi), dominion is expressed as a relationship that includes land ownership as a source of power, wealth, or both together. In Northern Europe those who work in the fields are shown laboring obediently and rhythmically under the control of an overseer: as in the Boucicaut Master's imaginative representation of the pepper harvest in Coilum, in the section of the *Livre de Merveilles* (c. 1410; Bibliothèque Nationale, Paris, MS. fr. 2810) devoted to illustrating a French version of Marco Polo's travels in South India.[5] Significantly, however, the location is established as non-European in the latter case by the dark coloring of the worker's skins, rather than by the vegetation or any concretely referential detail of the topography.

For wildness to appear as what lies beyond an implicit mental and spiritual frontier, rather than simply outside of an enclave of civil and administrative rule, required a concept of the exotic, as strange and outlandish and yet compellingly attractive in its foreignness, that only emerged into prominence in the eighteenth century, the term itself beginning now to be used that way.[6] Frans Post's seventeenth-century landscapes of the Dutch-occupied region of North East Brazil, done during Prince John Maurice of Nassau's governorship there (1637–44), show native vegetation and animal life and distinctive rural and urban architecture, based on drawings done on the spot.[7] But as far as the depiction of colonial and Indian life in that setting is concerned, it is hard to recognize purely on an internal basis where the material for the paintings was gathered. The presentation implies an outpost for the same patterns of life and basic uses of the land as one would find in European settings. And that leads back to the imagery of ownership as a power of possession over property, greatly expanded and enhanced by the mid-eighteenth century in terms of what it could do, and meant doing, to the natural resources of the countryside.

The form of group portrait known as the *conversation piece*, showing members of a family or other close-knit social unit interacting in a lively fashion with one another, came to flourish in eighteenth-century Britain because it encapsulated a particular sense of belonging, tied to social status. More specifically, it laid open to sympathetic scrutiny and retrospective appreciation ways in which ownership and the ordering of one's way of life expressed themselves, as if access to common and everyday patterns of behavior were being afforded to the viewer thereby. When the conversation piece was set outdoors, the environment became the estate on which that way of life took place, so that attention was drawn to the signs of care and cultivation that marked it out, as well as to the attachment invested in horses and other domestic animals kept there, and the expense of clothes and other finery for outdoor wear that consumer marketing was increasingly making available.

The same could equally apply to the components of a portrait that showed a single family member outdoors. Single figures or couples might be shown strolling through a

garden, or posed in front of a park setting, as was already the case in the preceding century in portraits by Rubens and Frans Hals. Alternatively, the claims on the attention of a landscape environment could be amplified by the inclusion in it of specific plants and trees, according to a practice that van Dyck had developed for his aristocratic portraits, doing botanical studies and also landscape drawings in alliance with that practice. But the attachment of a self-conscious awareness to the ownership of property is a more nuanced feature of eighteenth-century portraiture: nuanced, because for instance the architecture used as a marker of social position and ambition may be altered, transposed, or entirely imaginary in character, and the arrangement of tree branches may link itself expressively to patterns of feeling which the politely controlled behavior of the figures does not otherwise disclose. Typically, a welcoming gesture of hand and arm may serve as an invitation to direct the eye back into the landscape and see it as an extension of personality and interests—thus casting the figure making the gesture in the role of host or hostess on an imagined tour. Or the view may allude to other spheres of interest of the owner that supplement, in terms of the seriousness of commitment that they imply, the sense of play and warm-spiritedness attaching to what goes on in the foreground.[8]

The major practitioners of the conversation piece at mid-century in Britain establish typologies for it which have in common that the figures are relatively small in scale, and their relationship to the landscape is restrained. Arthur Devis, working mainly for merchants and country squires, shows parks with an almost manicured neatness and orderliness to their appearance. Tree stumps in the foreground indicate where arboriculture has been practiced; cultivated and flowering plants are shown arranged in beds; and delicate little bridges span the streams further back.[9] Thomas Gainsborough, working for a similar clientele during his early years in Sudbury (Suffolk), includes blasted trees, cottages, and wheatfields to the rear, with paths running back to them on a rhythmically attuned curve, as if they acted as conduits for a poetic extension of the thoughts and concerns of his couples, who are shown pausing attentively in a setting of rough ground, with trees immediately at their backs.

In the mid- to late 1770s, Francis Wheatley's portraits in landscape settings, group and single, use a vivid palette of colors and more informal poses to imply a leisure world in which the estate supplies recreation, and at the same time serves as a construct of the individual who has charge of the visual pleasures that it affords, when viewed from a suitable vantage point and in an appropriate frame of mind. Those pleasures center, in the portrait illustrated here (Fig. 41), on a serpentine stream traversing a valley and the curved bridge that spans it—all compressed into a small section of the landscape, as was often the case by this time on estates where elaboration of that sort was used to compensate for lack of size. By now enclosure, in the form of successive acts of Parliament that put under cultivation what had previously been treated as common land, or regarded as waste, had greatly increased agricultural production in Britain, by converting arable areas of land to profitable uses, and in so doing had put a more nakedly exposed power of property into the hands of estate landlords and entrepreneurial squires.[10] The landscape setting in a portrait like this spoke to moneyed interests, using openness to designate— more explicitly than with Devis or the early Gainsborough—a socially estimable aspect of

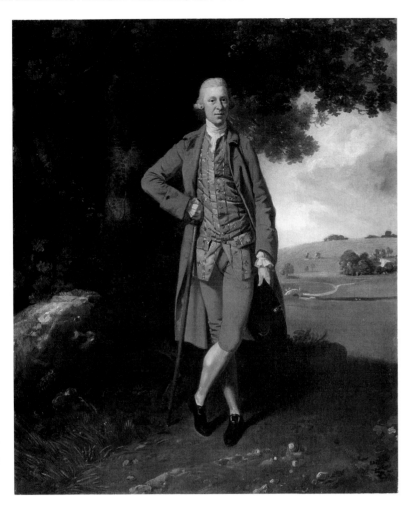

Fig. 41. Francis Wheatley, *Portrait of a Country Squire in a Landscape*, c. 1775–80. Oil on canvas, 30 × 25 inches. Archer M. Huntington Gallery, The University of Texas at Austin, lent by the Hascoe Foundation, 1985

material prosperity.[11] In the service of self-display it closed the gap between a genuine, informed feeling for the look of one's property, and a pretentious engagement in the aesthetics of beautification. Such a form of portrayal for gentlemen landowners does put in an appearance on the Continent a little later, but only after the passion for things English has penetrated there.[12]

The portrait of *Sir Bellingham Graham and Family* (Fig. 42), in a private collection which was previously attributed to Johann Zoffany, one of the major contributors to the outdoor conversation piece at this time, but more probably represents the work of John Downman—giving it a date of soon after 1780—shows its protagonist firmly planted on a chair, while his lady stands beside a tree, hands extended to touch its ivy. In front of her a younger man and woman, probably son and daughter-in-law, move arm in arm away from them. She gives the young man her attention and he points, for the benefit of whoever looks in on their exchange, in the direction of two horses being exercised in the middle distance. A glimpse of a temple appears in the clearing at the far left, and stretches of hedge or copse border in trim fashion the fields that stretch away in the vista to the right.

Fig. 42. Attributed to John Downman, *Sir Bellingham Graham and Family*, c. 1780. Oil on canvas, 30 × 22 inches. Collection of Sir James Graham Bt

In this way complementary interests of the estate owner are balanced against one another. But above all it is the warmth of atmosphere here, established in the handling of foliage and shadow as well as in the fresh complexions of the family, that leads visually out toward the edges of the composition, and in so doing links the behavior of the figures with an expansive and genially motivated spirit of belonging.[13]

Such an expansiveness is also found in the large family portraits from the 1780s by the Scottish artist David Allan, such as the one of Sir John Halkett of Pitfirrane (Fig. 43 and Color Plate V), surrounded by older and younger children, which dates from 1781. Birds in the sky and the hat taken off that lies on the ground with a flower in it serve to introduce a sense of informality here. The rhythms of the dance being performed across the center and the accompanying shapes of lute and tambourine at the left (where the third young woman holds open a book that is inscribed *Cotilon*) are echoed musically in the curves and angles of the tree trunks placed as framing devices. But in looking through and past them the viewer also picks out, in the doorway and windows of the house at the

Fig. 43. David Allan, *The Family of Sir John Halkett of Pitfirrane*, 1781. Oil on canvas, 60¼ × 94 inches. National Gallery of Scotland, Edinburgh

back right, figures alluding by their presence to Halkett's household responsibilities. A chapel spire and Grecian columns that are to be seen on the far horizon bring up equally his religious and civic responsibilities. Furthermore—like the Seventh Earl of Mar, whom Allan also painted with his family (Claremont House, Alloa, on loan to Scottish National Portrait Gallery)—Halkett had coal on his land, which he mined in a philanthropic spirit, claiming exemption from export duties until 1775 on the grounds that the veins were small enough to warrant this, and allowing the government to buy the right from the family for a modest sum in 1788.[14]

So the very configuration of the landscape here, as it passes from wooded slopes to more sparsely covered hillside, effectively condenses the different kinds of productivity that the estate and Halkett's dedication to it conjoined. Its farsighted governance, as evoked in Halkett's own pose, served as a source for familial growth and prosperity that was itself expansive.

DISLOCATION AND DISPLACEMENT

Any landscape setting that is marked off as a precinct or preserve must raise the question, not only of who owns it and who works to keep it that way, but also of what the natural

and cultural forces are that give to it, or withhold from it, a sense of plenitude and well-being as far as its occupants are concerned. What the imagery of occupancy provides here, in the way of a felt cohesion or the suggestion that such a cohesion has become dissipated or threatened with disappearance, constitutes a political aspect of landscape: one that brings up the consequences of its appropriation (as with foreign lands equally), and the terms on which those who have no ongoing right of ownership must inevitably become travelers, or lead an unstable and unsupported form of existence that even when it is based on the land, offers no real attachment to the place or places in question.

Those who do not fit into what remains of the natural countryside then become subjects of focus in their own right. But their relationship to the landscape is—insofar as the latter can be held responsible for their plight—difficult to specify visually. It is in this respect unlike the subject of the shipwrecked at sea, which becomes a favored theme for artists from the sixteenth century on, providing occasion as it does for subsuming the plight of the individual to a larger pattern of conflict, between man or vessel and the elemental natural forces that rage around them.[15]

When martyrdom is presented in a landscape setting, as it frequently is in the Renaissance, a harsh and refugeless location surrounding a scene of stoning is one that makes rocks for that purpose available. But the physical source of suffering that leads to death may not be so readily manifest. When in the Franco-Flemish illuminations for the *Chronique d'Angleterre* of Jean de Wavrin (c. 1470–80; British Library MS Royal 14.E.iv), death from famine is illustrated, this is done in terms of figures lying stretched out on the road, or locked in frozen positions there; but the way in which their suffering is connected with the state of the fields in the middle ground can only be conveyed insofar as the slopes in question are shown shorn of any resources of vegetation, and through the intermediacy of figures still active and passing in that setting, who look across to take cognizance of the death that threatens them also.[16]

In the later eighteenth century, in contrast, and on into the nineteenth, good husbandry, on the part of yeomen and small farmers, and domesticity, as reflected in the roles ascribed to women and family, are linked in tandem to the positive and encompassing vision of an organic community, which can use the land productively in the form of small holdings and cottage-plots. In so doing it can keep the familiar patterning of the countryside, including its common land and its undeveloped scheme of roadways, intact in the midst of a radically changing rural world and society.

Enclosure, beginning in the 1760s when the number of acts of Parliament devoted to it underwent a tremendous surge and on through the next decade, menaced the rural community in other ways than simply altering the landscape physically. In the parts of Britain most adversely affected, independent cultivators whose livelihood depended on access to common or wasteland, to feed their animals or gather wild food and materials for their fires, and thereby supplement what their own strips of land could produce, were exposed to the threat of having to sell up at any misfortune or downturn in the economy. Equally villagers who labored part-time or did piecework for the larger farms lost their right to pasture their own animals on the common: a benefit that had traditionally made for the difference between reasonable comfortableness and deprivation.[17] The depopula-

Fig. 44. Thomas Bewick, *The Departure*. Wood engraving, plate 6½ × 4½ inches, after a drawing by Robert Johnson, for *Poems by Goldsmith and Parnell*, 1795. By permission of the Houghton Library, Harvard University

tion and dispossession resulting from these changes in the rural economy form the theme of Oliver Goldsmith's poem "The Deserted Village," which achieved immense popularity following its publication in 1770. What is lost thereby and grieved over in the poem is the georgic idyll of "grassy-vested green," "sheltered bower," and "warbling grove" that had constituted the "former scene," at a time when according to the poet "every rood of ground maintained its man," yielding as much, and only as much in the way of production, as "life required." To the loss of intrinsic pleasures and the state of effective exile is joined awareness that a "barren splendor," of pomp and luxury (which is for the wealthy landowner), will take up the free space "that many poor supplied."[18]

When Thomas Bewick the wood engraver came to illustrate this poem, for a printing of 1795, his version of the "Departure" scene (Fig. 44), done from a drawing by Robert Johnson, used particularity in the costumes and in the construction of the cottages to give a popular audience—one outside of genteel metropolitan culture—a precise sense of how the currents of life that were being displaced enfolded and supported one another. The irregular roof-lines of the thatched cottage in this plate enclose those, old and young, who have no alternative vision to take with them, and the slow, sorrowful procession moves on a diagonal away from the preserve of nature, with its hitherto protective surrounding of hedge and wood.

Here and more generally, the pervasive risk in British rural imagery from the 1770s on was that of sentimentalism: of papering over with smiles or an atmosphere of soft sweetness (as sometimes seems the case in Thomas Gainsborough's work) what was actually happening in the countryside.[19] Landscape, in the opportunities that it offers for showing continuity over time and places of pause for the wayfarer, or the person seeking relief from city life, was a ripe field for both artists and viewers vesting themselves now in qualities of feeling that ran counter to the confronting of dislocation and dispossession. By 1800 at the latest, Thomas Rowlandson was using the medium of watercolor, on the side from his caricatures and his social subjects of depravity in its various urban guises, to characterize the charm of little villages with simple country incidents taking place in them, and to present these "backwater" images as an idealized version of rustic England, as if frozen in time. He used for this purpose the vignette form—developed by Bewick and now popular—focusing on specific evocative details, such as stone bridges, inns, and hitching posts, so that the viewer was invited to fill in imaginatively, beyond the limits of the subject itself, how far such pockets of rural tranquillity and unchangingness remained successful still in resisting disturbing intrusions.

George Morland's attraction to subjects of smugglers and poachers, and also gypsies (with whom his biographers report that he associated freely) was of an opposite order. Morland was criticized by his contemporaries for coarseness, or lack of refinement in his depiction of the rural poor. No doubt because of this—or because he was overproductive and all too ready to cobble up paintings in later life to meet the demands of his creditors—he falls repeatedly into what might lay claim to represent an unsentimentalized and unpatronizing response to the conditions of life in the countryside, were it not that facial gestures and expressions in his work seem to hanker after a higher kind of diagnostic seriousness, about the feelings of the poor and their relation to circumstance, than he can responsibly command.

Morland's landscape settings may appear, from this standpoint, strangely characterless. While never acrimoniously pointed in what they contain, they serve as a site for encounters and halts in which those who live, by habituation, in transit from one place of halt to another are effectively decriminalized. In comparison with Salvator Rosa's bandits, who have chosen harsh settings as their place of habitat in the same fashion as hermits and holy men once did, Morland's vagrants are more picaresquely adventuresome and resourceful. The appeal of the landscape in which they appear draws in what they accept, in its impoverished terms of availability, as sheltering and accommodating to them.

What were those terms of availability? By the 1790s, rising unemployment in Britain; food shortages, which would lead in some parts of the country to riots protesting the soaring price of grain; and a wiping out by inflation and taxation of the gains that had been made in wage level, as early industrialization spawned technically sophisticated factories and equipment—all were factors that raised intense concern as to how rural poverty should be handled as a problem. In particular there was concern as to the rising numbers of the rural population that stood in need of relief, and were in no position to command a wage on which they and their family could subsist. As a consequence of all

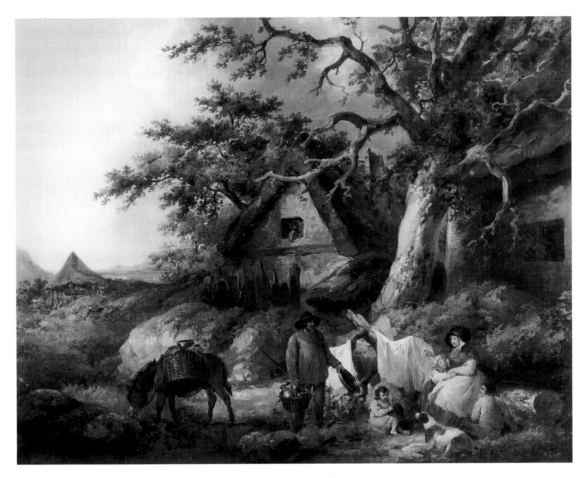

Fig. 45. George Morland, *View at Enderby, Leicestershire*, 1792. Oil on canvas, 34 × 46 inches. Sarah Campbell Blaffer Foundation, Houston, Texas

this, observers of the time noted a sense of demoralization, amounting at times to fatalism, among the displaced proletariat of the countryside.[20]

There is something akin to this in Morland's characterization of the life of vagrants who live outdoors or by their wits. In the view from 1792 illustrated here (Fig. 45), said to be of Enderby (Leicestershire), which is where Morland encamped himself that year to evade his creditors, a makeshift tent is being used for shelter by the woman who is grouped with her three small children. In front of a disused hovel, a peddler approaches her to offer his wares. A smoking enginehouse at the back left and a building at the right that serves as a horse gin allude to the development of rural industry; but if for coal-mining, as appears to be the case, these are not efficient in the state and setting in which they are shown, but simply indicative of the kind of rural economy in which and against which the poor must hold out to survive.[21] There is also, in opposition to the mere acceptance of indigence and vagrant status, a note of resilience and active expectation sounded: notably in the way in which a discontinuous lighting picks out facial expressions

and body movements intermittently in the more animated sections of the landscape. A counterimplication to the forces of hard necessity is set up in this way that—where Morland is at his creative best—serves as a smoldering undercurrent to the ensemble.

With the vast upsurge of the Industrial Revolution and its technological consequences for later eighteenth-century Britain, landscape sites could also be chosen by the artist because they afforded the natural resources, of coal, iron ore, and water that the smelting furnaces and the mills were able to draw upon, to empower their day-and-night activity of production; yet what the visitor or the tourist was exposed to there retained its isolation, and had a quality of mystery to it. At issue here was, first of all, the unevenness of industrial development in geographical terms, dictated as it was by the location in far-flung spots and sectors of the countryside of the raw materials that were to be extracted from nature and used. There was also the fascination provided by the new iron bridges and canal constructions, which had the mark on them of contributing to long-term improvement in the quality of life, as well as to commercial well-being. And so a sense of responsibility in the public sphere for what was happening to the landscape could be deferred, or expressed with overtones of nostalgia as to the changes and losses entailed: as happens when Constable, a mill-owner's son brought up on the River Stour in rural Suffolk, chooses to paint boat-building (1814; Victoria and Albert Museum) and the navigations of the waterway by commercial barges (1816–17; Tate Gallery). Constable does this in a retrospective framework that measures his own increasing distance from the world in which he grew up, along with his fond recollections of it. It is a framework effectively excluding from view, or later, as Constable became publicly successful after 1820, from the whole tenor of his art the magnitude and intensity of labor that had become required to support such enterprises.[22]

Up to the end of the eighteenth century, the changes wrought by industry to the character of the landscape were not yet seen as monstrous and deforming. They would come to appear that way only when industry had become concentrated and crowded so that—in metropolis and mill towns alike—it darkened the sky with massively looming shapes, wasted the environment with its pollution, and reduced the contribution of human activity to what seemed like mere rote. Attention then focused on the need to escape from the perils of further engulfment, by such seemingly uncontrollable forces. So there became revivified, with newly persuasive overtones of salvation and spiritual healthfulness, the long-standing theme of a lost Eden, to be discovered or established deep in the English countryside; as in Samuel Palmer's retirement in 1826 to Shoreham (Kent), to form a brotherhood of artists and poets living in virtual solitude there.[23] They read the Bible and *Pilgrim's Progress* together; they celebrated a totally hermetic rural peace, in which the sheep could safely graze, fruit and blossoms swelled in abundance, foliage gentled the view, and the vales all around stood thick with corn at harvest-time.

Denunciation of materialism and of bondage to the machine took on spiritual force much earlier than this, representing them as disturbances of man's, and woman's, natural state. But landscape and the presence of industry in it could equally be endowed with a benign, unthreatening aspect, when the technology in question was contained in scale, and when the purpose behind it gave a sense of enlightened innovation in the way that

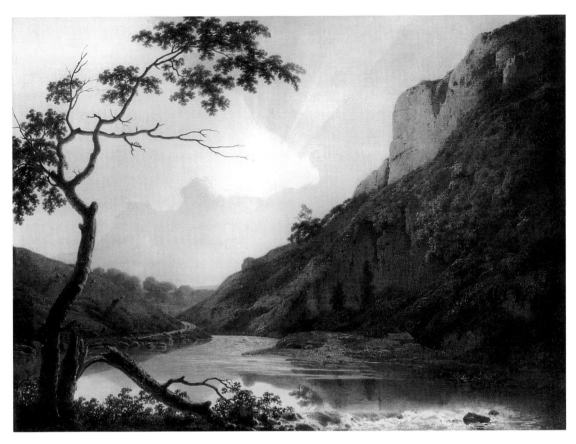

Fig. 46. Joseph Wright of Derby, *Matlock Tor, Daylight*, c. 1785. Oil on canvas, 28½ × 38½ inches. Fitzwilliam Museum, University of Cambridge

resources drawn from nature were being used. In Joseph Wright of Derby's *View of Matlock Dale* from the early 1780s (Yale Center for British Art, New Haven), the inclusion on the skyline of the chimney of a lead factory indicates that the view is toward Cromford (Derbyshire), where Joseph Arkwright had set up his first cotton mill in 1771. When Wright came to paint that mill by moonlight around 1783 (private collection), at a time when he was in personal contact with Arkwright to do his portrait, he chose to make the presence of nature, in the shape of the rocky gorge surrounding the mill, subtle and mysterious in character, and to convey accordingly that, in contrast to the light coming from within the mill, which represents the fires of production, the moonlight corresponds to the light of natural philosophy, by which nature is revealed.[24]

Wright's view of *Matlock Tor, Daylight* (Fig. 46 and Color Plate VI) from a year or two later might seem, with its flowing stretch of river and fallen tree trunk, purely idyllic. But the quality of the natural light, as it vitalizes the geological formations of cliff and crag, and the markings in the paint made with the point of the brush to convey the movement of the water, serve to suggest that the sun and the smoothly flowing Derwent are in fact sources of energy in this dale. They are available to be tapped as industry grows nearby, and the aura that they have as a result—like the aura of burning volcanoes and phospho-

rescent caves, which Wright had taken up as subjects during his stay in Italy in 1774–76—is displaced onto the character of the landscape. Whereas Gainsborough in his later work, after his move from Bath to London in 1774, is locked into making his views of wild mountain scenery depend (as his seascapes and woodland subjects with peasants also do) on the animation of arabesques, Wright needs no such bravura handling to bring into focus those "foundational" aspects of nature that, in a period of intense and systematic geological research, drew the attention also of the industrial entrepreneur.

COLONIALISM AND COMMANDERSHIP

Goldsmith's villagers were being driven overseas, most probably to North America. There, as early settlers encamped in new territory, they would encounter living conditions more thoroughly hostile and forbidding than those implied in Morland's images of harsh countryside or stormy seashore. But the appeal of foreign landscapes, as far as their visual representation on the part of explorers and colonists is concerned, would be vested contrastingly in the assortment of unusual topographical or botanical features that made those landscapes notable; or in the singularity from a scientific point of view of what they contained.

To look back over the way in which the character of foreign lands has been imaged in visual form is to recognize historically that, as the process of discovery on the part of Europeans unfolded, the physical structure and vegetation of those lands have, from one occasion to another, constituted a subject of study in virtue of an intrinsic and sometimes inordinate strangeness attaching to them, which invited both speculation and fantasy. From the factual reports deriving from Marco Polo's travels (page 93), through George Sandys's seventeenth-century explorations of the Mediterranean, and especially in the period of the Enlightenment when travel accounts and the critical attention given to them greatly multiplied, the key role performed by travel and exploration images in conjunction with text was to elaborate upon the eyewitness testimony of those who had been there, in the interests of novelty and of strikingness.

As the number of illustrations that was called for grew in the latter part of the eighteenth century, and the available sketches and drawings brought back by amateur or professional artists were adapted to provide the needed reportorial materials, it became important also, in doing this, to cater to the imaginative needs of a wide variety of readers.[25] In the exploration of the Pacific, and especially in the case of Tahiti, the effect of climate and environment on the way of life and the sexual mores of the natives accordingly became crucial to investigative focus. It generated in the latter part of the century an intense debate into which armchair anthropology intruded, and in which fantasizing was fed by the adaptation into engraved form of the firsthand images themselves.

This expansion of the appeal of landscape imagery forms part of an ongoing process in which, as Captain Cook's first biographer Andrew Kippis put it in 1788, "new scenes [are opened up] for a poetical fancy to range in."[26] It is a process that persists until occupation

of the territory in question finally subordinates its capacity to instill a sense of the marvelous to commercial and military interests. Then the landscape turns, in recompense, toward being a site of dream that takes place as if silently while civilization is changing all round. Or there is an attempt to impose on the presentation of this landscape a purified and implicitly magnified version of all those components that, in their purported reality, correspond to the most basic abstractions of a European viewpoint. What remains then as a source of scenic convincingness, and is instilled into the presentation, is the sense of jurisdiction over the territory belonging—as in the case of British India— to those who have taken command of it over time: a jurisdiction fairly and discreetly maintained, but firmly in place nonetheless.

Tahiti was discovered in June 1767 by Captain Samuel Wallis, coming from England into the South Seas in his ship the *Dolphin*; he commented on the natural beauty of the scenery as he first saw it, saying that it had "the most delightful and romantic appearance that can be imagined."[27] Surprise and a sense of excitement were mingled more elaborately in the journal kept by the master of the *Dolphin*, George Robertson, which described viewing as they drew near "a fine leavel country that appears to be all laid out in plantations . . . great numbers of cocoa nut trees . . . beautiful valeys between the mountains," amounting altogether to "the most beautiful appearance its posable to imagine."[28] When the French ships of Louis Antoine de Bougainville arrived the following April, the beauty of mountains and cascades and the island's fertility would earn similar eulogy, for a narrative that would be published in 1771 (prompting Diderot to write his famous *Supplément au Voyage de Bougainville*); George Forster, who would accompany Cook on his second Pacific expedition in 1772–75 along with painter William Hodges, was equally captivated upon sighting "the mountains of that desirable island, lying before us."[29]

So far the sense of an Edenic paradise on earth, come upon as if by magic, and even the very terms of description that are used echo what much earlier European travelers on their expeditions of discovery had sought to convey in similar circumstances. Columbus in the journal deriving from his first voyage of 1492–93 (published only in 1825) had described, in emotionally loaded choices of adjective, the experience of what would turn out to be Cuba: "There are here very extensive lagoons, and by them and around them are wonderful woods . . . in the whole island all is green . . . it seems that a man could never wish to leave this place." And Sir Walter Raleigh, penetrating the delta of the Orinoco, found as his expeditionary force drew closer to Guiana (according to the narrative of its discovery that he published in 1596) that he was exposed to "the most beautiful countrie that ever mine eies beheld . . . the grass short and greene, and in divers parts groves of trees by themselves, as if they had been by all the art and labour in the world so made of a purpose."[30] But it was also the case, with Tahiti, that once there was the opportunity to observe the native way of life firsthand, it became opportune to connect it interpretively with the nature of the environment and the climate. According to Bougainville's surgeon, Philibert Commerson, in a letter that he published in 1769 already in the *Mercure de France*, Tahiti was as close to representing an uncorrupted natural society, or Utopia, as one could come, inasmuch as its people "born beneath the fairest sky [were] nourished by

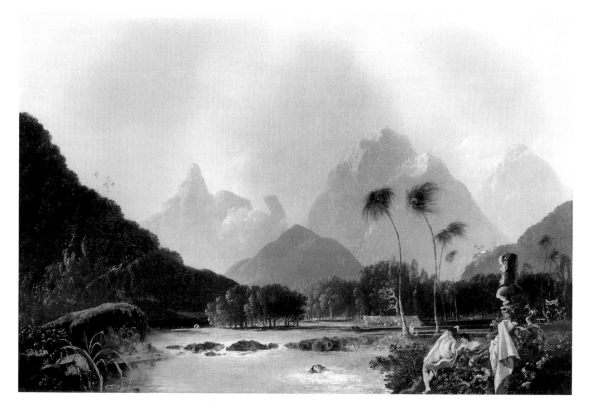

Fig. 47. William Hodges, *A View Taken in the Bay of Otaheite Pehe [Vaitepiha]*, exhibited 1776. Oil on canvas, 36½ ×
54½ inches. National Maritime Museum, Greenwich, London. By permission of the Trustees

the fruits of an earth that is fertile without cultivation." Or as George Forster conceived
the matter, more scientifically, the fact that shellfish and fruit were available in abun-
dance meant that the standard necessities of life were provided with only a little labor;
from this it followed that contentment, or lack of ambition, were at best justifications, or
at worst excuses, for an overall display of inactivity.[31]

In William Hodges's *A View Taken in the Bay of Otaheite Peha [Vaitepiha]* (Fig. 47)—
which is evidently the painting of that subject that the artist exhibited at the Royal
Academy in 1776, and a very notable example of his combining visual report with exotic
appeal—this same display of inactivity is marked off from current European experience by
the device of including in the landscape poses and actions that recall directly those of
nymphs bathing, in classical mythology and the art based on it. In this fashion the
Utopian quality of Tahitian existence is conveyed. But it is also shadowed presenta-
tionally by the "primitivism" that attends such a way of life, signaled here by the tattooing
of the body of the most prominent bather. To enforce the association, she is juxtaposed
with the presence of the ancestral image or *tii* which, in its size and aggressively simplified
appearance, dominates at the far right over the expanse of the bay.[32]

The natural pleasures of the Tahitian landscape appear here in abundance: mountains,
lakes, variegated vegetation that includes breadfruit trees and coconut-palms, deep views

under open skies.[33] These features of the depiction provide vicarious access to the kind of delight that explorers and scientists had experienced firsthand, and acknowledge in so doing their geographic remove from European civilization. But they accomplish this in a fashion that implies their being locked within an earlier and indefinitely bounded time-frame: as if before discovery took place.

What has been studied initially for the purpose of being known about becomes subjected in this way to the interests and valuations of culture. This painting and the companion subject of *Matavai Bay in the Island of Otaheite* (the versions now at Anglesey Abbey and the Yale Center for British Art, New Haven, were probably ones intended to hang together in the Admiralty) have accordingly a double-edged quality, as carriers of appeal or promise. While these images seek to make explicit, in their rendering, the captivating and enticing thrust of a directly sensual experience, they also bring under the control of a more "informed" judgment what it is, within the terms of relationship between way of life and environment, that instates the attraction itself. In critical response of the time to Hodges's art one finds, symptomatically in this regard, a dual movement both to acknowledge the power of the trained European artist that is applied to capturing the unspoiled beauties of such landscape, in richness and spread of paint; and also to find fault with what is taken to be an excessive roughness and summariness of handling.[34]

In the case of British-occupied India, the aura of mystery and the fabulous attaching to the country had already disappeared from the minds of the informed, or was dropping away by the time that artists came there, in the last decades of the eighteenth century and the first quarter of the nineteenth, in quest of subjects for paintings and graphic records that could form a basis for prints and book illustrations. Alongside the growing influx of visitors set on travel, the activities of the East India Company in surveying the provinces of Bengal that had come under its rule, and military and judicial expansion more generally helped to make this so.[35] Sites and scenes that appealed intrinsically to the European public for such art, as extensions of the picturesque into new or unexplored territory, included temples and ruins, great rivers and waterfalls, mountains and rock faces, as well as roadways and local architecture more generally. The special sanctity attaching to such places for the natives was recognized and considered descriptively important; but their actual role in everyday life and their religious use was only hinted at within the images, by the showing of a few token figures going about their business—or else the human presence was left out altogether, in favor of expanse and grandeur.

William Hodges, after playing the role described on Captain Cook's second South Sea expedition and after his contract with the Admiralty terminated, went to India in 1780 as a professional landscape artist. Following an initial stay of a year in Madras, during which he had little opportunity for excursions into the South Indian countryside because of ill health and the second Mysore War that was in progress, he moved to Calcutta early in 1781 and began to travel in Bengal, at the invitation of Warren Hastings, and to make upcountry tours. Over the next two years he extended his travels through Central and Upper India; he produced oil paintings from his many drawings for British patrons out there, and, after he had left the country in 1783 and returned to England, for exhibition at the Royal Academy in London from 1785 on. From 1785 to 1788 he was responsible for

the issue of a series of forty-eight aquatints, made from drawings that had been done on the spot. And in 1793 he would bring out the first edition of the sumptuously illustrated book recording his four-year stay, *Travels in India,* followed a year later by a second, corrected edition. In his preface to that publication Hodges indicated the attention paid in it to "the face of the country" as well as its "arts and natural productions," with a view to conveying to a "deeply interested" British public the "novelty" of the "impression which that very curious country makes upon an entire stranger."[36]

The paintings, drawings, and aquatints made by Thomas Daniell and his nephew William, who traveled in India between April 1785 and September 1794, are based on far wider tours than those of Hodges. But they share with the scenes that he depicted and chose to write about a limitation to the northern, western, and southeastern territories that were either under the jurisdiction of the East India Company, or subject by this time to its influence. The colored aquatints resulting were issued in series, under the general titles *Oriental Scenery* (1795–1808) and *Twenty-Four Landscapes* (1807), with further groups of prints covering antiquities and excavations.[37] In the plates from these series that show deep landscape vistas, formulas of the picturesque are modified to suggest an association of unspoiled nature with an unsophisticated culture: as if the natives themselves were unequipped to recognize the rich luxuriance of their land, in the way that a representative of the British colonial presence and its interests—looking out as if from an overseeing command post—was equipped to do.[38]

In the view illustrated here of Cape Comorin (Fig. 48), at the extreme south of the Indian peninsula, the large Hindu temple in the middle distance is described in the accompanying text as being near a specific small village; but there is no trace of such a complex, and the artist evidently invented it so as to make for an evocative relation with the huge gray mountain beyond, its peak emerging from a bank of white clouds. The figures grouped together by the river in the left foreground are not shown engaged in any activity, nor looking at anything, though their animals and a shrine are both close by. They seem to exist in a state of idle dream, which is equally linked to the temple in its mirage-like and spectral whiteness. The viewer that the print conceives of looks over the heads of these figures and past them, at the resources of the countryside. The appeal of the scene as a whole to such a viewer hinges on displacing, or replacing, what might once have appeared to harbor mystery with an assertion of fertility and breadth.

The task of matching a spirit of scientific inquiry to the giving of aesthetic pleasure, which is explicit in the book illustrations made from Hodges's paintings and in the Daniells' aquatints, had come to be a virtual requirement of travel illustration from the 1770s on. As in scientific manuals and in later gatherings of photographs, so in the travel reports of this time, image and text complement and mutually reinforce one another. The burin line of the engraver serves, as pen and pencil do in the drawings of Leonardo da Vinci, to equalize different aspects of nature with one another: the movement of water, rock formations, shorelines. But it does this in a more meticulous and particularized way, and at the same time uses tinting or shading within limited areas, to convey light and atmosphere in combination together.

This kind of attention falls into line with the cult, in travel accounts of the time more

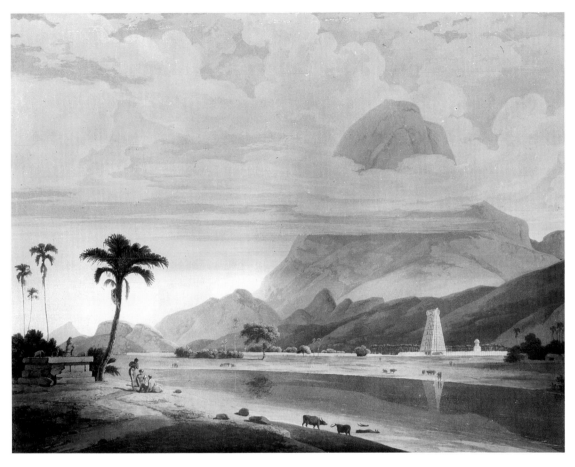

Fig. 48. Thomas and William Daniell, *Cape Comorin, Taken Near Calcad*. Color aquatint, plate c. 14 × 24 inches, from *Oriental Scenery*, 1797, vol. 2. By permission of the British Library

generally, of what was identified and characterized by the use of the term "singularity": a descriptive category that, applied to objects in nature that were unusual and remarkable, served to bridge scientific interest and aesthetic attractiveness. It might refer to the deposits and traces of natural history that were available to be studied like specimens; as in the renderings of glaciers and waterfalls done from the mid-1780s on by the Swiss artist Caspar Wolf. Or it might refer to individual masses: lumps and shapes with a very distinctive shape to them, like the piled-up rock formations painted in the 1780s and 1790s by the little-known German artist "Pascha" Johann Friedrich Weitsch, which show them specifically as an attraction to sightseers gathered in the foreground, and impressive from other vantage points also.[39]

In the engravings that accompanied the publications on the Americas of the German scientist and explorer Alexander von Humboldt similar considerations apply to the choice of subjects and the details of flora and fauna that are included. Introducing the "Personal Narrative" subsumed in his *Views of the Cordilleras and Monuments of the Indigenous Nations of the New Continent*, which was based on travels of 1799–1804 and first came out in Paris in

1810, von Humboldt refers to the way in which his "pictorial atlas," with sixty engraved plates, offered to Western Europeans for the first time an overview of the "ancient civiliza-tion of the Americans [and] their monuments," focusing on the art and architecture of the Aztecs, their hieroglyphic writing, calendar, and mythology; and how in addition he had included "picturesque views of the mountain countries which these people have inhab-ited," featuring particularly the "great scenes of nature" afforded by the formations of cataracts and volcanoes. But there was more to the underlying descriptive purpose than simply this. The richness and potential profitability of this South American countryside to European colonizers was implicitly being brought out. As von Humboldt put it in his *Political Essay on the Kingdom of New Spain,* in reference to Mexico:

> The physiognomy of a country, the grouping of the mountains, the extension of plateaux, the elevation which determines the temperature, everything appertain-ing to the geographical configuration has an essential relation to the progress of the population and the well-being of the inhabitants. This configuration includes the state of agriculture, varying with the climate, the possibility of internal trade, the communications, more or less favored by the nature of the terrain, and finally the military defence on which the external safety of the colony depends. From this point of view alone, great geographical surveys become of interest to the statesman as he computes the forces and the territorial riches of nations.[40]

In the engraving from the *Views of the Cordilleras* chosen for illustration here (Fig. 49), the air volcanoes of Turbaco are shown as a quite exceptional and geologically singular configuration. In the foreground there appear two figures side by side: one identified by his dress and stick as a leading member of the exploring party; the other by his nakedness as a native. The former points with outstretched arm toward the volcanic cones, as from a position of command where questions can be posed and knowledge gained; the latter seems to participate only diffidently, or as best he can, and yet it is he who has responsibil-ity for having brought the visitor there. And indeed the accompanying text recounts how, while von Humboldt and his party were residing in April 1801 in the little village of Turbaco in the Andes, three hundred feet above sea level and a "charming spot," the Indians who "accompanied [them] in their herbalizations" spoke often of a "marshy country" nearby where, "amidst a forest of palm trees," what the Creoles called the "little Volcanoes" were situated.

These Indians related further how, according to a tradition that had come down to them, the subterranean fire of the volcanoes had been put out by a pious vicar using frequent aspersions of holy water, thereby creating a "water volcano." But von Humboldt and his companions were inclined, from experience, to regard this as one of the "strange and marvellous stories which the natives eagerly recite, to fix the attention of travellers on the phenomena of nature." Nevertheless they were taken by the Indians to what turned out to be a "vast plain"; they were shown the small craters of blackish gray clay that gave off an emission of gas and a "muddy ejection" at regular intervals; a young member of the party made the sketch used for this plate. It was then left to them to analyze the gas and establish the physical cause of the whole phenomenon: thereby making the encounter—which

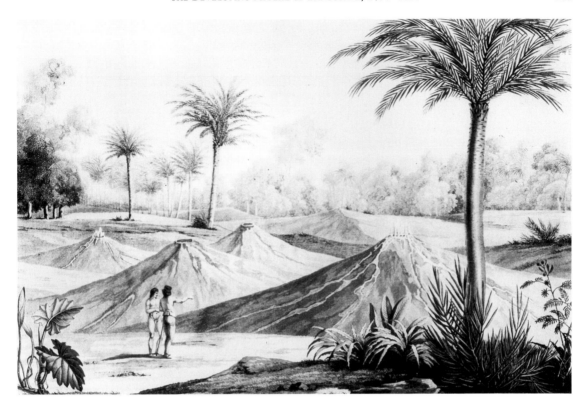

Fig. 49. Nicolas-Didier Boguet, *Air Volcanoes of Turbaco*. Color aquatint, plate c. 9 × 14 inches, for Alexander von Humboldt, *Vues des Corderillas*, 1814, pl. 41

would not have come about without the input and willing cooperation of the natives—"much more important than [could have been] expected."[41]

The natives, then, put their own knowledge and experience of the landscape to service. In other travel illustrations they are shown bringing the European—by boat or other means of transportation available—to the site where he can use pen and sketchbook, to record what is visually captivating and to build the ingredients of an investigative report. Once there, they defer to the Europeans' command of what it means to do this.[42] Like the natives of India made to seem as if they were still, somehow, locked in a state of inattentive reverie, they are shown as limited in their very order of being, or "otherness," by their way of life and the myths that support it. They are not free, socially and institutionally, to make the landscape into a site and subject of descriptive possession, as opposed to a (mere) habitat. As occupiers and users of its spaces and resources, they do not have any such position of advantage open to them.

SATIRE AND SEXUALITY

If satisfaction of social and political aspirations and desires could be found in the imaging of landscape, and also expedients of presentation that put unfamiliar and alien aspects of

the natural world into culturally tractable form, so also could selected elements of that world be summoned up and given shape in a spirit that appealed to imaginative longings, and to ultimately sexual impulsions within the psyche. The discovery of Tahiti in particular offered a "new Eden" that, once the vision of a green paradise was over and past, made the setting over into what seemed like a haven for a decontrolled and all-too-generously fecund sexuality. It was as if the configurations of that particular freedom were emergent from within the landscape. Analogously, the landscape of fantasy could shift from being an engaging composite of elements, evocative of an internal mental liberty, to reveal, as though spontaneously, the play of the unreasonable, and to suggest a harsh instinctuality at its core. Herein lies the kinship to satire, in the original meaning of that word.

For landscape motifs that, from a modern perspective, appear as sexually charged ones there is ample precedent already in the "paradise garden" of Islamic art and its Western equivalent, the medieval and Renaissance "garden of love." Those motifs include wine and roses, gently splashing water and shady greenery that plays over recesses and protected enclaves. But such a garden is understood basically as a place of repose: a locus of stable affections of the spirit and commitments of mind, that call for undisturbed meditation.[43] In Antoine Watteau's incursions into this tradition of imagery, which uses garden, park, and island for settings, the operative mood is brought closer to one of enchantment: an enchantment that, rather than being stable in the way in which it engages the senses and molds the behavior of those exposed to it, is fraught with the implication of fragility and evanescence. The graphic landscape of fantasy is, in contrast, essentially a *bricolage,* or piecing together of elements. It works by dint of invoking a homology, or interplay, between shapes and features that are contiguously made present to the eye, in different planes or at different angles to one another; and by the attendant suggestion of metamorphosis.

To understand this type of landscape, in its occasional appearances through history and its parallel painted forms, it may be helpful to speak of "as if" representation. In Hans Baldung Grien's woodcut of *Saint Jerome in the Wilderness* (c. 1511, especially its chiaroscuro impression), it is as if the upper body of the saint and the neighboring tree trunks were, in their material specificity of shape and markings, directly substitutable for one another; and as if the mane of the lion could be virtually interchanged, in its contributory character, with the drooping foliage above it, or the lines of the drapery edge with those of the protruding tree roots.[44] This is different from simply being asked to accept the kinship, for pictorial purposes, between two disparate or materially unlike things that are visually analogized, with qualities that would be expected in one context displaced onto another: as for example in the way in which the Dutch seventeenth-century artist Nicolas Berchem treats clouds and hill shapes, or Constable in his later coastal studies analogizes clouds and breaking surf. It is also different from incorporating into the representation of a specific object an equally specific and unmistakable presence such as is, in the workings of actuality, put there by the application of an imaginative process: as in Andrea Mantegna's penchant for including the appearance of seen faces in his clouds, and Piero di Cosimo's for putting into his landscape settings configurations of rock and path and tree shapes that are made to seem as if they were reacting responsively to the human actions and incidents taking place in front of them. For Vasari in his "Life

of Piero" such bizarre imaginative elements were a distraction from the decorum that narrative paintings should have.[45] "As if" representation, in distinction from those kinds of cases, requires an imaginative suspension of disbelief, as to how one substance and entity can be transformed, or transform itself, into another; this is why its motivations can appear historically as eccentric.

In Hercules Seghers's etchings from the early seventeenth century (page 78)— individualized and also colored, so that very few of the surviving impressions duplicate one another—passages representing successive stages of incision with the burin needle and the inkings performed on that area are so manipulated as to become readable as, for example, cliffs and rocks, with crevices and trees growing from them; and ominously suggestive areas of shading on the surface of hill and field are also created in this way.[46] In Alexander Cozens's "blot" method of drawing landscape, spots and stains serve comparably as a way of getting the imagination going. The fact that the drawings generated in this way were suggested initially by accident and worked up in improvisatory fashion, either on the same sheet or by the use of a superimposed tracing paper, rendered what Cozens did here a personal divagation of his, without parallel in painting. But when Cozens came to publish the results as a treatise in 1785, under a title claiming novelty in the assistance of original invention, he took pains to specify in his accompanying preface that the value of the method was of a transgressive order, inasmuch as it violated conventions of instruction that depended on the copying of old masters, or on a mechanical kind of copying from nature.[47]

Earlier in the eighteenth century the creation of a excursionary kind of graphic venture, with linked thematic materials forming a series and appropriately improvised settings, comes close to the original connotations of satire, as it was conceived in early Roman times. It puts emphasis as there on spontaneity, the performative freedom of the authorial personality and a crossing or intermix of genres, which features as a major part of its appeal witty or mocking commentary on the available typologies, and on the attendant proclivity of audiences to take what is offered in a certain way. The title *scherzi di fantasia* that Giovanni Battista Tiepolo used for his mid-century series of etchings, inscribing it on the frontispiece, exactly catches the spirit in question: one that was flexible enough, in its varied subjects and the roles assigned to its casts of characters, to combine imaginative playfulness and directed jesting. The settings there are rendered consistently so as to provide a flat and foreshortened terrain, reminiscent in its arrangement of a stage set, for interchange between closely grouped figures.[48]

In the sixteenth and seventeenth centuries the understanding of satire as a literary practice had included both pleasantly humorous witticism (following the example of Horace) and fiercely rhetorical invective (echoing Juvenal), and the applicability of the term to graphic art seems to have spanned both types of production, one taken as implicitly more trenchant than the other.[49] In the eighteenth century, the special term that came to be used on the more whimsical and arbitrary front was *capriccio*: a term already applied in the later sixteenth century to music, to mark out a generic leaning in that direction, and used by the early seventeenth century for collections of music. In visual terms it implied a freedom of invention, demonstrating skill and designed to please:

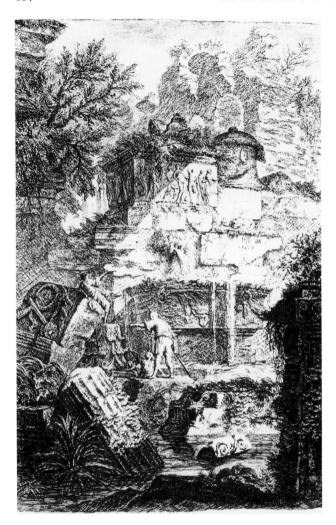

Fig. 50. Giovanni Battista Piranesi, *Ruins of an Ancient Tomb*, 1743. Engraving, plate 14¼ × 9½ inches, for his *Architetture et Prospettive*, part 1, pl. 6

this being how Giandomenico Tiepolo used the term, in adopting it for the posthumous publication of his father's *scherzi di fantasia* in 1775.[50]

The term *capriccio* was also applied in the eighteenth century to painted architectural views in which monuments and ruins, most often classical ones, were put into imaginary combinations or into an entirely foreign landscape setting, thereby controverting the transcriptional principles of the *veduta* (see Chapter 2) for captiously playful ends. It could be used in that spirit for the etchings of "invented architecture and perspectives" that the architectural draughtsman and printmaker Giovanni Battista Piranesi did in the 1740s, to stand alongside his *vedute* of the surviving Roman monuments and their settings. In one of the opening plates of his 1743 publication (Fig. 50), the role given to landscape, together with architectural and sculptural remains—which could from their appearance be either found or fabricated—is of a consciously telling sort. Stagnant water with plants in it and bushes or trees growing from crevices convey the decay that accrues to monuments and ruins over time; and a mood of oppressiveness is evoked more gener-

ally by the patterns of light and dark, which set up a flickering, discontinuous quality of surface.

Later in the century, the *capriccio* could take on an even more pointed and acerbic force of moral commentary, deploying topicality, sardonicism, and indecent humor to this end: as in Francisco de Goya's etched series of about 1793–98, which he chose to call *Los Caprichos*, holding up to mockery in successive plates the institutions, traditions, and social mores of contemporary Spain. There, however, the landscape settings that occur are of a token sort, or reduced to a minimum: perhaps because they would otherwise seem to constitute a poetic and fanciful interference with the satirical thrust, and the psychologically urgent presentation of human afflictions that came with Goya's deafness.

Goya is not generally thought of as a landscape artist. But his use of landscape settings is not simply a divagation within his art, nor do they serve merely as backdrops for his portraits and his genre scenes of town and country life. Through their very structuring, they come to have a force of comment on the way in which the natural world, its configurations, and the terms of its occupation feed particular kinds of imaginative introjection; in his only landscapes featuring human presence and activity in what appears to be an incidental form, the issue of sexuality as it infuses itself into psychological relations between man and nature is forced out even further.

The tapestry cartoons that Goya produced for the Royal Tapestry Factory in Madrid between 1776 and 1791 use for their backgrounds the basic vocabulary, to be found in Tiepolo's *scherzi*, of tree trunks and branches, upright or tilted so that they cross one another, and architectural blocks disposed at differing angles. But their piquancy of detail, rather than being primarily decorative in scope, is fitted—as with the settings of Gainsborough's "fancy pictures," showing cottage scenes with laborers in the company of their families—to the activities taking place; it refers to seasons and moments of work or pleasure that belong essentially to the populace of the countryside. And here it is important to understand Goya's access to a popular tradition of landscape imagery, represented in Spain by the works of Hieronymus Bosch and his artistic succession, which had been acquired by Philip II in the sixteenth century, and had in this way come to form part of the royal collections in Madrid. The manner in which the settings in that tradition of imagery are framed, so as to deal with encounters and presences out in the wild or in open country, forms a specific justification for the use of the term "popular." Thus in the background of the right panel of Bosch's altarpiece (now in the Prado) of the *Adoration of the Kings* figures, animals, and birds distributed in distinct tracts or pockets of space, in a larger context of trees, water, coast, and the edge of a city, conjure up such moments and the expectations attending them, to create an effect of the chilling, which resembles the seeking of such effects in the telling of folk tales.[51]

Goya's portrait of the *Duchess of Alba* from 1797 (Hispanic Society of America, New York) has a landscape background of river and trees that is animated by the character of its stroke-patterns in the same kind of way as the outdoor settings are in Gainsborough's full-length female portraits; but here the effect, compared to Goya's own previous portraits of that sort, is less poetically dreamlike, and more sensually provocative. The colors of the different parts of this landscape evoke all four of the elements, including earth and

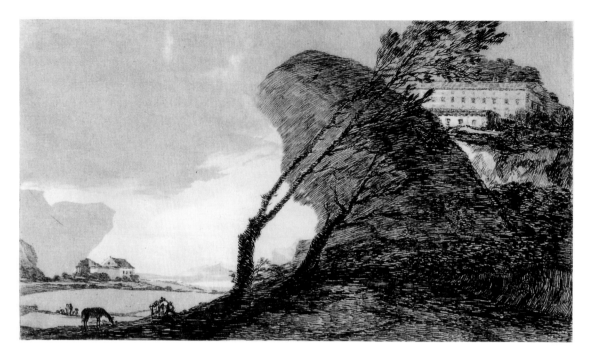

Fig. 51. Francisco Goya y Lucientes, *Landscape: The Big Rock*, c. 1800–1808. Etching and aquatint, plate 6½ × 11¼ inches. Art Institute of Chicago, Clarence Buckingham Collection, 1957

fire, and its fluidly evanescent shapes serve to comment satirically upon the duchess's fickleness as a sexual partner—whose favors Goya had enjoyed—and her changeability as a human being more generally.[52] Playfulness and decorative embellishment in scale with the figure are, then, no longer to the point here; whereas the *scherzi* of Tiepolo, which could be prized for exactly those qualities, did not become available until after this artist and his son had left Madrid in 1770, following an eight-year residence there, the print series of Piranesi's referred to earlier would have been available to Goya in 1771 already, when he was in Italy and spent time in Rome, four years before his own move to Madrid. The mobile dispositioning of light and shadow there, the sense of unseen natural forces at work to bring about change, and the overall mood of transmogrification to which the human presence is subject—all appear to find an echo in Goya's presentation.

The etching and aquatint of a landscape with buildings and trees that Goya went on to do soon after 1800 (Fig. 51) is even more evidently in this vein. Together with its pendant, the landscape with waterfall in the same medium, it features a giant rock rearing up into the sky, which is accompanied in the other case by a second, smaller rock to the right, while the nearer and further buildings of this print have their equivalent there in what may be either a building or part of a town high up on a hill. In the sole area marked by human activity in the work illustrated, a beast of burden grazes on the slope at the left, close to a group of small figures barely legible as such, while a still more diminutive group seems to be pausing from work in the field beyond. Above them towers and leans the tumescent rock, seeming to engage in a exchange above their heads with a cloud shape, also sexually charged, which appears in the lightly stippled sky.[53]

What Goya does here seems to oppose itself deliberately to the kind of "scientized" *capriccio* that toward the end of the eighteenth century and beyond, married the treatment of special effects of light—such as those created by the play of phosphorescence off the water surface in Italian grottoes (pages 103–4), or the limited illumination of underground caves and mines—to a painstaking descriptive topography, with the aim of conveying the qualities of the magical that landscape possessed in these natural, and at the same time accessible forms. In effect Goya fetishizes his landscape, as if in awed acknowledgment of magical powers that are to be inferred as belonging to it, amounting to occupancy by forces and presences outside human control. The extreme slant of his two trees must otherwise seem unaccountable; yet human life goes on despite and in the midst of this.

Goya's late landscapes depend, for their metaphysical import, on the role of darkness, or the lack alternatively of any reasonable clarity. In the *Colossus* (c. 1812; Prado) it is intrinsic to the treatment of the setting that it should appear as a site for disorder, of human actions and reactions to the visionary figure appearing beyond and above its periphery. Weirdly discontinuous and harsh effects of lighting contribute to this, as does the seemingly irrational shift at the horizon from hilltop and trees to sky.

The still later Black Paintings from the artist's own house (c. 1820–23; Prado), detached from their walls and preserved in a much-damaged state, answer in their settings to a mood of animalism and extreme pitiability, that characterizes all of the subjects here. Whereas Tintoretto's great cycle of canvasses for two floors of the Scuola di San Rocco in Venice (1576–87) treats darkness as a matrix from which human presences are swept up and forward into light, thereby giving the landscape a fluctuating and emotionally charged intensity of orchestration, and whereas El Greco's *View of Toledo* (c. 1610; Metropolitan Museum, New York) treats its overcast cityscape as if it were mystically galvanized into a crackling kind of activity, Goya, who could include in his most developed landscapes diaphanous and seemingly supercharged passages of pure coloring, gives to his later backgrounds a claustrophobic quality based on omission and suppression.

In this respect they are akin to the later settings of Matthias Grünewald, where—in direct contrast to this artist's earlier strength of feeling for colored light and transparency (see Fig. 21)—a darkness that is unyielding in its flatness and density answers to a mood of total anguish in the figures. In Grünewald's *Crucifixion* from the Tauberbischofheim Altarpiece (c. 1526; Kunsthalle, Karlsruhe) the dark background seems in effect to carry nothing on its surface except for a few traces of the brush, marking the process by which the perception of cruel sufferings is reduced to an absence of all palliatives, or equally of mollifying features as far as nature itself is concerned. It is toward this kind of aggravated play with the starkness of pure feeling, and what it excludes descriptively, that Goya also gravitates.

It is equally to the point to compare Goya's form of engagement with transformation and metamorphosis, and the way in which issues of sexuality are subsumed in this, with the art of Rembrandt, and especially with the prints of Rembrandt that Goya knew and admired greatly. In his 1643 etching of the *Three Trees*, Rembrandt's intense self-awareness in respect to process is apparent in his emergent treatment of the sky, including the shapes to be found in it; in the merger of the trees with one another in their scale and

positioning; and in the motif of the couple making love that comes into view, as if this pair were hiding in a lovers' bower that they had contrived for themselves, and which the artist-observer took the liberty of revealing, as key to their engrossed behavior.[54] What applies to individual motifs and passages here comes to apply in Goya's landscape etchings, it may be said, to the imaginative character of the print as a whole; and especially to its satiric and sexual intimations.[55]

The same kind of thing that has been said here about Goya's later work could be said also about Théodore Géricault's landscapes, from the first half of his short career; but on a different basis, which entails the role traditionally assigned to imagination and improvisation in order to give the whole physical context of an outdoor subject plausibility. If the plausibility in question was of a historical order—based on the premise that the setting for a historical event should appear as it could conceivably have looked at that point in past time, as in Claude's *Sermon on the Mount* (pages 75–76), set on Mount Tabor—then a set of criteria for reasonable inclusions followed. The sun's direction needed to conform geographically to the direction of the figures' movement; landmarks needed to be brought in, like an appropriate city to the rear; and the architecture in other parts of the setting, such as villages and dwellings, should equally prove itself appropriate. When William Blake, an obsessively imaginative artist, came to explain in 1809 how his fresco of the *Canterbury Pilgrims* was composed, for his "Descriptive Catalogue of Pictures, Poetic and Historical Inventions," which he had chosen to exhibit, the guiding principles that he specified were of exactly this order. He adopted this form of argument in order to make explicit how his treatment differed from, and was superior to Thomas Stothard's version of the subject, which made the mistake of giving the figures "a ride round about" their real route, as if they were somehow managing to go "by Dulwich Hills . . . to Canterbury."[56]

But the artist could also elect to improvise without respect for considerations of space and time that were consistent with the choice of subject. To do this was of the essence of the architectural *capriccio*. It represented a form of *bricolage* in which the piecing together of elements came close to an effect of parody, as that term would be understood to apply in the realm of art, with serious rather than purely humorous implications, later in the nineteenth century. In Géricault's case, the landscapes of 1818 contemporary with his *Raft of the Medusa* show the same appetite as there for lurid or disturbing detail cumulatively assembled. The use made of those elements controverts expectable architectural and spatial continuity to the point of parody, and the dark sense that is evoked of forces beyond human control becomes an analogue for sexuality of a disturbed and hampered kind: its blockages and frustrations.

The *Landscape with a Roman Tomb* (Fig. 52 and Color Plate VII) belongs to a group of three landscapes, with architectural ruins and figures, that were done on canvases, of exceptionally large size for Géricault, recorded as having been delivered to his Paris studio in July and August 1818. They correspond in their subjects to three of the traditional Times of the Day: in this case Midday, in the other two cases (Metropolitan Museum, New York, and Gemäldegalerie, Munich), Morning and Evening. That there was ever a fourth canvas to complete the series remains in doubt; nothing is known about a commission calling for these canvases, or about the place and setting for which they would have

Fig. 52. Théodore Géricault, *Landscape with a Roman Tomb*, 1818. Oil on canvas, 98½ × 86¼ inches. Musée du Petit Palais, Paris. Copyright 1996 SPADEM, Paris

been destined accordingly, and it remains possible they were undertaken on a whim and that the realization of a complete set never reached a terminal point. Nor is it clear that there was a specific order of hanging projected for the three paintings, and a corresponding sequence through the day in which the actions of bathers, travelers, and fishermen were to be read. Spatiotemporal cues are in effect juggled, or played with, in an improvisatory fashion that ends up parodying the kind of consistency that would logically answer such questions.[57]

The mid- to later eighteenth-century landscapes of Joseph Vernet (page 38), associating a view of ruins and surrounding country with a time of day, which served as exemplars for this kind of subject in Géricault's time directly and through the intermediacy of prints, had that sort of consistency to them: one that the very undertaking here sets out to controvert. For the architectural ruins in this case, and for the nostalgia for the Roman past that they invoke, a set of engraved plates of picturesque Italian views, published in France in 1804, served as the direct source; but in such a fashion that segments of two different tombs in Rome, those of Plautus and Cecilia Metella, are melded.[58] In addition the bridge over the river is shown as decayed and impassable, the river seems to run only in an impeded fashion and a sense of menace darkening the whole environment is conveyed by the storm clouds overhead. To aggravate the sense of anxiety and internal tension set up in this way, the eye picks out amid the shadows a gallows with severed arm and leg hanging from it; down below, a man, woman, and child appear pleading intensely with the fisherman in their boat to afford them passage.

To impose control on a landscape is, in military or strategic terms, to read and model it to suit one's projected wishes: as the commanding officer in the field was at this period taught to do. Géricault identifies psychologically in subjects like this, it may be said, with a corresponding spirit of command: as in his earlier painted studies, from around 1814, of officers and trumpeters of the hussars whom he situates on hilly eminences, as if momentarily detached from the action and surveying it from a safe distance.[59] But he also shows himself alert to a mood of apprehension in those figures, as to possible threats and dangers that the landscape may contain; it is in this ambivalence as to what is "out there" and how to deal with its potent "otherness" that fantasy, with a strongly sexual tenor to its workings, enters back in. Throughout the High Romantic period and beyond, the treatment of Oriental scenery on the part of European artists will, as a site for an imagined savagery and non-Western patterns of life, be replete with this kind of ambivalence.[60]

4

TROPOLOGIES OF THE NINETEENTH CENTURY

TROPOLOGIES IN THEIR PICTORIAL APPLICATION

The enormous increase in the power as well as the quantity of landscape art produced in the nineteenth century is grounded, from the standpoint of experience and feeling, in a number of overlapping factors. It relates to the increasing commodification of landscape, as a site of leisure activities and sought-after travel pleasures on the part of those who could afford this, as distinct from the urban cultural recreations made available for the middle classes by the growth of commerce and entertainment on a large scale within the city itself. There was also a movement at work to rediscover those rustic and primitive patterns of existence in nature that have a seemingly timeless strain to them; or later, a social movement to find roots in the countryside, in the shape of an inheritance of customs and practices binding the generations together.

Landscape art is marked accordingly by certain reductive or selectively maintained principles of inclusion and exclusion. The realm of nature is populated not by an intermingling of typical incidents and scenic richness, as it had been for instance in the art of Rubens, and again in the work of George Morland (see Chapter 3), so much as it is by elements that take on significatory power as controlling or ordering forces and factors in themselves. What are identified as the commodity values of this realm are foregrounded typically in the shape of water, rocks, plantings of trees, and greensward: all with their

counterparts in the parks and gardens found within the parameters of the city. These elements may be isolated, spaced out, or pictured in the barest guise, in terms of the density and weight that they have within the overall representation. But they have a force of identifying presence, which is like that given to moss, ivy, or lichen, growing over what has long been in place, in the assurance of continuity that invests them as markers of nature.[1] At the same time what is experienced by the traveler or tourist as unbounded and limitless—such as enveloping mist, or changing tides along the coast—is rendered in a condensed and summarizing fashion, which conforms to a deferring of consciousness, from the experience itself to its recollective embodiment. What could be regarded as innocent or unspoiled in the framework of apperception that links eye and mind, to give a sense of access to primal forces contained in nature, is thereby accorded its due.

There was a growing awareness too during the nineteenth century of the ultimate dependence of human existence and its support systems on the material qualities of the environment. The fitting into place of recurring patterns of activity, routine or otherwise, could be taken accordingly as being based upon a coming together of determinant conditions, which serve to give a particular texturing to what takes place in nature. More and more it had to be acknowledged that peasant life and the exploitation of the land for profit went on side by side in the country, under a common sky and within the broadly kindred overspread and interlinkage of field, forest, and farm.

There was equally a shift within the century as a whole from an imagery of landscape informed by religious belief, in the same persistent sense as mountains and groves were viewed from antiquity on as being invested with a quality of the sacred, toward an enfolding of spiritual intimations into the very substance of scenic and luminous experience. The transcendental impulse in particular addressed itself to the immanence of the divine in nature and its claims to being in evidence in the workings of natural phenomena, linking their temporality to eternity.[2] In a modern, secular, and urbanized world such an address offered promise, or at the least consolation for what had been effectively lost, in the way of a common faith in an abiding and foresighted deity.

All of this cannot be brought to account by style analysis, committed as it tends to be to ever finer discriminations of authorial personality. Too much is then left out, in the way of access on the part of landscape artists to critical thought and to the realm of ideas, as it offered opportunity for choice between conceptual alternatives. What is needed, rather, to contextualize the relationship prevailing between circumstances of production and the import of particular practices in landscape art, is an adaptation of the tropologies.

The tropologies represent, as the term will be used here, modes of seeing and depicting that correspond to figurative ways of constructing the world and what takes place there, and thereby making salient the nature of the emotive force that works itself out in the shape of a particular interpretative emphasis or accentuation. According to the fourfold categorization of tropes, or figures of speech, set up in the sixteenth century for the classification of rhetorical effects, the available modalities here—which are thereby given a larger application than fits with the specialized and sometimes technically abstruse character of the tropes themselves—consist of, or are based upon, those working principles of figurative language in general that go under the names of metonymy, metaphor,

irony, and synecdoche. By the later eighteenth century the tropologies, so understood, come to apply to works of art *as a whole* and the terms of response that they invite, rather than to particular elements *within* those works; the same holds for the writing of history now, or equally for imaginative literature.[3]

A tropology is therefore a form of presentation in which a particular stance, or practiced attitude toward the materials that are being worked with solicits a relationally matched tenor of response on the part of an intended audience. That response may be called a public one, in the manner in which it engages contemporary consciousness, insofar as reaching a public is defined traditionally in terms of communicative persuasion and the effective use of figurative language to achieve this—as opposed to an understanding of the language in point, which belongs only to privileged initiates into its character. In each tropology, then, an impulse asserts itself toward shaping and setting out the materials so that the treatment accorded them is viewable as being cast, structurally and imaginatively, in a certain key.

NATURALISM AS METONYMIC PURSUIT

Metonymy, which in its role as a figure of speech consists basically of naming one thing for (in place of) another, designates more generally, as a tropology, the selective choice and bringing into focus of particular features on one's subject-matter. Those features may be taken as representative either in virtue of their singling themselves out for this purpose, or because of an association that links them causatively to the way in which the subject is viewed.

The elements chosen for inclusion in the case of landscape may represent nature inasmuch as they stand in for and exemplify what is to be found, quite generally, in a particular area, region, or terrain. The foregrounding of rocks, for instance—their prominent or conspicuous placement in relation to other elements, which is a standard feature of early nineteenth-century travel prints—may have no other role than to epitomize the geological interest that the site in question holds for the unaccustomed visitor or tourist, and to stand as tokens of a roughness and wildness, in counterpoint to other surrounding or more distant scenic typicalities. A photograph of rocky landscape, in contrast, imparts a sense of literal, all-at-once exposure of its components to scrutiny. It is fraught at the same time with an impress of durability attaching to the view in question, from that particular angle and in those conditions of closeness or distance. The shift or slippage that takes place here, between on the one hand describing the image in a way that accords with familiar assumptions about its character, and on the other offering a mode of entry into what is singular or surprising about it, provides an analogue in the case of photographs to the literary figure known as *catachresis*.[4] Graphic images by comparison tend to be self-authorizing, as to what may be included and in what degree of prominence; they have less need correspondingly to pin down the attentive focus, and more to move it from one compellingly characterized feature of the whole to another.

Back in the seventeenth century, the term *naturalism* entailed convincingness of physical detail, arrived at on two counts within the artist's creative practice: through choice of motif, and by dint of a focus on concrete particular. There was, it may be added, no alternative term then, corresponding to what later came to be known as realism. Preparatory work outdoors, including sketching and the use of watercolor, had by this time become common practice in the case of landscape subjects. Working on the spot, from what the eye took in, was thereby made praiseworthy in its factual import, being taken as conducive to truth-telling about and in front of nature. But how this preparation was actually used does not seem to have been tied to any singular or necessary procedure of transposition or adaptation, into either painted or engraved form.[5]

It is Roger de Piles's contribution, at the very end of the seventeenth century, to have turned the discussion of outdoor naturalism in a different direction, by adding to the advocacy of truthfulness a feeling for those "affecting" qualities of landscape art, that compensate for the loss therein of narrative features, or of commanding social relations; he did this in his discussion of the landscapes of Peter Paul Rubens. In his *Abrégé de la vie des peintres* of 1699, translated into English shortly after as *The Art of Painting*, De Piles proposed as a matter of principle that not only did "prospects" need to be well chosen in landscape—as in the art of the Carracci and of Poussin—but also the strokes should be lively and the figures animated. In this way it could come about in the work of Rubens that Flemish prospects, "naturally ungrateful and insipid," were rendered piquant by the handling and by the "accidents" introduced. In his later *Cours de peinture par principes* of 1708, translated as *The Principles of Painting*, De Piles went on to distinguish between the "pastoral or rural" and the "heroick" styles in landscape, which he had first discriminated, in the art of Rubens as he had access to it, in his *Conversations* on the subject of painting published in 1677. He advocated now that the former category of landscape should contain, by way of counterbalance, not only a "great character of truth," but also "[an] affecting, extraordinary but probable effect of nature," which conveyed in itself a quality of simplicity, "without ornament and without artifice."[6]

In effect, De Piles was reinterpreting naturalism here to mean to cultivation of nature for its own sake, *rather than as* a background to human activities. On the one hand a system of open country and pasturage risked giving rise from a pictorial point of view to a rural landscape that was essentially unfocused, in the absence within it of culturally significant incident.[7] On the other, it remained for Rubens to energize the subject-matter of the Flemish countryside by attributing variety, distinctiveness, and a sense of occupation to those represented as belonging there—so that the landscape itself could be interpreted, in its atmospheric vibrancy and spaciousness, in relation to that spirit and situation of belonging which seemed, in De Piles's terms of praise, to invigorate by infusion the treatment of nature proper.

The establishment of a practical program of outdoor sketching and bringing into being small-sized oil studies from nature (in French, *esquisses* or *études*) proceeded apace during the eighteenth century, becoming part of the standard training for young artists prescribed by the French Academy in Rome. Instructional comments, made public in the last three decades of the century in the form of essays or manuals on the production of landscape,

Fig. 53. Pierre-Henri de Valenciennes, *Study of Clouds from the Quirinal*, c. 1781–84. Oil on paper, 10 × 15 inches. Musée du Louvre, Paris, Département des peintures RF 2987

stressed the immediacy of record that was entailed, and the valuable way in which such work could contribute to the subsequent putting together in the studio of either "histori-cal" landscapes, with narrative scenes going on in them, or topographical *vedute* (see page 82), devoted to the countryside for its own sake. But it was the activity in Italy from the mid-1770s on of an international group of artists, including the Welshman Thomas Jones and the Frenchman Pierre-Henri de Valenciennes, that laid the groundwork for an empirical approach to the study of nature: one that, relying on the senses to single out what is visually interesting in quite ordinary or humble kinds of landscape subject, combines this with a redolently atmospheric treatment of space.[8]

The use of the eye as an instrument of discovery and the contribution made here by an implied intimacy with the region depicted are particularly apparent in Valenciennes's surviving oil sketches, done in and around Rome in the early 1780s. One hundred and twenty-five of these *études*, preserved by the artist and by his pupil Anne-Louis Girodet so that they appeared in their posthumous sales of 1819 and 1825, were given to the Louvre as a group in 1930 by the granddaughter of the collector who had acquired them at those sales and kept them together. The example illustrated here, of cloud formations over the Quirinal Hill (Fig. 53), adopts an unassuming viewpoint, but one that promotes attention to the spatial disposition of the buildings, the alignment of their varying shapes and sizes

across the virtually elided hill slope, and the soft tones of violet and ochre in the masonry as these fall into accord with the thinly applied blue-gray coloring of the peaks beyond and the sable underside of the clouds.

In his lengthy and influential treatise on perspective and landscape, which appeared in 1800, Valenciennes emphasized the contributions made within the creative process, in the case of landscape, by the preceding study of separate elements that were fixed in their positioning, as well as attention to the conditions of lighting and weather belonging to different times of the day; he also advocated a rapid, bravura execution in the case of painted *études*.[9] But a sketch so created, matching informality of structuring to the familiar or ordinary nature of the subject, and to the mutations of perceptual experience that palpably modified that subject, could not as yet aspire to an independent existence. In respect, that is, to the scheme of values surrounding public exhibition and preparation for it, it could not, nor would for another half-century, assume a composed and ordered authority such as attached to a finished landscape. Rather, it simply formed part of a gathering of images, or taxonomic treatment of the subject material in successive aspects of its appearance (such as sunlight and shadow) that could profitably add up to a repertoire for the artist to draw upon subsequently.

Jean-Baptiste Deperthes, author of an 1818 treatise on the theory of landscape, followed Valenciennes in emphasizing the importance of direct and thorough study of landscape motifs, with particular attention to the role played by the sky and its illumination, as they affected the appearance of a scene: while for a setting that fitted the traditional category of "historic" landscape, with actions going on in it, he advocated "selecting from amongst the finest and greatest natural features," for "rural" landscape he gave a newly central role to empirically gained knowledge of a distinct, localized kind. To be familiar with an "expanse of country," including the sky dominating it and the light falling on it at a capturable moment, laid the necessary groundwork for being able "to reproduce with exact truth the appearance of every feature of [that] site."[10] But for the accurate, truthful description of a natural environment to yield more than just a sense of conversancy on these terms—for it to bring to account communicatively the selective and ordering process entailed in its composition—required there to be something in addition of a nonliteral order, which, as an adjunct of either subject or rendition, was perceived as being implicated. Representativeness and/or resonance had to appear to be at work—as in the setting of a historical landscape, but in this case without action or drama as the locus of entry into the whole—if originality on the artist's part, or at least purposiveness of presentation, were to be read in.

In the British development of naturalism in the first three decades of the nineteenth century, and in the critical response to its manifestations—now typically taken as being competitive with one another—two alternative ways appear of instilling figurative connotation into the rendering of sites and scenes, so that their metonymic presentation is thereby brought into parallel with the "metaphorical," in the loosest or broadest application of that term. One of these ways represents an extension of the principle of association, as it had been introduced and developed as an aesthetic premise toward the close of

Fig. 54. Peter de Wint, *The Cornfield*, 1815. Oil on canvas, 41¼ × 64½ inches. Courtesy of the Trustees of the Victoria and Albert Museum, London

the preceding century (see Chapter 1). Essentially, the range of natural elements selected and grouped together might be so harmonized and underlyingly unified as to bring into focus a power of feeling, or sentiment of a poetic order, attaching to the subject-matter in question.[11] The second way that offered itself of giving distinctiveness to the manner of presentation that arose out of working directly from nature was to take the character of the brushwork as instrumental in conveying the artist's personality. The emphasis here on process, rather than ideation, goes back equally to the later eighteenth century; but in this case to the practice of drawing alongside painting. For there the marks made on the page, rather than simply valorizing what in the aesthetic discourse of the Italian High Renaissance was termed *sprezzatura*—seeming spontaneity of execution that testified to command of when to leave off—served as the direct physical record, or "trace," of an individuality at work. And this was an individuality that took on substance in virtue of the material capacity that it had to give its own coloring (as in the coloring of a language) to the transcription of nature.[12]

Thus, in line with the first of those alternatives, Peter de Wint's *The Cornfield* of 1815 (Fig. 54) earned the commendation when it was shown the next year at the British Institution of being "of no small merit"; and since it received this praise even while figures and coloring were deemed inferior to the artist's usual standard, it must have been an import attaching to the subject and its internal detail that singled the work out so

positively.[13] Within the spread of open field here laborers are at work with rakes, the majority of them women; there is a seated group with children that seems to be picnicking in the center, and gleaners are simultaneously present, to gather what still remains at the close of the harvesting. The view, deriving from the Lincolnshire countryside, also takes in a wide horizon and the heavy shape, standing out against it, of a cart that is almost completely loaded up. This, then represents a version of naturalism in which, in broad principle, the eye is placed at a certain distance from the scene, while also registering features of it that imply intimate knowledge and an informality of access to what is shown going on. The patterns of action are generally nonobtrusive, so that whether or not the human presence acts as a keynote, the fitting together of natural and man-made elements builds to a sense of harmony and of placidity.[14]

To illustrate the second alternative, Richard Parks Bonington's *The Ducal Palace, Venice, with a Religious Procession* of 1827 (Tate Gallery, London) may serve. When it was exhibited at the Paris Salon in November of that year and at the British Institution the following February, it was praised by a leading French critic for its "vivacity" and "breadth of touch," and comparably by a British one for the "bold and well-placed touches" used to give "a character and an expression" to the buildings as well as the figures.[15] The different and competing premise of naturalism brought to bear here is that appearances are produced—as in the strokes used to render water—and brushmarks brought to signify in virtue of an enlivening resistance to what conventional idioms of representation imply, in respect to seeing and being made to see. As in the art of Ruisdael or Rembrandt—both of whom come in for special admiration at this time—the technical treatment singles out certain aspects of the subject, and calls attention in so doing to why, for the sake of "truth," those aspects should be emphasized or accented in that way.

John Constable's landscape art spanned both of those paths of access to a claimed, or purported naturalism. It entailed both a choice of motifs from nature, in which what belonged intrinsically to the subject, betokening its vitality or lending it an endemic spirit, seemingly came across by direct transcription; and also a rendering of the elements in question that put on view in the paint itself, and most notably in its surface formations, a marked individuality at work. In reviews of exhibitions in which they appeared, Constable's paintings were praised from 1815 on for their sparkle and freshness, as though they were reproducing in this respect characteristics that belonged to the landscape itself. Constable had called himself from early on a "natural" painter in this sense; but what was seen of his work also drew attention to personal qualities of handling, in the form of white "spottings" of paint over the surface, which some reviewers would point to as excessive. And in his later career he increasingly directed attention to the way in which pigment was applied over the entire surface, in the form of flecks or fresh, bright touches coming into prominence in the "six-footers" he exhibited from 1820 on. Those "traces" of process could be taken as signifying at a personal level his response to the tones and textures of nature, and also as tokens of his originality, in contrast to the now popularized conventions of the picturesque (see page 31).

In this way Constable was able to bridge increasingly the private and public spheres of artistic activity. His work imparted a private feeling for the subject, in terms of the

attachment to it which was conveyed. At the same time, in virtue of the scale of the finished canvases and the degree of engaged attention on the viewer's part they invoked, it put on display the kind of control and command necessary to rival other, more tradition-oriented branches of landscape production. It was essentially because of this bridging that Constable would prove so exemplary for French landscape practice, after the *Hay-wain* and two other canvases of his were sent over for showing at the Salon of 1824.

Constable's work was generally warmly received by the British press from 1817 on, and increasingly so as it became more known during the 1820s. But the duality of his alignment in respect to the two competing versions of naturalism that were sanctioned in the critical vocabulary of the time, to form a basis for evaluative judgment, is clearly implicated in the comments of his most consistent admirer in those years, Robert Hunt of the *Examiner*. Thus when *The White Horse* (Frick Collection, New York) was exhibited in 1819 under the title *Scene on the River Stour*, Hunt compared it with Turner's *England: Richmond Hill on the Prince Regent's Birthday* (Clore Gallery for the Turner Collection, London), taken as representing the kind of "poetry" that "gives a sentiment, a soul to the exterior of Nature." Constable's work was more in the vein of "portraiture," Hunt suggested, giving "[Nature's] look, her complexion and physical countenance, with more exactness." It was "indeed more approaching to the outward look of trees, water, boats, &c" than any other British landscape art could claim to be. Five years later, he reiterated his view of how Constable succeeded in capturing the "charms of [common] nature." Now, however, what "most of the other landscapes" wanted was "a certain appearance of identity, of freedom, without neglect in the representation of them." They wanted "more of that airiness of aspect in Nature" which, in Constable's *View of the Stour, near Dedham* (Huntington Library and Art Gallery, San Marino, California) made for a feeling of the "unrestrained."[16]

This two-sided framework for the evaluation of Constable's art was one that allowed for imaginative reading in. As another reviewer of the 1822 Royal Academy exhibition expressed it, such an "admirable portrait of the romantic variety and softer charms of nature and of rural scenery" lent itself to calling up "images and associations that mingle with the recollections of our early years."[17] Constable himself may have abetted this when he used times of day and unspecific indications of locale in the titling of his works for their public showing: *Landscape, Noon* in 1822 for *The Hay-wain* and again in 1827 for *The Cornfield* (both now in the National Gallery, London), *A Rural Scene, Suffolk* (unidentified) for the exhibition held at William Hobday's Gallery in April 1828, or simply *Landscape* in a number of instances, such as the views of Dedham Vale and of Hampstead Heath sent to the Royal Academy that same year.[18]

From subject to subject, key elements in Constable's art are primed to convey metonymically, in their foregrounding or grouping together, the need for the urban dweller or visitor from the city to adjust to changes in those features of a place that carry historical overtones, or are indicative of social continuity. Mill, cottage, and glebe farm (belonging to a parish church or ecclesiastical benefice, or yielding revenue to it) appear as an increasingly isolated form of survival, standing out as such amid the changing patterns of field, path, and hedgerow that make up the scenery surrounding them. Their

"truth" in this respect has a "breadth" to it that is apprised as going beyond mere topographical attentiveness.[19] Similarly *Salisbury Cathedral from the Bishop's Grounds* of 1823 (Victoria and Albert Museum, London), shown at the Royal Academy that year and at the British Institution early in 1824, earned from other reviewers again comment on the architectural knowledge that was entailed—privileging as a focus of attention what held the external details of this great cathedral together harmoniously—and also how the landscape and cows of the setting here could be taken to "speak of that rich fat country ever to be found about the church."[20]

When outdoor naturalism extended itself in this period to take in coastal and beach scenes, the opportunity asserted itself for making those subjects—in choice of viewpoint and in selected imagery—redolent of patterns of interaction not only between what was fixed and what was materially changeable, but also between the old and the new as defined in the current and developing uses being made of the sites in question. Clouds and breaking waves, the fisherfolk and their boats, the equipment of the catch and the debris of the tides were motifs that could be foregrounded for their quintessential representativeness, as well as for the variegations of tonality and atmospheric texturing that they set up. But there was also the visible evidence, on the shoreline or adjacent to it and forming a background, of how—as with river and port subjects equally—commerce in its newer forms was overriding or displacing the traditional market practices of the local inhabitants and their associated lifestyles. History, presenting itself locally in the shape of castles, fortifications, and old churches that appeared as landmarks, and formed familiar shapes or silhouettes for recognition from the sea, was in competition visually with new bridges, piers, and wharfs.

Patterns of movement involving groups as they gathered, moved about and interacted with the coastal scene were equally changing, as a result of the influx of tourists and visitors and their shared spectatorial interests. On the Normandy coast, where Richard Parks Bonington spent time in the 1820s and made watercolors, new bathing establishments were springing up concurrently, at Dieppe and Boulogne, under aristocratic patronage that made them fashionably attractive.[21] Across the Channel, Brighton as a "watering-place" offered a similarly changing face, along with Folkestone, Worthing, Margate, and Hastings, all taking on popularity because of the sea bathing in summer and expanding their resort facilities accordingly; while on the Norfolk coast Great Yarmouth remained more of a port, with a shipyard and other industries in evidence.[22]

Openness to the horizon and an unconfinedness of format had in such marine and shoreline subjects their own validation, as was already the case in seventeenth-century Dutch beach scenes. They brought in a sense of salubrious well-being that could be shared, or of easiness of occasion for going out by boat and coming back. When Trouville and Deauville in Normandy became middle-class resort sites in the Second Empire, with a much increased visiting population each year, Eugène Boudin painted their beaches complete with bathing cabins on wheels and the horses waiting to draw them into the water. But he preserved a sense of openness by placing his figures, in their smart clothes, against the horizon with drifting clouds above, and showing them as exposed to the wind and spray as they walked or conversed together.[23]

In the depiction of the French countryside around mid-century, naturalism similarly takes on a more socially attuned character. Partly this is because of the growing middle-class appeal of the villages and unchanged roadways of that countryside, which could readily be reached from the city now by train service or by steamboat. No longer could freedom of access be associated with a sense of private space available for relaxation and retreat. But by choosing to disregard history, the country enthusiast could come to terms with the presence of industry there and other related changes in the character of the environment, finding them to be a necessary and therefore acceptable aspect of the present. So the imagery of landscape could include correspondingly tourists, whose very attitudes imply that they are there to enjoy what they are doing in a leisurely fashion; or the depiction of an artist at work at a chosen spot in the country could convey the same.[24]

When Constable's *Hay-wain* put in its appearance at the Paris Salon of 1824, the novelist Stendhal, writing as an art critic, praised it for being "as truthful as a mirror." This traditional form of praise for the achievement of fidelity in art, going back to the Renaissance, entailed now, in its application to landscape, that the "mirror" in question gave back in static fashion only what was contained within its format and visible from a certain angle within its reflective surface. And indeed Constable had shown the whole of his country scene as if it were being viewed from alongside the loading dock at the near edge of the pond, so that all action appears stilled. That horse and wagon are in the midst of a crossing to the further bank has to be inferred, from the direction in which they are pointed; the dog and the preoccupied figure at the water's edge are both equally impassive; although there are harvesters at work in the distant field, their work insofar as it is made visible seems to go on outside of time. Stendhal found this depiction of "a hay-wain fording a stretch of stagnant water" to be "delightful" accordingly, but he wished that "a magnificent site like the mouth of the Valley of the Grande Chartreuse near Grenoble" were being shown: a subject entirely outside of Constable's repertoire.[25]

John Ruskin, a landscape artist himself obsessed with the displaying of botanical and geological knowledge, treated Constable's supposed deficiencies more moralistically in the first volume of his *Modern Painters*, issued in 1843. Constable, he wrote there, though "thoroughly honest [and] free from affectation," and deserving deep respect on those counts, evinced "strange want of depth in the mind," so that his "motives of English scenery," however much "affection" they might inspire, had only a limited appeal "when regarded through media of feeling derived from higher sources." The detail in them showed them to be wanting in veneration towards nature.[26]

When the Pre-Raphaelite painter John Brett first exhibited his work in 1856, it was as a protégé of Ruskin's, and his *Val d'Aosta* (Fig. 55 and Color Plate VIII) of two years later was painted under Ruskin's tutelage. But Ruskin, having shared the Northern Italian view in question, found fault with its depiction when it was exhibited at the Royal Academy the following year.[27] Though Brett accumulated detail subtly and precisely here, to show what was to be seen from a particular spot, including rocks with their textured overlay, poplars, and vines, and though the treatment of dewy pastures and meadow conveyed rest—as Constable's treatment of the outdoors failed to do in its technical busyness—what resulted as a totality seemed to Ruskin "wholly emotionless" in its lack of

Fig. 55. John Brett, *Val d'Aosta*, 1858. Oil on canvas, 34½ × 26⅞ inches. Private collection, England

noble purpose and failure to convey a sense of passion. "I never saw the mirror so held up to Nature," he concluded, "but it is Mirror's work, not Man's."[28]

At that time, in fact, a meaning for naturalism had begun to crystallize that was more directly oriented to human concerns and human experience; thereby harking back to the seventeenth-century use of the term noted earlier in this section. In the French critic Jules-Antoine Castagnary's Salon reviews of 1859 to 1870, and especially that of 1863, it was used to designate a truth-telling emphasis in painting that was brought "into equilibrium with science." It came to signal on this basis—in keeping with Stendhal's line of thought about Constable—a bare factuality of treatment. Its premises were ones that gave up on the notion of a commanding view encompassing man and nature, such as Ruskin had wished onto Brett, in favor of a more stringently limited and particularized treatment of local and material detail.[29]

But the term so used, with a capital N—as for literature in the form of the novel—was never applied to the depiction of landscape *alone*. In the paintings by artists such as Jean-François Raffaelli and Léon Lhermitte that came to the fore in France in the 1880s in France, and in comparable work done in the 1890s by British, German, and Scandinavian artists applying themselves to working-class and country subjects, governing frameworks of space and time were effectively interlocked with one another, in the same basic way that applied in photographs that were taken by a number of these artists and used for reference purposes.[30] Essentially, this manner of representing figures in their outdoor habitat, to the exclusion of anything more urgent than painstaking social observation, was not metonymically oriented because of its equalization of emphasis throughout; it needs to be kept apart accordingly from developments in naturalism with a small n.

Camille Pissarro by contrast, in his landscapes of the later 1860s and early 1870s, used unobtrusive actions on the part of country figures, occupied in working or walking, and nuances of lighting to tie together human presences and setting. His river scenes of this time featuring the smoking chimneystacks, wharfs, and barges of industrial development neither attribute social significance to the factory as a newly prominent component of the landscape, nor earmark it as being of direct economic consequence; rather, they invoke a coexistence with the natural that is acceptable within its ordered limitations without being entirely harmonious. Pissarro follows in this respect the example of Charles-François Daubigny's river and canal subjects, which had been directly important for him in his early work up to 1865. He does, however, allow modulations of contour that limit the degree of separation between shape and ground, and delicate keynotes of tone and color to convey in their recurrence how the suburban landscape and the tenor of life experienced there relate to the countryside beyond rather than falling into discord with it.

In the example of Pissarro's work illustrated here, a Pontoise landscape of 1873 (Fig. 56), the importance of the site and its selected detail is twofold. The series of closely spaced beds running up the foreground slope, with a figure in working clothes moving on the roadway alongside, are identified by their formation with the market gardening practiced by the peasant or proletarian segment of the population that made its living by sending in produce to the city. The bordering wall behind has a door in it that gives access to a heterogeneous group of related buildings, and the one edifice distinct from that group, at the upper right,

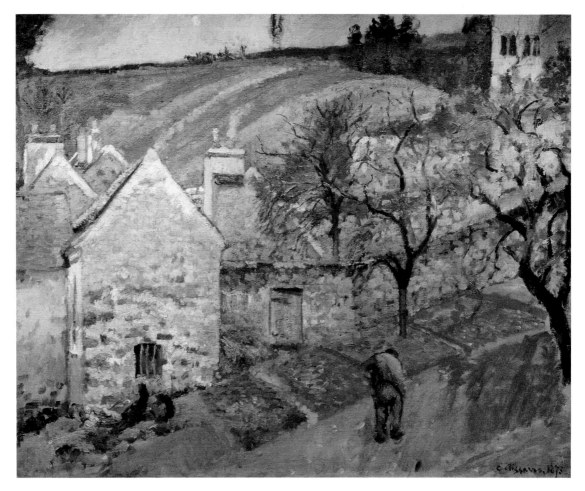

Fig. 56. Camille Pissarro, *Hillside at the Hermitage, Pontoise*, 1873. Oil on canvas, 24 × 28¾ inches. Musée d'Orsay, Paris

has the contrasting shape and size of a suburban villa. These architectural motifs are therefore representative of a conjunction within the Pontoise community—where Pissarro had settled the previous year—with strong socioeconomic overtones to it.[31] Their keynote, figuratively speaking, is one of adjacency and adjustment.

Pissarro also painted this subject in winter, and the markings in paint, different as they are in the two cases, testify to a particular sensibility brought to bear on his part: an innate perception that is acting here upon a bourgeois cultural environment. The critic Thoré-Bürger (Théopile Thoré using a German nom de plume) had written in 1844 in reference to the art of Théodore Rousseau, one of the leading figures in French landscape art a generation earlier, that a painting could "penetrate into the intimate life of nature" on the basis of a use of personal experience to respond to its traits of character (*caractères*) in a sentient way.[32] What the clustering of the paintmarks builds to in Pissarro's case may be thought as staking out, in the domain of feeling, an apprehension of solidity. In the metonymic operation of naturalism, as it extends itself here to convey a felt value of that

order, what is solid in the buildings and speaks to their unforced adaptation to new circumstances becomes interactively linked to the environment as a whole.

Musicality in Alliance with Metaphor

Metaphor as a figure of speech associates two different entities with one another (such as "home kingdom" or "garden paradise"), in terms of aspects selected so as to convey particular qualities or affects that they have in common. It makes the association in such a fashion that the tension or emergent contradiction that attaches to the coupling brings to the fore suggestively what is entailed. Extended beyond the individual phrase or sentence, it entails a play with the possibilities of analogy and alliance between differing conceptual frameworks. Working in a fashion that, in the case of a fresh or engaging metaphor, is itself enlivening, it creates a structure of relations that can be employed for cognitive as well as evocative purposes. It is the principle of interfusion and the activity of interpretative distillation entailed—rather than of singling out and bringing into focus, as with metonymy—that is particularly germane to landscape art.

The concept of "musical landscape" belongs to the domain of metaphor, in that the linkage of those two terms with one another and the kind of stretching of percipient response that comes from their being so linked could only take place (as in the examples of metaphor cited) in virtue of a transfer of implication from one term to the other. The musicality in question constitutes an aspect of the landscape image that is motivated in its presence so as to be capturable through a form of vicarious "listening" it invites: one that depends on an interplay with the receiving consciousness, and not just a choice and arrangement of elements that are evocative in themselves.[33]

For such a notion of musicality to be given imaginative credence in the way that landscape art was apprised, two conditions of understanding in respect of music had to be fulfilled. One of these was that the constituent elements of music—whether notes, phrases, rhythms, or harmonies—had to be freed from being thought of as corresponding to individual constituents of the subject that was being conveyed (words, sentences, tones, and accents of speech as the case might be), as the theory of rhetoric underwriting musical composition and its interpretation in the Renaissance and Baroque periods required that they should correspond.[34] The musical evocation of landscape, according to that way of thinking, arose from finding equivalences to the sounds, movements, and the very objects conjured up descriptively in nature poetry. But in Charles Batteux's French treatise of 1746 on the principles underlying the arts on general, the "portraiture" of nature, as it is called there, in the form of such "animated sounds" is distinguished from the deployment of "non-passionate sounds and music" to form "a kind of landscape painting." Musicians who "linger on to paint a brook, a breeze, or another word which makes for a musical image" are criticized accordingly, for giving attention to "an idea . . . accessory and almost indifferent to the principal subject," as opposed to the expressive potency of "the general tone . . . spread over the whole piece."[35] And the German

Christian Gottfried Krause, in his essay of 1753 on "musical poetry," affirmed similarly that storms and murmuring brooks are "musical only inasmuch as they contribute to the arousal of an effect or special feeling of pleasure," so that success in evoking a landscape was a matter of emotional empowerment rather than mimetic aptitude.[36]

The second condition was that the meanings generated by musical composition should be understood as ones that the listener constructs. Descartes in a text of 1618 on music, published posthumously, had maintained that music gives pleasure if the listener's temperament resonates with it; and painting, poems, and music had often been compared from the Renaissance on in terms of individual expressive means and their contributive agency.[37] But it was the insight of the French encyclopedist Denis Diderot, writing on the subject of the blind and the deaf in 1751, that the source of pleasure in all three of these arts lies in relations that are perceived, like those of tone in music. The fact that "the most arbitrary and the least precise" of these three arts should be the one that "speaks" most directly in expressive terms could be explained, he suggested, by the fact that "in showing less [in the way of objecthood], it leaves more to our imagination." And he emphasized the degree to which wealth and density of texturing could exercise appeal in terms of "pure and simple sensations," irrespective intrinsically of kinship with objects or the part played by depicted incident.[38]

Those two forms of understanding effectively come together in Jean-Jacques Rousseau's essay on the origins of language—written probably around 1753, but published only after his death, in 1784—in a passage suggesting why painting should be closer to nature than music. "Music is a more human art," Rousseau avers, because "it can paint things that one cannot hear." While painting "is often dead and inanimate," music brings into its tableaux "sleep, calm of night, solitude and even silence." It operates artistically through "the movements that its presence excites in the heart of the person contemplating." And it does this, not by showing as painting does things that one can see, while falling short in the capacity to represent things that cannot be seen, but rather in "being able to paint things that cannot be heard . . . by arousing through one of the senses responses akin those that can be aroused through another."[39] This is one of its great advantages, and the figurative potential affirmed in this way marks out how the capacity to "paint" musically can be transferred from here on back to the pictorial arts.

The landscape subject of the eighteenth century that lent itself most readily to being thought of in musical terms was one featuring ruins.[40] Why that should be so, and how its being so fits with an emphasis now on pervasive tone of expression, and on contemplative input on the viewer's part, is brought out particularly by consideration of Hubert Robert's paintings and drawings on this theme. Diderot, writing as an art critic, devoted a long section of his extended essay on the Salon of 1767 to Robert's group of paintings that appeared there. In a passage that has become celebrated as a literary tour de force he referred to the variety of moods that ruins can induce in the beholder: especially ones that build to a sense of the passage of time and the ephemerality of human existence. Robert, he felt, needed to immerse himself more fully in the poetic of ruins, and to restrict the figures that he included to "those which will add to the solitude and to the silence."[41]

The moods that Diderot conjures up in this passage, including as they do sensations of

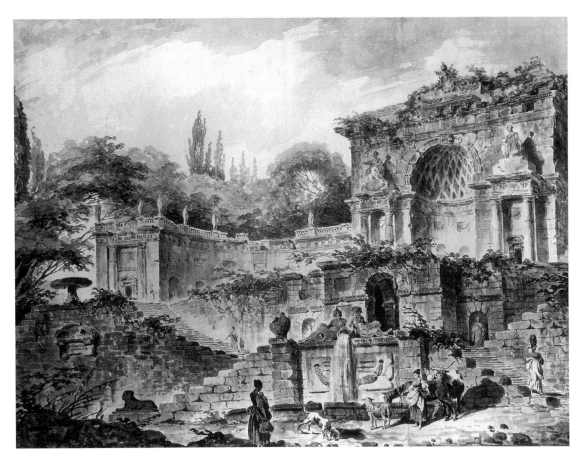

Fig. 57. Hubert Robert, *Remains of the Ruins of the Villa Sacchetti, Rome*, 1760. Watercolor and ink on paper, 13½ × 18 inches. Albertina, Vienna, Graphische Sammlung

crumbling and of imminent peril, could scarcely all be generated by one image. Hubert Robert's cast of genre figures, and the various animals that appear along with them, are in poses conveying no awareness of any such intimation. But he also includes statues and pieces of architectural sculpture enlivened in their gestures and body movements so that they appear to participate as accents of energy in the scene. In his drawing from 1760 of the ruined Villa Sacchetti in Rome (Fig. 57), ones so activated appear in different parts of the architectural complex, and it is they who seem to be responsive to the environment around them, inasmuch as their gazes can be taken that way.

In using such elements to engage the viewer and stimulate the imagination, Robert, and his contemporary Jean-Jérôme Servandoni likewise, were treating ruins as a subject as they had already been treated in the later Renaissance. In the fresco scheme created by Paolo Veronese and assistants, around 1560, for the Villa Barbaro at Maser in Northern Italy, views within a fictive architecture, as though through windows giving onto an imaginary outdoors, include glimpses of ancient ruins and their settings. Inasmuch as this was Daniele Barbaro's country villa and estate, used for the purposes of relaxation at a distance from the city of Venice as well as intensive farming, the choices of subjects and

their disposition over the walls in successive rooms were counted on to make a similar play for the viewer's attention, based here on competition with the actual landscape surrounding the villa itself. Views encapsulating portions of that scenery are included in two of the rooms, and there are also frescoes of female figures playing instruments, singly or in groups, that serve to evoke a desirable and restorative mood of harmony achieved through the agency of music.

But what takes place there with the imagery of ruins needs to be understood more specifically in the light of how those elements were garnered. Use was made for this purpose of two recently published series of prints of the ruins of Rome, by Hieronymus Cock and Battista Pittoni respectively.[42] The emphasis in the adaptation of that source material is on the detachable part or excerpted portion of a larger scheme. Displaced from its familiar and expected context of appearance, together in the case of the Pittoni prints with the topography of the surrounding landscape, this recreative imagery was to be enjoyed by Daniele Barbaro's guests in a participatory and wit-infected spirit.

In the work of Robert, in contrast, the major contributions to the figurative tenor of the whole are different in kind. The repetition of architectural detail and the extrapolations built into its internal sequencing correspond to what was termed, in musical practice of the time, embellishment: a heightening of ornamental detail, taking the form typically of counterrhythms to the main melody, added notes or trills. There are also rapid alternations of light and dark throughout and, in the drawing illustrated and others like it, the garden vegetation (which is in watercolor) seems to deliquesce: to dissolve gradually and become liquid by attracting moisture from the air. The implication here, in short, is of movement toward a metaphorical order of language, coming into operation through the way that the medium is used.

The increased favoring of instrumental music from the 1770s on, in terms of the opportunities for performance which it presented, was accompanied by a growing emphasis on the values of immediacy and sensualism in such music. To give pleasure in those terms, as by changes of tone or mood, represented itself as an inbuilt appeal in "pure" symphonic music such as Beethoven's. But if immediacy took the form of a bursting forth in which strong emotions were generated as if spontaneously, room needed also to be found for reflective meditation and ratiocination on the listener's part, drawing on the resources of the mind. A bridge between those two seemingly incompatible forms of response was offered by Friedrich Schlegel when he wrote in one of his "Athenaeum-Fragments," created for the journal of that name that he and his brother founded in the last years of the eighteenth century, of the role of thought in music. Noting "a certain tendency of all pure instrumental music towards philosophy," which extended beyond its commonly supposed limitation to a language of feeling," he asked: "must not [such] music create a text for itself? and is the theme in it not as developed, confirmed, varied and contrasted as the object of meditation in a sequence of philosophical ideas?"[43]

In German landscape art of the early nineteenth century, two different ways appear of instilling into the presentation, through thematic sequencing and internal traits of structure, the sense of a patterning of thought at work that is philosophically tempered along

lines like those that Schlegel invoked for music. What may be called the tincturing of a schema, as in the art of Philipp Otto Runge, may serve to introduce abstract connotations, such as attach to universalized ideas; the schema in question being simplified, symmetrical, and systematized by the very manner of its internal enframement. Alternatively, the communication of a metaphysical "presence" attaching to the way in which the subject is developed may, as in the art of Caspar David Friedrich, offer a sense of putting or pulling together within the work's compass what could not equivalently be expressed in words, and thereby opening to apprehension aspects of experience in the world, and of the world, that would otherwise be at odds with one another. What links those two alternatives with the domain of instrumental music, and through it with the operations of metaphor, is that the work of art so conceived combines effect on the sensibility with a nonparaphrasable content of "ideas"; and invested in its spiritual urgings there lies the potential, belonging also to an extended metaphor, of transformation, rather than (as in the classical account of metaphor going back to antiquity) mere substitution in the way in which the component elements are interactively taken to signify.

Thus in Runge's project of 1802–10 for four compositions on the theme of the *Times of Day*—only one of which, the *Morning*, was brought to completion in 1808–9, in the form of a small version in oils (Kunsthalle, Hamburg) and a larger, unfinished version that would survive only in fragments—the disposition of the imagery entailed from the first the use of a continuous framed field, with a framed border around it. This and the deployment of transparent and opaque passages alongside one another create an effect of layering that is nontemporal in the relationships of action and gesture to space that it sets up, and without comparative register as to what is near and what is far. The rhythmic disposition throughout of both human forms and natural ones, and the play with primary hues (red, green, yellow, blue) which is apparent in *Morning* further set up an implication of metamorphosis back and forth between the naked figures and the separately individuated plants and flowers that accompany or surround them: one that is both life-giving and life-enhancing in its pulse, so that it negates thereby that the project could consist essentially in the embroidering of a mythological narrative set outdoors.[44]

In Friedrich's landscapes, by comparison, there is a kinship of another sort with German instrumental music of the time. In respect to the terms brought in now for characterizing purposes, both call up what may be called an incipient synergism. An unidentified reviewer said of Louis Spohr in 1808–9 that his instrumental compositions mixed "gloom and tender melancholy," in a fashion that this reviewer "would not object to calling Romantic."[45] Two years later the Weimar author and art historian Johanna Schopenhauer—who was also an amateur artist and mother of the philosopher—commented on the "melancholy and mysterious religiosity" of Friedrich's landscapes. Referring to the choice of atmospheric subjects and the suppression of middle ground, she wrote that they "strike the soul rather than the eye."[46] What these comments have in common is that they put words together to convey qualities and affects that draw upon distinct strata or opposed categories of expression and feeling—doing this in such a way

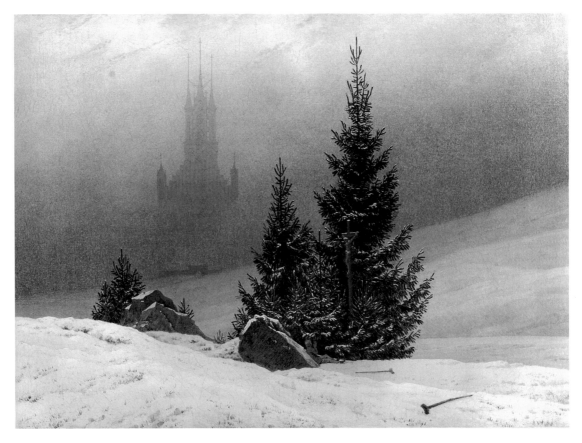

Fig. 58. Caspar David Friedrich, *Winter Landscape with Church*, 1811. Oil on canvas, 13 × 17¾ inches. National Gallery, London

that their discrete cooperation generates a stronger suggestiveness than the sum of their independent parts. The kinds of mood called up in these nonverbal art forms are in this way brought into parallelism.

One may go further and say that in Friedrich's landscapes a temporality of being and becoming is conveyed in stopped form. This is achieved by the role given to duration, of either parts or whole, in the musical sense of that term, and by the weightings of intensity that go with this: an intensity such that, as in Beethoven's music of the time, exploration of the basic nature and ultimate limits of the universe that the artist deals in becomes a preponderant factor in shaping the kind of language that is at stake, and the inbuilt tensions that it entails.[47]

In Friedrich's *Winter Landscape with Church* of 1811 (Fig. 58)—chosen to illustrate this characterization of his art, as it takes on force in the first half of his career—three fir trees of decreasing size are brought to the fore as iconic elements. Not only is their symmetricality stressed but they are also colored evenly, as if that coloring were eternal, and loaded with snow in the same places. The wayside crucifix before one of them stands as a familiar and timeworn component of a countryscape such as this; but it is energized by its crisp contour and the rhythmic sweep of the branches either side of it, as well as by the

intersection of gaze coming from it with that of the pilgrim figure looking up. The cathedral facade, shown as if hovering aloft with its base invisible, links up with the basic geometry of the firs and seems to interpose itself between them in its size and shape. Its solemn, visionary outline is softened in its strictness by diffused orange lighting coming up behind its pinnacles, so that the seemingly impenetrable mantle of fog, or heavy mist, that obscures it down below opens up and appears dissipated into separation from it. Beyond the large and harshly projecting rocks, which are the only natural feature of the scene besides the firs, and grouped to form a comparable triad in reverse, there lies an utterly featureless stretch of snowfield; and at its limit, as if leading to the cathedral's entrance, a low and isolated gateway can be discerned, to which the eye is directed in between the rocks.

So far only the landscape has been described, in its limited but powerfully evocative particulars and the intervals as well as the connectives between them. But what the layout of the imagery posits, in terms of temporality and duration, has to do with the situation of the pilgrim figure, resting horizontally against the nearest of the rocks with hands joined in prayer; the pair of crutches on and beside the path to his right, evidently discarded by him successively as he made his way to this point; and the promise of a future in which he might pass through the gateway, which cannot as yet be seen from where he is, and so out of his bondage to the encompassing snow. What makes for the metaphorical here is, first of all, the sense of there being an aspiration at work, to be freed from the constraints of an earthbound and time-bound situation; and then, through that and in tension with it, the issuance of a perspective that leads past the everyday and the familiar, with an imminence of contradiction as it tenders this possibility, to a discretely imagined yet nevertheless spiritually compelling beyond.[48]

In his later work, after 1820, Friedrich used a somewhat softened or less precisely detailed handling, and the personal associations of his imagery become more evident and pointed. But the fact that his views of mountainside, flatland, and seashore, in their seemingly limitless stretch and lack of any implied continuity with the viewer's own space, offered only a skeletal infilling in the way of material detail, meant that he was largely ignored by contemporaries who wanted landscape painting to induct the viewer by degrees into an accord with its loftiness, and to create, within its packed scope, a finite apprehension of past and present merging with one another.[49] Friedrich failed expectation on both counts by characteristically using an observer figure within the scene, or a rock surface that acts like a preserved memory of where that observer would have stood, so as to cut off such a possibility of concordance or merger, and supply in its place a mood of bleak coldness.

This *Rückenfigur*, or observer seen from the back who appears in many of Friedrich's landscape subjects, looking out and away—either alone or accompanied by one or two other figures in a like stance—mediates in effect between the artist's own role as solitary observer and that of a viewer placed in front of the painting. In comparison with the part played in van Eyck's and Bruegel's art by such figures (see Chapter 2), Friedrich's internal observer, sometimes female, performs such a mediation more metaphorically: the transfer of attention set up in this fashion, from the actual to the envisioned, is encapsulated in

the very stance and attitude of the figure and what, in their power of condensation, those two markers of response leave inaccessible. What counts as actual is vouched for by the figure's concreteness of experience of it, without being made manifest in any necessary detail. What is envisioned is at once both intensely private and—insofar as a particular aspect of nature is brought into suggestive correlation in terms of what is seen *in it*—potentially universal in scope.[50]

Friedrich's later landscapes are static, as if everything that prompted meditative reflection in front of nature were congealed, and only suggestive iteration conveyed—cumulatively rather than syntactically, as in Schubert's song-cycles—a plangency of resonance that comes to pervade the picture as a whole.[51] When he paints the four *Times of Day* as a series in 1821–22 (Niedersachsisches Landesmuseum, Hanover), the sun's controlling agency in the bestowal and withdrawal of warmth and light is soft-pedaled in favor of concern with more diffuse atmospheric conditions to which it contributes, and in which imperceptibility and vacancy serve as exclusionary counters in their own right. The moon is correspondingly shown in other paintings as a slim portion of its total shape, an emollient source of radiance or a pale disc floated in the sky. The kinds of religious or spiritual impulse traditionally associated with exposure to nature's workings are not so much dislodged hereby, as they are substituted for in the shape of a rapt attention to the way in which the different material components of landscape can exhibit a tangency of relations to one another, ad infinitum; whereas ships, humans, and spires are holdouts from this, pinpointing themselves always, and with seeming inevitability, as coldly distinct silhouettes.

When there are no such presences included—as in some of the late landscapes that represent memories—the question comes to be posed, at least implicitly, of what the minimal determinative features or the ultimate constituents are, that make a landscape readable as such. The horizon line between sky and earth appears as crucial, providing as it does a homeomorphic consistency. And from a group of oil sketches of *Evening*, not intended as finished studies, that Friedrich did in the autumn of 1824 (Kunsthistorisches Museum, Vienna, and Kunsthalle, Mannheim) it is evident also that, where sky is the keynote, there should be a stretch of cloud formations, or a flattened indication of their spread, that reaches out across the atmospheric space without permeating it completely. It is one of the most interesting sidelines to the art of the High Romantic period that "minimal" landscapes of this sort should be found in the work of other artists equally, French and British as well as German. They have a place in Delacroix's and Boudin's production in pastel and in watercolor; in Turner's watercolors, notably those that touch in lightly the radiance of sunsets over water; in seascapes of Carl Blechen's done in the later 1820s in Italy, probably after he saw an exhibition of Turner's work in Rome; and later in watercolors by Whistler, and ink and charcoal drawings of Daumier's.[52]

The enlargement of scope and opportunity in the application of musical terminology to landscape painting that takes place in France toward and after the mid-nineteenth century is led into by a number of assisting factors in the domain of music itself. Increasing chromaticism, which had served as a key element in the enlargement of enharmonic change of the part of Chopin and Schubert, took on a new importance in the operatic

music of Richard Wagner by the mid 1840s. The role of coloring in landscape art could be thought of analogously, both in the centrality accorded it for the purpose of conveying feelings, and as a matter not simply of the choice and disposition of hues, but rather of a complex harmonization of tones and texturings that were weighted and extended so as to give reverberation to their recurrence in other parts of the work. A new or renewed critical stress on the commanding way in which the overall tenor of a piece of music came across in performance meant that terms like "lyrical" and "sonorous," which could be applied to the imagery of a sector of landscape, its governing rhythms and tempo, came to be used in reference to the artist's interpretative phrasing. Such terms could equally be used to characterize in isolation a musical piece that formed part of a larger undertaking or cycle, or one that was constituted by design as a fragment. What is left incomplete in a landscape subject or allowed to blur out at the peripheries of the image—as in the vignette form in printmaking, which had attained growing popularity during the first half of the century—calls similarly for a show of accompanying words: not for definitional purposes, but to encapsulate poetically, as a musical title can, what would otherwise seem enigmatic or blankly meaningless about the "unframedness" of its congeries of allusive details.[53]

Such considerations regarding the agency of musicality in landscape art, understood as a configurative means of instilling suggestiveness, apply in a very general way to the mature work of the major figures who drew critical attention as painters of the French countryside between the early 1830s and the 1860s: most particularly Jean-Baptiste Camille Corot and Théodore Rousseau. Both of them are reported by their early biographers to have been steeped in the practice of listening to classical music, reflecting on its rapport with painting and viewing it as paradigm for their own variations on a motif and how these were to be understood.[54] Corot is more concerned in his French subjects with the structural interplay of intimacy and openness, soft tonality and touch being crucial to conveying how these two modes of imaginative access to quiet rustic scenery hang together; after 1850, his "souvenirs" devote themselves more comprehensively to establishing a dreamy atmosphericity. Rousseau is more interested by the 1840s in the varying dramatic moods of landscape and in juxtapositions of mass and bulk evincing how their diversified texturing is acted upon by light and atmosphere. But what links the two is a concept of *effect* in landscape that had come to the fore in the second quarter of the century, and is musically oriented inasmuch as it empowers in pictorial practice a vigorous, fluent, and at the same time broadly oriented way of creating mood.

Effect, that is, came to be understood by mid-century in a special way. It was not simply a matter of pleasingness and strikingness as brought out by controlled arrangement. It could refer in landscape either to broad massings of light and shade, or to an operative quest for an extreme of softness or suavity. In both instances precedence was given to the interplay of light and shadow over the arrangement of color, for the establishment of a harmonic substructure; it was also crucial that, in the terminology of the time, the "sacrifice" of certain details should be entailed.[55]

Thus, in its metaphorical purview, effect could accommodate both what was given by the subject and what was experienced on the viewer's part; both Corot's concentrated yet

bleached lighting, as reflected on smooth water surfaces in purified form, and Rousseau's giving of scintillation to the cold touches of morning frost on a still darkling expanse of green. Such renditions did not describe nature, but rather extrapolated a set of harmonies from its underlying character. And the term that came into currency later in the century to designate such a harmonization was *ensemble*. Used by Corot toward 1870 in conjunction with *effet*, it was extended in commentary on Monet's art in the 1880s and 1890s to denote the importance given there to the "complete expression" of nature, as opposed to its piecemeal transposition into painted form.[56]

Another musical term that came to be applied to landscape art late in the century was *improvisation*. Changing performance practice had made it growingly apparent after 1800 that improvisation was not a mere exercise in creating imaginative and inventive variations on a script, or an equivalent thematic basis, but a "surplus" added in performance through the opportunity this gave for displaying verve and spontaneity, in a kind of free partnership with the composer. In that perspective of order and freedom, a controlled handling of paint did not have to be tightly elaborated; where its point of departure and its adaptive bent licensed this, its inflections could reach over into the territory of the extempore. Different and seemingly incompatible conceptual frameworks, governing how and to what purpose paint is applied, put their stamp accordingly onto the use of the term "improvised," giving it a metaphorical cast.

The landscapes that Adolphe Monticelli painted between the mid-1850s and the mid-1880s show in acute form the problems that the term posed, in its combination of positive and negative implications as to how the medium was instrumentally manipulated and the coloristic and excitatory qualities of the end result. The article written on Monticelli's work in 1881 by a certain Adolphe Meyer singles itself out as being the first to try to deal with these qualities and the personality that lay behind them, rather than dismissing the work as earlier commentators had done in the light of its bizarre and evidently eccentric character. It appeared in a Provençal newspaper associating art of the region with the local landscape. At that time Monticelli had been living for a decade in virtual isolation in Marseille, and alongside portraits, still lifes and some seascapes, he had brought into existence a steady output of imaginative woodland and forest views, with and without figures. Meyer called Monticelli a "master of improvisation" because, though freely inspired by emotion and unable to put a curb on that pressure of inspiration, he nevertheless placed seemingly unrelated colors into "carefully coordinated" harmonies and relationships of adjacency. So while his subjects proved sometimes hard to make out and his figures were prone to blending indistinguishably into their settings, his very failure to refine into composed form the products of accident or instinct aided and supported him in producing "dreams of color" in the outcome.[57]

Meyer went on to refer to the "inspiration [of] fine music," placing this in the context of access to artistic models enshrining the cult of sentiment and poetry of the High Romantic era. And indeed Monticelli had taken direction early in his career from Delacroix and from the richly embroidered landscapes of the Barbizon artist Narcisse-Virgile Diaz de la Peña; before his existence took on a nomadic cast, he had found some success as a painter of *fêtes galantes* set in the Bois de Boulogne. But from a later landscape

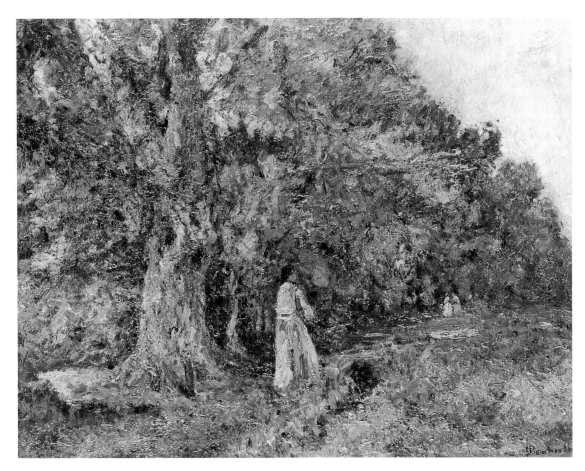

Fig. 59. Adolphe Monticelli, *The Old Oak, Landscape of Sainte-Baume,* c. 1872–73. Oil on panel, 20½ × 26½ inches. Nationalmuseum, Stockholm

of his like the one shown (Fig. 59), with its hyperactivated oak tree bending and pulling across the foreground and its strangely positioned figures, it can be seen why the problem of improvisation posed by Meyer persisted. The American Marion Hepworth Dixon, writing of the "verve and freedom" of Monticelli's later treatment of nature, signaled at the same time "its almost ferocious impasto . . . its tentativeness, its inconclusiveness"; while the artist's first biographer of 1900, André Gouirand, would advert to a "music of colors" brought into being that was essentially indescribable in its "total effect."[58]

Berthe Morisot's work contemporary with that landscape of Monticelli's, such as the view of boats on the Thames in pastel that she showed in the third Impressionist exhibition of 1877, could equally be taken as entailing improvisation on her part. Indeed, the critic Paul Mantz used the term in his review of that exhibition, in reference to the sense that was imparted of a registration and rendering of personal sensations that appeared as frank and sincere.[59] In Morisot's oil paintings of outdoor subjects—most often with figures included, or at least one prominent figure, but sometimes unidentified as to site or empty of the human presence—thinness of pigment, lightness of touch, and the labile distribu-

tion of stroke patterns cause the work to appear not incomplete, since it extends to the edges all round, but as only partially filled out. So the sense of being let in on an early stage of pictorial development emerges through and within the handling. What that stage entails in the way of a concentration is pointed toward the action of light. Morisot had been guided early in her career by the example of Corot, with whom she studied, and absorbed into her own practice his way of giving rhythmic elasticity to the play of light down the side of tree stems and over masses of foliage. But in her 1885 view of the forest of Compiègne (Fig. 60 and Color Plate IX), what bright sunlight does to the shapes of trees, in a relatively open and warmly irradiated stretch of woodland, is more in the vein of Fragonard (see Chapter 1), from whom she also learned, in its ellipses and discontinuities, used in such a way as to suggest intermittent but decidedly present cadences linking one surface with another.

The musical term, available but not used in this case, to designate such an organized busyness activating the canvas surface is *notation*. In the graphic work of Dürer the confronting of relatively intractable landscape subjects, as on his travels (see page 62, where the word notation was used) impelled the devising of a scheme of marks and ligatures on the page for recording purposes. To register in this fashion what was yielded or discovered in the way of an interplay between different thematic materials, each of which had its own spatial and textural strain to it, was to call into operation a set of inscribed equivalences that can join themselves together denotatively, in the same broad sense as a musical composer calls upon visual equivalences to indicate and make readable a certain conjunction of musical sounds.

But beyond such a denotative functioning, with marks standing for individual notes and their combinations, there can also be a connotative dimension to the way in which readability is extended and made to work in the case of musical scores, by additions or amplifying supplements that become part of the notation itself. This is what happens in the nineteenth century and especially its second half, when it becomes a consistent practice for musical notation to have specific devices introduced into it that serve to guide performative phrasing (as in the use of slurs and beams, between notes and linking them). So there is then a metaphorical form of association at work, between the different components of the schematic language that are coupled together and brought into an articulated relationship with one another, in such a way as to enliven understanding. In this same cause a composer can fashion and put into circulation his own specific forms and practices of notation.

Morisot's oil study of 1885 is, then, a melodically phrased notation of what she sees the sunlight doing, across the surfaces of trees and in between them. As in a landscape planner's sketch, the "bare bones" of her delineation—its denotative component, based on a practice of markings that has molded itself to a specific kind of undertaking and the conversances it requires—is allowed to stand as such. But there is also the connotative implication of different types and strata of surface being brought into interplay, by the seemingly cursory action of the brushmarks and what they do to put coloring into place in an abbreviated or floating form. This way of working on Morisot's part came to be seen as symptomatically feminine from 1877 on—as evidence of a "hand completely without

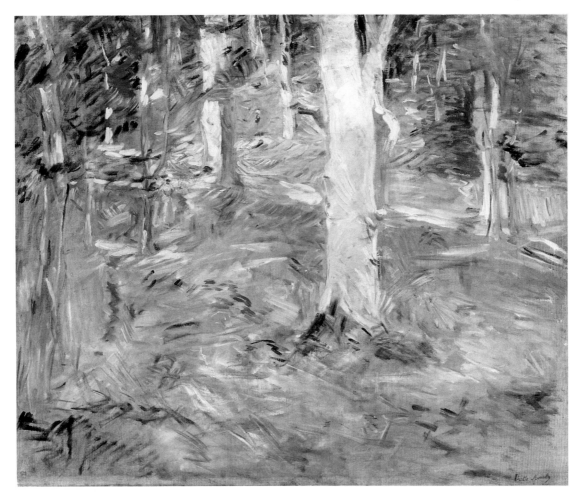

Fig. 60. Berthe Morisot, *Forest of Compiègne*, 1885. Oil on canvas, 21¼ × 25½ inches. Art Institute of Chicago, Bequest of Estelle McCormick, 1978

treachery," in Mantz's words, as well as a delicately oriented sensibility—when it could have been invested metaphorically with the stamp of being inherently musical, without any such attachment of gender-based innuendo.[60]

Irony Applied to Interactions with Nature

The trope of irony introduces into discourse a quality of self-affirming artifice, whereby whatever represents a different or contrary stance toward the subject in question than the one being put forward is effectively held up to ridicule. Its application to visual imagery hinges on their being an implied commentary, on human behavior as it relates to nature in the widest sense, which the viewer is familiar with already or can reactively supply. The relationship to nature that is in question here commonly comprises both states of

existence in the world that cast a depreciative light on what might be hoped for or thought of as possible, and displays of instinct that take their cue from what is going on around, as if under the shaping guidance or indomitable pressure of natural forces at work. In its extended form, irony as a tropology is then rife with a sense of unavoidable contrast between the everyday world of experience, as it typically and recurrently proves itself to be, and whatever might lie beyond its determining physical structures and its delimited temporality.

Landscape provides here not just a setting, but a context that must appear to be cooperating, willy-nilly as it were, in the individual figure's directedness of action and behavior, or that of the group at large: as if working in counterpoint to the psychological conditions that accompany such action, even while independently maintaining its fixation, or simulating its own obduracy of being in this world. Such a role given to landscape is already apparent in Bruegel. In his painting of *The Hireling Shepherd* (Philadelphia Museum, see page 55) the shape and force of the shepherd's dereliction is acted out in a curvature of paths coming forward insistently from field and riverbank, to intersect with his track of flight past an island of tree, grass, and stone, as if to mime descriptively a confluence of betrayals here. In *The Misanthrope* of 1568 (Museo Nazionale, Naples) the spareness of brown-gray coloring of the landscape, with its windmill and solitary shepherd tending to both black sheep and white ones, and its dispiritedness of mood strike home as impassively congruent with the condition of the foreground figure that gives the painting its title. And in the engraving of *The Wedding of Mopsus and Nisa*, posthumously printed in 1570 with an identifying line from Virgil's Eighth Eclogue attached to it, the landscape similarly does not serve as direct agent in the establishment of the figures' unseemliness of behavior; but faces that can be made out in the shapes of the trees next to the house can be taken as simulating, or touching in as a response that might be in place on the part of nature, a sportive merriment in key with what is going on. In all of these cases— for the humanist most especially who was versed in the literature of pastoral and its underpinnings—the irony is turned in an antipastoral direction.[61]

On the same basic principle, views of cities of ineffable grandeur, Rome especially, could have the serenity and durable impressiveness of their monuments offset by the inclusion of the riffraff of the streets, lolling about and playing together. This is what happens in the middle decades of the seventeenth century, in a particular extension of urban imagery that stems from the group of Dutch artists active in Rome, named I Bamboccianti in recognition of the leading role played for them by Pieter van Laer, who was known as Il Bamboccio (rag doll) on account of his deformed body. Insofar as the melee of figures in these scenes is implicitly under constant exposure to the monuments close at hand and all round, without capacity or ground for registering what they signify, irony here has an anticlassical as well as an anti-urban bent to it.[62]

But the very fact that an ironic form of social commentary can be read in here illustrates a troublesomeness that presents itself, in making the term viable equally and more broadly for nonfigurative components of the scene. There is a difficulty of distinguishing, in respect to what the city offers and represents as of now, between what could be being internally intimated by juxtaposition and contrast, and what is clearly being

forced out into the open. Such a form of presentation of the urban environment in its more and less attractive components is essentially more akin to the literary figure known as *meiosis* or *litotes*—an ironically moderate form of statement that can set the rude and the offensive into their place in the scheme of things—than it is to full-scale irony.

By the second half of the eighteenth century, a more broadly emergent social tension characterizes the relationship of figures, representing labor in progress, to the environment of estate and park, viewed in terms of what gets pleasurably altered in consequence of such labor and the desires and pressures to improve upon raw nature that are thereby satisfied. In Richard Wilson's treatment of this area of subject-matter from the later 1750s on, there is an extension of anticlassical and anti-urban ironization to the premises of the work as a whole. Wilson, of Welsh origin, had returned to Britain in 1756 or 1757 from an extended stay of six or seven years in Italy during which he produced numerous views of the Roman Campagna; and compositional models that he brought back with him from that stay would serve as the inspiration for further variations and adaptations of later date that are structured and populated in the same Claudian key. But he also turned to painting British scenery and became involved with commissioned views of country houses. His *View over the Thames of Syon House* from about 1760 (Neue Pinakotek, Munich) places the grand mansions dominating the further bank so that they are framed by trees and idyllic in their surrounds of wood and greensward. But the only figure who pauses for contemplation in this setting is the worker with a wheelbarrow in the right foreground. He does this from across the river, from the area where the middle and lower classes come to trample and disfigure the open terrain of public gardens. He himself is engaged in remodeling, and the *W* of the artist's signature is placed squarely on his wheelbarrow.

It has been suggested that Wilson used the classical ideal of harmony and serenity in those years to bring his estate views into accord with the values of a patrician culture, which stressed leisurely retirement from the city, authority exercised in a gentlemanly fashion, and a backward-looking pride in the past. And indeed the patronage of wealthy, cultured landowners seems to have largely dictated, up to 1765 or thereabout, the sense of enhanced perfection and unstrained sentiment embodied in this artist's country-house landscapes. But by the early 1770s, in the views painted on a huge scale for Sir Watkin Williams-Wynn of his country seat in Denbighshire, and especially *Dinas Bran from Llangollen* (two versions, the second in the National Museum of Wales, Cardiff) the sheer energy and brute force of the tree-root chopping and hauling of something that is left invisible going on in the foreground set up a rift with the peacefulness of the estate castle, on its wooded slope further back (Fig. 61 and Color Plate X). The subject of forced beauty and regularization imposed on nature, by what may be perceived as an authoritarian control, combines here to ironic effect with the prominence given to the expenditures of sweat and toil that make such imposition possible.[63]

Since irony in its extended form—applied to the work as a whole, as comes to be the case from the mid-eighteenth century on[64]—carries the implication that the facts, or state of things in the world could not be otherwise overall than the artist has indicated them to be, it is understandable that its presence finds no direct echo in the tone of critical response of

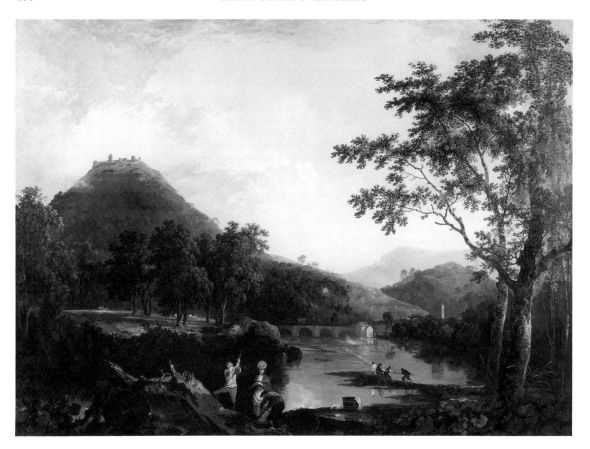

Fig. 61. Richard Wilson, *Dinas Bran from Llangollen*, 1770–71. Oil on canvas, 69 × 93 inches. Yale Center for British Art, Paul Mellon Collection

the time. Such a response has to take up a stance, as the artist does not, somewhere between fatalistic acceptance and the supposition that what is rebarbatively unsightly and unpleasant about the presentation of the world in question lies open to amelioration. It is only with the advent of the nineteenth-century theory and practice of Realism that such material unsightliness comes to be positively exploited as a source of artistic subject-matter, and one that draws into account, by evidential substantiation of its own sort rather than by ironic intimation, the social and economic forces that can be regarded as responsible for its having this quality.

When the British connoisseur and collector William Beckford visited Holland in 1780, aged twenty, as part of his Grand Tour through Europe, he wrote of an expedition that he made into the countryside near Haarlem:

> I promised myself a pleasant walk in the groves, took up Gasner [idylls written by the eighteenth-century Swiss poet and artist Salomon Gessner] and began to have pretty pastoral ideas—when I approached the nymphs that were disposed on the meads, & saw faces that would have dishonoured a flounder.[65]

Fig. 62. Carl Blechen, *In the Park at Terni* c. 1830. Oil on canvas, 41¼ × 31 inches. Collection of Georg Schäfer, Schweinfurt

The German Carl Blechen, in the wake of his Italian journey of 1828–29 (see page 142), did at least five versions of the subject of the park at Terni (Fig. 62), with its glade of tall sheltering trees and stream used for bathing, and its glimpse of bare hillside caught through openings in the boscage where the sunlight reaches down. His young women shown enjoying the water in this setting, one quite naked with her lower legs immersed and the other almost totally disrobed as she stands adjacent to it, have like Beckford's Dutchwomen the appearance of nymphs, in their attitudes and the fall of diffused light onto their exposed bodies. But in the later versions they are identified—as their clothing on the rocks would equally indicate, if studied close up—as demure *demoiselles* responding to the spectator's presence, and doing so in a manner that renders their physical appearance by no means graceful or idyllically quiescent.

This undercutting of expectation deriving from the nature of the setting by a debased

actuality is closely akin, in its ironic substance here, to the experience that Beckford projected. And while Blechen's rendering of Italian sunlight and shadow, in the group of studies that he had shown at the Berlin Academy in 1830, had simply been taken by critics as harsher and less convincing than it should be—no doubt because he failed to conform to a pastoral and poetic way of seeing that world—G. K. Nagler the lexicographer wrote in his *Neues Allgemeines Kunstler-Lexikon* of 1835 that Blechen in those studies "show[ed] more of the irony than the charm of the Italian landscape."[66] In other words, he caustically or out of adamant truth to his perception refused the landscape any quality of gracefulness.

Some of Turner's late works, with coastal wreckage as their subject, also use light as an agent of irony, but in a more directly corrosive way: one in which substance and shadow, the broken-down pieces of a ship and its contents and the disfigured fragments that amass themselves, as dimly recognizable ghosts of what they once were, are put into relation both to the sea from which they came and to the shore where they await cleaning up. The landscape as a whole is actively dissolved here, so that the deposit of flotsam and debris is assimilated in these canvases both to the shipping in a stationary position, out on the sea but close in, and to the figures engaged in labor or in scavenging, who are given an appropriately skeletal kind of presence. This makes it seem as if seafolk generally share in a common world of experience, in which passage from the active and hopeful to the derelict implacably holds sway.[67]

In Jean François Millet's paintings of the French countryside and the labor taking place there, which came into prominence at the annual Paris Salon and took on a controversial savor after the Revolution of 1848—an event, or series of events that drew attention to the situation of the rural peasantry and forcibly suggested the social and political threat that it could pose—the treatment of the scenery is devoid of any suggestion of the restorative warmth of sunlight, or of delectation offered to the senses by what grows and represents fertility in the domain of nature. This is already apparent in Millet's project of 1851–53 for a painting based on the biblical story of Ruth and Boaz, which was sent to the Salon of 1853 under the altered title of *Harvesters Resting*. The setting adumbrated there, with sheaves being brought in and a pause for refreshment taking place in front of the stacks, adverts directly to the material and social factors that give such a rustic occasion its character, without seemingly any distancing mechanism being at work that would render the atmosphere of the scene congruent with what took place long ago.[68]

Millet went on to do landscapes in the 1850s, and again in the last decade of his life (1865–75), that are intensely evocative of the area of Normandy where he had grown up, especially the village of Gruchy, his birthplace, which was loaded with personal memories and associations for him. The character of the local architecture, the low stone walls and the specifics of tree and hedge are all important correspondingly in these paintings, as already in the drawings on which they are based.[69] What happens to this recreative vision of Millet's, as it comes to be appreciated later in the nineteenth century, is itself ironic. For it is seen as expressing visually a cultural consciousness in search of roots, in such a way that subjects of his such as the plow and harrow on an open plain in winter (two versions, Kunsthistorisches Museum, Vienna, and Nationalgalerie, Berlin) stand as arche-

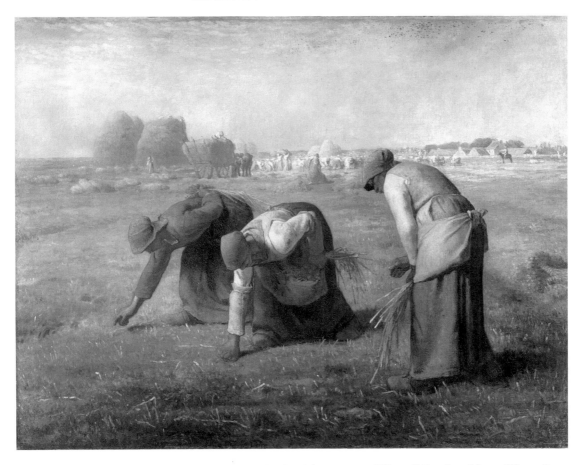

Fig. 63. Jean-François Millet, *The Gleaners*, Salon of 1857. Oil on canvas, 32¾ × 43¼ inches. Musée d'Orsay, Paris, Gift of Mrs. Pommery, 1890

types in the broadest sense. Van Gogh, transcribing this image into painted form from an etching after it by E. Delaunay, when he was confined indoors at the hospital of Saint-Rémy at the beginning of 1890, added indications of snow having fallen that are his own interpolation.[70] He invests the Millet in that way with a stability of affect on which his imagination can feed, in order to reinject temporality.

In fact Millet was responsive to a less objectified and more austerely stoical conception of what the soil or earth, as the "field" of peasant labor from year to year and season to season, represented. The most ambitious of his paintings of such labor in progress after *The Sower* of 1850 (Museum of Fine Arts, Boston, and Yamanashi Prefectural Museum, Kofu), and the subject of an equally hostile reception by critics and public when it was shown at the 1857 Salon was *The Gleaners* (Fig. 63). Not only did Millet make the stubble of the field here redolent of a harsh physicality, imposed by the continuing practice of letting such gleaning take place only when the harvest itself had been completed (as the stacks in the background indicate, as with the De Wint; see pages 127–28), and then under the watchful supervision of an overseer, shown on horseback. He ironized also the back-breaking character of the labor and its slow momentum of movement across

the field by making it seem—too brutally, for his critics—as if there could be no hope for these women (unlike the biblical Ruth) of any other lot in this life than an enforced subjection to doing things this way.

The farm buildings hold their place as another assertive shape besides the stacks, on the horizon of this rural world. Unlike the case of Bruegel, whom Millet seemingly admired for his attribution to peasant existence of a Protestant kind of work ethic, the irony pinning down the gleaners, younger and older, to their place in the scheme of things is here more total, and more tinged at the same time by the felt exigencies of a subsistence level corresponding to the land's bareness of nutritive remainder, immediately before burning takes place.[71]

SPECTACLE AS SYNECDOCHE: VERSIONS OF THE SUBLIME

Synecdoche as a figure of speech is often taken as a subdivision or special case of metonymy: one in which an aspect of a larger whole is singled out for expressive emphasis in virtue of its perceived representativeness (as with the storminess of ocean, or the majesty of mountainside in the case of natural scenery), and particularized features that can be put into association with the exhibition of that aspect are given a supporting role. But the relationship of part to whole is not, as that account might suggest, an identifying bond here with the terms in which metonymy operates.

There are, in fact, two key differences in respect to the workings of figuration. An element of exaggeration or hyperbole tends to be present in synecdoche, comparable to the role played in the case of irony by the opposite tendency, meiosis. And there is a link to allegory, insofar as it is a basic principle of allegorization to personify abstract qualities, and to have elements of a staged ensemble link up with one another cumulatively in support of what is being conveyed. Synecdoche functions so that in place of the selective focus of metonymy and metaphor there comes to be an additive and amplificatory distribution *through* the image of implications relating to its main communicative thrust, which is to be grasped in a catenatory fashion. In that way an aspect of the subject is put on display that has come to be regarded as essential in virtue of convictions entertained about it; or one that invites being so regarded, to the point of its becoming emotionally and spiritually infused with an aura of persuasiveness.

In the later Renaissance the concept of spectacle or staged pageant, including landscape as a prime ingredient, already embodies the premises of visual synechdoche in vivid form.[72] At the court of Charles I in London, following a Stuart tradition, Inigo Jones in the mid- and later 1630s designed the scenery and costumes for elaborate masques. Their staging was modeled, quite directly in some instances, on the theatrical festivals of the Medici: particularly Bernardo Buontalenti's designs for *La Pellegrina,* put on in Florence in the spring of 1589 to celebrate the wedding of Fernando I de' Medici and Christine of

Lorraine, and those by Giulio Parigi for the pastoral *Judgement of Paris* performed in the autumn of 1608 at the nuptials of Don Cosimo de' Medici and the archduchess of Austria. These designs, known to Jones through published prints, included in the one case a Parnassian scene as *intermezzo* set in the forest of Delphi; while in the other case the setting throughout was the countryside near Mount Ida, with forest, hills and meadows, barns and huts represented.[73]

In Inigo Jones's staging of the masque titled *Britannia Triumphans,* with text by the court poet William Davenant, which was mounted for Twelfth Night in January 1638 in the Whitehall Palace, under its newly decorated ceiling by Rubens, an opening invocation referred specifically to the tradition of "spectacles & personal representations" staged by princes to "recreate their spirits wasted in grave affairs of state, & for the entertainment of their nobility, ladies and court." And according to the published description: "A curtain flying up discovered the first scene, wherein were English houses of the old & new forms intermixed with trees, and afar off a prospect of the city of London & the River Thames; which, being a principal part, might be taken for all of Great Britain."[74] The quality of representativeness that is made explicit in the last sentence here corresponds to the ambition of the masque as a whole: to celebrate the peace and prosperity which Charles I's rule by divine right had brought to the country in its entirety.

Opera, which similarly called for a combination of basic architecture and elements of natural scenery for its settings, became in the eighteenth century the prime medium associated with the task of making "spectacle marvelous" so that, in Charles Batteux's words in his treatise of 1746 on the fine arts cited earlier (page 135), it could both "strike the eyes and occupy the imagination."[75] For this instillment of pleasure in the viewer to be squared with the arousal of genuinely felt emotions required—in the case of an art form without words—that the whole scene be depicted so convincingly that it struck home with a force and concreteness corresponding to the spectator's own experience. To be invited to enter into a depicted illusion such as that of vastness, or pleasantly laid out space through which one could roam, was then to put oneself in the place of those who actually went through what was entailed in the way of an exposure, or a range of activities that were shown taking place. As through the proscenium frame in the case of theater, one was drawn from an outside viewing position into registering specific states of mind and emotional responses, to which the natural setting as it was represented gave rise.[76]

The governing terms on which such an identification on the spectator's part takes place were spelled out for one of Joseph Vernet's seascapes, his *Port of Cette* which was on exhibition at the Louvre late in 1757, by an unnamed reviewer:

> One is frightened by the stormy weather and the tempest which is admirably depicted. The illusion is carried so far that one cannot stop oneself from fearing for the buildings that one sees in the sea. One experiences sensations of commiseration and pity at the sight of this alarming spectacle, the horror of which one shares in, and in effect the picture, the image disappears and nature in a quite terrible state of display remains.[77]

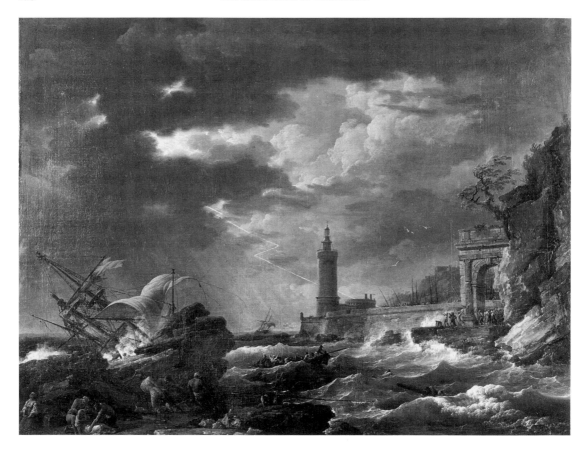

Fig. 64. Claude-Joseph Vernet, *Storm on the Coast*, 1754. Oil on canvas, 36 × 49 inches. Haworth Art Gallery, Accrington (Hyndburgh Borough Council)

In Vernet's *Storm on the Coast* (Fig. 64) of three years earlier, commissioned by a merchant of Marseille and closely related in theme to the *Storm with a Shipwreck* (Wallace Collection, London) done that year for the marquis de Marigny and shown at the 1755 Salon, lightning striking the port buildings and a windblown tree on a cliff face are added to the ingredients of bare rock, breaking surf, and ships in distress that make palpable the human struggle with and against the elements.[78]

Diderot in his Salon reviews (see page 136) shows himself very much aware, in the commentary on Vernet's seascapes that he offers from 1763 on, of this premise of Enlightenment thought requiring that the spectator respond to the painting as a form of dramatic spectacle. But he also puts forward the idea that the spectator should enter into the picture and wander about in it freely, in a state of reverie that allows for reflective response to the experiences depicted as taking place there, and others like them. This idea, which accords with more reposeful subjects of Vernet's—such as the landscape done as a pendant to the marquis de Marigny's *Storm*, described as showing figures by a river fishing and laundresses at work, with buildings and a view of mountains in the distance[79]—was applied by Diderot in his *Salon* of 1763 to one of Philippe de Loutherbourg's early landscapes (see page 82) with figures and animals; to the so-named

Russian Pastoral of Jean Baptiste Le Prince two years later; and in 1767 to works by Hubert Robert (see page 136) and a whole group of subjects by Vernet, including shipwrecks.[80]

By 1767, in fact, Diderot had been exposed to Edmund Burke's concept of sublimity, as set out in his *Philosophical Enquiry into the Origin of Our Ideas of the Sublime and the Beautiful* of 1757, a French translation of which had appeared in 1765. This is clear from the way in the discussion of Vernet takes up now Burke's example of the agitated ocean as an aspect of nature that is particularly likely to fill the mind with terror on account of its sheer scale, and from the reference to a whole range of external stimuli to the imagination that can engender a sense of the sublime, through the way in which they impress the sensibility as having in them "[some] *je ne sais quoi* of the terrible, the grand, the obscure."[81]

Early in the eighteenth century, the sublime had meant basically, as a term in art criticism, whatever strikes the mind as marvelous and surprising. This was the way that Longinus—the name given to the author of an ancient treatise on literary criticism, probably written late in the first century A.D.—was understood to have used the term. That text in Greek, which was first referred to under the English title *On the Sublime* in 1698, had become known in the mid-sixteenth century with the appearance of printed editions; in the following century it was translated first into Latin, then into English in successive versions from 1652 on and also into French. But like other ancient writers on rhetoric whose texts of earlier date were known (Demetrius of Phalerum, Hermogenes) Longinus was mainly concerned with grandeur of diction or phrasing, and with the kind of stateliness of delivery that could carry the hearer away by its force.[82] It was not until 1747 that John Baillie in a short and otherwise undistinguished *Essay on the Sublime* designated it as an aesthetic quality arising in the sensory experience of objects, rather than one attaching to the objects themselves, so that the stimulation that it afforded could derive from nature as well as from writing, "as it were painting to the *Imagination* [in the latter case] what *Nature* herself offers to the *senses*."[83]

Burke, in his far more influential text of a decade later, essentially adopted this way of thinking in the extended distinction that he put forward between the "merely sensible qualities" of the beautiful—which he characterized as consisting of comparative smallness, smoothness, internal variety or interfusion of parts, delicacy, and "clear and bright" or else diversified coloring—and those belonging to the sublime, which were productive of "astonishment [as a] state of the soul," or in their "inferior effects," with less power to them, of "awe, reverence and respect."[84] The emphasis here on extreme psychological states brought into being in the viewer, and on the sublime as a distinctive mode of aesthetic experience, building upon the emotions of pain and fear rather than pleasure and delight, sanctioned thereafter in British art not only subjects such as *The Destruction of Niobe's Children,* which used a wild and mountainous setting to intensify responsive sympathy (as in Richard Wilson's large-scale versions of the subject from the early 1760s on: one of them now in the Yale Center for British Art, New Haven) but also Miltonic, Shakespearean, and more generally poetic subjects in which, following Burke's recipe, the setting provided an appropriate dimension of grandeur, gloom, or "absolute and entire solitude." It also promoted, as a matter of spreading taste, the cult of those parts or aspects

of nature itself—mountainside especially, and also cliffs or precipices and great sounding cataracts (mentioned by Burke as one example)—about which the same could be felt.[85]

Both the qualities Burke took over from earlier writers as sources of the sublime—infinity, vastness, power, magnificence, and obscurity—and those he added himself, to make up a coherent theory (such as vacuity and silence, which he joined up with darkness and solitude under the more general rubric of "privations," melancholiness of coloring, and sudden changes from light to dark and back again) were ones that could be applied to the depiction of nature without human incident, or devoid of any kind of activity taking place except that of natural phenomena such as Burke had singled out in his references to lightning and storm. Thus in France, in the wake of Diderot's musings on Vernet's art and his access to Burke's terminology, one finds Jean François de Saint-Lambert writing, in the *discours* of 1769 prefacing his poem *The Seasons*: "[Nature] is sublime in the immensity of the skies and seas, in the vast deserts, in the infinity of space, in its unlimited strength and fecundity and in the innumerable multitude of its creatures. It is sublime in the great natural phenomena such as earthquakes, volcanoes, floods and hurricanes,"[86] in which spirit Vesuvius belching out smoke and flame in front of reverential spectators would be painted by the French artist Chevalier Volaire, as well as by Joseph Wright of Derby (pages 103–4).[87] And the previous year a new edition of Nicolas Boileau-Despréaux's 1674 translation of Longinus had used as the illustration above its title a pure landscape of shore and sea, with the sun coming up on the horizon and lightning breaking through a patch of dark cloud.[88]

Immanuel Kant in his *Critique of Judgement* which first appeared in 1790 in Germany devoted a sequence of chapters, among those dealing with aesthetic judgment, to the topic of the sublime, and he made explicit reference there to Burke's argument, having come to know it through Moses Mendelssohn's summarizing review of 1758, or perhaps more completely through the German translation by Christian Greve that had appeared in 1773. But he did this in order to distinguish the physiological grounding that Burke, preeminently amongst previous writers, gave to the understanding of the concept from his own "transcendental exposition," in which the sublime is demarcated for descriptive purposes as consisting of "an object (of nature)" that is so far beyond the reach of the mind in the way in which it represents itself that its elevation in this respect becomes "equivalent to a presentation of ideas."[89]

Two crucial differences follow from this, in respect to the workings of what Kant refers to as the "dynamically sublime in Nature": most notably its display of might. First of all, in "trac[ing] power through its several gradations unto the highest of all, where our imagination is finally lost," Burke found that the instillation of terror was an invariable accompaniment, growing along with it in its capacity to energize the sublime. Hence when it came to the contemplation of the Deity, the almighty and omnipresent character of his power—forming as it did the most striking attribute of the way that in prevailing or commonly shared perception his Godhead was taken to operate—was bound to affect the imagination with a sense of due awe and trembling. For Kant, in contrast, the very idea "of the *sublimity* of a religion and of its object" required that man be "in the frame of mind for admiring divine greatness, for which a temper of calm reflection and a quite free

judgement are required." This, in fact, was what intrinsically marked off religion from superstition, in which "dread and apprehension of the all-powerful Being to whose will terror-stricken man sees himself subject" substitutes for the sense of reverence instigated by the sublime. So just as "deep respect" for the "idea of the sublimity of that Being" is based in this argument on the ability to confront his displays of might without fear, so the overwhelming spectacles on the part of nature that Kant takes over from previous discussions of the sublime—overhanging and threatening rocks, massed thunderclouds, and lightning flashes, volcanoes and hurricanes, unbounded ocean and high waterfalls—are not for him the expressive evidence of mighty forces at work, to which man is inherently inferior; but rather charged with conveying something more abstract and ultimately intangible. Inasmuch as the viewer is challenged to discover a power of resistance within the self to that seeming omnipotence, the intimation of there being a divinity present and in command can serve as impetus to spiritual enthusiasm of a sublime order, and that freedom from affection, as Kant calls it, that a consciousness secure in its feeling of rising above nature enjoys.

The second key difference has to do with the visual impact of nature's forces. Whereas for Burke it was axiomatic that the ultimate upshot and measure of nature's imposition of sublimity on the viewer lies in the kind of astonishment that is generated in response, Kant's explication of the sublime rests on an incipient paradox. What is not graspable in its sheer magnitude, so that it cannot form the basis of a sensual kind of appeal, is nevertheless fascinating in its sheer scale by comparison with human beings and their perspective on the world. In order to experience the conditions in point, the spectator must bring into being a kind of disembodied self that can transcend the limits and boundaries of normal experience. So whereas in Burke's conception the sublime conveys vitality and energy to an overwhelming degree, and is actively desired or sought after for that reason; for Kant, response to those forces is replaced by an internalization of the aspirations that attend such desiring: their embodiment can be made accessible in the way that nature is perceived only in a partial, synecdochic form.[90]

These abstract threads of argument are brought down to earth by Henry Fuseli when, in his lectures on painting delivered at the Royal Academy from 1801 on, he makes reference to actual practices, past and present, in the choice and rendering of landscape subjects. Born in Zurich in 1741 as Johann Heinrich Füssli and first brought to London at the age of twenty-four by the British ambassador who had met him in Berlin, Fuseli had spent long years in Italy in the 1770s and had then made his name in England from 1780 on, assuming the post of professor of painting at the Academy from 1799 until he resigned in 1805. In his fourth lecture, on invention, which was given in 1804, he chose to subdivide the field of landscape quite peremptorily into "views" on the one hand, representing in their essentially topographic character no more than "the tame delineation of a given spot, a kind of mapwork"; and on the other a more revelatory and intimately affective kind of landscape, in which different and varied orders of lighting were crucial to the effect of "nature disclos[ing] her bosom." Fuseli posited here a continuity of practice from the High Renaissance on—embracing Titian, Pier Francesco Mola, Salvator Rosa, Poussin, Claude, Rubens, Elsheimer, Rembrandt, and Wilson whom he named in that

country-to-country order—that was antithetical to "mapwork" in the imaginative prompt-ings to which the treatment of nature gave rise. And on this latter front he referred to landscapes expressing "large general concepts," such as "height, depth, solitude [which] strike, terrify, absorb, bewilder in their scenery": thereby epitomizing what was most pertinently compelling in the larger cult of the sublime, and the figurative mode of operation that went with this, governing the relationship of landscape presentation to idea.[91]

Fuseli, whose Shakespearean and Miltonic subjects drew upon a different line of indebtment to Burke's *Enquiry*—more horror-filled or more emotionally tense where the subject sanctioned this, and oriented to the display of muscular human energy—introduced landscape settings into his compositions that called for them only in summary or abbreviated form. But by 1820, when he published the lecture in question, a type of painting extending the premises of the sublime had attained to notoriety, precisely be-cause of the kind of spectacle that it afforded: one based on scale, controlled lighting, and the giving of imaginative access to an unbounded, seemingly limitless expanse of space. While Turner had sought grandeur in historical and mythological subject-matter from early in his career—emulating what was taken to be the Claudian sublime in the form of deep vistas over water, lit from behind by the setting sun, and challenging other past masters whom he admired with a combination of architecture and majestic scenery—it fell to John Martin to popularize now in a much wider way a particular kind of biblical painting, densely filled and highly elaborated, in which diminutive human figures are shown grappling with their fate, or in desperate throes of some kind: dwarfed in either case by vast expanses around and behind and darkly overhanging skies and, where this was dramatically fitting, surging waters and fantastic agglomerations of rock.

Martin made his opening moves to assure the public appeal of this kind of painting with his *Joshua Commanding the Sun to Stand Still upon Gibeon* of 1816 (United Grand Lodge of Great Britain) and his *Fall of Babylon* of 1819 (present location unknown), both measur-ing around five feet by eight feet. Beginning with his *Belshazzar's Feast* of 1820, shown at the British Institution the following year, he not only continued with that kind of scale, but also made a pamphlet available to viewers with an engraving in it indicating diagram-matically how the painting was to be read. Copies in glass (in one known case at least, the *Feast*) were used for advertising purposes; the Egyptian Hall, familiar to both Londoners and outside visitors as a public venue, housed in 1822 a showing of Martin's major paintings to date that centered on the newly completed *Destruction of Pompeii and Herculaneum* (now in a private collection); and inexpensive mezzotints of his grandest ventures would be issued in succession, serving the interests of further promulgation. From 1822, landscape came to feature as an increasingly important coordinate of the total scene, as in the *Seventh Plague of Egypt* of 1823 (Museum of Fine Arts, Boston) and the lost version of the *Deluge* shown at the British Institution in 1826 (known from the mezzotint after it and the enlarged version of 1834, Yale Center for British Art, New Haven); Martin was followed or rivaled in this respect by Francis Danby, in his equally large and imaginative *Delivery of Israel out of Egypt* of 1825 (Harris Museum and Art

Gallery, Preston) and his *Attempt to Illustrate the Opening of the Sixth Seal*, shown at the Royal Academy in 1828 (National Gallery of Ireland, Dublin).[92]

Unquestionably there was an active sense of competition at work here with the differing forms of theatrical spectacle and performance the London scene provided at this time (see Chapter 2) for a large and avid public. But the closest analogue among those rival offerings was in fact the Cosmorama, a peepshow of miniature paintings in oil that came to prominence under that name from 1820 on. Contemporaneously with the works of Martin described, it used black frames around the paintings to enhance their intrinsic detail when seen through a magnifying lens, and coupled sensational choices of view with dynamic lighting to similarly charged effect.[93] Conflagrations, which figure as a high-keyed and virtually cosmic agent of destruction in Martin's art, were strongly represented. Spectacle was in that way put on a recreative footing, where each painted image caught the pulse of what it felt like in a given set of circumstances to be exposed to a strong perceptual denouement; and rather than an engagement of interest and feeling based on identification with those circumstances, a larger, quasi-allegorical sense of how cause and effect held together was synecdochically precipitated.

A shift from this point on to the eastern seaboard of the United States and the cult there of large-size exhibition pictures in the second and third quarters of the nineteenth century elucidates how there too the subject-matter of landscape, and the compelling grandeur of presences and forces in nature that impress with their overwhelming scale and the quality of spectacle they afford promoted an extension of the sublime: one that paralleled the European extension in its synecdochic terms of operation, but made its appeal to American painters and their audiences on a differing cultural and cognitive basis as far as the landscape itself was concerned. The key figures here are Thomas Cole, a British-born artist trained as an illustrative wood engraver, who was familiar with the premises of the sublime by the time he began to travel to the Hudson Valley and Catskill region, from 1825 on, in search of subject-matter for landscape; and Frederic Edwin Church, who became Cole's first pupil in the 1840s and was inspired by knowledge of Alexander von Humboldt's writings on the exploration and depiction of tropical landscape to do large-scale depictions of the Andes for public display in the later 1850s and 1860s.

Speaking to the American Academy in New York in November 1825, the merchant and patron of the arts Richard Ray discoursed on the "peculiar advantages" this country afforded to the landscape painter. "Vastness and grandeur" could be combined in the spirit of Titian with "rich and golden hues of coloring," as in the Catskills; or "laughing scenes of plenty," reminiscent of Claude, could afford "the same delicious repose and serenity, which have been claimed for Italy alone." Alternatively,

> if [the artist's] half-savage spirit, like Salvator Rosa's delights in rocks, and crags, and mountain-fastnesses, an unattempted creation rises at a distance to invite him. There he may lose himself, till a wild scene of cascades, of deep glens, and darkly shaded caverns, is frowning around him; and though, thanks to our equal

laws, no bandit is seen issuing from his hiding place, yet there he may plant the brown Indian, with feathered crest and bloody tomahawk, the picturesque and native offspring of the wilderness.[94]

It was precisely this combination, of vast spaces and sights of nature on an enormous scale with so far untouched landscape and the presence of an indigenous race, that proved compelling now to emergent or would-be specialists on that front—as was coming to be true at the time in American travel literature equally.[95]

Cole began sketching outdoors in 1823, and he gravitated over the next five years to subjects that included river, forest, waterfall, autumn coloring, mountain, sunset, and expanse of sky. Native themes that carried historical and legendary associations were placed in such settings on occasion; most notably in the form of stories about Indians and representations of their characteristic activities. In these ways he was responding to a developing aesthetic of American sites and subjects, built around scenic choices of theme that could find their own level of patronage: in Cole's case, the supportive interest and purchases of the Baltimore collector Robert Gilmor Jr. being particularly consequential at this period.[96]

Traveling to London in June 1829 for a stay of almost two years, during which he showed at the Royal Academy and British Institution galleries, Cole was correspondingly none too impressed when he visited Turner in his studio and saw his work. While he admired the *Snow Storm: Hannibal and his Army crossing the Alps* of 1812, as well as *Dido founding Carthage* (1815, National Gallery, London) for its Claudian poetry, and made a drawing in his notebook after Turner's *Ulysses deriding Polyphemus* when it was shown in the Royal Academy exhibition of 1829, paying particular attention to its color and chiaroscuro, he nonetheless found the more recent work artificial, lacking in solidity and obsessed with technicalities. He remained steadfast himself in upholding the example of Claude, Gaspard Poussin, and Salvator Rosa, with admiration left over for Richard Wilson as a more recent epigone of the same Italianate tradition (see page 149).[97]

Journeying to Paris in 1831, and then on to Florence and Naples, Cole wrote to Gilmor from Italy in January 1832 about the first painting in a projected set he had in mind for this patron. It would show

> a savage wilderness—the sun rising from the ocean & the stormy clouds of night retiring tumultuously over the mountains—the figures must be Savage—clothed in skin & occupied in the Chase—there must be a flashing chiaroscuro and a spirit of motion pervading the scene, as though nature was just waking from chaos.[98]

This was to be the large canvas known as *A Wild Scene* (Fig. 65), worked on for seven months in all and described to the secretary of the National Academy of Design, J. L. Morton, when it was first in progress in more explicitly synecdochic terms, relating choices of motif to a larger communicative thrust. It showed, Cole wrote, "a romantic country or perfect state of nature, with appropriate savage figures." And he went on to

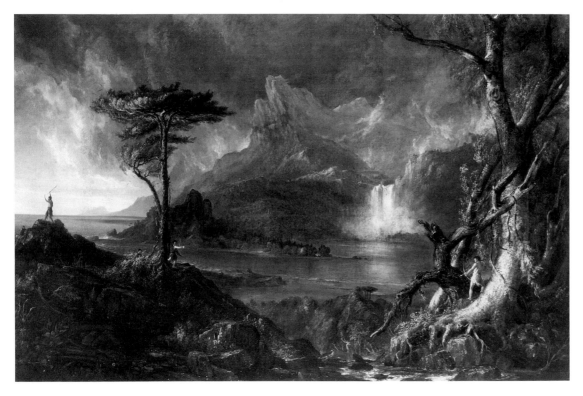

Fig. 65. Thomas Cole, *A Wild Scene*, 1831–32. Oil on canvas, 50¾ × 76¼ inches. The Baltimore Museum of Art, Leonce Rabillon Bequest Fund, by exchange, and Purchase Fund

claim: "It is a scene of no particular land but a general idea of a wild; and when you see it, I think you will give me credit for not having forgotten those sublime scenes of the wilderness in which you know I so much delight; scenes whose peculiar grandeur has no counterpart in this section of Europe."[99] In this painting as it was completed, bare mountainside and cliff faces, foaming cascade, intertwined tree trunks and above all the dramatic roseate and blue-green color scheme all set a mood, as well as establishing a terrain for the actions of the natives with their bows and spears, and their costumes, which are made to appear as artifacts fashioned from the contiguous bark and tendrils.

Cole's invocation of the sublime here, however much prompted by his recent exposure to the British art scene, was not a new element in his thinking. He already introduced the term, quite conventionally, in his notebook entries of 1826–27 describing a mountain climb and the states of mind and quasi-visionary experiences that accompanied exposure high up to an intense, frightening storm; and he used it also in a poem of the time on the theme of "The Wild."[100] A running list of possible subjects for treatment that he compiled in 1827 includes "A picture the principle of which must be vast height and depth," and he made more or less direct borrowings at that time from John Martin's *Paradise Lost* illustrations for his own painting of *The Expulsion from the Garden of Eden* (Museum of Fine Arts, Boston, Karolik Collection).[101] A year after Cole's return to New York, the version of the sublime in landscape that Martin had first popularized in the way described earlier was

further represented and expanded upon by the showing at the American Academy of Francis Danby's *Opening of the Fifth Seal*.[102]

In essence, then, Cole's *A Wild Scene* represented, for an American context of exhibition and patronage, a technically ambitious and competitively compelling, as well as a thematically fitting exercise in the sublime mode. And like Turner in his notebook jottings, Cole would develop in letters to his patrons, Robert Gilmor and from 1833 on Luman Reed of New York—the intended recipient of his allegorical series *The Course of Empire* (New York Historical Society), completed finally only after Reed's death in 1836—a whole theory of themes suitable for sublime treatment and their implications.

Church became Cole's pupil in 1844; by which time Cole, having returned to Italy in 1841–42 to spend time in Rome and Sicily especially, was painting views such as *Mount Etna from Taormina* (two versions, Lyman Allen Art Museum, New London, 1843, and Wadsworth Atheneum, Hartford, 1844), and would embark shortly on a subject with an Italian country shrine as its central mood-setting motif, *Il Pensoroso* (Los Angeles County Museum of Art, 1845), named along with its companion *L'Allegro* after two paired poems of Milton's. Church would produce in the mid- to later 1840s a number of paintings of the Catskill Mountains at sunset and also New England landscapes with specific historical associations attaching to them.[103] But while a sense of harmony and tranquillity in nature would persist in his work thereafter, like Cole he increasingly assigned it to the past. More important for him was to communicate the feeling of being in touch with the natural world as an inner and transcendent experience, so that the operations of creation and renewal governing that world could be conveyed in representative shapes and forms, independently of any metaphysical parti pris.

In his publication *Views of Nature* (first issued in Germany in 1808), Alexander von Humboldt, whose travel writings were taken up in Chapter 3, had stressed how, for the depiction of characteristic types of scenery, it was important that there be accuracy and specificity in the rendering of plants; their individuality and variety should be observed and recorded by the artist, in a fashion informed by the natural sciences, so that what was unfamiliar to European eyes and visually impressive was precisely conveyed. European travelers to Latin America in the first half of the century concretely followed this recommendation in the plates that they produced.[104] In the preface added to that book in its revised versions of 1826 and 1849, which became available in English translation at mid-century, von Humboldt indicated how he hoped to stimulate the study of nature, by compressing together "results of investigations on a variety of interesting subjects," and in so doing to "heighten the enjoyment of nature by vivid representations, and at the same time to increase, according to the present state of science . . . insight into the harmonious co-operation of forces."[105] And in his synthesizing work of the 1840s titled *Cosmos*, the first two volumes of which were translated in 1849–52, von Humboldt included a chapter on landscape painting in which, reviewing its history from the Romans on down, he advocated for artist-explorers the making of colored sketches on the spot and separate studies in large numbers. Given that "in every separate portion of the earth, nature is indeed only a reflex of the whole," it was important that such artists should be "susceptible of seizing on the total impression" of each zone where they worked—including tracts

of forest, large rivers, and mountain summits—and able to make the salient characteristics accessible and understandable in the pictures that they went on to work up back at home.[106]

In America, meanwhile, a more expansive view of the native landscape had appeared by mid-century, and one no longer geared to a mere craving for the picturesque. In 1851 an album of essays and engravings appeared in New York titled, in still typical fashion for such publications, *The Home Book of the Picturesque, or American Scenery, Art and Literature*. Dedicated to the leading painter of the Hudson River School, Asher B. Durand, it featured essays on various regions, by James Fenimore Cooper, Washington Irving, and the poet William Cullen Bryant among others; and it was illustrated with vignettes by Cole and Church of scenic subjects that they had painted, a lake view by Jasper Francis Cropsey, and Catskill subjects by Durand himself and John Frederick Kensett. In the introduction to this compilation, an essay on "Scenery and Mind" by Elias Lyman Magoon, a Baptist minister from New Hampshire and a collector of paintings, a somewhat different, though not essentially discordant note was introduced. Magoon wrote of how "the diversified landscapes of our country exert no slight influence in creating our character as individuals, and in confirming our destiny as a nation. Oceans, mountains, rivers, cataracts and wild woods are elements and exemplifications of that general harmony which subsists through the universe, and which is most potent over the most valuable minds."[107]

A year later George William Curtis, a New York literary figure who was associated early on with the Transcendental movement, traveled extensively in Europe and Egypt between 1846 and 1850 and served as associate editor of *Putnam's Monthly*, wrote in his volume of essays *Lotus-Eating*, with chapters on the Hudson and the Rhine illustrated with vignettes by Kensett, of how, compared to European lakes and valleys or the Mediterranean coast, there was a "positive want of the picturesque in American scenery and life." This was so inasmuch as the picturesque—which had effectively become by now a code-word for touristic attractiveness—had to entail not just "water, woods and sky" in themselves, but "beautiful details and the impress of Art upon them." The sublime, contrastingly—and by a similar reduction to the level of shared experience of a socially undiscriminated sort—was a matter of natural features so powerful in character that "one cannot in any manner improve or deepen by Art the essential impression" that they make. Given, in that light, that "space and wildness are the proper praises of American scenery," Niagara—which would be painted by Church a few years later (Corcoran Gallery of Art, Washington, 1857, preceded by a small version of 1856)— "annihilates all other scenery in the world . . . is the type of the country, proclaims the extent of that country as the final argument in the discussion of scenery, and bears down with inland seas and the Father of Waters, and primeval forests and prairies and Andes, to conclude his triumph." Without, in this view, the "charms that follow long history" in Europe, Americans have "only vast and unimproved extent, and the interest with which the possible grandeur of a mysterious future may invest it."[108]

Church could also read in the chapter on landscape painting in *Kosmos* Humboldt's expression of confident hope that this art "will flourish with a new and hitherto unknown

brilliancy when artists of merit shall more frequently pass the limits of the Mediterranean, and when they shall be enabled, far in the interior of continents, in the humid mountain valleys of the tropical world, to seize, with the genuine freshness of a pure and youthful spirit, on the true image of the varied forms of nature."

In South America, Humboldt had gone on to point out, heavily populated cities are located almost 14,000 feet above sea level: "From these heights the eye ranges over all the climatic gradations of vegetable forms. What may we not, therefore, expect from a picturesque study of nature, if, after the settlement of social discord and the establishment of free institutions, a feeling of art shall at length be awakened in these elevated regions?"[109]

Church first traveled to Latin America in 1853, and the sketches that he brought back formed the basis for the South American subjects that he exhibited very successfully at the National Academy of Design in New York in the spring of 1855: views of the Cordilleras, the Magdalena River, and the Tequendama Falls (near Bogota). He went back for a nine-week visit in 1857, concentrating this time on the mountains of Ecuador. The result of his intensive sketching while there and the strong impressions retained in his memory was the huge canvas titled *The Heart of the Andes* (Metropolitan Museum of Art, New York, 66 × 119 inches) which he completed in 1859. It recapitulated in its components all of the subjects of 1855—teeming river, waterfall, mountain ridges, dramatic light effects—with the addition of the conical, looming mass of the volcano Chimborazo.

This painting was first shown to the public in New York in the spring of 1859, in a rented gallery space on Broadway. A colossal frame of black walnut had been built for it, which projected a foot and a half on each side and rested on the floor, so that looking toward a horizon-line within the work that was situated some six feet above ground level gave the impression of standing before a spacious window, or on a terrace, with a deep and wide vista spreading out before one; and lines and paneling within the frame as well as concentrated gas lighting (replaced by direct natural light from above when the work was moved after a month to the main gallery of the Studio Building on Tenth Street) served to enhance further this control over the viewer's terms of engagement with what was there to be wondered at. Opera glasses were available, for those who wanted to see particular parts of the picture magnified. And two friends of the artist's provided texts to aid appreciation: a pamphlet including in its terms of analysis aspects of the scene that were not actually visible, and a much longer "companion," both of which served to promote imaginative participation. The picture in this way became a huge draw, as well as a succès d'estime in its treatment of an obviously splendid subject.[110]

The model for this highly artificial and consciously spectacular form of display lay first of all in the showing of large exhibition pictures in a specially reserved and darkened room in the London of the 1850s—including John Martin's *Last Judgment* triptych of 1853 (Tate Gallery, London) and Church's own *Niagara* when it was sent on tour to England and Scotland in 1858. And then behind that stood the conjuncture of oil paintings subject to magnification with lessons in geography and the riches of travel, that the Cosmorama especially, as a popular form of peepshow (page 161) provided.

Church's second huge canvas of the Andes, his *Cotopaxi* of 1862 (Fig. 66 and Color Plate XII), was similarly shown in New York in 1863 and in London two years later; but

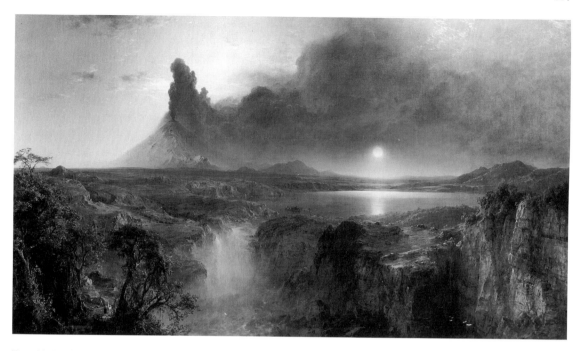

Fig. 66. Frederic Edwin Church, *Cotopaxi*, 1862. Oil on canvas, 48 × 85 inches. Detroit Institute of Arts, Founders Purchase Fund

the pamphlet specially written to go with it was in its case never issued. After his first visit to Ecuador, which yielded an oil study, Church had painted this volcano on a small scale in 1855 (two versions, National Museum of American Art, Smithsonian Institution, Washington, D.C., and Museum of Fine Arts, Houston); and he emphasized there, in line with the description of this site that von Humboldt had given in his 1810 *Views of the Cordilleras* (see pages 109–10), the "perfect cone" formed by the summit which, von Humboldt wrote, "covered with an enormous layer of snow, shines with dazzling splendor at the setting of the sun and detaches itself in the most picturesque manner from the azure vault of Heaven." But Cotopaxi had also been identified in that text as the "most dreadful volcano" of the region, "its explosions the most frequent and disastrous."[111] Church had come to know what this meant on his visit of 1857, when he was witness to unceasing eruptions. He gave attention in his views thereafter, and especially his 1861 oil study (collection of Nelson H. White, Waterford, Connecticut), to the phenomenon that resulted of orange and dark-brown smoke streaming up from the peak into the sky. To this he added the effort of the sun's yellow rays to break through the surrounding miasma with their warm intensity, and in so doing light up the landscape that lies closer to the eye.

James Lenox, the New York collector who commissioned the 1862 version of *Cotopaxi*, had been the first American purchaser of the work of Turner. In 1832 he had acquired *Staffa, Fingal's Cave* (now in the Yale Center for British Art, New Haven), painted that year and showing a geological phenomenon off the coast of Scotland. Its imagery combined the light of sunrise with smoke coming from a prominent steamboat, and several reviewers writing about Church's painting three decades later linked aspects of its pictorial handling to Turner's example; one of them specifically saying, of the smoke included

in it, that "Turner knew what to do with this material" and Church had "used it admirably."[112] But Church also brought out, in his handling of lake, waterfall, and fissures of rock in the foreground, his intrinsic powers of observation applied to tropical light and vegetation. He vouched in this way for the authenticity of his work, as an engagement with the underlying forces responsible for the creation of the natural world and its subsequent transmutation over vast eons of time.

Writing in March 1863, the *New York Times* critic described *Cotopaxi* as "throbbing with fire and tremulous with life. It is a revelation of the volcanic agencies which make the landscape of Alpine South America what it is."[113] But Church, rather than limiting himself to "revelation" in those terms, showed the early morning sun striking the rocks at the lower right with an ethereal kind of radiance. The painting is not only a form of spectacle, bringing together within its comprehensive scope features of the Andean countryside that make a grand impact as a conspectus of regional scenery. It is also synecdochic, in that the landscape depicted in this way has creation and subsequent destiny written all over it: in effect pressuring or molding its components into a state of being that—without invocation of the Divine in any traditional religious sense—is declarative about its Maker.

By the 1860s, experience of the American frontier as it extended itself westward was coming to be reflected in large-scale paintings of the Rocky Mountains, and of the Yosemite Valley. Arctic subjects and ones from the Southern Hemisphere catered equally to the new kinds of visual fascination opened up by government-sponsored expeditions into uncharted territories. Paintings produced in response to such imperatives were, in their order of command over topographical, geological, and anthropological detail, in implicit competition by now with glass-plate photography. In order to put themselves into line with the kind of replete information those plates provided, and with the practical claims they made to furthering scientific progress, size as a positive and compelling factor had to be coupled with an equivalent clarity and degree of precision throughout. But as an anonymous critic put it, writing in 1861 on the subject of Church's painting of that year *The Icebergs* (Thyssen-Bornemisza collection, Madrid): "we do not find much of [their] grandeur . . . as the imagination pictures them floating on ocean in stately magnificence. On the contrary, the picture suggests a combination of glacier forms and rocky islands covered with snow, not floating but firmly anchored."[114] Such paintings, in other words, were too steeped in the claims of science to be any longer grandly compelling in the vein of synecdoche. They served as stately records, invoking wonder to be sure, but leaving no room for an indefiniteness, at the interstices of the natural and the Absolute, of the kind that the sublime provided.

TROPOLOGIES AND THE FRAMING OF WORLDVIEWS

The prevailing tropologies of landscape art in the nineteenth century, as they have been set into place in the preceding sections in relation to the structuring of particular works

and the operations of consciousness in grasping the implications of those works, can now be associated more generally, in explanation of their role, with four philosophical "worldviews" that come into force during this century. Certain key strands within those philosophies single themselves out for this purpose: ones appropriate or adaptable to the natural world as subject of study, and to the way in which the understanding of such study, over time and under differing terms of engagement, is conceptualized. Observing, sensing, grasping, and intuiting and seeking to record, distill, make intelligible and render coherent represent processes and concerns in human beings, all of which in cognitive terms fall within the province of dealing with the natural world, and abut onto one another. Like the tropologies themselves, such terms of engagement align themselves along a continuum, commenting upon and illuminating one another through the very differences of orientation they empower, in both artist and spectator.

Naturalism as a metonymic pursuit, which in its nineteenth-century development gives a role to representativeness and/or association that goes beyond mere transcription (see pages 126–27), aligns itself accordingly with Comtean positivism. Comte himself, in the synthesis of his system that he published in 1848, conceived of art as "an ideal representation of Fact," which served to cultivate one's sense of perfection. It was saved from constituting mere imitation, so that it required no special language—like common prose as distinct from poetry—by the intrusion at a second stage of the factor of expression; the holding up of "a mirror to nature" thereby became modified, by the heightening, alteration, or suppression of features in the light of an internal mental model. But the input of communicative intensity that accrued in this way had, as with the generality of scientific explanation in its highest forms, to have the material world as its starting point.[115]

Comte's followers in the second half of the century were generally agreed that truth in recording the phenomena of reality was dependent on what could be known about the world as a consequence of direct observation, and the inferences drawn from it.[116] But the figure who in the 1860s stood out as the key representative of positivism—without being importantly in debt to Comte, thanks to other mediating influences—was Hippolyte Taine, who in 1864 began to lecture at the Ecole des Beaux Arts in Paris, as professor of both aesthetics and the history of art. Taine did not in any of his subsequent presentations—covering in succession Italian, Netherlandish, and French art—discuss anything but figure subjects. He put landscape painting at the bottom of the ladder of subject-matter, and he argued increasingly for the historical relationship of art to a triad of factors he named as race, milieu, and moment. But it is relevant for present purposes that he took it that the greatest artists, even when copying nature, lent added qualities to the materials that they drew upon. Such qualities, in his general theory of the nature of the work of art, were explained as a matter of rendering "essential character," and doing so in such a way as to communicate a "strong personal impression" of the "original sensation" that had been experienced.

Taine went on to speak in this connection of how the talented artist can use such a faculty to "penetrate to the very heart of things," and more specifically, how precision here entailed designating "the vivid spontaneous sensation which groups together a body of ideas to alter, amend, metamorphose, and employ, in order to make itself manifest."[117]

And in the introduction to his 1871 volume on Italy he referred—in terms that recall Comte's necessary first stage in dealing with the material world—to the powers of observation as an "instrument" that, in his experience "derive[d] greater pleasure from natural objects than from works of art; nothing seems to it to equal mountains, seas, forests and streams." And so the "natural" work of art could be born of a "profound passionate sentiment" and the shaping role that it exercised upon the processes of "translat[ing] impressions accurately and completely."[118] This amounts to saying that the view taken of nature is always a view through lenses that color, associatively or by the imposition of a controlling insight, the way things are made to appear. So the forcing out of salient features of a subject in nature, which are the product of an emotionally charged attachment to it, can be the basis for an interpersonally shared conveying of the attitude or outlook that is responsible for drawing attention to those features.

The alliance of music and metaphor, as it bears on the transformative ways in which condensation and suggestive interfusion can be taken to operate with landscape subjects and the special role given to "effect" toward mid-century (page 143), is paralleled in the philosophy of Schopenhauer. For Schopenhauer, the images that art offers present the things of this world as they would be, if freed of the will's unending demands to act upon them, and in so doing impose upon their reality for practical or empirical ends. Works of art are akin in their functioning to metaphor in its cognitive role (page 135), taking on a power of penetration beyond the surface of things; and like Friedrich's metaphorized presentation of the impulsions and aspirations that are canalized from within the psyche by exposure to nature (page 141), they bring together in the doing of this inner and outer worlds. The artist uses the knowledge available to him in this form to give, in Schopenhauer's parlance, virtual and implicit access to the truth, thereby enabling others to recognize it.

For Schopenhauer, music is, among all the arts, "in the highest degree a universal language." In virtue of the analogy of its melodies to the "inner spirit" of the phenomenal world of nature, it has the power vested in it to make "every picture, indeed every scene from real life and from the world" that it takes processually as its subject "appear in enhanced significance." Inasmuch as it is able to reproduce inner emotions of all sorts at a complete remove from reality, it has "inexpressible depth." And its supreme role comes above all from the concentrated and elucidatory qualities attaching to the kinds of "effect" that it creates.[119] The idea here of artistic production as the making visible of something that lies beyond the confines of normal seeing, and the kind of response that is elicited in return can be transposed to the visual arts at what is, for Schopenhauer, a lower level of the will's "objectification;" but one in which spirituality and suggestiveness can nonetheless gain recognition, as they are laid open to comprehension in the creative act. Such a transposition has to depend, in the case of landscape, on the connective step (itself metaphorical) of positing an equivalence there to the musical qualities of abstraction from the real world in its perceived particulars, and a homogeneous tonality that is wrought so as to make for "complete harmony."[120]

For Friedrich Schlegel, irony represented a form of philosophizing: a clear foreshadowing of the expanded role that the concept took on in German thought of the nineteenth

century. To understand how it came to emblematize a type of situation, born of a sensed disjuncture from the character of the world itself, in which human impulses can find no outlet directed toward the attainment of freedom is to bring into consideration first how Hegel, in the *Lectures on the Philosophy of History* that he gave in the 1820s and revised and supplemented in the following decade, presented nature in its "immediate reality" as "the original basis from which man can achieve inner freedom." In order for man to maintain his "sensuous connection with nature" in a form that promotes the attainment of freedom "by means of internal reflection," it was necessary that, in the contrapuntal juxtaposition and conjunction of man and his environment, nature "should not be too powerful in the first place." And as Hegel phrased it in the introduction on reason in history that he drafted in 1830, development, which in the natural world is a "harmful and peaceful process of growth like that of organic life," is marked contrastingly in the world of the spirit—inasmuch as it does not contain only a "purely formal" aspect there, but is directed toward "the realization of an end whose content is determinate"—by the waging of a "hard and obstinate struggle with itself."[121]

In Karl Marx's writings historical irony turns toward material issues of social class and the forms and conditions of laboring that can win no qualitative reward in the bettering of social and economic life. Man is taken as needing to dominate, control, and form his natural environment, thereby rising above the frustration of human impulses in a world which is alien to them. The condemnation of manual labor to work within physical limits and contexts of production dictated by the class system can only be resolved accordingly by lifting one's eyes from the earth—which Millet's peasants barely do.[122]

The philosopher who provides a counterpart, later in the nineteenth century, to the psychological impulses attending the cult of the sublime in its most universalized forms is Nietzsche, when he writes of "ecstasy"—using the word *Rausch* in a double sense melding intoxication with elation—as having as its essential feature, which makes art possible, a "feeling of increased strength and abundance." In his *Twilight of the Idols*, composed in 1888, Nietzsche proposed in this connection that "idealizing does not consist, as is generally believed, in a suppression or an elimination of detail or of unessential features." Rather, the "most decisive factor" here consists of a "stupendous *accentuation* of the principal characteristics [so that] the minor [ones] vanish."[123] Chosen aspects of a subject are given prominence and force in their characterizing role, in such a way as to endow the terms of felt response to that subject with a compression or overlay of a potentially transfigurative sort; which may be said equally of the workings of synecdoche as a rhetorical trope.

In the early 1860s, when he was seventeen, Nietzsche had read admiringly Ralph Waldo Emerson's Essays on "Nature" and on "History," in their German translation of 1858, and had marked in his copy numerous passages of which he approved. Emerson had affirmed in those essays how a creative, cosmic spirit seemed to act through each and all of the physical aspects of nature. In effect, he had stated in a passage that Nietzsche underlined, "there seems to be a necessity in spirit to manifest itself in material form"; but what man knows of those processes is filtered through imagination and feeling, as well as perception itself. So the growth of organisms, for Emerson, entails the creation of new

forms of life, which the human sensibility admires in nature as representing (in another phrase that Nietzsche underlined) "accumulations of power."[124] This becomes a source in Nietzsche for the notion of an affirmative display of energy and strength as part of human beings' striving for preeminence. At the same time, Nietzsche insists that nature can *only* be seen from a certain perspective, and turns that perspective into a position expressing a larger attitude or state of understanding. Each person will choose accordingly his or her own form of "command" over "alien" materials that are found in nature and serve as a source of fear or impotence. This subjectivization of forms of power derived from nature— in the shape of their imaginative recreation or their increasing personalization—is seen equally in the conceptual framing of the sublime so that ongoingly, as the nineteenth century unfolds, anthropomorphic projection in this sphere can be looked on as a liberating factor.

What has been singled out here is, of course, only a fractional component within the total thought of those major and contrasting philosophers of the period. But these "fractions" are, in each case, of profound importance for tracing basic ways in which the suasive or broadly affective power of visual presentations can be understood. Thus it is the way in which the philosophical argument is developed, and the forms of analogy that can be based thereon, rather than any direct connectives to the art itself that are to the point in the present context.

What has been said in the preceding sections should by no means be taken to imply that *all* artists of this century and practices in the depiction of landscape necessarily subsume themselves under one or another tropology. To the contrary, more than one tropology can be combined within a single body of work or group of works; or a bridge may be constructed between tropologies. The watercolors of John Sell Cotman, one of the leading landscape artists of the so-called Norwich School (a term of convenience only, in the names that it brings together) can be taken as both metonymic and metaphoric in their terms of operation, depending on subject and structuring. Some of them show subjects of local agricultural interest, or of particular architectural moment at the time (such as the earliest Norman parts of Norwich Cathedral), evidently singled out so as to play on the associations in question. Others show drifting vessels out on the sea, and technical and architectural feats of construction, in the shape of bridges and aqueducts that had quite recently come to enhance the landscape by their presence, as ways of achieving an effect relating to key emotional values—such as those of heroism and independence—that are strongly embodied in contemporary poetry.[125] Lighting especially serves as a key transformative agent in relation to the total structure that is focused upon in these cases.

In analogous fashion, marine subjects by American painters of the so-called Luminist School (again a term of convenience, for East Coast artists of the 1840s through the 1870s who can be linked together only very loosely in their ways of working) combine reference to commercial enterprise and the forms of livelihood drawn from the sea by boatmen and fishermen with motifs, such as the lonely ship, evoking isolation and endurance. Fitz Hugh Lane, for instance, who worked in Boston and nearby Gloucester

and also made trips to the Penobscot Bay area of Maine, shows a mixture of vessels, often under full sail, and the harbors and icefields, islands and sounds through which they pass, negotiating their way over what is characteristically in his art a still, reflective surface of water. In his last years, which coincided with the final campaigns of the Civil War (1864–65) Lane adapted this imagery so that his wrecked or battered hulls can be taken to evoke the now mind-haunting specter, for the whole nation, of dead or crippled soldiers lying on the field where they had fought.[126] In a painting of 1873 by the Russian Arkip Ivanovich Kuinji showing Lake Lagoda (Fig. 67), similar elements of imagery are combined with intense observation of light reflected on and under the water; except that here the association carried by the fishermen in their boat appears more scriptural, and the foreground rocks and stones are treated as inherently more substantial than this boat and the isolated sailing ship beyond it.[127]

In Puvis de Chavannes's allegorical painting of 1870–71, *Hope*, shown at the Salon of 1872 (Musée d'Orsay, Paris), the landscape setting around and behind the nude figure equally couples irony with synecdoche. While Puvis's settings of the 1860s and later are for the most part broadly generalized ones with a classical flavor to them, expressing the idea of an unspoilt and harmonious "golden age" world preexisting civilization, irony is present in this case within the simplifications of natural form, in the shape of the ruins and grave markers alluding to the devastations and carnage of the Franco-Prussian War. Synecdoche enters in with the inclusion of the plants and flowers surrounding the fragile nude, that are there to accentuate the promise of renewal, while the olive branch that she holds up associates hope for the future with peace.[128]

Like Turner before him (see earlier in this chapter),[129] Courbet as a landscape painter can be seen to exploit all four of the basic tropologies, in different phases or aspects of his work, and to do so in resistance to any typecasting that critical commentary of the time would impose. His close friend and supporter of the 1850s, the social critic Champfleury, would write in February 1862, in the biweekly guide to the French art world published by the Parisian dealer Martinet, a piece on the contemporary importance of landscape paintings in which he advocated simplicity of motif—as exemplified by Corot's misty morning subjects or the rocks, water, trees, and greensward of Courbet—as having a fundamental attraction to the exhausted and enervated city businessman.[130] But in fact Courbet had treated the geology of nature anthropomorphically in his early work, making reference in metonymic form (as Swiss and German artists had done before him) both to the dynamic changes wrought by human and national forces within the region that he adopted as subject, his native Ornans and its environs, and to slow organic processes of natural evolution, as represented most typically in the stratification of rock surfaces. He equally chose to allude within his work to the pictorial and physical making of the material product in question: as in the metaphorical role played within his famous *Studio of the Artist* of 1854–55 (Musée d'Orsay, Paris) by the central image of himself at work on a landscape subject, oblivious to the world around and to the figures and personalities who had previously helped to sustain him. He sits and works there as if he were located within the landscape of rock and water in question, and his deletion of the genre figures

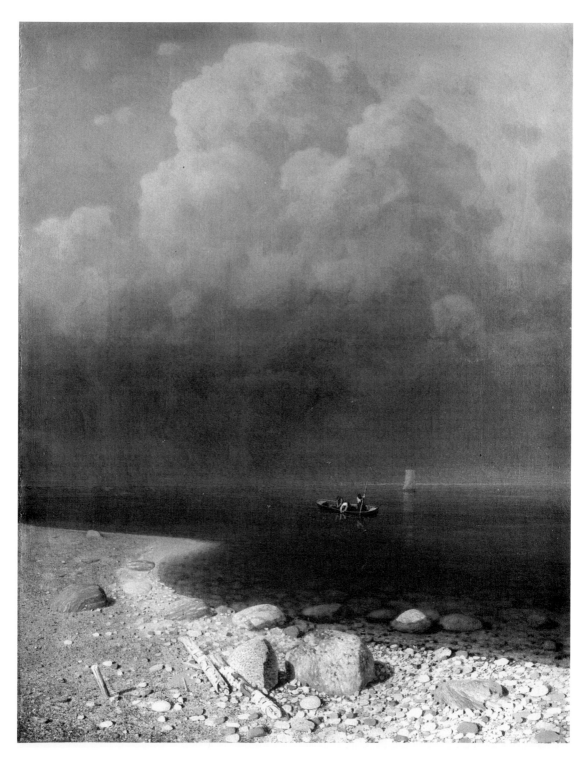

Fig. 67. Arkip Ivanovich Kuinji, *Lake Lagoda*, 1873. Oil on canvas, 31¼ × 24½ inches. Russian Museum, St. Petersburg

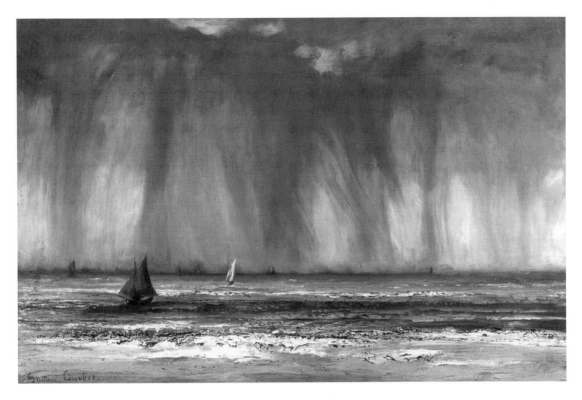

Fig. 68. Gustave Courbet, *Marine, The Waterspout*, 1865. Oil on canvas, 17 × 25⅞ inches. Philadelphia Museum of Art, The John G. Johnson Collection

that he had originally planned to include (a miller, his son, and their ass) draws attention, more suggestively than would be the case with a peopled landscape, to the primeval state of inaccessibility and enclosure in which he immerses himself. He does this in order to become, as it were, part and parcel of this materially dense and forthrightly concrete presence of nature: making the assertion his own that such is the case in virtue of the linkages from the landscape and back into it established by the brushwork itself.

In the period of later production dominated by landscape, 1857 to 1871, Courbet went so far as to create a spoof on poets and painters titled *The Source of the Hippocrene*—which he is then said to have painted over with the *Thicket of Deer at the Stream of Plaisir-Fontaine* of 1866 (Musée d'Orsay): a typically frozen image of tranquillity in nature. He equally made ironic reference to the unspoiled countryside in its freedom from both industrialization and political oppression, at a time when technology had vastly increased the opportunity for travel to just such regions, for touristic purposes. And his seascapes of the later 1860s, which depict spectacular phenomena of nature such as waterspouts (Fig. 68)—based most probably on seeing such a "rainstorm," made up of water rising out of the sea, at the fashionable resort of Trouville—energize synecdochically, with dark shapes that could (as caricaturists recognized in their parodic versions) be taken as blots or curtains, what would otherwise be a virtually empty and bleak amalgam of sky, cliffs, and land in the upper half of the canvas.[131]

Thus Courbet's ventures into landscape art seem in their fullness of implication, rising to the level of obsession, to reverberate across the major tropologies, breaking down the distinctions between them. Impressionist landscape, in contrast, in the key years of the group exhibitions (1874–86) eluded or evaded categorization according to those same tropologies. The reasons for this are to be sought, first, in the term *impressionism* itself; second, in the circumstances of the successive group exhibitions, the strategies for achieving notice that they embodied, and the kinds of commentary from supporters and critics that they solicited; and third and last, in the range of landscape subjects represented in those exhibitions, including urban scenes of park, quayside, and racetrack as well as the suburban pleasures of river, garden, and countryside.

The term *impression* carried, by the 1860s, the implication of a desideratum: to be able to convert the *ébauche*, or quick preliminary study into a completely realized image; but also of a claim, to detach the essence of a subject in the natural world, while remaining true to the first sensations that the eye received in situ. To call a painting an "impression"—which has two different senses in French, as it does in English—identified it on the first score as a record of fugitive, evanescent experiences put down on canvas; while on the second score it came to signalize a pictorial rendition of what could only be caught "on the wing," in the nature of the perceptual process itself (as it was currently understood). So Impressionism would be associated in the 1870s with transcriptive freedom and directness; but also with aspects of the social and natural world that the artist's sentient personality was attracted to, as a source for penetrating and visually compelling accent placed on whatever might be detached from the ephemeral for this purpose.[132]

Impressionism went through several distinct stages in its self-definition, both as a loose alliance of convenience between different artists wishing to appear "independent" (which was the basis for the first exhibition in the spring of 1874), and as a critically recognized development linking together subject-matter and specific pictorial means. It suffered in this regard from the diverse, sometimes directly antithetical cues to understanding provided by its early critical supporters. For Armand Silvestre, writing in 1873 for an album of prints put out by the dealer Durand-Ruel, to show the various artists whose work was to be viewed at his gallery, the "even more contemporary . . . group" of Monet, Pissarro, and Alfred Sisley that was introduced at the close produced works bearing "no resemblance at all" to the older figures considered, and having only a "distant and indirect" ancestry to them, apart from what they owed to the example of Manet. They had in common a reliance on "simplicity of . . . means," to achieve a "harmony" based on finely attuned relations of tone. And their subjects were overtly pleasurable ones, recalling those of the Japanese print—well known in France as a source of inspiration for Western artists for a decade and a half now—but also pervaded by a distinctive "blond light":

> Everything is gaiety, clarity, spring festivals, golden evenings, or apple trees in blossom. . . . Their canvases, uncluttered, medium in size, are open in the surface they decorate; they are windows opening on the joyous countryside, on rivers full of pleasure boats stretching into the distance, on a sky which shines with light mists, on the life of the outdoors, panoramic and charming.[133]

For Castagnary in contrast, who was cited earlier in this chapter for his conspectus on naturalism, the loosely bonded group represented in the 1874 exhibition, which he chose to review, was not a new, revolutionary "school" but offered an extension of the freedom of naturalism that was marked by talent and intelligent understanding. Summary brushwork served with these artists to "render not a landscape but the sensation produced by a landscape," put down in rapidly determined fashion where the interest and appeal of the subject was inherently suited to this.[134] This, in antithesis to Silvestre's courting of those who wished to invest financially or ideologically in the "new," rather than in the successful art of the Salon, was a systematic type of approach to characterizing the work, with its foundations in the physiology of perception.

Critics' attempts to give some kind of a formal definition of Impressionism, while responding also to the evident differences between artists, continued in the wake of the second group exhibition of April 1876, where the hanging allocated a separate section to each participant. Asking "What is an Impressionist painter?" and noting the lack of a satisfactory answer to date, Emile Blémont proposed that the goal pursued was "to render with absolute sincerity, without any arrangement or attenuation, by simple process, the impression aroused . . . by the various aspects of reality." These artists, he went on, relied on synthesis rather than on analysis, the "method of science." And given the differences of seeing between any "two men in the universe [looking at] relationships in the same object," they did not need feel a need to "alter their personal and direct sensations in order to comply with any particular convention."[135]

For Edmond Duranty, who was associated as a novelist with the Naturalist movement in literature, these artists—in contrast to the preference coming out of Romanticism for landscape "treated [in dark tonalities] as though it were an oven or the back of a shop"—had "for the first time understood and reproduced, or tried to reproduce" the ephemeral phenomena of the outdoors, and particularly "light and color vibrating." Duranty's essay of 1876, *The New Painting,* is in its discussion of such phenomena and their treatment concerned primarily with the example presented by Degas; but he speaks also of a "new approach" and "freedom" being used to express a "feeling for the structure of the land," which as a guide to the character of nature in France has been missing in almost all landscape art.[136] Théodore Duret, in his pamphlet of two years later, "The Impressionist Painters," followed Duranty in affirming the artists' concern with atmosphere and tonality, which he presented as a form of investigation deriving from the naturalistic outdoor painting of Corot, Courbet, and Manet; he also, however, brought up afresh the role played by the example of the Japanese print, now in terms of the key structural feature found there of "vivid, piercing colors set side by side."[137]

As for the range of outdoor landscape subjects brought together in the group exhibitions for public scrutiny, in immediate vicinity or close adjacency to one another, these represent choices of motif in which one is prepared for a high rate of physical change and intrinsic diversity: in weather conditions, lighting effects, coloring, and more generally seasonal aspects of the scene as a whole, such as snow and ice or autumnal hues. A recognizable segment of nature is shown, or one that the title of the work identifies, including in either case the people, activities, and kinds of detail that would be expected

in that topical context; and its continuation beyond the frame is asserted, as an intrinsic part of the semblance in question. But there is a lack within the chosen segment of any central emphasis or focus promoting a sense of preferred importance, or any internal hierarchy of details that would allow that kind of paramountcy to be inferred. The agglomeration of elements is evened out in this way, both in distribution over the painted surface and in degree of explicit definition.

A single text, Frédéric Chevalier's review of the third group exhibition of 1877 evokes, better perhaps than any other, the conceptual and categorical confusions that Impressionism set into motion, almost from its inception. The distinguishing characteristics of these artists were, he wrote:

> the brutal handling of paint, the down to earth subjects, the appearance of spontaneity which they seek above all else, the deliberate incoherence, the bold coloring, the childish naiveté that they mix heedlessly with exquisite refinements—this disconcerting mixture of contradictory qualities and defects is not without analogy to the chaos of opposing forces that troubles our era.

Oscillating unevenly between positive and negative evaluation, and refusing reference to any of the artists represented in 1877 who, by any normative standard, could be judged as sober and directed in their practice, Chevalier saw the intermix of "audacities of composition, unprecedented dissonance and insolent harmonies" as making for "a savage, irreverent, disordered, heretical art."[138]

How did the individual artists fare in all this? The terms of appraisal for Pissarro's art were wished onto the only member of the group who, as a matter of loyal and principled commitment, would participate in all eight of the joint exhibitions. For Duret in his 1878 pamphlet, Pissarro was the most purely representative of the naturalist viewpoint, applying it to the rural subject-matter of tilled or harvested fields, trees blossoming or bare according to season, roadways bordered by pollarded elms and hedges, village houses with their gardens, and farmyards and ponds. Like Millet before him, he endowed the rendering of "cabbages and cottage garden salads" (see page 133) with an intrinsic poetry. Writing two years later about an autumnal woodland scene of Pissarro's from 1876, with a man and a woman halted on its pathway, Armand Silvestre echoed this judgment associating the artist's "sincerity" and the "impression of great truthfulness" that he created with the example of Millet. But just as Pissarro had been assaulted in 1877 for the indecipherability of his landscapes, whether looked at close up or at a distance, so Emile Zola commenting in 1879 on a similar woodland subject of 1877 found that his "scrupulous research sometimes produce[d] an impression of hallucinogenic truth"; and Silvestre himself had trouble with the "irresolute execution" of a harvest painting. Essentially the qualities of "sincerity" and "truth" testifying to Pissarro's engagement with rustic life were incompatible, when it came to landscape itself, with the kind of persistently crude handling of surface that gave rise to the charge of incomprehensibility. It was as if, in his version of naturalism, the metonymic impulse that induced the choice of socially redolent details, such as cabbages in their plots or stone walls, became obscured by the treatment of them.[139]

Morisot was also a very loyal participant in the group exhibitions. She showed in 1874 and 1876 on a par with Monet and Renoir in terms of the number of works and media represented, including in her case watercolor as well as pastel. Then in 1877 a whole section of one wall was given over to her work: the first of the exhibitions that individuated the artists by means of the hanging itself, as well as the first to adopt the formal label of "Impressionists." As Morisot was in 1876 and again this year the sole female participant, comments directed themselves accordingly to her womanhood (see pages 146–47), using terms such as delicacy or, in the case of Georges Rivière's long description of the exhibition, more simply "charm." But the sense of space and airiness that she brought into play in her works was also recognized, as by Duret. She reappeared in the 1880 exhibition (having missed that of 1879 because she was having a child) and now one critic, Henri Mornand, wrote of a "serious effort to paint truthfully" as motivating her "refined and elegant style." But comment also veered, or ricocheted, toward referring to the "feeling of a phantom world" created by "indistinct tones," or to "attentuations of color" that gave a sense of "fleeting and floating shadows"; and again in 1881 of forms that are "always vague," but animated by a "strange life" of an essentially evocative order. The metaphorical aspect of her art was acknowledged only grudgingly, insofar as absence or thinning out recognized in it played against an expected substantiality.[140]

Perhaps Stéphane Mallarmé came closest to reconciling these radically different alternatives with one another in the understanding of impressionism, writing in 1876 of Manet and his "followers" and applying aesthetic notions akin to those that inform his early poetry. This text in its English version, the only one known, is by no means Mallarmé's most brilliant piece of critical writing. It straightens out the vagaries and variations of actual "influence" by setting up Manet as "head of [a] school," and/or the "initiator" of a movement leading to landscape paintings by Monet, Sisley, and Pissarro that are "wrought so much alike" as to seem scarcely distinguishable on first acquaintance; and his constatation that they dealt observationally with "subtle and delicate changes of nature" is not essentially different in kind from Blémont's definition of purpose cited earlier. But in his larger argument Mallarmé on the one hand takes modernity as entailing, in the hands of these younger artists, a keenly tempered and controlled combination of touch and tone, which can be a source of "original and exact perception" here because it matches up with the attentive quality of their gaze. And on the other hand he attributes to their way of proceeding, in small format where landscape is concerned, an openness of handling that can preserve suggestively the key qualities of air and color that attach to an outdoor subject in recollection, and an inherent "energy" which is that of the "modern worker," as opposed to the "old imaginative artist." Pissarro accordingly is one who has no fears of "solidity" in his rendering of the luminous atmosphere of "summer woods"; Morisot in her atmospherically charged subjects of "green lawn" and seashore instills a purity that is redolent of an artless kind of innocence, or the "perfection of an actual vision."[141]

With Manet's own landscapes of the 1870s there was an opportunity, not taken up by any commentator of the time, for detecting whiffs of irony. Mallarmé, in his account of April 1874 of one of the submissions of Manet's rejected by the Salon that year, the

Swallows (Bührle collection, Zurich), could be taken as implying that in this view of grassy dune in northern France "stretching back to a village on the horizon behind which one can feel the sea," the insubstantiality of the setting, as rendered in paint, and the "so vast . . . atmosphere" surrounding the two seated women commented by implication on the "unframedness," by conventional standards, of the action or interaction embracing those figures and the volatile swallows themselves. But if so, Mallarmé did not apply any such insight to the "followers" whom he wrote about two years later.

In his large, four-foot by five-foot, view of the Seine at Argenteuil from the same year (Musée des Beaux Arts, Tournai), with a smartly dressed man and women seated side by side in front of the sailboats, Manet could equally be ironizing the relationship of such leisure activities to this now commercialized and industrialized setting. Pieces of rope hanging from the end of the nearest sail (as they turn out to be on close inspection) line up with the centralized factory chimney beyond, as if they might constitute its reflection in the water; and the comment of one critic when the painting was shown in the Salon of 1875 that the "indigo river hard as iron and straight as a wall" had for its background "a view or rather a stew [*marmelade*] of Argenteuil" links up with the caricaturist Hadol's comic image of the river here as discolored by the effluvia of an actual indigo factory, that of nearby Saint-Denis, with its by now only-too-familiar smoking chimneys resembling those at the back left in the painting.[142] At a time when Manet was becoming recognized as the leader of the "plein air school"—thanks in good measure to Mallarmé's interventions on his behalf—such a loaded counterpoint of sail and factory would have had the effect, if taken as ironic, of detaching Manet's attitude toward the leisure subjects of river and beach that he was now increasingly favoring from that conveyed by Monet's Argenteuil subjects of 1873–74 and those of Renoir working alongside him.[143]

As for Monet, who was the key figure for the definition of plein air Impressionism in the 1870s—not because of the concern with surface, or flatness, and the atomization of color that later criticism attributed to him, but because of the summary descriptiveness of his landscapes, giving the sense of rapidity of response to transitory optical sensations, and their invocation of light and warmth as elements that opened up the experience of the outdoors—he would come to be seen by the later 1870s as having distilled the essence of certain subjects, especially ones involving water, in the way that the Japanese printmakers whom he admired and collected intensively had done for their landscape (page 176). But it was only after Monet turned to north and south coast subjects in the 1880s, and from the Creuse Valley in the center of France to series of canvases depicting poplars, grainstacks (*meules*) and mornings on the Seine that he became recognized at large as having expressed the character of the French countryside, rather than drawing inspiration, like the Barbizon painters and Millet before him, from a single region within it.

Thus, writing in June 1888 of the ten canvases of Antibes that were on view at the Boussod Valadon gallery in Paris, Gustave Geffroy would affirm that Monet had been able to explore here "all that was characteristic of the area [as well as] the deliciousness of the season." Three years later, the Monet of the *Grainstacks* had become a "dazzling and powerful poet . . . [who] will take his place amongst the greatest artists who painted the landscape of France." And by 1900 the *Mornings on the Seine, Grainstacks* and *Cathedrals*

together prompted Charles Saunier to say: "Glory . . . to the artist who with the aid of a few lines and some dashes can so grandly synthesize the land where he lives."[144] Thereafter, Monet's late subject-matter of waterlilies and his garden at Giverny became like a microcosm standing for the totality of his experience of seeing and painting nature, in all its variety and changeability. This was a triumph in the cause of synecdoche, as well as a triumph of self-presentation.

5

ETYMOLOGIES OF MODERN PURPOSE AND PRACTICE

POST-IMPRESSIONISM AND AFTER

It can be inferred from the preceding chapters that the relative ordering and placement of differing component elements gives signification to landscape images, by bringing the emphasis attaching to one ingredient into accord, or contrast, with the attention that others invite. Contributory features within the image serve also as a record of an authorial personality at work, on the basis of which an attitude to nature and a governing intention can be adduced, even without direct evidence to this effect. Other features again introduce a form of play with the imaginative and conceptualizing capacities of the viewer. The address that a depicted landscape makes to the scanning eye is based in principle on an intermix of these three factors.[1] But the balance between the three constitutes, or becomes, part of a larger *historical* issue that is particular to this type of creation.

Up to the later fifteenth century in European art, the address in question takes place in relation to a main scene, to which the landscape is secondary or subordinate. But the non-narrative elements expand by degrees, to become like an enhanced stage setting and a competing, even distracting, appendage to the main locus of invention or thematic variation, around which the image pivots in what may be called a nominal fashion (since titling tends to depend upon it), or as a matter of residual pretext for what is shown.

Thereafter the role given to landscape comes to depend increasingly, in significatory

terms, on sets, groups, or sequences of motif within the work, and on the implicit or actualized positioning of the viewer in relation to them. In the case of oil painting especially—but the same applies equally to the medium of watercolor, and to certain kinds of graphic notation—the agency of the artist's hand comes to be perceived as more nakedly instrumental in achieving a "knit," or bonding that is made materially evident, between the layout of features that dispose themselves to give a sense of the natural world and the kinds of response that the depiction sets on foot in an elemental or pre-verbal sense.

One could speak accordingly of a shift toward increasing self-reference, or reflexivity, in the rendering of landscape subjects. Where relations are concerned, between one and another of the assembled components, the shift is in the form of authority for ordering and arrangement that nature itself, as known and familiarly schematized for viewing purposes, can be taken to provide. As the kind of comparative sanction that rests on plausibility is displaced, from within the work, by a growing autonomy of regulative principles governing the relation and affiliation of each concretized element to its neighbors, so the private side of imaging, that sets itself in one way or another against prevailing ways of seeing, poses problems of access that only deepen when there is nothing made present as a source of reference to the viewer that could count as a verifiable simulacrum of the world. Markings in paint offer a form of temporal insight into the stages or layerings of the creative process that give definition and substance to particular depicted things; but they may also come to impinge upon, or actively violate the overall sense of completeness, by drawing attention to the gap between the concrete experiencing of nature and its partial or fragmentary reembodiment. Qualitatively, the sense conveyed in a landscape subject of intimacy with a particular mood or aspect of nature will not so much disappear, as become invested in generalized fashion in the rendition of consistently treated parts: as is traditionally the case with Chinese landscape art from the Sung dynasty on.

In the 1880s in France there was an emergent ideal for landscape art, in which harmony, clarity, and extended and assured rhythms were the qualities most admired. They were found present by young artists and sympathetic commentators in Puvis de Chavannes's ongoing work, which could claim, in accordance with principles that this artist had already established in the 1860s (see page 173), to purify natural scenery and give it a sense of unaltering duration.[2] Essentially the same qualities were read into the Japanese color print, comprising landscape as a favored ingredient, which was now—after an initial surge of interest affecting Impressionism (see Chapter 4)—being collected and appreciated more intensively in Western Europe, as a wider range of examples by the leading artists and their followers became available.[3]

Ideas held over from the Romantic period came into play here, supporting the critical concepts of transformative imagination, vigorously energized handling of the medium, and musicality in the shape of harmonies or "symphonic" color combinations. Originality had to stake out its claim to attention on the avant-garde scene within such parameters: it struggled or wrestled with itself to affirm the workings of a controlling intelligence, at the same time as seeming illogic, crudity, and arbitrariness provided occasion for hesitancy or a tone of unpreparedness in early response.

With Vincent van Gogh's and Paul Gauguin's landscape art of the mid- to later 1880s, the factors constituting the cutting edge of originality were, in this perspective, their selective improvisation with the grouping and sequencing of motifs (as with the gardens of Arles, the hills and fields of Brittany); brushwork stretched and patterned so that it activated each separate segment of the canvas surface in its own right; color enhanced area by area, and contours intensively rhythmicized. With Georges Seurat and with Paul Cézanne the equivalent features had come to be by then the manipulative collocation of landscape elements in an inconsistently receding space; the individual stroke or touch of paint serving as an iterated building-block; and the paradox or quirk of seeming detachment from an intensively worked-up mood. The term *Post-Impressionist* as it came to be used for all four of these artists confuses rather than clarifies the nature of the interconnections between them, insofar as it posits a shared ground of development toward an alliance of independently theorized interests; for personal and artistic relations between one and another of the four in the 1880s by no means made this the case.[4]

From 1890 on, on the other hand, the critical issue came to the fore of how the treatment of landscape was to be put in place in the larger scheme of picture-making, so that it held the possibility of contributing in an essential way to the felt presence of spirituality in the work on the one hand; and on the other to the achievement of decorativeness, considered not merely as a unifying feature implanted by material skills, but as a needed and imaginatively sustaining aesthetic quality. The inserted activity of figures was set apart in this way from being narrowly story-telling in function; and the kind of paint application was disesteemed that, as in Courbet's case (see Chapter 4), massed itself as a pictorial counterpart to sheer physical substance, to become assertive of presence and plasticity in its own right. Such concerns were out of line in their orientation with the most essential priorities now put forward.[5]

To address the claims of the spiritual was, according to those priorities, to express ideas that came from within the self, through a choice and arrangement of forms so that they took on a power of suggestion that was potentially universal in its reach, or the scope of its appeal. The concept of the decorative, applied concordantly to landscape, meant that flattened layering or organization of the setting into zones, disposed horizontally in parallel to one another, tended to eliminate an assertive sense of boundaries or spatial limits. A specific or consistent vantage point onto the whole scene was in varying degree abrogated, so as to keep the viewer at a distance experientially. And states of arrest or an appearance of suspended being in the figures tended to merge them with their surrounds, or associate their tenor of existence with the mood that the landscape projected.

Here the contributions in landscape of the same four artists were all, in their different ways, formatively important. And the same would continue to apply early in this century, in terms of the rendition of related subjects with a comparable or a more extreme license that their work sanctioned, as it became known and exhibited more widely.

Van Gogh took over basic elements in the thematic vocabulary of the earlier nineteenth century. To mention only those pertaining to the tropologies of landscape art discussed in the last chapter: during his years in Holland he did subjects of beach and coast, at Scheveningen in 1882, that conformed to the naturalism of his relative Anton

Mauve, from whom he had gained instruction in watercolor a year earlier, and Jacob and Matthijs Maris of whom he wrote admiringly, in the inclusion of significant details representing labor and leisure, as well as conditions of weather and atmosphere.[6] From 1887 on he painted plants, grasses, and flowering trees, with air and light playing over them and resonant rhythms and keynotes of color, in a metaphoric distillation of nature's life that emulated the example of Japanese prints (see Introduction). At Arles he juxtaposed smoking factories on the skyline with traditional rural occupations, shown taking place in the fields bordering the town and beside the waterways.[7] At Auvers he called into being an extended imagery of the wheatfields, in which the sense of "vast peace and majesty" to be found in their expanses was synecdochically conveyed.[8]

But van Gogh also treated landscape from his youth on, in pictures by others that had a direct and powerful appeal for him based on their thematic content, as carrying in its components and their conjunction a broadly affective capacity that was related to the actions shown taking place, but operated independently of them in the activation of a spiritual order of response. In a letter to his brother Theo of August 1876, written from Isleworth to which he had gone in a schoolmastering post, he recalled a painting by George Henry Boughton that he had seen previously and that he referred to as "The Pilgrim's Progress," relating it in that light to Christina Rossetti's poem "Up-hill," from which he quoted one stanza. Finding the picture "an inspiration," he would use it in that spirit and describe it very similarly (now without giving name or title) in a lay sermon that he preached two months later. And he expatiated particularly on the character of the setting in each case, writing in his August letter:

> It is toward evening. A sandy path leads over the hills to a mountain, on top of which is the Holy City, lit by the red sun setting behind the gray evening clouds. . . . The landscape through which the road winds is so beautiful—brown heath, and occasional birches and pine trees and patches of yellow sand, and the mountain far in the distance, against the sun.

and adding in the sermon

> on the right-hand side a row of hills appears blue in the evening mist. Above those hills . . . the grey clouds with their linings of silver and gold and purple. The landscape is a plain or heath covered with grass and its yellow leaves, for it was autumn . . .[9]

Given the account that goes with this of the actions of the figures depicted in this setting—a "pilgrim, staff in hand" inquiring of a "woman in black" whom he encounters "on the road" about the journey to the city—an analogy may be drawn with the Southern Netherlandish print of the Road to Emmaus discussed previously (see Fig. 9) and the contribution of its setting. While the iconography of the subject there derives its tenor from a preexistent text to which the representation conforms, the landscape and its constituent features complement that narrative presentation with implications of their

own, having to do equally with pilgrimage. So also the landscape in the Boughton was taken by van Gogh as enlarging upon, and enhancing in communicative impact, the tenor of the narrative components coordinated through and within it—all of them Bunyanesque, but seemingly misremembered by him in their detail, or creatively misread.[10]

The dialectic that enters into the terms of description here—between material specificity and spiritual implication, between compressed contiguity in space and suspended temporality—came back in force into van Gogh's thinking at Saint-Rémy, in the second half of 1889 and the first months of 1890, as an expression of his basic cast of mind at that juncture about figures in landscape. At Arles in the summer of 1888 he had reported to his brother on how the Provençal countryside, in the "delicious . . . [and] extraordinarily harmonious" range of colors that it was currently taking on, needed to be painted "with the blended tones of Delacroix"; and he saw that kind of response to the "rich color and rich sun of the glorious South" as being paralleled in the work of Monticelli, who had painted extensively in that region (see page 144) and some of whose landscapes van Gogh remembered having seen during his two-year stay in Paris. He also associated the cypresses, oleanders, and sunshine of the region with the example of Puvis de Chavannes, and this admiration came to be reflected in the two schemes of decoration that he painted that autumn featuring what he called the "Poet's Garden." When he returned to painting cypresses in June 1889 at Saint-Rémy, he now linked the intimacy of nature represented in this way, and the mysterious character of the light that went with it, with both Delacroix and Monticelli; and he wrote also that in order to express the purity that this countryside had in comparison with Paris, the example of Delacroix could be followed, not only in color but in the form of a "more spontaneous drawing."[11]

In a letter of May or June 1890 that was drafted from Auvers to his friend the painter J. J. Isaacson, van Gogh put together in retrospect the examples of Delacroix and of Puvis, as representing jointly the possibility that needed to be carried further of combining "research on the subject of colors and modern sentiment." He went on to refer in detail to the paintings of olive groves that he had done at Saint-Rémy, saying that he had sought with them and with the cypresses to encapsulate the character of this Southern part of the world in a way that might, in the hands of others after him, "reveal [the] symbolic language" that these trees could be found to express in their shapes and patterning. The previous November and December he had done a series of paintings of the olive orchards, into which he had inserted young women (and in one case a man) engaged in picking, so that they worked together among the twisted trunks and branches, reaching out and up into the greenery in a suggestively peaceable fashion.[12]

The following February van Gogh would add to one of his *Cypresses* (Rijksmuseum Kröller-Müller, Otterlo) the figures of two young women in pale white, out walking together. And in his last month at Saint-Rémy he returned to the pilgrimage theme of his 1876 sermon—as imaged in the shape of wayfarers seeking a resting-place for the night in the poem "Up-hill" that he had drawn upon there—in his *Road with Cypress and Evening Star* (Rijksmuseum Kröller-Müller, Otterlo) and his *Evening Walk* (Museu de Arte, São

Paulo). Both show paired figures of peasants making their way home through the country-side, under a crescent moon and evening star; and in the former, alongside the landscape imagery of mountain ridge and richly textured wheat, horse and cart in motion, and a low-slung lighted cottage at the end of the road, there is in the swirling shape of the huge tufted cypress the suggestion of a bridge between earth and sky; and in the undulating curves, which pull the rhythmic aspects of the treatment as a whole into harmonious accord with one another, an evocation of the flow and passage of life itself.[13]

Gauguin's landscapes are marked by what may be called a dream effect; but the pursuit of this on his part only comes into strong evidence in his work after 1891, when he left Europe to live and work in Tahiti. In a letter of August 1888 he advised his friend Emile Schuffenecker, who was moving rapidly into the role of a close follower, not to be overconcerned with working from nature but rather, taking art to be an "abstraction"—by which he meant a simplification and exaggeration of shapes and colors and their con-sciously patterned arrangement—to concentrate to this end on "[drawing] from nature while dreaming before it, but thinking more of creating than of the actual result."[14] And the following month he demonstrated the effects of such a working principle in the setting of his *Vision of the Sermon* (National Gallery of Scotland, Edinburgh): as he described its color scheme, in relation to the group of praying Breton women and "the struggle going on in the landscape" between Jacob and the Angel which they envision, "a [dark violet] apple tree spreads across the canvas: the foliage is defined in masses, like greenish *emerald* clouds, with greenish yellow interstices of sunlight [while] the ground is *pure vermilion*."[15]

Long prior to this, in his landscapes of 1879–86 Gauguin had assimilated Cézanne's way of placing brushmarks in extended formations parallel to one another, to serve constructively like a form of hatching, and also Cézanne's modulation of a single basic color over an extended area of the canvas by means of texturing introduced into the paint surface itself. The subjects of shoreline and woodland that Gauguin did in Martinique during his stay there in 1887, with sea and mountain forming a backdrop beneath a pale yellow or pinkish sky, and patches of tropical vegetation and separately rhythmicized tree trunks providing accents in the foreground imply response on his part to the example of the Japanese print, with its flattening of shapes and its melding of foliage into masses now making a strong contribution.[16] The way in which Puvis de Chavannes provided a sloping terrain of a continuous color and substance for his figures, nude and clothed, to stand upon equally seems to have been adopted by Gauguin as a device of spatial organization appropriate to his outdoor Breton scenes of the first half of 1888. If so, this was based on the opportunity there was for him to see such compositions of Puvis's as his *Women by the Sea* of 1879 and his *Doux Pays* (Gentle Country) of 1882 on exhibition in Paris at the end of 1887, after he had returned there from Martinique.[17] But it was in his fan designs done in gouache and watercolor from 1884 on that Gauguin—while working within a basically Impressionist idiom of figures at work and rest and other everyday constituents, fitting into place within an open-ended sector or segment of natural scenery—was most able to give his landscape settings a dreamlike quality.

Along with the basic nature of the medium here, lending itself to delicate nuance and a

fluid merger between elements of an opposed material character, Gauguin used the creative procedure that was termed earlier (page 118), in reference to the eighteenth-century *capriccio bricolage*: that is, an improvised piecing together of elements that is designed to create an evocatively charged interplay of relationships between them.[18] In Gauguin's fan designs, the elements in question have a signification embedded in them from an earlier existence of theirs. He used for this purpose motifs from works that had come to form part of his personal collection dating from earlier in his career, by Pissarro and Cézanne especially in the case of landscape, and from 1885 on ones adapted from earlier works of his own. He freely displaced and regrouped these motifs in relationship to one another, and to the surrounds devised or concomitantly restructured to fit the format in question. The result is an atmospherically enlivened zoning or layering of space, with suspended or floating relationships in that space and in time becoming emphasized for their own sake.[19]

When Gauguin was interviewed by Jules Huret in February 1891 at the Hôtel Drouot in Paris, in advance of the auction sale of his paintings which was set up to help finance his imminent departure for Tahiti, he spoke of how he was going there "to immerse [him]self in virgin nature." Once "rid of the influence of civilization," as he tendentiously put it, he wanted only "to do . . . very simple art . . . with the aid of nothing but the primitive means" that were available to him as they were to savages and to children.[20] But as to the nature of those means that he proposed to draw upon, the newspaper in which Huret's text appeared had published in advance a week earlier the text that the admiring critic Octave Mirbeau had composed for the catalogue of the auction sale itself. There Gauguin was characterized as set on being able to find, in addition to silent peace and solitude, "still dormant, inviolate, the elements of a new art conforming to his dream." In Mirbeau's overelaborated psychological interpretation, this instinctual search, motivated by the artist's desire to recover lost but effectively remembered experiences of his tropical childhood in Peru, was one that had already led him to Martinique four years earlier. To explain how, from that point on, the guiding dream had led toward "spiritual synthesis," Mirbeau also had the example of the *Yellow Christ* of September 1889 (Albright-Knox Art Gallery, Buffalo), prominent in the auction sale, to refer to. It featured as setting, beyond its Golgotha-like mound, edge of field, and bounding wall, a Breton hillside that struck a spiritual note of its own, with its "agonizing" yellow of late autumn matching the coloration of the Christ figure.[21] In terms of free and fantasizing invention of this sort, Gauguin already had a developed creative procedure that gave license to indulge in the generation of dream effects, without reliance for this purpose on European typologies of landscape.

The scenic components of Gauguin's first Tahitian period (1891–94) are not essentially different in their basic structuring. Movement is stilled, key contributory details are magnified or enlarged in their texturing and patterned interplay, and coloring in each sector is made arbitrary. But there is a difference of intonation also. As in the virgin forest and jungle landscapes of the Douanier Rousseau (from 1904 to 1908), there is an accommodation of exotically potent "otherness" to Western traditions of pictorial handling that serve to conjure up the organic configuration of each tree and plant species in a given

domain or preserve, and Western reverence for nature conceived of in a visually idealizing and finally poetic way. In Gauguin's way of transposing Tahitian landscape imagery into a variety of media, including oil painting on window glass—as also in the Douanier Rousseau's *bricolage*, combining freely improvised fantasy with adaptations from botanical and zoological illustrations and other popular visual materials—"synthesis" entails bringing into being, in objectified pictorial form, a relation between images belonging to different cultural categories.[22]

The works of Gauguin's second stay in Tahiti (1895–1901) in large horizontal format could certainly be seen in parallel to Puvis's work of the 1890s as a creator of mural decorations. This is what Gauguin presumably had in mind—having expressed admiration for Puvis's work afresh during the course of his last stay in France, in a review of a group exhibition in Brussels in which he saw it prominently represented, and in his choice of reproductions to hang on the walls of his Paris studio[23]—when he chose to show at Ambroise Vollard's Paris gallery at the end of 1898 an ensemble of eight closely related works surrounding his frieze-like *Where Do We Come From?* of 1897 (Museum of Fine Arts, Boston).[24] The paintings in question were evidently planned in advance as a coherent group, and they share with one another the compressed, stylized, and ornamental qualities that were coming to be admired now in Puvis. But there is also a spiritual aspect to them that is a matter of inference from the way of life depicted and its setting, as filtered through Gauguin's imaginative construction of both the richly typical and the enduringly mysterious. That these statuesque native figures have an active and sustaining, yet also an unworldly relationship to their surrounds—as Puvis's figures do to their environment—is something that Gauguin has to establish and communicate *for* them. And so, for the purpose of affixing a quality of timeless luxuriance to the depicted landscape, without making it appear as if it were used by the Tahitians quite unthinkingly, the earthy and the numinous are brought together and evocatively intermeshed.

Seurat seems to have drawn on both Japanese prints and the work of Puvis during the first half of his brief career (1881–86), finding an incentive in them to refine the quality of contour and develop modular proportioning of horizontal and vertical elements in both figures and landscape. But he was more centrally concerned early on, following Corot and Impressionist practice of the 1870s, with the kind of touch that could activate the picture surface and sustain a sense of consistent atmosphere, without losing the look of homely ordinariness that it gave to riverbank, field, or roadway. He did landscape drawings in soft *conté-crayon* at this time, featuring buildings of a physically unassuming but atmospherically redolent sort in rural settings, and ones belonging to the industrial suburbs, which appear also in a few paintings. This latter kind of motif he would extend, again from early on, to include subjects of drawbridge and railroad; the Place de la Concorde in Paris itself, with silhouettes or mere wraiths of figures and carriages crossing it in the gloaming; and the area known as the "zone," kept vacant between the city limits and the new industrial suburbs so that it appeared as a desolate region with unpaved and unlit paths winding through it, and an intermittent traffic of workers and whoever else might use it for passage. What all of these drawings have in common, along with the polarities of light and dark and intermediate variations empowered by the medium, is a feeling for the main

shapes that represent defining constituents of the scene, and a wispy or even scratchy kind of infilling that makes its own free suggestion of planar consistency.[25]

When Seurat takes to using more saturated colors in the mid-1880s and to peopling his major compositions—those featuring the riverside at Asnières and the nearby Island of the Grande Jatte—with a whole panoply of figures, who, individually or in pairs, are separated physically and psychologically from one another, he treats the landscape containing these figures as a sequence of planar surfaces, each of them appearing as spatially consistent from its own point of sight, which is effectively imposed on the viewer. He also strongly emphasizes the man-made features of the environment as a whole, even making this the case in a few independent canvases in which there is no human presence in the landscape at all. The latter procedure becomes particularly marked in Seurat's first seascapes, done at Grandcamp in eastern Normandy in the summer of 1885; and in those from the following summer, which were the fruit of a similar choice of beach and harbor subjects, this time from Honfleur, the roles of industry and commerce in shaping the environment and giving it specific uses are pointedly brought out. Docksides, jetties, and quays are taken as prominent motifs, while the individual sailboats that follow a wind-dictated course are made small or less conspicuous in their relative placement.[26]

In the groups of summer seascapes done at Port-en-Bessin in 1888, Le Crotoy in 1889 and Gravelines in 1890 the balance established between the sense of a frozen moment and a unifying timelessness of vision becomes crucial to the mood imparted. A delicately attuned flexibility as to what is included sustains that mood, by limiting or playing down any implication of internal tensions. So also does the viewpoint implicitly adopted, bringing near and far into counterpoint, and the emphasis that goes with this, area by area over the whole surface, on the decorative rather than descriptive role of the pointillist dots as they flatten out and form an aggregate.[27] The way in which the play of color and of light in these seascapes makes itself felt as a virtuoso embellishment and orchestration of the ordinary is germane, in fact, to the kinds of creative procedure that Symbolist poets were working with at the time.[28]

In that connection, the question of whether Seurat's absorption in nature and his resultant ability to distil a potent poetic mood outweighed the "superficiality" of his technique was a subject of active debate among contemporaries of his who were involved as writers and critics with the Symbolist movement. It could be argued—as the novelist Joris-Karl Huysmans felt was the case—that Seurat's treatment of figure subjects consisted merely of static contours overlaid with a system of dots, so that the effect was soulless, unthinking in its tenor, and without any potential such as the seascapes had to stir up reverie.[29] But a view that was truer to the essential character of the seascapes was presented by the Franco-Flemish Symbolist poet Emile Verhaeren when he wrote in 1891 of their "precision of harmonies" and the "special and clear sonority" that they achieved. Those done at Gravelines the previous summer were, he felt, Seurat's "triumph," establishing that there could be a "harmony born just as successfully from a combination of light and blond tints as from strong and vibrant ones."[30]

As for Cézanne: he had appeared in the Impressionist exhibitions of 1874 and 1877, showing two landscapes done at Auvers on the first of these occasions, and on the second

three more (among fourteen canvases of his), together with a group of watercolors, two of which from the later 1860s were labelled "impressions from nature." This latter touch seems to have represented his way of showing solidity with the group. But the critical response to his work on that occasion was consistently deprecatory, with the exception of Georges Rivière who in his long review of the exhibition praised him and found that his landscapes had an "imposing majesty" to them.[31] The paintings of the bay of L'Estaque with factories and houses that he did at this time have the kind of flattened shapes and assertive color of a single basic saturation associated with playing-card imagery; and so whatever sense there might be to them of a temperament focused on working directly from nature became lost in their suppression or distortion of expected spatial relationships.

During the 1880s Cézanne was increasingly an isolated figure, and the disciplining of earlier impulsiveness on his part that was entailed in his systematic study of a few narrowly chosen motifs in the Provençal countryside, as if to extract their essence, was not yet seen as a way of giving concrete structural expression to an original approach to the rendering of nature: one that was so attitudinally focused that it took on the force of an informing "idea."[32] The work was seen, at most, as strangely hermetic in accordance with its concentrated intensity of focus and the slow, meditative pace of observation and paint application that it entailed.[33] After 1890, when three canvases of Cézanne's received a showing with the Vingtistes in Brussels, and more especially after an exhibition devoted to his work was held at Ambroise Vollard's Paris gallery at the end of 1895, critical admiration for his art gradually grew, complementing that of younger artists who had perceived for themselves his importance. But reservations were still attached, and it was not until much later that Cézanne's landscapes of the 1890s, including a much-increased production in watercolor, would gain an appreciation in keeping with their enriched coloring and more skeletal frameworks.

Two points especially contributed in this context to a coming to terms with what Cézanne's art represented, as a product of unremittingly steady and endlessly repeated confrontation with nature. First, the seeming mystique of his way of working could be seen as having a spiritual dimension to it: in his very isolation and his commitment to "sincerity" of a self-affirming and self-trusting kind, without overt theory to support it, he could not be aligned with any other development.[34] Second, there began to emerge around 1900 an anticipation of the early twentieth-century view of Cézanne as a great decorator. Georges Lecomte in particular, while he remained unable to exorcise a concern about the failure of the "various lines of the landscape to recede into the atmosphere," wrote of how the studies of nature gave the impression of a "sumptuous tapestry." The use within them of "closely related values or very simple flat tones" that withheld any sense of distance took on the fully laudable effect of creating "exquisite harmonies."[35]

Thus the attraction of ideas regarding the spiritual and the decorative that Post-Impressionism introduced, and the concomitant concern for harmony of a physically based kind that could combine with the achievement of gravity and a sense of mystery lie at back of two different orientations of purpose and practice that coexist in early twentieth-century landscape art. On the one hand there is the "aesthetic" landscape that, from Whistler's work of the 1870s on, follows in the tradition of watercolor in being

predisposed toward flatness, thinly painted and condensatory of sensations; but that becomes more self-consciously set now on promoting the sense of a rarefied or occluse and seemingly visionary world, through both suggestiveness of organization and the quality of the paint itself.[36] And there is also alongside this a landscape art that is more robust and declarative in conveying the sense of a struggle with an immediately available environment, so as to extract poetry from the rhythms of nature to be found there. Part of this poetic effect may derive from the adaptation of new subject-matter, or new variations within a set range of themes, to a project of a broadly "decorative" order that is (as with van Gogh and Gauguin) already in process.[37]

For aestheticizing purposes, the subject of still surfaces of water with light coruscating over them became in the later 1880s and early 1890s one to which the Neo-Impressionist techniques of Seurat and his followers could readily be applied: especially with the sea, it allowed for a total or almost total absence of incident and for a suppression of any real clues as to the regional identity of the site.[38] Gustav Klimt, who had begun in 1897–98 to do landscapes during his summer vacations without people in them, extended this practice after 1900 to paintings of the Altersee, in the foothills of the Alps. Often working from a boat, he began these canvases in square format out on the lake in question—without apparent guidance from sketches or studies—and while some were brought to completion in the open air, the majority were finished back in his studio in Vienna. This and the use of pointillist dots, probably deriving from the example of Paul Signac, account between them for a hermetic quality that is found here: with no opening up of further space, nature is kept airless, static, and seemingly unaltering.[39]

For a more robust treatment of landscape subjects, of the kind undertaken by Henri Matisse and André Derain as a central part of their contribution to Fauvism between 1904 and 1907, the concept of the arabesque proved itself crucial. Deriving in principle from the treatment of natural elements such as flowers, fruit, and leaves in the arts of the Orient, and extending on occasion to figural motifs there also—as it would come to do in its application to the graceful line of a dancer's whole body—it implied accordingly an extended pattern of rhythmic curvature. How this concept could be applied in a basically "decorative" but at the same time enhancing way to landscape is brought out in a letter of André Lhote who, as a contemporary of the Fauves thinking along similar lines to them, wrote in 1907 of "[expressing] the rhythms of nature in a fictive way, by arabesques that intertwine, that intersect one another harmoniously, that divide up musically."[40] A principle of selection and organization in dealing with nature is adumbrated here, through which powerful forces in the artist's temperament can express themselves in controlled fashion, by his setting up and ordering for this purpose figurative equivalences in the natural world.[41]

It is perhaps no coincidence that these two developments, in some ways complimentary to one another, should coincide in point of time with the rise to immense popularity of the tourist postcard. As compared with the garden and park, or the beach and coast photographs contemporary with the opening phases of Impressionism, such postcards offered a flattened comprehensive view, or a "report" on life in remoter parts of the world that were becoming growingly reachable now by sea or land travel. They promulgated to a

widespread, potentially limitless audience the canonical viewpoints from which cele-brated sites and regional attractions (such as beaches and ports) were to be seen; where color was added, it was of a superimposed and essentially token kind. What landscape painting could provide was on the one hand more rarefied, and on the other less familiar. It offered a different idea of what was immediately available in nature, both to fashion a sense of poetry and to match up with a particular cast of temperament.[42]

The extent to which such arrangements of imagery and such effects of coloring did or did not bear on the temper of experience and patterns of perception belonging to the modern era was in fact a topic of argumentative reflection, as the new century took on shape in these respects. Writing on Claude Monet's paintings of *Waterlilies*—forty-eight of which from the period 1903–8 were exhibited together in Paris in 1909—Claude Roger-Marx found this artist's approach to landscape painting "in tune with our times," thereby proving "a high level of technical knowledge" on his part. In this critic's view, the "dizzying speed" of life now, and the demand of "the creative person . . . [for] quick and violent impressions" as the only way of "seizing what is going by" made "an interdepen-dence established by impersonal relationships" altogether more important than "the concrete reality of things." What Monet "aspires to do and does so well," he wrote, is to paint "air and light . . . affinities and reflexes," and also "atmosphere and harmonies," the latter of a "pleasant and light" kind. In the way in which he accomplishes this for the "intimate life of the out-of-doors," an animating enthusiasm causes the viewer to "know and to love beauty everywhere" through the intermediacy of his vision; this is a beauty that eludes "both a casual glance and scientific examination with lens and compass." Monet's "extraordinary sensitivity . . . succeeds in making us share his own emotion, joy and humanism." In his ability to "[give] close attention to even the minutest details" and the sense he conveys of "an inner poetic life," he is truly, in the phrase of the early Romantic philosopher Novalis, "a harbinger of Nature."[43]

Three years later, the British painter-teacher Ernest Govett would express extreme irritation with any such critical view of the achievements of Monet. For him, no one writing in praise of this artist's *Waterloo Bridge*—a version of which had recently been acquired by the Gallery of Modern Art in Dublin—had been able to explain "where its supreme beauty lies," or show "how the shadowy form of an ugly bridge in a foggy atmosphere can be permanently beautiful under any circumstances." Later in his book *The Position of Landscape in Art*, which appeared under the nom de plume "Cosmos," he made almost exactly the same complaint about Whistler's *Battersea Bridge* (in the Tate Gallery, London) of some three decades earlier. But it was not just nostalgia for a time before such pretentious claims were made that moved him to remonstrate in this fashion. He believed that, aside from "matters of invention dependent upon the artist individu-ally," there cannot in the painting of landscape be "higher, or in fact any other concep-tions"; for there are no "mental attitudes" that come into play here and "the character of the signs is fixed."

Four great artists in "pure landscape"—"Claude and Turner as to distance, Hobbema and Ruysdael as to near ground"—had in Govett's estimation brought this branch of art to perfection through their special skills: in aerial perspective in the case of Turner, in

"details of small and natural phenomena" with the last two. And since "there is nothing more in nature," when it comes to desiring to "paint a great picture," than what is put into evidence in the work of those four, the student must make his choice between the two "departments," not hoping to become supreme in both; and other artists' work must either be "good" in the sense of being suitable for wall decoration, or on the basis of "pot-boilers" turned out in allegiance to "ephemeral schools." Landscape painting represented for Govett a field of "comparative simplicity," and given the essential fallacy of the Impressionist argument for "suggestiveness" that Monet's work exemplified, it was inevitable that advocacy of it, and of Post-Impressionism also, should have proved a source of "degrading and devastating influence upon modern art." "Poetry" in painting and a heightening of color to express emotions of the artist's were both inappropriate, to the achievement of beauty and to the giving of an ongoing place to landscape—including whatever capacity it might have to provide an illusion of movement—in the present-day world of thought and creation.[44]

LANDSCAPE AND THE NOVEL

How did the interests and concerns of landscape art in fact position themselves early in this century, in comparison to the role of landscape in the major literary form of the novel? To arrive at a just measure of comparison here, one can turn back initially to the novels of Thomas Hardy. Those for which he gained critical recognition begin with *Far from the Madding Crowd,* published in 1874, and continue down to the appearance of *Jude the Obscure* in 1896. And landscape in them has an extraordinary—one might say unparalleled—quality of resonance, weaving together the temper and occupations of human beings with the character and mood of the environment in which they lead their existence, and the settings through which they move as actors in a larger drama.

As a result of his initial training and practice as an architect, Hardy was drawn to using a pictorial language for the description of landscape in his early novels: one that embraced not only foreground, middle distance and perspective, line and tone, but also more technical terms such as "planes" of illumination and "strata" of light and color. When he characterized his *Under the Greenwood Tree* of 1872 on its title page as "A Rural Painting of the Dutch School," he was drawing on the opportunity he had had in London in the 1860s to expose himself to works on view at the National Gallery and in the Sheepshanks Collection at the Victoria and Albert Museum; he also responded to summer subjects of woodland, meadow, and cultivated field on view in the annual exhibitions of the Royal Academy.[45]

In key with the four tropologies discussed in the last chapter, Hardy's major novels have homely details of rural activities spread through them, each in its appropriate regional setting, and also evocations of an idyllicized pastoral world, where this fits the tenor of the writing in terms of the associations brought in. He makes use of a belated metaphorical elaboration of the pathetic fallacy when he endows the natural world with a mood matching the destiny of his protagonists, as with the violent raging of the elements; and it

is germane here that in a note of 1887 he associated Turner with the portrayal of nature as a mystery, the revelation of "[a] deeper reality underlying the scenic," and at the Old Master exhibition at the Royal Academy two years later he discerned in each of the watercolors of Turner on view "a landscape *plus* a man's soul."[46] Hardy sets into play an ironic counterpoint between passionately charged moments, such as those of lovers parting from one another, and the concurrent appearance of the surrounding scenery, changing in its forms and colors to become funereally gray and cold. And in his descriptions of Egdon Heath he offers a sense of the sublime—based, it seems, on a reading of Burke's *Enquiry* (see Chapter 4) on his part around 1875—as persisting even in a highly industrialized world: but only in a "chastened" form that conveys "a sense of brooding, infinite loneliness."[47]

Pictorialism of this kind, elaborated and thematically encompassing—as in van Gogh's descriptions in his *Letters* of subjects in nature that he might choose to paint—breaks off after 1900, as a mode of interchange between the arts. And perhaps this was inevitable, in terms of the alterations in the character of visual experience and accompanying patterns of perception that were alluded to by Roger-Marx in the passage quoted earlier. To put philosophically the difference that is entailed: the space of the twentieth century is a space in which the artist's acts situate themselves in relation to one another, so as to take on purpose and direction, without any reference to an experiential unity that can be taken as serving as ground for those relations, other than that of the unfolding logic of creation that warrants the works appearing as they do. In the tradition of eighteenth-century and later empiricist theorizing, memory was given the role of bringing together past moments of consciousness, to be compared with one another and with the present. In that way individual sensations were placed under the envelope, or within the compass, of a larger unfolding of consciousness that reached through time. The depiction of landscape had to become reconstitutive in its operations accordingly. It dealt with experience from the standpoint of making publicly accessible what was no longer wholly immediate and personal, in its impress on the awareness and what was made of it, and yet remained moment-oriented inasmuch as it engaged with a potentially repeatable actuality, of what was there to be perceived and retained.[48]

Such a space to be grappled with, and such a reconstitutive practice on the artist's part are, from the standpoint of self-definition and reflexivity, more readily or properly located in the world of the studio than in the outdoors. The unfolding achievement of both Cézanne and Monet late in their careers, and especially after 1900, affirms this; as do equally the passages having to do with landscape included in Marcel Proust's *Remembrance of Things Past* (1906–22), and the recuperative purposes that it is made to serve there.[49] Under such terms of concentration and focus, landscape is put on a par in principle with portraiture, still life, and painting from the model. Its role tends toward the provision of a generic type of outdoor view, or at the very least, what counts as a genuine image of nature or record of experience—as against what is "found" within the act of making—becomes confused or obscured. Such is the case with the landscapes of Cubism from 1908–9 on, and in Pablo Picasso's and Georges Braque's case more endemically so; one striking example being a very large painting—known only from a studio photograph

showing it in an unfinished state—that was embarked on while Picasso was staying at Céret in the south of France in the summer of 1911. He described it in a letter to Braque as including in its imagery the geometricized shapes of houses, round and square; round windows and dark apertures with light playing over them; and a "stream in the middle of the town," with some kind of bathing scene going on there.[50]

It would appear along these lines that, in the new century, landscape as subject increasingly offered occasion for an arrangement of components that was without internal strain to it—even, or in some cases especially, where man-made and natural elements were conjoined—and that in this way contemplative response became linked to a more evidently iconic quality (as with Piet Mondrian); or to permutations on a self-limiting repertory of motifs (as with Derain after 1908). A thinning out of both internal specification and directly emotive resonance could be inferred in literature equally, as compared to Hardy's example. But it is also the case that two different developments, in imaginative prose writing early in the new century, lead away from the kind of pictorialism that Hardy represented.

To stay for the purposes of continuity here with what happens in England: D. H. Lawrence puts emphasis in his early novels on the tie of human beings with the earth (rather than the land, which is owned and inherited) as a source of fertility, instinctual rhythm of being, and organic strength. For this purpose, in *The White Peacock* published in 1911 (but begun already in his first year at university), and more especially in the long segment of *The Rainbow* (1912–15) which is devoted to the courtship of Will and Anna at harvest-time, he emphasizes coloring and texture in his descriptions of nature. He does this in a reverential spirit that at the same time implies an extended familiarity with European paintings from the Renaissance on. From those paintings comes a strong counterawareness, of the evidence to be found in them of what Lawrence calls in Turner's case an "utterly bodiless" response to nature: one based on an increasing propensity to deal with it in terms of intellectual and spiritual "abstraction," and individualism of a essentially solipsistic kind.[51] There is an implicit parallel to this viewpoint in the desire for a deepening interaction with nature, at a personal and popular level, that feeds into the art of the Worpswede colony in northern Germany (founded in 1889) from the mid-1890s on. The impulse at work here, picking up on the role assigned to landscape and nature in the Arts and Crafts movement, and continuing the Romantic spirit of response to industrialization and urbanization (see Chapter 3), is to generate a kind of "intimacy" that modern life is felt to lack. Brown moors and canals, birches, pines, and willows become for those artists of the colony who work specifically with landscape, such as Otto Modersohn and his wife Paula Modersohn-Becker in her work of around 1904–5, choices that are not only distinctive to the region, but carry an underlying valuation of opposing themselves in color and texture to impure man-made things. Rainer Maria Rilke, in his 1903 short text on the art of the colony, referred poetically in this connection to "contrasts resound[ing] together like gold and glass."[52]

Wonder and desire, on the other hand, are engaged directly, as emotional forces bound up in response to landscape—together now, rather than separately as in earlier periods— in W. H. Hudson's *Green Mansions* of 1904, subtitled "A Romance of the Tropical

Forest." Hudson was an ornithologist and naturalist who had become a cult figure with the appearance in 1884 of the account of his travels and adventures in Uruguay, which he called *The Purple Land that England Lost*. Born in Argentina, he had visited Patagonia to study the birds there before he moved to England in 1874. But he had never seen any rain forest like the one in Venezuela that he conjured up in the opening chapters of his "romance": so named because it tells the story of the passionate love of its narrator for the bird-girl Rima. He takes up residence in a mountainous district of Guyana, west of the Orinoco, in a village peopled by Indians who will in the end destroy Rima. Their motivation comes from her presence in the adjacent forest, which they treat as a malign force and refuse to enter. The mysterious character of its spaces—penetrated by the sunlight to create extraordinary richnesses of tint and interplays of light and shadow, but enclosing a terrifying darkness during the night hours—serves as a locus of spirituality that fosters a deep sense of well-being, as well as affording an intensely luminous vegetal ambience. In these respects Hudson's sentient evocations of flower and frond, foliage and the fascination of light build together, to offer at the close a vision of "beauty and freshness of nature," as if created "over all again."[53]

There is a strong analogy in this case to the landscapes of Henri Matisse, beginning in 1904, and especially his Moroccan subjects of 1912–13. It is arguable that even in his Fauve years, 1904–7, Matisse paints the world of the outdoors not as experienced through the pulse and drift of sensations—as Derain and Henri Manguin amongst the other Fauves do, using heightened tones and pure colors for this purpose—but rather as a series of marks or patches setting down selected aspects of that world, so that they are metaphorized as they are felt or, one might say, encoded accordingly.[54] Both ironic wit and an imaginative condensation of essentials come into play in this fashion. In his *Luxe, calme et volupté* of 1904–5 (*Luxury, calm and desire*, now Musée d' Orsay, Paris) Matisse combined an invocation in the title of Baudelaire's poem "L'invitation au voyage" ("The Invitation to the Voyage" of 1854, with this refrain) with a south-coast beach scene and reminiscences of Cézanne and of Signac (who acquired the work). It may be that the figure stretching out her arms on the left there corresponds to luxury, the seated mother figure to calm, and the child who stands looking at the nudes to the birth of desire. In which case each of those figures has, like Bruegel's hunters (see Chapter 2) a matching vector in the landscape itself: those of horizontal mountain ridge, curved shoreline, and diagonal beach with a boat moored to it.

Neither *Pastoral*, done in the summer of 1906 at Collioure in the south of France (Musée d'Art Moderne de la Ville de Paris) nor the two versions of *Le luxe* from 1907 (Musée National d'Art Moderne, Centre Pompidou, Paris and Statens Museum for Kunst, Copenhagen) have the kind of elegance and self-regarding shapeliness to them that is in key, thematically and expressively, with the tradition of such subjects involving the nude; rather, the landscape seems to be pressured and constrained into echoing the exposure of the figures in its somewhat awkward or primitivistic sensuality. The counterpoint in the open-window subjects of 1908–13 between indoors and outdoors can then be understood in a related light. It entails, among other things, a running contrast between

the expansive invitingness of outdoor spaces and the closed interior world of pattern, decoration, limited time, and enduring arrangement. Internal framing suggests how that expansiveness and the bestirring rhythms of landscape associated with it can be domesticated and reshaped to bring them into keeping with a contemplative world of stillness and order, in which artistic creation of a containing kind takes place.[55]

Matisse's Moroccan landscapes heighten the implicit tension at work here between description, as it fashions a depictive framework capable of generalizing aspects of nature that are charged with sensory appeal, and evocation, as it relays reflexive preoccupations of the artist's. Their treatment encompasses both what is veiled and mysterious in the role of intense light, and the kinds of transparency and internal richness of coloring that in a concretely physical sense, correspond to the spread of that light. Matisse went to Tangier twice over within a thirteen-month period, staying from late January to April 1912 and again from early October to the following February, so that he was there in both cases off-season. In the three large canvases of a villa garden that he did on the first stay, after the rain ceased (Moderna Museet, Stockholm; National Gallery of Art, Washington, D.C.; and Museum of Modern Art, New York, featuring respectively acanthus, palm, and periwinkles), and in the handling of sky, trees, and roadway in the *Landscape Viewed from a Window* destined for the Russian collector Ivan Morosov (Pushkin Museum of Fine Arts, Moscow, evidently begun at that time and brought back with him later for reworking) Matisse both refused sweetness and maintained an extreme mobility in all of the components in question. Perhaps because the tourist postcard as he knew it conveyed an altogether too easy or bland assimilation of the exotic to material well-being, and allowed key decorative elements of mosque and gateway to meld in deep, rich shadowing with motifs of native life and custom, rather than assert themselves individually, he summarized essentials of perceptual experience, which included in the last case the structuring of buildings in space. But in modifying his method of paint application from canvas to canvas, he was also concerned with promoting, in the amalgam of colors and shapes, the ascendancy of a visionary quality.[56]

With the coming of World War I—not at its outset, or during its opening years, but from mid-1916 on—all such response to landscape, oriented toward the conserving of a sense of intimacy as with the Worpswede artists, or the enkindling of wonder and desire, as with Matisse, became irrevocably condemned to lose its hold on the visual and poetic imagination. This was especially the case amongst those who had seen service on the Western Front, and had come to recognize through that experience what was actually entailed, physically and mentally, in what was referred to—euphemistically and in turn ironically as the war progressed—as the "making of a New World." Paul Nash would give a landscape of his that title. Returning to the front in 1917 as an official British war artist, he did a pastel of *Sunrise, Inverness Copse* that would come to be used as a related study; on the back of a photograph of it he wrote:

> The most dreadful place I ever saw. The sun was just breaking white pale shafts of
> light. Against it stood gaunt broken trees: they seemed to reel. The ground as far

as the eye could see was churned and twisted, gouged and heaped in fearful shapes . . . no man lingers in this country.[57]

How could there be any active appreciation on the part of a viewer for such a landscape, in which human beings became starkly insignificant or appeared as the agents and victims of mechanized warfare on a vast scale; one where natural forms were totally absent, swallowed up or torn apart, and any sense of a background to what one saw disintegrated or became derationalized? If, indeed, such a viewer were present, he would be one with small prospect of survival.[58]

The novelist Ford Madox Ford, on duty at Ypres in September 1916, the third month of the Battle of the Somme, wrote of the sheer difficulty of describing in words a "wide landscape," with close to a million men engaged in it when the two sides were totaled, and yet one that did not allow real purchase on what was "beneath the eye, or hidden by folds in the ground," so that the effect was of being "upon a raft in space."[59] And the poet Wilfred Owen commented in a letter home of January 1917 on Muirhead Bone's series of two hundred drawings, which were being published in monthly installments from late 1916 on with an approving foreword by Field Marshal Haig and commentary on each plate by an intelligence officer attached to GHQ, and which showed hilltop views assuming the kind of purchase on each sector that Ford was bewilderedly unable to find. Those "Somme Pictures," Owen wrote,

> are the laughing stock of the army. . . . No Man's Land under snow is like the face of the moon chaotic, crater-ridden and uninhabitable, awful, the abode of madness. To call it England [because we keep supremacy there]![60]

Such hideous disfigurement of nature was equally brought up by Arnold Bennett—a novelist of pre-war vintage—in the introductory note that he contributed to the catalogue of Nash's 1918 exhibition in London, titled "Void of War." Bennett referred specifically to "the wave-like formations of shell-holes, the curves of shell-bursts, the straight lines and sharply defined angles of wooden causeways, decapitated trees, the angle of obdurate masonry," and he underscored how those repeated features found their way into the art on view, inescapably, because they represented "the obsessions of trench-life."[61]

One of Nash's most poignant war drawings (Fig. 69), embodying a particularly shrill configuration of lines and starkness of shading, was done after he moved from the battlefields around Ypres to Vimy Ridge and to the area of some fifty square miles around Passchendaele that, after a three-month campaign of intense bombardment, was totally devastated by the end of October 1917.[62] Thin diagonal strokes, slanted and in places intermittent, crisscross the segment at the top of this sheet, to evoke both searchlight beams and the tracery of bullets. The field itself is made up of uneven lumps or clods, with ultimately shapeless paths or unprotected areas of trench dispersed through it. There are water-filled holes, stretches of barbed wire that have been ripped apart, pieces of broken laddering that turn into crosses; and, not so easily made out at first viewing, bodies lying

Fig. 69. Paul Nash, *After the Battle*, 1917. Pen and watercolor on paper, 18¼ × 23½ inches. Imperial War Museum, London

without a vestige of dignity where they fell and a gaunt skull adding pathos, with its semblance of sight and expression, to the uniformed corpse in the center. The signs of destructive force enumerated in this fashion combine with the skewed vestiges of a structure remaining, to give the bare setting of slopes and escarpment an identifiable overall shape. Wonder, at the extent of the ravagement, becomes overridden by disgust or by a sense of fear, as if an equivalent to the ancient wrath of the gods had been visited upon the natural world in this way.

When forms of landscape imagery that are unrelated in principle to the war and its aftermath came to have a newly restored importance in the 1920s and 1930s, these can be taken as representing a fresh piecing together of possibilities, into which there fed some element of antipathy to the pre-war hallowing of landscape on sectarian or spiritualized grounds. Joan Miró, after he began making regular trips to Paris in 1920–21 and attaching himself to its art scene, moved away from the openly nationalistic emphasis of his earlier landscapes, done at and around Mont-roig in his native Catalonia and showing, in 1917–18, details of local architecture along with the patterning of fields and vegetable gardens.

Though he would sometimes use national emblems in his paintings thereafter—including the Catalonian and Spanish flags, or color schemes based upon them—he was concerned above all, as a Surrealist, with the freely poetic ways in which diversified associative elements could be brought together. And Matisse in those same years, having moved to Nice at the end of 1917 and found its light and the framework of social life there intensely congenial, chose outdoor subjects that directly reflected this combination of factors, including views of the bay and ones of the coastal road seen through the windshield of a car. A more relaxed and even indolent spirit governs the behavior of the figures—mainly smartly dressed ladies—that are included in these settings.

Two broad alternatives in the treatment of landscape come to the fore at this juncture. The first of these might be called, by way of a distinguishing overview of its character, the "landscape of presence." Fantastication here, spiritual or surreal in flavor or a combination of the two, serves to evoke a world of nature lying beyond human order and control. In Paul Nash's case the idiom of "anti-landscape" spelled out how far devastation had gone by the use of futuristic devices, in conjunction with an absence or withholding of defining viewpoint. In the landscape of "presence," contrastingly, the bizarre and the irrational are elaborated to the point where what appears as a totally liberated spontaneity of imagination speaks for the artist's whole personality, as it defines itself and gains purchase in this form.

For precedents in earlier art for this kind of elaboration in landscape and the quality of the uncanny that goes with it—with the elements that are used for that purpose made unfamiliar, as in a dream, and seemingly divorced from any implication of human activity, even where figures constitute part of the scene as a whole—one can turn back to Albrecht Altdorfer's *Battle of Issus* of 1529 (Alte Pinakotek, Munich); to the images of forest and wooded mountainside conceived by the Fleming Roelandt Savery early in the seventeenth century; and to the nocturnal subjects done on copper by the German-born painter Adam Elsheimer, active in Rome between 1600 and 1610. The elements of landscape are conjured with in those cases, so that they become like a container in themselves (rather than a conduit, as with Bosch or Patinir) for moods and feelings that bring rhythm and significant detail, space and light, into imaginative accord with one another.

What is done to achieve "presence" of this order takes off in character from the kind of insistent activation that one finds in a loose sketch; or from the tenor of attentiveness to line and coloring that appears to engage an artist independently of a fully conscious and controlling mental mechanism. That painters should be attracted by this kind of process in principle begins to speak for itself by the eighteenth century, as an incentive for their taking things further (see page 113). Earlier than that, all that can be said of the motivation of the transformative process is that it remains implicit in the internal structuring of the image that is generated, rather than depending on the nature of a given and preceding subject. Consequently it stands in doubt what kind of ruling tone should register as being at work; and the very word "play" may be misleading.[63]

Miró's imaginary landscape settings of 1926–27 are, when one puts their contents together, peopled with a combination of animals and birds, and insects and flowers also.

Figures too appear, schematized like the animals to emphasize certain of their body parts. Stones along with their trajectories and an ascending ladder help to embody the mesmerizing effect of the whole upon the creatures who find a stopped place or hang in suspense within its bounds. But none of those elements impinge upon the setting, in the sense of breaking into its continuity and self-containedness.

The purest poetry of "presence" is to be found in Miró's large *Landscape with Rabbit and Flower* of July–December 1927 (National Gallery of Australia, Canberra). The red ground there and the blue above stand in for earth and sky, with the semblance of a dividing ridge of hill in between. This kind of hilltop contour had first been introduced by Miró in a Mont-roig landscape (Sant Ramon) from the summer of 1916, and it reappears in schematized form as a horizon in his *Catalan Landscape: The Hunter* of 1923–24 (Museum of Modern Art, New York). But the fluidity of the medium has become during that time period a stimulus to invention it its own right; and when Miró returns to using this kind of contouring for landscape in the mid-1930s, it will be subject to still further metamorphosis. Like Altdorfer's tract of strongly lighted but seemingly frozen sea, the terrain that is conjured into being in this way has resonances of extent and depth given to it, without its becoming a floor. Similarly dreamlike qualities come to govern Max Ernst's fantasy settings in the later 1920s.[64]

As to the second broad trend in landscape painting that gathers momentum during this period: Matisse, in his taking up of themes associated with Impressionism and with the social pleasures of the belle époque, may appear as caught up in the postwar years in socially conservative retrospection. But his understanding of frame and of the placement of incident within it, and likewise his command of touch bestow on what he does with the outdoors in the early 1920s a quality of surface organization more akin to watercolor than to the solidities expected of oil painting, especially in the delicacy of spread that is given to liquid colors and the softening of shapes that goes with this.

Matisse applies that way of working to what may be called generically, in the context of social history in the interwar years, the "landscape of tourism." Such landscapes serve to express a quality of life that is visualized as belonging to a particular region and its local people: a quality that—as if in resistance to growing popular appeal—is mythologized as being intrinsically simple, and fascinating when seen in terms of its long-standing continuity. From the late sixteenth century on, beginning perhaps with Annibale Carracci's *Fishing Scene* (Louvre, Paris, c. 1587), visitors to the Italian landscape are depicted in the role of entranced bystanders; in the seventeenth century they are shown taking in beauty spots there and in the North, either on foot with a guide or from horseback. In the eighteenth century such visitors turn into cognoscenti, on the Grand Tour: a totally secularized version by this time of the medieval pilgrim. But it is when the more secluded resorts and the coastline beaches and villages close to them become desirable places of summer residence—as happens in the later nineteenth century, for colonies of artists especially—that the growing commercialization that attends this development brings with it an aestheticized vision of what the local culture takes from the landscape, and gives back to it symbiotically in return.

The three canvases of the *Large Cliff* that Matisse does at Etretat in Normandy during

Fig. 70. Henri Matisse, *Large Cliff with Fishes*, 1920. Oil on canvas, 36⅝ × 29 inches. The Baltimore Museum of Art, The Cone Collection (Copyright 1996 ARS, New York / Succession H. Matisse)

the summer of 1920 include, beside the one illustrated (Fig. 70), versions in exactly similar format with an eel (Columbus Museum of Art, Ohio) and two crayfish (Norton Gallery of Art, West Palm Beach, Florida). This site was one that Gustave Courbet had visited and painted in the 1860s, followed by Monet later in that decade and again in the mid-1880s. Matisse equally paints the massive cliffs and shoreline, but he puts the hollowed and distinctively curved "portal," which is one of a trio linked to this site, further back in the middle distance, and uses generally more attenuated tones or paler colors. Above all, he adopts the fish brought in from the sea as a predominant, enlarged motif that sits on a bed of seaweed on the beach and fills up a large proportion of its vacant foreground space.[65]

This occupation of the available surface closest to the eye introduces a classical quality of composure here, like that found in ancient wall paintings of cliff, rock, and water that have a preeminent centralized motif. Its significatory role is to valorize in contribution to the scene what the visitor with similarly overlooking gaze would appreciate as a regional

"catch," and expect to find correspondingly. As compared to Picasso's shorelines from his summer of 1928 spent at Dinard, which serve as a kind of minimal playground for his grotesque figures and other inventions, there is in Matisse's case a foreshadowing of the local flavor to which younger artists—such as Christopher Wood, working in the Tréboul area of Brittany in 1929 and 1930—would more explicitly dedicate themselves. The imaginative simplifications of shape and color that attend such practice mark by that time a projection onto the character of the landscape. What can seemingly remain simple and straightforward enough to preserve, in a world of increasingly disruptive change, its interlocking dignity of appearance and quiet calm is for that very reason idealized.[66]

LANDSCAPE AND NATURE POETRY

One way in which to characterize the structuring of an Impressionist canvas in its most distinctive aspects, as they appear to us today, would be to say: it is as if the painter, looking through a window or some other form of framing at the view outside, chooses to represent what appears *on* the window itself, as opposed to depicting the view *through* that frame and beyond. To do this is to bring into being on the canvas surface a web of strokes and patterns that could appear indistinct or illegible in respect to what exactly is depicted, part by part. But it is also to offer to the viewer a "picture" of the landscape in question that, however broken up and lacking in full definition it might appear configuratively, could be understood as a representation if its particular choices of accent and its informing harmonies and contrasts were taken as the product or upshot of a continually active process of rearrangement and redefinition practiced upon the surface.

What is being said here about the Impressionist endeavor entails in fact a postulate that is not one belonging to that time-frame, but rather to the twentieth century, in which it comes increasingly to the fore.[67] According to that postulate, the marks and patterns made on the two-dimensional surface signify collectively a certain way of seeing the world. When put together in aggregate they serve as sign-formations, composing a landscape for the viewer, and imposing also an ideology in the shape of an implicit set of directives as to how that landscape is perceived.

Now if the ideology in question is thought of as one that gives special place or charge to the adulation of what passes in contemporary consciousness as being a "poetry of nature" and is subsumed under that name, the fashion in which it does this become crucial. On the one hand, the notion of "nature poetry" that applies here is itself a twentieth-century construction.[68] It entails looking back in the case of England, for a perspective on the countryside, to so-called retirement poetry of the eighteenth century, which promoted rural pleasures as a form of retreat from the city and from society; to the image of John Clare as "peasant poet" based on the publication in 1820 of his *Poems Descriptive of Rural Life and Scenery*; and above all to the modes of feeling and forms of language that William Wordsworth had adduced, to ground the sense of an ongoing transaction taking place between his own imaginative perceiving and the powers and sources of pleasure belonging

in that perception to nature. The relationship between poet and painter that this histori-
cal construction adduces is in turn one of an easy or natural cross-fertilization between the
arts that has not as yet narrowed itself to specific materials that are singled out, or motifs
in common. Constable and Constant Troyon serve similarly as exemplars from the Ro-
mantic period in the case of landscape painting. Ideologically, they offer the assurance of
there being a quality of rustic sentiment like theirs to be sought after and recuperated in
the present; what that sentiment expresses about nature is made for this purpose to seem
detachable from the economic and social conditions of the actual countryside to which it
refers.

Out of this there comes in turn a beguilingly potent form of nostalgia. In the 1920s and
the 1930s—to continue with the case of England—it fosters the mythologization of the
countryside as an essentially unchanging expression of the national character, so that it
offers both shelter in radically changing times and a humanely satisfying and enduring
tranquillity of existence. The visual imagery that becomes sanctified as a result is one of
embowered gardens and sunlit meadows; while at the popular level of magazine illustra-
tion and calendar page, thatched roofs, old timbered inns, verdant country lanes, cottage
doors wreathed with roses and borders in which hollyhocks, larkspur, and snapdragon
abound become the preferred images—not new in this respect, but constantly renewed—
expressing what is felt to be most fundamental to the way of life in question.[69]

But there is also—to come back to the notion of the windowlike canvas and what may
be taken as being inscribed on its surface—a more self-proclaiming and vitally modernist
deployment of natural elements as signs. Such a use of signs, as it presents itself to
cognizance and takes on force in painting, equally has its analogue in poetry: the common
factor here being the way in which the operations of feeling are conveyed, by the finding
and appropriation, from within the totality of the outdoor world, of an image or sequence
of images that can serve as a formal and reflexive counterpart to those feelings. Wallace
Stevens, for instance, begins his poem of 1921 "The Man whose Pharynx was Bad" with
the lines

> The time of year has grown indifferent.
> Mildew of summer and the deepening snow
> Are both alike in the routine I know . . .

and in the final stanza he returns to the image of "such mildew," to bring up the possibility
there would be, if one became "less diffident," of "plucking neater mould" from it.[70]

A painting by Jacques Villon that was well known to Stevens, in that it formed part of
the collection of his friend Walter Arensberg (in whose circle he was currently spending
much time), served as the sketch for a canvas of 1912 titled *Puteaux: Smoke and Trees in
Bloom, No. 2*. In that sketch (now in the Philadelphia Museum of Art) the darker areas
that may be taken as smoke become in effect like a floating extract from the shapes and
coloring of the blooms: one arrived at in virtue of contiguity and some traits of formal

resemblance, yet also marked by subtle differentiation, as with the relation of "mould" to "mildew" in Stevens's poem. Or again, Stevens's "Of the Surface of Things," which dates from the same period, starts out:

> In my room, the world is beyond my understanding
> But when I walk I see that it consists of three
> or four hills and a cloud,

and the stanza following then opens with "From my balcony I survey the yellow air."[71] There is an interesting affinity in this case with another Cubist painting that Arensberg owned, Juan Gris's *The Open Window* of 1917 (also in the Philadelphia Museum now). Ledge and open shutters there give onto what yields to being read as a landscape, with the suggestion of hill and sky at the top; but a piecing together of the separate components in their spatial and atmospheric interplay, of the kind that the lines quoted enact, is necessary in order to arrive at this determination.[72]

The way in which, in this kind of parallel to poetry, landscape in general becomes "sign," standing for an abstract metaphysical quality independent of any question of correspondence to a physically present and concrete actuality, is anticipated already in certain paintings of the later nineteenth century, such as Arnold Böcklin's *Isle of the Dead* (Museum der Bildende Künste, Leipzig, 1880 and other versions), in which the imaginative legacy of Romanticism remains strong. But rather than mythologizing as Böcklin does there the conjunction of more-or-less plausible natural elements and a dominant mood, the twentieth-century version of that kind of fictionalized imagery—reminiscent today of effects that have become familiar in the world of the cinema—abstracts more elliptically or allusively from the colors and shapes of a region or locale. It resists the progressive desacralization of landscape that has taken place in the modern world, as a consequence of technological progress and the invasions or sums of destruction that it has brought about; not by resort to nostalgia for what once might have been, but rather by bringing to the fore a sense of pristine access to certain persistent forces or ingrained qualities of being the domain of nature is taken to contain. It also draws upon the kinds of expanded perception that airborne flight and modern photography have made possible, offering an alternative to the requirement of "mastery" over nature; an alternative that recalls in lieu the kind of seeing, over nature or into its very heart, that was once attributed to figures of myth such as Icarus and Persephone. In these ways landscape is given, or has restored to it pictorially, what may be called a mythic dimension of perception.

It is important to bring out here what landscape painting, in contrast to literature of the same time period, *cannot* do. It cannot really provide the sort of evocation, of barrenness and the total demise of organic process, that is found in T. S. Eliot's lines:

> There are flood and drouth
> Over the eyes and in the mouth,
> Dead water and dead sand

> Contending for the upper hand.
> The parched eviscerate soil
> Gapes at the vanity of toil,
> Laughs without mirth.
> This is the death of earth.[73]

At most, landscape painting can offer signs that serve as symptoms, or more broadly as archetypal models, of the larger patterns of change in the modern world that are at work here. The imagery of industrial and technological intrusion into the natural environment bears this out from the mid-nineteenth century on; and its modern contribution to signalizing for evocative purposes the emptiness and sheer silence of landscape forms part of that ongoing symptomatology.

By the 1840s already, in Europe and more especially in the United States, the railroad had come to be identified in a potentially symbolic fashion with material and technological progress. Whatever it might signify for the individual artist—mechanical energy personified, control over the processes of territorial expansion, or the destroying of natural beauty in the name of improvement—it was leading to ever-increasing deforestation, and introducing into the pastoral scene an already disturbing or potentially oppressive keynote of desolation. The result, on this front, of seeking to make the specific and the general contrast with each other in an ongoing way, would come to be a straightforward inversion of the mythologization of landscape referred to earlier: an inversion whereby the denaturing forces and presences to which the imagery gives shape become the key carriers of mood. By the 1920s and 1930s tracks, utility poles, and wires are counterpointed as time-bound and instrumentally efficacious constructions against the simplicity of the landscape itself, as in the railroad paintings of Edward Hopper. Or again, the white cubic masses and harshly repeated shapes of industrial plants are patterned, in the art of Charles Sheeler, onto what remains skeletally of a natural setting comprising earth, water, and sky.[74]

Yet those forms of inverse mythologization that use the railroad and the setting through which it inflexibly stretches as a basic image lack the heavy irony, involving the loss of human scale and the stifling of the air with "bleak dust," that pervades the famous passage of F. Scott Fitzgerald's from the same period that was quoted in the Introduction. And though the landscapes of pure imagination brought into being in Surrealist paintings of that time—such as those of Yves Tanguy—may carry the suggestion of a bare, planetary kind of surface or the vacancy of ocean floor, nothing about them comes close to conveying the implication of natural scenery that has drastically "gone wrong," that begins to fall now within the province of science fiction; as for instance in this passage from John Wyndham's *The Chrysalids*, describing the "shocking" appearance of the "Fringes" that are reached just before one comes to the "Badlands":

> Things which are against God's laws of nature [are seen to] flourish there, just as if they had a right to . . . giant, distorted heads of corn growing higher than small trees; big saprophytes growing on rocks, with their roots trailing out on the wind

Fig. 71. Chaim Soutine, *Landscape at Céret*, c. 1920–21. Oil on canvas, 22 × 33 inches. Tate Gallery, London (Copyright 1996 ARS, New York / SPADEM, Paris)

like bunches of hair, fathoms long; in some places . . . fungus colonies that you'd take at first sight for big white boulders . . . succulents like barrels, but as big as small houses and with spines ten feet long. . . . There are plants which grow on cliff-tops and send thick, green cables down a hundred feet and more into the sea . . . hundreds of kinds of queer things, and scarcely a normal one among them—it's a kind of jungle of Deviations, going on for miles and miles . . . a weird, evil land.[75]

The nearest that painting can come to this kind of tormentedly confused and dismayingly anti-organic character to landscape may lie in the canvases that Chaim Soutine produced at Céret (Fig. 71), during his three-year period of residence there that began in 1919. This was the small town in the Pyrenees, close to the frontier between southern France and Spain, that Picasso had found congenial as a source of subject-matter in the summer of 1911. But the scope and implications of Soutine's rendering are entirely different. He focuses on a hillside of steeply narrowing proportions, which he then

populates in successive canvases with houses and roofs out of kilter; violently twisted shapes identifiable from their coloring as tree branches or pathways up the hill; and superimposed agglomerations of paint.

What was called in Chapter 3 the "as if" principle of representation—whereby shapes and markings belonging to different parts of an image are made to appear directly substitutable for one another—becomes extended here, effectively, to the treatment of the subject as a whole.[76] Extreme agitation or a convulsive kind of vibration becomes attributed as a result to the entire visible surface of the hillside: as though, one might say, giant insects with grotesque proportions and bizarrely attenuated shapes were crawling their way over it.[77] Such a principle of animation and incremental growth, that is completely foreign to contained and peacefully quiescent landscape, reappears, contemporaneously with the passage of science fiction cited, in the landscapes of Jean Dubuffet dating from 1952 to 1956.

But a modern landscape can also be so characterized and rendered that it takes on a "mythic" character in another sense altogether. The opening of Isak Dinesen's story "Snow-Acre," from her 1942 collection *Winter Tales*, indicates—in its poetic rather than prosaically descriptive choice of language and syntax—the basic sort of way in which this can be the case. The "low, undulating" Danish landscape is endowed, in the opening line there, with the quality of being "silent and serene, mysteriously wide-awake in the hour before sunrise." Its more specific contents and attributes carrying an emotive charge are then filled in:

> The thin grey line of a road, winding across the plain and up and down hills, was the fixed materialization of human longing, and of the human notion that it is better to be in one place than another. A child of the country would read this open landscape like a book. The irregular mosaic of meadows and cornlands was a picture, in timid green and yellow, of the people's struggle for its daily bread. . . . On a distant hill the immovable wings of a windmill, in a small blue cross against the sky, delineated a later stage in the career of bread. The blurred outlines of thatched roofs—a low, brown growth of the earth—where the huts of the village thronged together, told the history, from his cradle to the grave, of the peasant, the creature nearest to the soil and dependent on it, prospering in a fertile year and dying in years of drought and pests.
>
> A little higher up, with the faint horizontal line of the white cemetery-wall round it, and the vertical contour of tall poplars by its side, the red-tiled church bore witness, as far as the eye reached, that this was a Christian country . . . a plain, square embodiment of the nation's trust in the justice and mercy of heaven.
>
> The child of the land would read much within [the] elegant, geometrical ciphers [of a large country house] on the hazy blue. . . . They spoke of power. . . . They spoke of dignity, decorum and taste. . . . The country house did not gaze upward, like the church, nor down to the ground like the huts; it had a wider earthly horizon than they, and was related to much noble architecture all over Europe.[78]

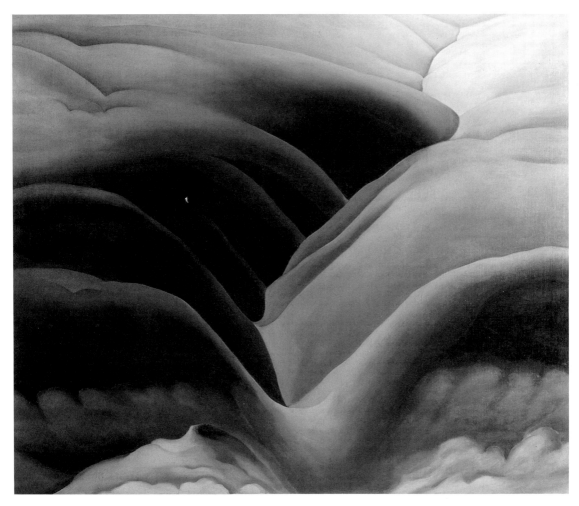

Fig. 72. Georgia O'Keeffe, *Black Place*, 1945. Oil on canvas, 30 × 35¾ inches. Collection of Mary Griggs Burke, New York

An analogue to this is to be found in some of the landscapes of Georgia O'Keeffe, which are the product of her long communion with the vast spaces of New Mexico, its rocks, desert, and sky coming to carry for her a sense of primal mystery and irreducible essence, related in turn to the prevailing climate and to the input of the human spirit in giving an absolutely distinctive appearance to the region. O'Keeffe's paintings from 1929 to 1930 of the little mission church of Ranchos de Taos (Phillips Collection, Washington, D.C.; Amon Carter Museum, Fort Worth, Texas; and Metropolitan Museum, New York) could be thought of as landscapes of "presence," with a condensed spirituality to them, inasmuch as they combine ascetic coloring with a harmonic keying together of simplified curves and swelling shapes that are derived inventively from the governing structure of the building. But O'Keeffe went on to do paintings, like the *Black Place* series of 1944–45 (Fig. 72), that exhibit a "deep structure" with a potency of suggestion to it that is unrelated to the ordinary, quotidian play of consciousness and its moorings in reality. The

rhythmic contours that serve as indicators here of the transitions from one sector or component of the "Place" in question to another seem to impose a separate, distinct positioning for the gaze in each case, and relative scale has to be inferred from an internally constituted set of proportions. A particularly interesting feature of this series, furthermore, is that the sound patterning of the title goes with the visual image declaratively, in the same sort of fit-finding way that a set of sound-images, such as "dark, dark, dark," can have its signification inferred from the independently perceptible context in which those sounds are enunciated.[79]

Mythologization, as the term was used earlier, entails the endorsement for ideological purposes of a conveniently fictional story, of origins in the past and destined character, attaching to the landscape in question. Here, in contrast, what takes place is very different. If myth and ideology are interlinked, this is because remnants of what was once prevailing mythic thought, having to do with the "blackness" taken to be there in certain places in the natural environment and the fears and superstitions attaching to those places, has been transposed into the form of aesthetic structures. These are ones that have a static and timeless quality of being to them, so that the vitality of signification once inherent in myth is preserved analogically in this way.[80]

POST-1950 PERMUTATIONS

Early in 1958 the Whitney Museum of American Art mounted an exhibition, mainly of New York painters who had come to maturity since 1950, that was titled "Nature into Abstraction: The Relations of Abstract Painting and Sculpture to Nature in Twentieth-Century American Art." Its premise, set forth in the catalogue introduction by John I. H. Baur, was that there was an established tradition entailing such a use and valuing of nature as the title invoked: a tradition reaching back to earlier in the century, so that it justified the inclusion of Joseph Stella (with a work of 1914, *Spring*); of O'Keeffe with an oil of 1919, *From the Plains*; of Arthur Dove, who had died in 1946 (with his *Sunrise I* of 1937); and of John Marin, who had died five years previously and was represented by a painting of 1947 titled *Movement—Sea or Mountain As You Will*. In support of the claim Baur printed statements that he had solicited from the younger artists, regarding their use of nature.

These statements proved to be of a generalizing kind, with very little specified in most cases about the actual creative process. Nature had never, in the declaration of one participant, served as specific source for any image of his; according to another, the affect that it inevitably had was filtered in the form of an indirect approach on his part; or again, in a third case, it was taken to provide a springboard for meditation and for recall of the feelings attaching to specific places. Critically speaking, such generality was in keeping with the tenor of the questionnaire sent out to the artists, in which nature was taken as excluding, with an oppositional kind of force, whatever was man-made. It left room equally, without obtrusiveness, for the subdividing of the works brought together in the

exhibition into three sections, titled respectively "The Land and the Waters"; "Light, Sky and Air"; and "The Cycles of Life and Season."[81]

Jackson Pollock and Willem de Kooning were both accorded a place in the exhibition, but no statements of theirs were introduced. Pollock's life had ended abruptly in August 1956, with only three statements of his having being promulgated in print up to that point: his response to a questionnaire of 1944 that allowed him to make some personal declarations about himself, a short text of 1947–48 regarding his method of painting on unstretched canvas tacked to the wall or floor, and an interview of 1950 in which he answered questions about his work. De Kooning had begun producing only a year or two earlier, as an alternative to figure subjects, canvases that were distinguished from his previous engagement with urban imagery by the references contained in them to the landscape of suburbs and country. But he would not discuss this shift of subject-matter publicly until 1963; by which time he had moved out from New York City, to what had become for him in the interim a settled place of residence on Long Island. In the Whitney show he was represented in the third subdivision by one of the large landscapes of 1957 in question, titled *February* (79½ × 69 inches, then in the collection of Dr. Edgar Berman, Baltimore) and Pollock, in the first subdivision, by the even larger painting of 1953 titled *Ocean Greyness* (57¾ × 90 inches, acquired in 1954 by the Guggenheim Museum, New York).[82]

The following year Pollock and De Kooning emerged as leading figures of what was termed "The New American Painting," in the titling of an exhibition that, from May 1958 on, traveled under the auspices of the International Council of the Museum of Modern Art, New York to eight European cities and then returned to its parent institution for showing there in the summer of 1959. The major reason for their assuming this position, relative to the fifteen other artists included—some older or younger, but most close to them in age—lay in large measure in the terms that Alfred H. Barr used in his catalogue introduction, to characterize what their varying concerns had in common with one another. Barr referred particularly to the challenging, mural-like size of the canvases, and to the basically anti–illusionistic flatness of organization that went with this; to the "struggle for order," of an "intuitive" kind, that was reflected in their "high degree of abstraction." At the same time as the artists insisted on their being deeply involved with "subject matter or content," they gave to their paintings a "sensuous, emotional . . . and at times mystical power" that was increasingly attracting a following. Barr related the individualism of the artists, in its strikingly "uncompromising" bent, to their having absorbed some of the values of existentialism, and also of Zen philosophy and of Surrealism in its automatist phase. As to the pictorial precedents contributing to the "central core" of Abstract Expressionism, so understood, Barr specified a wide range of stimuli, both European and native, giving particular place to the Surrealists who had come to New York as refugees during World War II, and alongside them Picasso, Miró, and Jean Arp, who had remained in Europe.[83]

Barr was compressing here into the space of a few deft pages what had been said about Pollock's work in particular, by critics who took a positive view of it, from the time of his first one-man exhibition in New York, held at the Art of This Century Gallery in

November 1943, through the early 1950s. Miró, Picasso, and Mexican painting, Kandinsky and Surrealism were all put forward as sources of inspiration for him— appropriately for the works of 1937 through 1946—and after Pollock embarked in 1946– 47 on his paintings in the "drip" technique, a continuity could be inferred from the absorption of those kinds of pictorial procedure to the energetic use of free calligraphic rhythms in paint, spread out over a large surface.[84] Such a trajectory of development, insofar as it incorporated allusions to landscape along the way, gave these allusions a very generalized evocative tenor. As in Arshile Gorky's last landscapes of 1945–47, which were represented in the touring exhibition, and as in De Kooning's paintings of 1948–50 in oil and enamel, which culminated in the large *Excavation* of 1950 (Art Institute of Chicago), the quality of paintwork surrounding "late Cubist," or more simply abstract shapes was taken as generative in itself of the kind of sensual and affective appeal that traditionally belonged to landscape imagery.

The critical paradigm that came to dominate the New York art scene in this connection was one that allowed that there could indeed be "abstract" landscapes combining a dynamic sense of processual energy with expressive color relationships, and with an imagery or fragments of an imagery that drew, directly or indirectly, upon the study of nature. Such a paradigm admitted under its creative ordinance both Hans Hofmann's Provincetown landscapes of 1935–43, which (before Hofmann had to give up this form of output for physical reasons) had had a great instructional importance for those who attended his summer schools; and also Helen Frankenthaler's work in oils of the early 1950s, such as her *Mountains and Sea* of 1952 (86 × 117½ inches, National Gallery of Art, Washington), which reflected her study with Hofmann in 1950 and her admiration for the triad of Gorky, Pollock, and De Kooning and also for Kandinsky and Miró, Marin, and Dove.[85] The application of the paradigm was complicated somewhat by the Museum of Modern Art's acquisition in 1955 of one of Monet's very late paintings of *Waterlilies*, almost twenty feet in length (c. 1917–19, destroyed by fire in 1958), since its harmoniously nuanced and atmospherically charged activation of an enormous surface suggested an alternative, for those purposes, to a "late Cubist" form of organization.[86] The possibility of an "Abstract Impressionist" painting, opposing itself to Expressionistic concerns in its more subdued delicacy of handling and its leaning toward poetic lyricism, appeared briefly as if it might serve as a gathering point for a subgroup of New York painters.[87] But claims to this effect had begun to whittle away by the time of the 1958 Whitney exhibition, as Baur recognized in his passing reference to them, and they had no anchorage or could be bypassed in Barr's scheme of development. For in that scheme allusion to the "forms, textures, colors and spaces of the real world" was barely allowed to be of suggestive consequence—beyond carrying a possible overtone of the "mystical"—in that serious weight given to it "might compete with the primary reality of paint on canvas."[88]

Yet this account of the events leading to the canonization of Pollock and De Kooning as quintessentially American painters in the later 1950s, and the offering of their work to European viewers in confirmation of such a standing, along with that of other painters grouped as coevals of theirs, cannot, beyond a certain self-evidence as to what occurred, pose any real claim to illuminating purpose and practice in an etymological sense. Begin-

ning with the showing of those two painters and Gorky in the American pavilion at the Venice Biennale of 1950, as a triad of younger figures whom Barr was charged with selecting, and continuing with the larger representation of De Kooning in the same Biennale four years later, it is a story of growing authority and matching institutional promotion, in which the claims of American culture to rival or outdo comparable European achievements were deeply invested. Yet for all of its causal determinacy in that respect, it omits saying anything about the specific sign-formations that were instrumental in enlisting an audience for such aggressively or nakedly modernist forms of pictorial language; or of what may be called their psychic impress, linking them, in the case of sets or series of works involving landscape imagery, to aspects of modern experience and attendant forms of consciousness that were integral to the post-1950 American scene, and its reformations and renewals of what was relevant from within its own past.

In order to provide an ideological framework for explanation of that order—going "behind the signs," so to say, for the purposes of diachronic as well as synchronic analysis—it is necessary to begin with the transposition to New York, during and more especially after the ending of World War II in 1945, of the situation of the avant-garde that had prevailed in Paris, and in other European cities following its lead, from the 1880s on. Not only were there small art galleries that emerged now, serving a directly similar kind of function; there was also a still limited audience for the showing of modern art in a museum context, with a larger interest developing and beginning to be met by journalism and critical writing. Above all, there was the sense of a loose gathering of artists engaging in contact and interchange with one another, which was not yet theorized as to what in essence it entailed, but allowed certain figures (such as Pollock) to be hypostatized as key contributors to a larger alliance of purposes, or to a sense of momentum that invited ongoing participation.

In Pollock's case, furthermore, there was the practice adopted—once he had ceased to be a regionalist in his pictorial interests—of naming his works on what was basically a Surrealist model. From 1946 on, when he began the "drip" paintings, poetic titles were adopted in specific cases where they suited, or were chosen for him; alternatively he shifted (from 1948 to 1952) to using a system of numbering for his finished canvases, which followed the example of Kandinsky. His works were framed so as to draw attention to what came to be called their "all-over" treatment, which included the edges in its compass. And he showed those works, including black-and-white paintings or drawings and watercolors, in groups that were internally related in terms of motifs and handling. In his involvement in the avant-garde situation referred to, Pollock, and other New York painters who became equally engaged in it, developed their own version or adaptation of Symbolist tenets of the 1880s and 1890s, allying painting and poetry. A bridging was comparably sought between purely personal connotations attaching to the imagery that was brought into being, and intimations that were made present on a more broadly accessible basis, in the very terms of structuring and presentation adopted: ones that did not call for any privileged or specially informed kind of knowledge, in order for the viewer to be potentially equipped to respond to the resonances that they carried. And there could be a specifically modern "mapping" of the experience of the world, including

nature, ordered in such a way that it opened itself to intuitive or broadly spiritual apprehension on the viewer's part.

To give a sense of how this Post-Symbolist continuity of procedural principles— whether deriving from Europe, on the basis of its persistence there, or arrived at independently—operated in Jackson Pollock's case, reference can be made to the cata- logue introduction that Alfonso Ossorio wrote for the one-man show of twenty-one works of Pollock's, all of very recent vintage, that was held at Betty Parsons's New York gallery at the end of 1951. Ossorio was a close friend of Pollock's at the time, a fellow artist and the joint owner of a number of his paintings, including the one of 1950 poetically entitled *Lavender Mist* (67 × 118 inches, in oil, enamel, and aluminum paint) and *Number 5* of 1948 (96 × 48 inches). This text of his would be reused, with minor alterations, for the Museum of Modern Art's 1952 exhibition of "15 Americans," and again for the catalogue of the 1959 touring exhibition. No doubt Barr approved of it because it opened by outlining in summary fashion a number of specific formal features, that could be taken to apply to other artists brought together in those exhibitions: scale, "tension and complex- ity of line," closely knit movement, preservation of the surface plane of the canvas linked to rich interplay upon that surface, and "rupture with traditional compositional devices." It also referred to the imponderable character of "the forces that compel [Pollock] to work in the manner that he does," and in its closing section, to the way in which complete personal identification with the work involved him in "a denial of the accident." But in between those paragraphs Ossorio wrote of how

> Void and solid, human action and inertia, are metamorphosed and refined into the energy that sustains them and is their common denominator. An ocean's tide and . . . the bursting of a bubble . . . are as inextricably meshed in the corusca- tion and darkness of his work as they are in actuality. His forms and gestures germinate, climax and decline, coalesce and dissolve across the canvas. . . . The picture surface . . . gives us the never-ending present [in the form of] a visualiza- tion of that remorseless consolation.[89]

In those terms of characterization Pollock's mature art is essentially polysemic, so that, in its freely rearrangeable terms of organization overall, it can equally be taken to evoke disorder, chaos, and confusion.[90] But at the same time it offers a range of new "signs," in the disposition and operation of which specific referentiality is dissolved or aborted before it can take hold. De Kooning's work of the same period can be considered, quite contrast- ingly, as offering "signs" of an essentially unitary perceptive and selective intelligence. Signs of this latter kind function in their ordering as both intellectually and emotionally charged expressions of personality and attitude, while also standing elastically for aspects of the real world on which the work draws for its subject or genesis.

Thus, to extend this contrasting of the two artists further, in Pollock's most productive period relations back and forth between substantiality and its denial, processes laying open to view a consistently movemented tracery or overlay of paint, and qualities belong- ing to overall coloring, such as "lavender" tonality or "greyness"—all had a signifying role

to play in making the evocation of landscape work for the viewer in terms such as Ossorio invoked. Pollock's visionary bent, his power of imaginative incorporation in a quasi-religious or mystical sense, gave persuasion to his search for a specifically American identity as a painter: a search that—as in the poetry of Walt Whitman and more recently that of Carl Sandburg—built on an ideology of wide-open spaces, dissolved boundaries or limits, and struggle to take in elements of widely differing size and proportionate importance and web them together assimilatively.[91]

Such a linkage of landscape to national character had in the mid-nineteenth century empowered a specific mythification of American destiny (see Chapter 4), which was promulgated verbally and offered itself as an inspiration to painters who were in search of outdoor subjects holding broad and sustaining appeal. In European countries that were small-sized nations at that period, such a claim, boosting the prospective development of a hoped-for national art, could validate to that end an exactly opposite premise to the linkage than one based in the American style on rough aggressive strength, territorial open-endedness and inherent diversification. This was what the physicist and natural philosopher Hans Christian Ørsted did for Denmark, when he wrote of a "consensus in seeing modesty, sober-mindedness, goodnaturedness and cheerfulness as Danish national characteristics—[which] accords well with the character of her natural features."[92] But in the present century, as with Mondrian and the Dutch landscape, the basis for such a linkage to be made becomes conceptually quite different. The key features there that the painter was in a position to foreground and make telling were ones that assimilated extreme logic of horizontal and vertical layout, without distractive coloring, and clarity of vision, extending uninterruptedly to a low horizon over flat ground and immeasurable distance.[93]

De Kooning came from that country, Holland, and had lived there into his early twenties, before taking ship to America to live in Hoboken and then Manhattan in 1926–27. He had attended the Rotterdam Academy, where he was exposed to the kind of landscape painting, in the tradition of the Hague School, to which Mondrian conformed in his early ventures in that field of 1898–1907. Later, in the 1930s, Mondrian's example was important for De Kooning procedurally, in terms of the like economy of his work using geometric forms; and so in the early 1950s were Soutine's Céret landscapes, when it came to taking on urban imagery with a similar pliancy and expressive activity of paint.[94] John Marin's work also was probably appealing to him as it appeared in a retrospective exhibition of 1936 at the Museum of Modern Art in New York, and again in the Venice Biennale of 1950, in which De Kooning was one of three younger American artists represented; if so, this was presumably because of the scope of Marin's imagery, in oil and watercolor equally, spanning both city subjects and the native scenery of coast and sea, and defying in this regard either regional or purely local categorization.[95]

De Kooning's Long Island and extra-urban subjects, of 1957 to 1960, were described by him as "landscapes and highways and sensations of that . . . with the feeling of going to the city or coming from it." They represented "glimpses," as he put it, of the highways and adjoining countryside, as they would be seen fleetingly from within a passing car.[96] And while these "abstract landscapes" share with Pollock's "drip" paintings a sense of evocative

expansiveness, and attention to process and spatiality in the application of paint, the fragmentation and reconnecting of the visible they embody is of a qualitatively very different and nonencompassing order.[97]

Besides the greens and blues that are traditionally associated with the subject-matter of the outdoors, these paintings make room for creamy and pastel-like passages of color. And there are personal references in the titles, to memories of places and persons (*Ruth's Zowie, Forest of Zogbaum, Suburb in Havana, Parc Rosenberg, Souvenir of Toulouse*) as well as to seasons and times of the year (*February, September Morn*) and thoroughfares familiarly traversed (*Merritt Parkway, Montauk Highway, Brown Derby Road*). In order to see the sign-formations that operate here in a Post-Symbolist perspective that is, as with Pollock, appropriate to their character, one can make a particular point of comparing Hart Crane's poem "The Bridge" as it was received critically at first, and then later was revalued in that perspective. This poem in fact contains a number of analogous features: processes of fragmentation and recombination that constitute its intrinsic basis; juxtapositions of the near and the far; the sense of time stressed in addition to space; and above all the interrelating of urban-industrial and rural-arcadian motifs. These features help to explain the opportunity that the poem had presented for Crane to attempt a crystallization of urban subject-matter of the 1920s and 1930s—as typically represented by John Dos Passos's 1925 novel *Manhattan Transfer*—using for this purpose constructive devices and abstracting strategies similar to those that were made available in American painting of such subject-matter, from Joseph Stella on.

In critical commentary of the first two decades following its appearance in 1930, *The Bridge* was related back to the *Illuminations* and other writings of Arthur Rimbaud—an archetypal figure from the 1880s on for the understanding of Symbolism as a broad current extending into the twentieth century—in three distinctive ways. First of all—to quote individual critics on each of those fronts—there was the play of "tonal nuances, tangential allusions and verbal color" that they had in common. Then there was the question in both cases of the poet "surrendering to his sensations of the object in his effort to identify himself with it," and the relative degree of intellectual and aesthetic "disorder" that was to be seen as resulting from this. And finally there was the shared "instinct . . . for the depths," for the "deepest mines of the poetic psyche." "Visionary fervor" and disruption became in that light tokens or symptoms of how and where Crane did not succeed in his fashioning of an epic poem.[98]

But in the 1950s a more positive critical overview of the poem came into being, in which Crane's imaginative approach to the "Bridge as object" was seen as being built upon images of inclusion and transcendence that "can be felt": the macadam highway that "leaps," in the "Van Winkle" section of the poem, or the railway in the "River" section that "strides the dew [and] straddles the hill." Such imagery was taken as giving the actions in question an "immediately apprehensible character" and a symbolic cast, as well as an emotional emphasis that drew on the "affective power" of the Bridge itself. Verbs of motion more generally, that create an effect of blur and confusion, were taken accordingly as forming part of a "[unifying] technique of expression, somewhat in the manner of the French Symbolists." They "abstract[ed]" from the Bridge "properties of motion and of configuration" that link together the natural and the man-made and do so

most notably in the form of "images . . . of light and of whiteness" that are built into the poem. It is on this basis—of a repertoire of signs used to convey the energy and inner structure of the modern urban and exurban landscape—that a painting of De Kooning's such as his *Down to the River* (Fig. 73) of 1960 can be compared with one of the most symbolistic stanzas from the "River" section of *The Bridge*:

> O quarrying passion, undertowed sunlight!
> The basalt surface drags a jungle grace
> Ochreous and lynx-barred in lengthening might;
> Patience! and you shall reach the biding place!

Imagery that crystallizes out of the "glimpses" referred to, including white paint put on so as to convey the splintering action of light, is equally made both recognizable and accessible, to a public willing to grapple with such a language in terms of what is being abstracted and sensorially recombined.[99]

In Richard Diebenkorn's ongoing *Ocean Park* series, first embarked on in 1967, the factor of self-reference is even more strongly enmeshed in the character of the work than it is in De Kooning's case. The kind of evocative expansiveness of handling that is found there combines with the sense of a distilled experience that is so central to the work of O'Keeffe (see page 211). This in turn goes with a visible record of process, as in Pollock's case; but here the record of search that is to be found inscribed on and over the canvas surface, in the specific form of *pentimenti*, is one that entails painting out and re-creation, over and over again.

The notion of the series, introduced by Monet for landscape painting in the 1880s (see Chapter 4), is extended by Diebenkorn in two ways. First, the marks made with the brush resonate, as components of a constantly renewed language, with a sense of what it means to return to the same site—a section of Santa Monica where the artist has his studio— and to its key components of beach, sky, and sea over such a extended time-span, of decades rather than years or months. Second, those markings evoke in a charged way Matisse's special and salient contribution to the internal structuring of such views. The works of Matisse in question are, in particular, his views of Notre Dame from his studio window done in the early 1900s, and his return to the subject-matter of the framing window and the view through and beyond it, in canvases of 1913–16 that strongly reflect his response to the structural challenges of Cubism.

That subject-matter harks back to nineteenth-century precedents, such as are found in the work of Friedrich and of Morisot. There is also a precedent closer in time in certain watercolors of Paul Klee's, beginning with a group done when he traveled to North Africa in April 1914. But they are quite modest in scale, and Diebenkorn expands the treatment of the view so as to identify the window frame, as Matisse had done in his cityscapes, with the edges of the canvas. As the version of 1979 from Diebenkorn's series chosen as illustration (Fig. 74) brings out, he also turns the ebb and flow of light and coloring into an invocation in themselves of the world of nature, in the kind of "cool" way that is found contemporaneously in the "New Age" poetry of Californians such as Gary Snyder.[100]

Jack Chambers, a Canadian who lived and worked from 1961 to his death in 1978 in

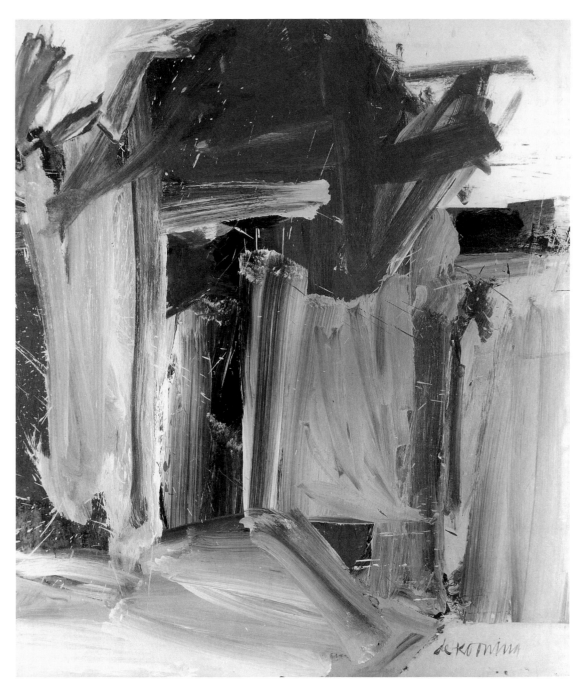

Fig. 73. Willem de Kooning, *Down to the River*, 1960. Oil on canvas, 80 × 70 inches. Collection of the Whitney Museum of American Art, New York, purchased with funds from the Friends of the Whitney Museum of American Art

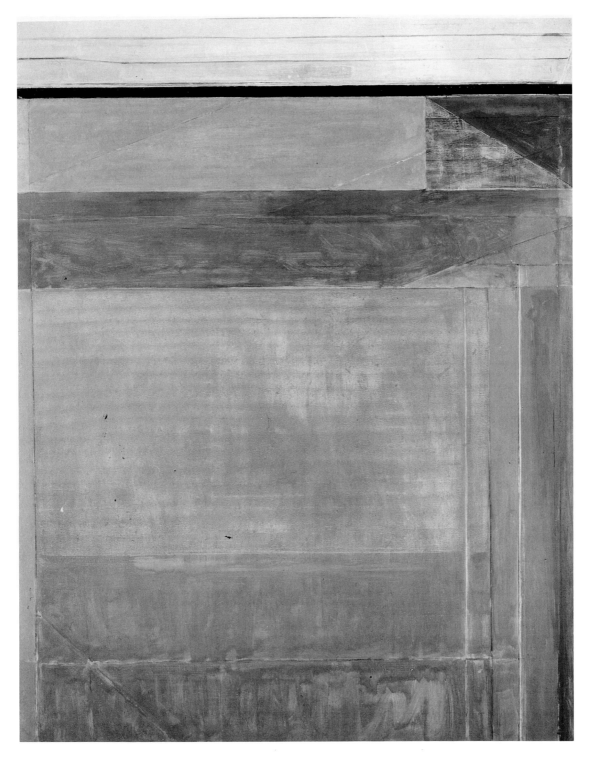

Fig. 74. Richard Diebenkorn, *Ocean Park 115*, 1979. Oil on canvas, 100 × 81 inches. Museum of Modern Art, New York, Mrs. Charles G. Stachelberg Fund

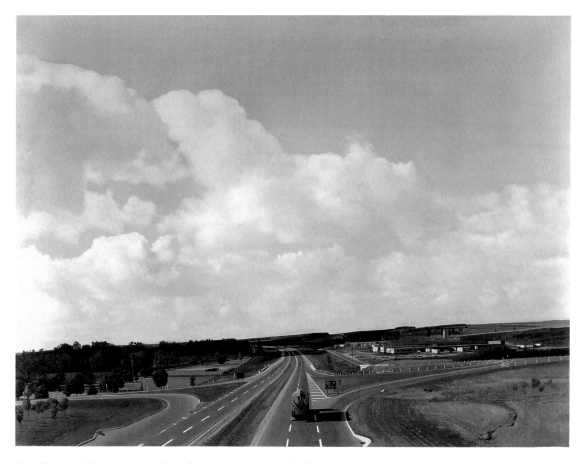

Fig. 75. Jack Chambers, *401 Towards London No. 1*, 1968–69. Oil on mahogany, 72 × 96 inches. Art Gallery of Ontario, Toronto, Gift of Norcen Energy Resources, 1986. Courtesy of Estate of Jack Chambers and Nancy Poole's Studio, Toronto

London, Ontario (from which he originally came) produced landscapes that stand in diametric contrast to those of De Kooning and Diebenkorn, in having all traces of process eliminated from them, and in their display of an equalized descriptive detail of the most precise kind throughout. Large-size works of his like the one illustrated here (Fig. 75), which is based upon a color photograph taken by Chambers from an overpass so that it could be used for this purpose, respond to the extraordinary potentialities of the modern camera for capturing a tract of modern scenery, and all that it encompasses, as if at a perfect moment of arrested time that allows everything to fall into place. Like other landscape artists of the period who were labeled correspondingly Photo-Realists, Chambers used the photograph as a point of reference and as providing a competitive standard of completeness and accuracy, in the same sort of way that artists of the early nineteenth century had responded to the challenge of the panorama and diorama (see Chapter 2) by emulating their spectacular qualities of illusionism. A compelling sense of being shown exactly what would have been visible in a rearview mirror at the moment in point— including buildup of cumulonimbus clouds in the midday sky; a pool of standing water from a recent rainstorm at the extreme bottom right; and on the main highway from

London to Toronto a truck identified by its shadow as a tractor-trailer, with two cars up ahead of it, one passing the other—was from this standpoint crucial. But in the very imitation in paint of what the camera offered, as a form of substitute experience reproducing such detail—without any quality of style that might qualify the resultant image as being in some way artistic in nature—Chambers also drew upon the potential for revision and falsification of the originating percept that the pictorial image had always inherently possessed and used to advantage.[101]

Specifically, the framing device that gives the painting its 4:3 proportion in the ratio of height to width is in fact a fiction. Cropping was needed in order for the product of a film camera to give this proportioning, which it could not have without such alteration. Also the large green sign to the right of a truck, which stands at the top of an exit ramp, was altered in both direction and destination to read 59 WEST LONDON instead of 59 SOUTH DELHI. In this way it introduced into the image a signalization of the road that, not incidentally, led back to the artist's own place of origin and his home.

Such an awarding of place to the concrete and local, extending down to the smallest particulars, offers surety in principle that the sheer extension of space and the generally unremarkable constituents that it contains over a broad span are in fact perceptually graspable.[102] In the framework of cultural thought that, in Europe and North America since the 1960s, has earned itself the label of Postmodernism, the minute duplication of the real, as it can draw for its inherent basis on a medium such as photography, has come to be seen as lending itself to manipulative "simulation." What achieves appeal, as a result of such trading in substitutional satisfactions and purely superficial forms of credibility, does so—as in the case of advertising—at the cost of any interactive responsiveness to the world as it actually is, or proves itself to be in concrete social terms. But Chambers's painting still implies there to be an individuality of performance with brush and paint, which, in its very painstakingness, subverts the notion that new developments in technology can replace the human factor. All that such a practice implies, and has implied in past history in the way of experiential skill and deliberated choice can still be made and seen to operate as an extension of that technology.[103]

Rather than setting up an arbitrary point of closure for the coverage in this chapter of twentieth-century landscape art, it seems appropriate to end the discussion of particular practices and how they fit together etymologically with the figure of Kimura: an artist of Japanese origin and training who moved to Paris in 1953, when he was in his mid-thirties, and worked in southern France with outdoor subjects for twenty years prior to his death in 1987.[104] At a time of growing multiplicity of cultural awareness across the entire spectrum of the art field, and also of strong sensitivity to Japanese appropriations of European and American culture that adapt themselves to a very different and finally incompatible kind of audience input, it is particularly interesting to consider the ideological coloring having to do with interaction between Japan and Europe that the work of this painter projects.

Already in the fifteen-year period running from 1888 to 1903 there was a small group of Japanese painters that chose to form a colony at Grez-sur-Loing—one of Corot's favorite sites—and to paint landscape there on lines that reflect the example of the Barbizon School, and of Impressionist outdoor practice.[105] Monet in his lifetime (which ended in 1926) had as many as twenty Japanese visitors at Giverny, who had come a huge distance

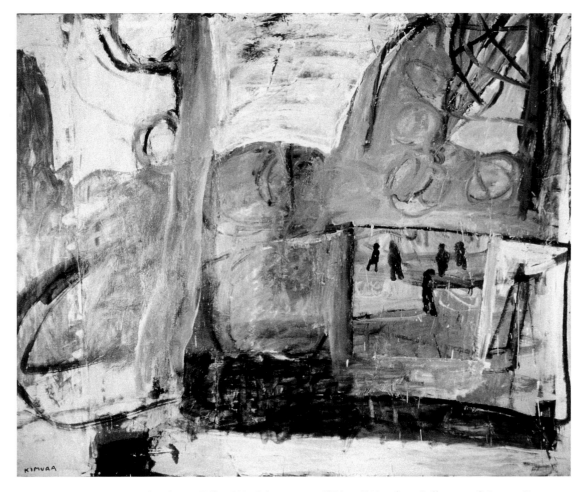

Fig. 76. Chuta Kimura, *People Taking a Walk*, 1982. Oil on canvas, 57⅛ × 63¼ inches. Collection of Numura Securities Co., Tokyo

so that they could relate the experience of the artist's garden and lily-pond to the paintings done there that they were interested in seeing or acquiring.[106] Today, this form of homage to the place—now restored and since 1979 open to the public—continues apace with a constant influx of tourists from Japan. There are no paintings in situ, so they must relate what they know about them back to the site itself, now memorialized, which can be looked upon as the generative force behind their creation.

Kimura's purpose in moving to France was equally—as his paintings convey—to pay homage to the mastery of landscape art, in the hands of that country's greatest modern practitioners: Cézanne, Renoir, Monet, Matisse, and perhaps most especially Pierre Bonnard, who from 1900 on had devoted himself increasingly to sun-drenched outdoor subjects. But Kimura remained Japanese in his personal and national identity, never learning to speak French. His way of working with landscape scenery is at first a puzzling intermix of figurative and abstract elements, seemingly unplaceable etymologically. Those elements are linked, as with Bonnard, by rich and luminous swathes of color. But the figures—grouped together, in the work of 1982 chosen for illustration (Fig. 76 and

Color Plate XII), within a rough rectangle suggesting a window frame—and the skeins of pigment linked to tree forms to suggest foliage float in relation to the canvas surface in the way that had been a hallmark of the Japanese landscape print in its heyday. Kimura's surrounding space manages similarly to be both filled and at the same time translucent.

O'Keeffe had learned early on, from Arthur Wesley Dow with whom she studied at the University of Virginia in the summer of 1912 and then more intensively at Teachers College, Columbia University, in 1914–15, about the importance of space filled, as in Japanese art and the art of the Orient more generally, by surface patterning and tonal variations rather than devices of composition that had an illusionistic raison d'être. Dow in turn had for his mentor in the understanding of Japanese decorative and spatial principles Ernest Fenellosa, who having served for some years as curator of the Japanese department at the Museum of Fine Arts, Boston, had joined the faculty of Teachers College in 1903.[107] The work of O'Keeffe's discussed earlier, *Black Place* of 1945, was chosen to illustrate the role of nature in her work because it belongs to a collector of Japanese art. She has written specifically of the role played, in the formation of her taste, by its "shadowless space . . . [with] strong and clean color," and by the working method that it exemplifies of doing long series based on a single motif.[108] Reversing the direction of that flow of ideas from East to West, Kimura is one of a line of Japanese landscape artists who, over the course of the last century, have, so to speak, returned the compliment.[109]

To perceive landscape through the eyes of the Japanese is to see connections between things: especially between creatures and their environment, and between human beings and the earth itself. In the last part of this century, a leaning toward a more spiritual view of the world, and the spread of interest in New Age explorations of ecology and the need for conservation of natural resources have made Western perceptions more sensitive to what once seemed simply an absolute kind of difference between Eastern and Western cultures. Distinctions remain, but the gap may at present be closing, from growing realization of the fragility of our planet.

Conclusion

Recognition and Reading on the Viewer's Part

It is of the essence of works of art such as paintings that they mobilize specific mental and perceptual activities that, with or without accompanying words, enable viewers to process cognitively what the image in question shows. The activities in question are best thought of as inferential ones. They do not start from particular premises and conclude with a state or form of logically deduced comprehension. Rather, they make it possible to put together particular features of a representation. In so doing they draw upon and respond to its character nondemonstratively. The response takes place in a particular context of seeing and experiencing, either given or chosen. How the act of putting together shapes itself accordingly introduces greater diversity of procedural mechanism and outcome to the processing than is allowed for in the model of a coded form of communication, where a key to decipherment made available to the viewer (or an internally emergent set of such keys) is given an applied elucidatory role.[1]

One inferential activity that is not sufficiently given a place by that model consists of disambiguation, as in the encounter in spoken or written language with alternative possible senses of a sentence or phrase. "Textuality" in a work of art, the embedding of text-based qualities or features in the response that it invites, facilitates disambiguation

on the viewer's part in one or more specific ways. As seen in Chapter 1, it serves in general as an aid to the formation and display of a competence to describe appropriately, on the basis of, or in step with the play of a trained sensibility upon the work in question. The terrain of cliff and rocks that forms the setting of the Odyssey Landscapes (Fig. 6), rather than stopping and starting again each side of the painted pilasters, is inferred to continue behind them. It represents, from one section to the next, both the land of the Laestrygonians and the island of Circe, linked ongoingly to one another in such a way as not to be clearly distinguishable in their basic rendition. They can nonetheless be differentiated in terms of specific features that locate sites in Homer's narrative.

A second kind of inferential activity practiced on works of art is directed toward the resolution of what would otherwise appear as indeterminacy or vagueness. Like utterances, specific images can be contextualized in their communicative tenor in terms of worlds of knowledge and belief to which their recipients have access. Such "worlds" differ potentially, without excluding overlap, both from the artist's own world, and from that of persons who are represented within the image. Chapter 2 took up certain kinds of communicative import entering into the workings of visual images in virtue of their special relevance to viewers of the time and the frameworks of understanding—dispositions, assumptions, presuppositions—that such viewers were equipped or prepared to bring to bear. The mysteriously captivating atmospherics of a Roman seascape or a Venetian pocket of countryside, the complexities of internal organization and sequencing of motifs in a Poussin or a Claude—these each require making connections within the image as a whole between elements of the natural world and what has been placed there, the contribution of which is left incompletely specified. What the viewer is given to process opens itself accordingly to preformed expectations, and to habits of attention more generally. This responsive engagement contributes pragmatically to what is made of the image.

Chapter 3 dealt with the capacity of viewers to draw out references or infer associations from the subject-matter and presentation of landscape, particularly in its charged political and social aspects. Chapter 4 treated viewers' capacity to take what is offered in a figurative light, in accordance with four standard figures of rhetoric. A literal image—one that is taken to show just what it shows and only that—represents in that conspectus one that carries no additional implication arising from its context of appearance, as to what was put in or excluded from depiction and why. Chapter 5, in turn, was devoted to the more purely symbolic values that visual images of landscape can have ascribed to them: as with the expressive valuation of the color black embodied in O'Keeffe's *Black Place* (Fig. 72) series. Here, as also in verbal forms of expression, an association of structure and content is established by the workings of symbolism, such that the meaning conveyed is based on the relationship of one element, or value, to all of the other components of the structure of which it forms part.

In the viewer's construal of landscape images it is the operation of certain *principles*, rather than *rules*, that underlies what takes place. A pertinent example of a rule would be: that trees cannot be shown growing from the sky upside down, and still—without some special order of explanation appended as to why—form part of a presentation that is

identifiable as a landscape. Principles in contrast pertain to features that are *sufficient* only, for the purposes of processing images such as those of landscape, not *necessary* ones. They regulate, in particular, the threshold at which a decision has to be made, as to whether a perceptible presence or absence pertaining to the makeup of the image is to count for or against its having a certain identity. It may or may not, for instance, be Cologne Cathedral that appears in a particular landscape view. The features that warrant its identification do not necessarily correspond in any precise way to an actual or concrete form of knowledge that one possesses of the edifice in question; they do not have to persist in the memory as records of a specific experience, of having seen or visited the place, or parallel what has been read about it. They are also distinct from conventions of representation, which facilitate and empower recognition: like, for example, projectability into three dimensions, which implies congruity with other representational systems. Basically, what counts for cognitive purposes depends—as with the hearer's knowledge of what to abstract from a string of sounds that the ear picks up—on detection of what proves *relevant;* or, as in the case of a dream image, on what can be taken to support a presumption.

The most important aspects of verbal construal—those that in the study of cognitive processing have been given the names of scope, specificity, background, perspective, and prominence or salience—are all ones that can be transposed, as operative principles, to the recognition and reading of landscape imagery.[2] An example serving to illustrate all five aspects would be the presentation of an oak tree. *Scope* here corresponds to the genus or species to which the tree in question may be taken to belong on the basis of features of the depiction apprised as being relevant, such as overall shape and the form of the leaves. *Specificity*, of color or texturing, is evidenced in the amount and density of paint used in any one place, as it serves to intimate comparative attention given to the tree, or to portions of it, in those respects. *Background* has to do with the degree to which the tree stands out from its surrounds, or from the sky against which it is seen, in virtue of the overall treatment used to characterize its shape and contours. *Perspective* brings into consideration relations of distance and proximity, as they are linked to the viewer's assumed positioning in respect to the scene as a whole, and as they correlate with the point of sight that must singly or multiply be implied for any grouping of depicted objects. Relative *prominence*, or variability of emphasis, allows for the recognition of an internally designated focus of attention within the image: as with a substructure, say, of meshed leaves or floating branch-ends, that singles itself as carrying an expressive weight of its own. *Salience* goes beyond prominence insofar as it brings in explicitness of a more absolute kind and raises issues of objective credibility: as with the sheer girth of a truly massive tree trunk.

It is important also to note in connection with visual images the signification of absence—as in other arts also—for the making of inferences. There may, for example, be an area within a depicted landscape where color is separated from form, and still at the same time has a family resemblance to color elsewhere not so separated. The reappearance of this color may then be taken to imply the presence of the same feature—such as a stretch of blue water or of grass—in both areas of the picture, even in places where there is an outright lack of designation as to what the color belongs to. In the same way light

failing to fall on an area or object within a landscape may be adduced as a significatory component of its character and mood, given the grading system of relative darkness that presents itself as in force, as it typically would be in the governing circumstances and conditions of viewing implied by the painting.

The symbolic factor that attends the salience of certain specific properties or formations in landscape art opens itself to being understood on the viewer's part by extrapolation from other kinds of perception. The most abstract form in which world-knowledge is preserved and encoded is in the shape of an idea or concept with which, in the case of visual images and the reading of them, the viewer is familiar in principle: as for instance with the premise that things at a certain distance from the eye tend to appear as merging with one another. This premise can be recognized as being at work in the representation of landscape, on the basis of its being in its customary place in visual awareness of the world. Correspondingly it identifies and brings under consideration, with landscape subjects taken from that world, the many differing kinds of structural application that it can have.

That a great oak may be taken as embodying an indomitable quality of endurance and rootedness rests on a similar though more singular assumption. The premise at work here is one that can activate in principle a reading of the image of such a tree relating aspects of form and content to one another, and bringing in also elements of the representation associable with a taking of position on behalf of political independence and freedom on the part of the artist choosing the tree for depiction. Gustave Courbet's *Oak at Flagey* of 1864 (Fig. 77 and Color Plate XIII) brings up issues of local interest and regional pride for those familiar with the tree of this name and the historical tradition attaching to it, identifying a claimed site of Gallic resistance to Caesar's armies. These join up with the general capacity of a depiction such as this to evoke, without contradiction, both extreme stability of appearance and the liberty invested in outdoor nature to grow and expand over time.

Historic reference and politically charged association are to be found equally in Frederic Edwin Church's *The Charter Oak* of 1846–47 (two versions, the later one preserved at Olana Historic Site, New York State). It took as its subject a tree located south of Hartford, Connecticut—Church's place of origin—that, according to story, had served in 1686 as hiding-place for the founding charter of that city, which the first governor-general of New England was trying to wrest away. But the viewer is invited to make comparison in that case—as tourists could do, until fire and storm razed the site—with a vigorous young elm growing alongside which, in its pointing to the future, contrasted with the age and grandeur of the patriarchal tree.[3] In Courbet's representation the virtual eclipse, the overwhelming of the surrounding scenery, the focus on density and upward spread, the thrust of the tree beyond the upper limits and framing edges of the canvas are all structural features that lend themselves to the play of inference. While serving to bring a central concept into focus, they also effectively challenge the viewer to apply an associated set of ideas to the image.[4]

To seek to recover content or attitudes in landscape painting of the past through study of the works is to embark on inferential formulation as to why such a merger of elements or integration of constitutive features should occur in them: to what communicative end. Interpretation of this sort remains always open-ended, in keeping with viewers' changing expectations and interests. It is nonetheless feasible to extrapolate hierarchies of ordering

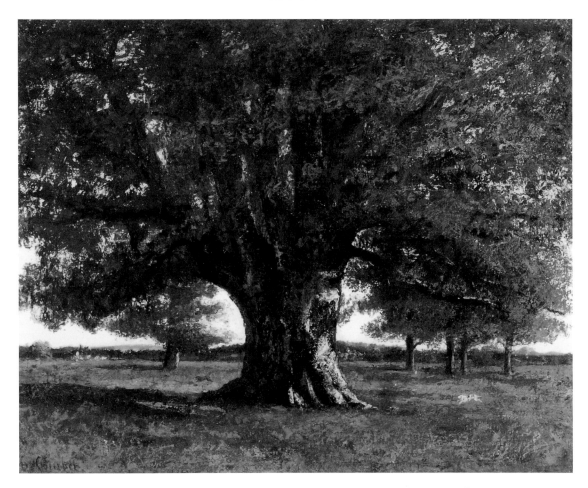

Fig. 77. Gustave Courbet, *The Oak at Flagey*, 1864. Oil on canvas, 35 × 43⅜ inches. Murauchi Art Museum, Tokyo

practice, for a period and its leading artists, based on series or groups of works with common features. Such hierarchies coordinating the identifiability of landscape imagery with its structural treatment operate largely as constraints on practice. They make reference to a restricted set of options governing what landscape painting is seen *as*, or taken to be at the time. In so doing they provide boundaries for the range of variations that may be encountered in individual cases.

THE ROLE OF MEMORY IN LANDSCAPE ART

In the preceding chapters landscape art has been shown to be marked by artifice and varying degrees of semblance formed into suggestive overlays, rather than by transparency. Of course its subject-matter belongs to the real world, in terms of its common components and how they are brought together. But one does not gain a sense of the rendering being so unaffectedly telling in character that one can seem to look through it,

and so gain direct access to the reality from which those components were drawn. If moreover such a sense is imparted, it is the result of contrivance to that effect, within the terms of representation themselves and the kinds of information that they are set up to deliver. The very appearance of guilelessness will then be of an achieved sort.[5]

The notion of "languages" around which the book is built has carried the implication, from section to section and across time, that landscape art is to be understood as a means of transmitting a certain view or awareness of the natural world, and as a way of giving substance to the impress upon consciousness of that view or awareness. It follows that the role and functioning of memory, only touched upon in a few places, needs to be drawn out more explicitly. Memory is first of all a faculty: one that, in the words of Saint Augustine in his dialogue *De magistro*, enables us to speak of "things we have thought and felt." In communicating the remembered, private mental contemplation allows what is now no longer present to the senses to serve as a basis for recognition of a shared experience. This spoken shape of images "held in the halls of memory" carries accordingly a quality of truthfulness for others.[6]

The relationship between memory, as a repository of images permeating consciousness, and the conveying and recognition of feelings has important implications here. The way in which the physical world is dealt with as it registers visually and takes on potency is deeply germane to the handling of the materials of landscape art. The terms of the relationship allow experience to be captured in a first-order sense. This happens through the very processes of representation that constitute the faculty of memory, and not as a psychological by-product of the perceptions and thoughts attaching to that experience.

Memory is at the same time socially and culturally constructed, in what it brings together and foregrounds.[7] In dealing with pictorial and sensory particulars separated from one another in time, it is essentially a social operation that defines how they go together, or what they have in common, and that then allows those particulars to be recuperated in retrospect, as if in already sorted form. It is on a culturally shared basis, equally, that nostalgia about place and past (see page 206) entails a harking back toward an earlier state of existence, marked by a commonly held and recalled role that is given to nature.

Memory can be trained correspondingly, in both active senses of that word: upon a landscape subject, and in a manner that matches and responds familiarly to its saliencies. Exercise of such training informs both the artist's memory and the choice of delineative means, so that the work can speak to social and cultural issues and may be empowered to reach beyond the place and time of its inception.

Writing about landscape can be like its depiction in paint, insofar as memory is used creatively in both cases—often together with notes taken at the time—to conjure up something that is no longer before one's eyes. Rather than simply serving nominalistic ends, naming or marking specific elements so that they can be identified, the act of representation is charged thereby with bringing back remembered effects, especially ones of a generalized kind involving coloring, light, and space. This evocative equivalence in the medium in question is what leads to, or can make happen, a form of strong actualization that is separate from description.[8]

Memory was always in this sense crucial for artists. With some exceptions outside Europe, where and at which time the role given to it had its own justifications and

established traditions to draw on, it was not consciously privileged over descriptive skill, as a primary mental process serving as a source of insight and feeling, until the Romantic period. It had certainly functioned earlier as an inherent or unstated justification for self-absorption on the artist's part. But it was then that its contribution became prescriptive in regard to creativity itself. For Constable, the pleasure-giving aspect of landscape art lay in what he called "reminding" as opposed to "deceiving."[9] Thomas Cole, in a letter of 1838 to his fellow artist Asher B. Durand, wrote: "I never succeed in painting scenes, however beautiful, immediately on returning from them. I must wait for time to draw a veil over the common details, the inessential parts which shall leave the great features . . . dominant in the mind."[10] And Eugène Delacroix noted in his *Journal* in September 1852 how, while on the coast at Dieppe, he had made a study from memory "from this side of the sea . . . golden sky, sailboats waiting for the tide so as to get back to port."[11]

When the question of "when?" as well as "where?" is admitted on those lines into the discussion that landscape art elicits, it falls to the viewer to adduce the factor of temporality that attends the depiction and that can have a specific part to play in the grasp of its character: as if drawn out from its internal structuring (as in the case of verb-tense change in descriptive prose).[12] When images of landscape are marked by a vagueness from which a few selected elements emerge, as with Turner's later art, then the viewer's task becomes one of being invited to construct from the available cues what has become indistinct and evanescent. And the manner in which such construction operates stands in evident relation of kinship to the recuperation of memories themselves, through residues of elements filtered out for portrayal: elements that then empower recollection itself.

Taken in this way, the use of memory implies, or becomes interfused with, a form of "truth-telling" on the artist's part. It can be recognized as such according to two distinct and broadly applicable negative criteria. Reliance on memory does not, on the one hand, introduce a "redundancy" of particular features of the kind that one encounters in seeking to register what is before the eyes in a straightforwardly descriptive analysis. Nor, on the other hand, does it exhibit a "wilfulness" incompatible with the unfolding of reflective consciousness upon the impressions that it has garnered. The words in quotes here are John Ruskin's. The most remarkable statement of this dual premise as it can be taken to apply to landscape art is to be found in his account in *Modern Painters* of Turner's bringing of the use of memory to bear in the *Pass of Faido* (Fig. 78). He depicted this Alpine landscape on the Saint Gothard route into Italy, which he took in 1842. The concrete features of the rendition exemplify, according to Ruskin, Turner's supreme powers and the way in which they built on memory.

Ruskin reproduced in the form of an etching a "topographical outline" of the "scene" in question that he had elected to draw when there himself, showing the "blocks of rock" filling the bed of the Ticino River at this point (Fig. 79). The torrential stream had either disgorged the massive boulders, or winter avalanches had brought them down from the mountain above. Ruskin compared this to the line drawing that he had made back at home after Turner's sample study. That "memorandum" of the place, done in pencil with a few added touches of watercolor, served as the basis for the finished watercolor version of the subject, commissioned by Ruskin in 1843. Ruskin made his drawing and comparisons at Turner's request and with his express approval of the result.

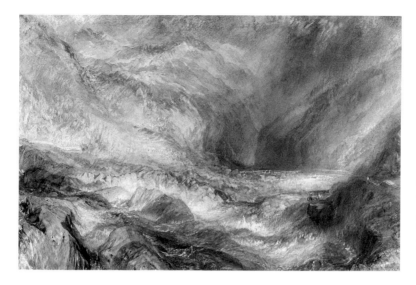

Fig. 78. Joseph Mallord William Turner, *The Pass of Faido*, 1843. Watercolor on paper over traces of pencil, 11⅞ × 18½ inches. The Pierpont Morgan Library, New York, The Thaw Collection

Turner raised the height of the rock either side of the ravine or "couloir" formed by the floods and storms to about twice its actual height of four to five hundred feet. He also imaginatively restored the further-off road, which had once led over a bridge of which only the abutments remained, with the addition of a traveling postchaise at the turn on the far right. There were other changes as well that, yet more tellingly for Ruskin, seemed "not so much to be wrought by imagining an entirely new condition of any feature, as by *remembering* something that will fit better in that place." Specifically, Turner turned the bank on the right into more of a rock buttress, firm enough to resist the torrent's force, making it in so doing "very nearly a facsimile" of one at the Devil's Bridge, far above on the same road. This in fact he had drawn some thirty years before, and used as the basis for an engraved plate, never actually published, to go in his collection of landscape motifs that he titled the *Liber Studiorum*. Putting this example together with other instances of a similar sort with which he was acquainted, Ruskin felt they were "numerous enough to induce a doubt whether Turner's composition was not universally an arrangement of remembrances, summoned just as they were wanted and each in its fittest place."

Judging the finished watercolor of the subject to be a supreme exemplar of the "temper" of Turner's creativity in the last part of his career, Ruskin generalized from it about the role in the work of "all great inventors," both literary and artistic, of "an involuntary remembrance, at exactly the right moment, of something they had actually seen." In Turner's case, "strong memory of the place itself which he had to draw" formed the primary basis for "obedience to his first vision." But it was combined secondarily—without perhaps his recognizing this to be so, and as if he were submitting to a "dream-vision"—with "memories of other places . . . associated, in a harmonious and helpful way, with the new central thought" that had now moved to the fore. To be able to recognize, in response, "the real nature of the imaginative mind" at work here means correspondingly that the viewer's mind is laid open to having generated in it, at a remove from the scene in question, "precisely the impression which the reality would have produced." This comes about, not through expecting to have sensations aroused such as

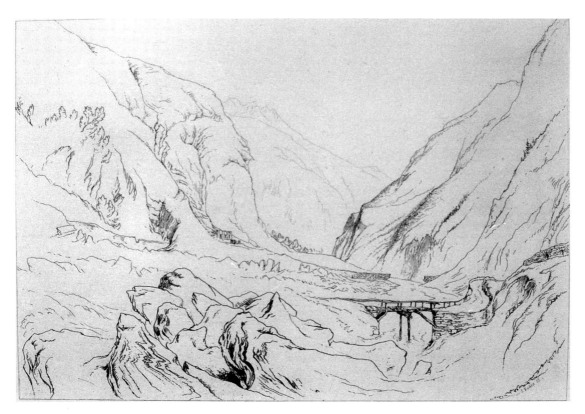

Fig. 79. John Ruskin, *Simple Topography of the Pass at Faido*. Engraving, plate 7⅛ × 4¾ inches, for his *Modern Painters*, vol. 4, 1856

the "facts themselves," seen in relation with others, would have generated; but by recovering what would have been the state of one's heart, had one actually been there.[13]

THE BASES OF ATTRACTION

The idea of a single intrinsic form of attraction that landscape art is set up to provide obviously has the advantage of retrospective sweep. It assumes, however, too much about constancy and uniformity in the cultural and philosophical frameworks of perception and thought that are brought to bear in this connection. Representations of sites, scenes, and settings draw their signification from such a variety of factors attending the viewer's response and the artist's motives that it would prove broadly impossible to chart them. In addition, the words used to convey such signification have their own ongoing and incremental history. No one kind of underlying interest or vein of sentiment about nature draws together, either stereotypically or unfoldingly, the "languages" of landscape that patrons and public have across time found congenial.

But to think of response to art of this kind as self-adjusting and aesthetically changeable, in the very shape of the discourse it promotes, is too open-ended as a conclusion to

be drawn from the terms of examination of this book. It leaves out what verbal descriptions conveying the visual experience of landscape and memories preserving it in imaged form share with treatments that offer access to it in its framed pictorial guise. One needs to gain a sense of guiding forces at work behind the project of communication with those three kinds of materials—related in the forms of awareness they imply, and in some respects interactive with one another—and the conduits through which they impact, psychologically and socially.

What landscape art actualizes—makes concrete and potent as a stimulus to feeling— lies already in the past. Such is the case even when, in terms of the quality of experience transmitted, focus is placed on an immediately precedent and in principle repeatable past. The factor of time is thereby introduced, as an explicit part of being able to address the nature and (re)workings of the stimulus in question. Down to the Impressionists and in many cases beyond, it may be said that landscape art always refers *backward*: to the experiences that brought it into being, such as pertinent knowledge of literature and lore, or travels and journeys; to the processes of its making, including the use of drawings and watercolor studies as preliminaries; and to types of landscape image that have served as models in the past, or in one's own more immediate past. The linkage to discourse, to being able to talk about the representation and rendering of the experience in question, depends on these forms of reference and what they imply about time: time of execution, the more distanced time in which memory deals, and the putatively or manifestly fictional time, of seeming presence before the viewer (as with Poussin's long-ago), that the representation constructs.

Psychologically—to push the question of affectivity brought up here a stage further— landscape art offers a form of sublimation; socially and intersubjectively, it offers a form of vicarious participation on the viewer's part. The first of these tendencies has predominated historically in the Italian tradition of landscape, down to Corot; the second has stood more to the fore in the north of Europe, down to Turner and beyond. But since both still life and genre painting can lay claim equally to having those basic potentialities built into them, it is important to emphasize the application of certain substantive differences pertaining to affect.

Genre painting and still life are always liable to be treated in principle as if they offered substitutes for the interactive and expressive components of narrative art, where the force of an event or action is shown registering in a particular moment, or a succession of moments brought together. But their terms of construction diverge in opening themselves to freely speculative hypothesizing of what came before in the way of incident, and what will come next or follow after. They are effectively staged for this purpose, to give what they put on display (a quarrel in progress, the end of a dinner) a fictive aura of attendant causation. Landscape images, unless they contain narrative actions or incidents within them that partake of a past and anticipate an outcome, do not call for this to be the case, or make much of it emotively.

As a consequence of this divergence, literal aspects of the depiction and figurative implications are less easily separated in the case of landscape than they are with genre and still life. Even to say of a painting, in the simplest terms, "This is Flatford Mill as seen on

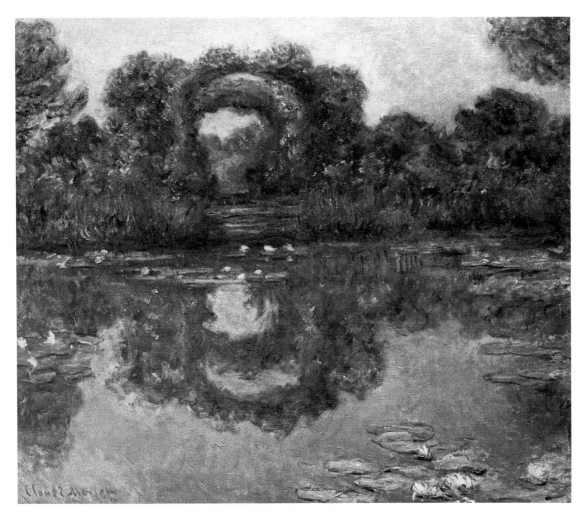

Fig. 80. Claude Monet, *The Rose Arbor, Giverny,* 1913. Oil on canvas, 31¾ × 36½ inches. Phoenix Art Museum, Arizona, Gift of Mr. and Mrs. Donald D. Harrington

a late summer afternoon in the early nineteenth century" is to invoke a whole set of suppositions as to how one regards and responds to the factuality of the depiction. In still life, in contrast, things of this world seem pressured into taking their places in a particular spatiotemporal context in a fashion that is manifestly arranged, to give form to their known and observed character.

What is at issue here, finally, is how the sense given of approximation to an actual experience of things goes with a potential of revelation, as to what is possible and conducive in its possibility to an expansion of awareness. At Giverny, Monet's restored garden (see pages 223–24) serves at once as a measure of his closeness, in spirit and in rendition, to what he constantly trained his perception on, and as testimony to his opportunity here to coerce and artificially order nature in fulfillment of his fantasy (see Fig. 80).[14] Landscape art mediates directly, or more directly than any other category of

pictorial depiction, between those basic alternatives of subjection to concentrated scrutiny and freely extravagant indulgence.

In another garden, that of Harold Nicolson and Vita Sackville-West at Sissinghurst (1930–39)—where he was in principle responsible for the planning, and she for the execution—two sides to the creation of actual landscape effectively come together, which can be thought of as "feminine" and "masculine" in their underlying impetus.[15] The patiently nurturing, intimate, and domestic side to such creation, and the structural side, the directing of what a private space should contain and come to represent, partnered one another harmoniously. Landscape art too holds the possibility, and perhaps always has done in a way that overrides or tempers the male/female gender of its creator and viewer, of supplying a comparable kind of enjoyment: the enjoyment of wandering through it on one's own imaginative terms, responding both to its larger order and to its personally chosen details.

NOTES

The books, articles, and catalogues that are cited here, with appended comments, do not by any means represent a full or even partial bibliography. They are limited to sources that I have directly drawn upon or referred to, in developing my own arguments and findings. Particular emphasis is placed accordingly on publications of recent date, in a coverage that extends to the end of 1993.

For their thoughtful and critical reading of my manuscript drafts, I am much indebted to Bettina Bergmann, Ann Bermingham, Norman Bryson, David Carrier, Robert L. Herbert, Laetitia Lafollette, Sura Levine, Richard Shiff, Paul Staiti, Christopher S. Wood; and for bibliographic advice and broader suggestions, to John Barrell, Walter Cahn, David Freedberg, Judith Fryer, Martin Kemp, Joseph Koerner, Joel Upton, and my colleagues Iris Cheney, Craig Harbison, and William Oedel. From outside art history, help with concepts and definitions was given at my university by William M. Johnston, Gareth B. Matthews, and Barbara Partee. Among my students, David Carroll, Marion Grant, Claire Daigle, Karen Koehler, Claire Renkin, Richard Schindler, and Julie Wolf have been particularly helpful and supportive, and the editorial role of Gretchen Fox proved invaluable.

INTRODUCTION

1. General introductions to understanding the role of landscape in human perception and experience include particularly Jay Appleton, *The Experience of Landscape* (London, 1975), together with his followup publication *The Symbolism of Habitat: An Interpretation of Landscape in the Arts* (Seattle, 1990); Denis E. Cosgrove, *Social Formation and Symbolic Landscape* (London, 1984; Totowa, N.J., 1985); and Paul Shephard, *Man in the Landscape: A Historic View of the Aesthetics of Nature* (New York, 1967; 2d ed., College Station, Tex., 1991). Related cultural studies are Leo Marx, *The Machine in the Garden: Technology and the Pastoral Ideal in America* (London, 1964); Raymond Williams, *The Country and the City* (London, 1973); Barbara Novak, *Nature and Culture: American Landscape and Painting, 1825–1875* (London and New York, 1980); Mick Gidley and Robert Lawson Peebles, eds., *Views of American Landscapes*, with foreword by Leo Marx (Cambridge, 1990), which brings together a variety of literary and visual topics; and the volume of essays edited by Simon Pugh, *Reading Landscape: Country, City, Capital* (Manchester, 1990).

2. John Constable, letter of March 1812, in *Correspondence*, ed. R. B. Beckett, 7 vols. (Ipswich, 1962–75), 2:78.

3. Isak Dinesen, *Out of Africa* (New York, 1937), chap. 1.

4. Notable contributions to the field of cultural geography are Yi-Fu Tuan, *Space and Place: The Perspective of Experience* (Minneapolis, 1977); the collection edited by D. W. Meinig, *The Interpretation of Ordinary Landscapes: Geographical Essays* (Oxford, 1979) and E. C. Relph, *Rational Landscapes and Humanistic Geography* (London and Totowa, N.J., 1981). John A. Jakle, *The Visual Elements of Landscape* (Amherst, Mass., 1987), offers a related focus on perception, particularly that of the tourist.

5. Charles Dickens, *The Old Curiosity Shop* (London, 1841), chap. 46.

6. F. Scott Fitzgerald, *The Great Gatsby* (New York, 1926), chap. 2.

7. A general introduction to the field of landscape painting that is still appealing and thought-provoking as a starting point is Kenneth Clark's *Landscape into Art* (London, 1949; retitled *Landscape Painting*, New York, 1950; rev. ed., London and New York, 1976, with added

plates). Brilliantly conceived in its chapter headings and the categories of discussion they set up—suggesting basic ways of seeing landscape and making pictures from it that match their character to those ways of seeing—it suffers in a present-day perspective from its author's lack of social awareness, its bypassing of the specific functional needs that landscape satisfied, and a tendency to eliminate or relegate to the margins secondary figures whose practice is key to the continuity of specific traditions. Two subsequent publications that take over Clark's categories and approach in specific areas bring out the kind of stretching needed to do this: Derek Pearsall and Elizabeth Salter, *Landscape and Seasons of the Medieval World* (Toronto, 1973), and Estelle Jussim and Elizabeth Lindquist-Cock, *Landscape as Photograph* (New Haven, 1983).

The text by Enzo Carli for *Il Paesaggio*, ed. Mina Cinotti (Milan, 1979), trans. Mary Patton as *The Landscape in Art* (New York, 1980), introduces what is primarily an anthology of pictures; the same applies to Konstantin Bazarov, *Landscape Painting* (London and New York, 1981). General studies of landscape art in German, not so far translated, that are developmentally organized and marked by the search for underlying conceptual or philosophical principles, include most recently Mathias Eberle, *Individuum und Landschaft: zur Enstehung und Entwicklung der Landschaftsmalerei* (Giessen, 1979; 3d ed., 1986); A. Ritter, ed., *Landschaft und Raum in der Erzählkunst* (Darmstadt, 1985); Erich Steingräber, *Zweitausend Jahre Europäische Landschaftsmalerei* (Munich, 1985), which expands upon its author's contribution to the exh. cat. *Im Licht von Claude Lorrain, Landschaftsmalerei aus drei Jahrhunderten*, Haus der Kunst, Munich, March–May 1983 (cat. by Marcel Roethlisberger, Munich, 1983); Barbara Eschenburg, *Landschaft in der deutschen Malerei vom späten Mittelalter bis heute* (Munich, 1987), with good bibliographic references in its notes; and for the modern period, Oskar Bätschmann, *Entfernung der Natur: Landschaftsmalerei, 1750–1920* (Cologne, 1989).

My formulation about the operation of landscape art on the viewer's consciousness draws for its general framework on Dan Sperber, *Le symbolisme en général* (Paris, 1974), trans. Alice Morton as *Rethinking Symbolism* (Cambridge, Mass., 1975).

8. For the social history of art, in its concern of recent years with a spectrum of related issues brought up by the landscape art of the nineteenth century, see especially John Barrell, *The Dark Side of the Landscape: The Rural Poor in English Painting, 1730–1840* (Cambridge, 1980); Fred Orton and Griselda Pollock, "*Les Données Bretonnantes: La Prairie de Représentation*" (review of exh. cat. *Post-Impressionism, Cross-Currents in European Painting*, Royal Academy, London, Novem-

ber 1979–March 1980, section on France, with essays by John House and MaryAnne Stevens), *Art History* 3 (1980): 314–44; Paul H. Tucker, *Monet at Argenteuil* (New Haven, 1982); Michael Rosenthal, *Constable: The Painter and His Landscape* (New Haven, 1983); T. J. Clark, *The Painting of Modern Life: Paris in the Art of Manet and His Followers* (New York, 1985), chaps. 1 and 3; Kathleen Adler and Tamar Garb, *Berthe Morisot* (Oxford, 1987); Robert L. Herbert, *Impressionism: Art, Leisure, and Parisian Society* (New Haven, 1988); Paul H. Tucker, *Monet in the 90s: The Series Paintings*, exh. cat., Museum of Fine Arts, Boston, Art Institute of Chicago, and Royal Academy, London, 1989–90 (New Haven, 1989); Eric Rosenberg and Miriam Stewart, intro. to exh. cat. *The Harvest of 1830: The Barbizon Legacy*, Sackler Art Museum, Harvard University, Cambridge, summer 1990; Nicholas Green, *The Spectacle of Nature: Landscape and Bourgeois Culture in Nineteenth-Century France* (Manchester, 1990); Richard Brettell, *Pissarro and Pontoise: The Painter in a Landscape* (New Haven, 1990); Paul Smith, "Pissaro and the Political Colour of an Original Vision," *Art History* 15, no. 2 (1992): 223–47; Griselda Pollock, *Avant-Garde Gambits, 1888–1893: Gender and the Colour of Art History* (London, 1992), 28–35, 49–59.

9. The notion of an "ideal" or "model" reader, who responds to a text/image in ways asked of him or her—by the text, not the author—is put forward by the classical scholar Gian Biagio Conte in his *The Rhetoric of Imitation: Genre and Poetic Meaning in Virgil and Other Latin Poets* (trans. from Italian, with Foreword by Charles Segal [Ithaca, 1986]), intro. 28, 30, with a use of rhetorical theory in particular as support for this approach. With appropriate adjustments, such a notion of the reader's activity can be transposed to viewers and the response on their part that a pictorial image calls for, as a matter of what Conte elsewhere terms "communicative strategies" addressed to them.

10. For semiotics as a recasting of traditional concerns within art history, linking it to other fields of the humanities, see especially among recent writings on the subject of landscape, John Dixon Hunt, *Garden and Grove: The Italian Renaissance Garden and the English Imagination, 1600–1750* (London, 1986), to be compared with his earlier *The Figure in the Landscape: Poetry, Painting, and Gardening During the Eighteenth Century* (Baltimore, 1976); James A. W. Heffernan, *The Recreation of Landscape: A Study of Wordsworth, Coleridge, Constable, and Turner* (Hanover, 1984), together with the volume edited by him, *Space, Time, Image, Sign: Essays in Literature and the Visual Arts* (New York, 1987); and John Gage, "Color in Western Art: An Issue?" *Art Bulletin* 72 (1990): 518–41. Ronald Paulson's *Literary Landscape: Turner and Constable* (New Haven, 1982),

though sometimes suggestive, is hampered by the desire to make its symbolic readings (whether thematic or psychological in cast) function as an extension of traditional art-historical interpretation. See contrastingly for this period Ann Bermingham, *Landscape and Ideology: The English Rustic Tradition, 1740–1860,* (Berkeley and Los Angeles, 1986); and Alain Corbin, *The Lure of the Sea, the Discovery of the Seaside in the Western World, 1750–1840,* trans. Joycelyn Phelps (Berkeley and Los Angeles, 1994; French ed., 1988), both using structuralist categories for their analysis of nature and culture. See also the important contributions for the nineteenth century, with a theoretical orientation to them that is basically semiotic in cast, of Richard Shiff, *Cézanne and the End of Impressionism: A Study of the Theory, Technique, and Critical Evaluation of Modern Art* (Chicago, 1984), part 1; Alex Potts, "Picturing the Metropolis: Images of London in the Nineteenth Century," *History Workshop* 26 (1988): 28–56; and Joseph Leo Koerner, *Casper David Friedrich and the Subject of Landscape* (London and New Haven, 1990).

11. As suggested by Martin Kemp in reviewing John Shearman's book *Only Connect . . . : Art and the Spectator in the Italian Renaissance* (A. W. Mellon Lectures in the Fine Arts, 1988; Princeton, 1992) under the title "Prospecting in the Pictures," *Times Literary Supplement,* 2 April 1993, 13. He argues for a word combining the Renaissance idea of "seeing through" in a systematic manner, associated with perspective, with the modern conception of a rigorous analytical scrutiny.

CHAPTER 1

1. Transposability distinguishes itself here from translatability (from Italian into English or in and out of code). The content of a sentence or statement is translatable in those cases, word by word or morpheme by morpheme; whereas there may be an absence of parallelism between languages requiring that, to make the change from one to another, a particular grammatical pattern be transposed into a different construction.

2. Details of this fresco and the others belonging to the same scheme (West House, Room 5) are taken from Christos G. Dounas, *Thera: Pompeii of the Aegean* (London, 1983), chap. 4.

3. For a parallel between these frescoes and Minoan/Mycenaean language of the time, see Sarah P. Morris, "A Tale of Two Cities: The Miniature Frescoes from Thera and the Origins of Greek Poetry," *American Journal of Archaeology* 92 (1989): 551–35. Morris differs from me, however, in insisting that an epic type of narrative is to be read in here. She assumes correspondingly, as others writing on the frescoes also do, that the

presentation has to be a synoptic one, entailing temporally correlated incidents put together within the same space, rather than just a combination and sequence of scenic details. To question this assumption is not to say that song, celebrating events in a descriptive fashion, would not have existed at this early time; and also a prose of a cataloguing kind anticipating, in abbreviated or simplified form, the "listing" sections of the *Iliad*; but see G. S. Kirk, *Homer and the Oral Tradition* (Cambridge, 1976), 2, 19–22, 84, on whether those linguistic systems should be accorded the status of anticipating Homeric narrative—and doing so this early, in a fashion that allowed for the description of two or more associated happenings occurring in synchronism with one another.

4. For such Hellenistic epigrams, by Antiphilus and Archias, which refer to landscape elements within paintings. See A. S. F. Gow and D. L. Page, eds., *The Greek Anthology: The Garland of Philip and Some Contemporary Epigrams,* 2 vols. (Cambridge, 1968), 1:122–23, 143; 2:410–11, 442.

5. On ancient landscape in general I have used J. J. Pollitt, *Art in the Hellenistic Age* (Cambridge, 1986), chap. 10, "Pictorial Illusion and Narration." The most important discussion of the subject, in terms of what follows later in this section, is that of Peter von Blanckenhagen (with whom I took part as a graduate student in a seminar devoted to this topic), "The Odyssey Frieze," *Mitteilungen des deutschen archäologischen Instituts, Römische Abteilung* 70 (1963): 100–146. A recent, plainly worded restatement of the argument to the contrary against Hellenistic derivation is to be found in Roger Ling, *Roman Painting* (Cambridge, 1991), chap. 4, pp. 107–11; his chapter 7 equally plays down pre-Roman precedents for this sort of scheme.

6. Vitruvius, *De Architectura* 7.5.2.

7. Ibid., and see 6.5.9 on theatrical scenery: *On Architecture,* trans. Frank Grainger (London and New York, 1934), 103–5.

8. Pliny, *Naturalis Historia* 35.96.

9. On Demetrius, see Diodorus Siculus (31.18.2), and also Valerius Maximus (5.1.1) calling him *pictor. Topographia* was the term used in antiquity for the geographical description of regional features, but it could also mean more generally the graphic representation of a place, whether pictorially or in words.

10. Philostratus, *Imagines,* trans. Arthur Fairbanks, (London and New York, 1931), 1.9, 12, 19, 25; 2.17.

11. Vitruvius, as in nn. 6–7.

12. Satyric landscape including both the Bellini and the Titian is discussed by David Rosand in his contribution "Giorgione, Venice, and the Pastoral Vision" to the exh. cat. *Places of Delight: The Pastoral Landscape,* Phillips Collection, Washington, D.C., in

association with the National Gallery of Art, Washington, D.C., November 1988–January 1989, 73–77.

13. This print is discussed by Marjorie B. Cohn, "Christ on the Road to Emmaus: An Art History Whodunit," News from Harvard Art Museums 2, no. 3 (1990): 1–2, with a suggested attribution to Theodor de Bry. It is now catalogued by the museum as "Circle of Lambert Lombard."

14. The volume of essays Intertextuality: Theories and Practices, edited by Michael Worton and Judith Still (Manchester, 1990), includes a general introduction to the subject, with bibliography. I have used the term as in Martin Steven, "The Intertextuality of Late Medieval Art and Drama," New Literary History 22 (1991): 317–30, where no explanation is given, but a form of comparison helpful to both kinds of "text" is proposed. David Rosand, "Pastoral Topoi: On the Construction of Meaning in Landscape," in The Pastoral Landscape, ed. John Dixon Hunt, National Gallery, Washington, D.C., Studies in the History of Art 36 (Hanover, 1992), 160–77, discusses "groupings of motif" as a key to affective appeal, giving the example of a presentation of the Holy Family, in a landscape with shepherds, paralleling Sannazaro's pastoral version of the Nativity story. For another kind of case involving the interpretation of landscape art in terms of what may be thought of as an intertext, see Pamela M. Jones, "Federico Borromeo as Patron of Landscapes and Still Lifes: Christian Optimism in Italy ca. 1600," Art Bulletin 70 (1988): 261–72, esp. 266–67, suggesting that landscapes that the cardinal owned by Jan Brueghel the Elder and Paul Bril be read, in their plant and animal imagery, in the light of devotional treatises of his that were to be published only in 1625 and 1632.

15. Lodovico Dolce, Dialogo de . . . i colori (Venice, 1565), 51v., trans. Rosand, "Giorgione, Venice," 76.

16. Dolce, Lettera al Mag. M. Alessandro Contarini, in Lettere di diversi eccellentissimi huomini, ed. L. Dolce (Venice, 1559); reprinted and translated in Mark W. Roskill, Dolce's "Aretino" and Venetian Art Theory of the Cinquecento (New York, 1968), 217.

17. Standard accounts of the theory of the picturesque in Britain are Christopher Hussey, The Picturesque: Studies in a Point of View (London, 1927; 2d ed., 1967), and Walter J. Hipple Jr., The Beautiful, the Sublime, and the Picturesque in Eighteenth-Century British Aesthetic Theory (Carbondale, Ill., 1957). More recent publications offering additional materials on the subject include John Dixon Hunt, The Figure in the Landscape: Poetry, Painting, and Gardening During the Eighteenth Century (Baltimore, 1976); Peter Bicknell, Beauty, Horror, and Immensity: Picturesque Landscape in Britain, 1750–1850, exh. cat., Fitzwilliam Museum, Cam-

bridge, July–August 1981; David Watkin, The English Vision: The Picturesque in Architecture, Landscape, and Garden Design (London and New York, 1982); Malcolm Andrews, The Search for the Picturesque: Landscape Aesthetics and Tourism in Britain, 1760–1800 (Stanford, 1989); James S. Ackerman, The Villa: Form and Ideology of the Country House (A. W. Mellon Lectures in Fine Arts, 1985; Princeton, 1990), chaps. 7 and 9; Sidney K. Robinson, Inquiry into the Picturesque (Chicago, 1991); John Dixon Hunt, Gardens and the Picturesque: Studies in the History of Landscape Architecture (Cambridge, Mass., 1992); Gina Crandell, Nature Pictorialized: "The View" in Landscape History (Baltimore, 1993).

On associationism and the viewing of landscape, I have drawn particularly on John Barrell, The Idea of Landscape and the Sense of Place, 1730–1840: An Approach to the Poetry of John Clare (Cambridge, 1972), chap. 1, "The Idea of Landscape in the Eighteenth Century," and Ann Bermingham, Landscape and Ideology: The English Rustic Tradition, 1740–1860 (Berkeley and Los Angeles, 1986), chap. 2, "The Picturesque Decade." For a clear exposition of the primary texts in question, see also K. Claire Pace, "Strong Contraries . . . Happy Discord: Some Eighteenth-Century Discussions about Landscape," Journal of the History of Ideas 40 (1979): 141–81, part 4.

18. This painting is reproduced, along with a related poem, in the anthology The Genius of the Place: The English Landscape Garden, 1620–1820, ed. John Dixon Hunt and Peter Willis (New York, 1975), 298–400.

19. James Thomson, "Spring," from The Seasons (1730, rev. ed., 1744), in Hunt and Willis, Genius of the Place, 94–95.

20. See William Gilpin, Three Essays: On Picturesque Beauty, On Picturesque Travel and On Sketching Landscape (1792), discussed by Hussey, The Picturesque, 116ff., and Remarks on Forest Scenery (1791), excerpted in Hunt and Willis, Genius of the Place, 338–41.

21. Uvedale Price, An Essay on the Picturesque As Compared with the Sublime and the Beautiful (1794), excerpted in Hunt and Willis, Genius of the Place, 351–57.

22. Richard Payne Knight, The Landscape: A Didactic Poem (1794), excerpted in Hunt and Willis, Genius of the Place, 342–48.

23. Archibald Alison, Essay on the Nature and Principles of Taste (1790, expanded ed. 1811; Boston, 1812), 79–83.

24. Alison, Essay, 1812 ed., 107.

25. Richard Payne Knight, An Analytical Inquiry into the Principles of Taste (1805), excerpted in Hunt and Willis, Genius of the Place, 349.

26. See the discussion of the layout of both Stowe

and Stourhead in Ronald Paulson, *Emblem and Expression: Meaning in English Art of the Eighteenth Century* (Cambridge, Mass., 1975), chap. 2.

27. Knight, *Analytical Inquiry*, (1805), 350.

28. I am indebted to the present owners of Norbury Park, Frank and Wendy Chapman, for letting me see the house and its painted room as restored for them since 1987.

Alternative proposals by George Barret for the scheme are preserved in the form of watercolors in the Paul Mellon Center for British Art, New Haven (showing the landscape through an open grille) and the Courtauld Institute, London (showing inset ovals with miniaturized landscape views in the painted baseboard, which forms an important part of the scheme, seemingly stopping the path into the room of a descending torrent of water). The gold filigree work at the top of the walls all round appears on inspection to be a later addition; interfering as it does with the perspective of the trellis, it was no doubt added, along with the present mirror above the fireplace, subsequent to the sale of the property in June 1819.

29. John Timbs, *A Picturesque Promenade around Dorking* (1822; 2d ed., London, 1823), 10–11, introducing "Mr Lock's Painted Room." A comparable account of a landscape painting with associations built into it, Samuel F. B. Morse's *The View from Apple Hill* of 1828–29, is provided by Paul J. Staiti, *Samuel F. B. Morse* (Cambridge, 1990), 136–48, using as intertext the related writings of James Fenimore Cooper.

30. Gilpin's text on the subject is reprinted in Christopher Hussey, " 'Italian Light on English Walls': Two Eighteenth-Century Painted Landscape Rooms," *Country Life* (17 February 1934): 162–63. Correspondence between Gilpin and Lock regarding the scheme, while it was in progress, is cited in Carl Paul Barbier, *William Gilpin: His Drawings, Teachings, and Theory of the Picturesque* (Oxford, 1963), 125–27, and it included some sketches with suggested components (now in the Bodleian Library, Oxford, MS Eng. Misc. d. 574, fols. 181–84).

31. William Shenstone, "Unconnected Thoughts on Gardening," first published in *The Works in Verse and Prose of William Shenstone Esq.*, ed. Robert Dodsley, 3 vols. (London, 1765), repr. in Hunt and Willis, *Genius of the Place*, 289–97.

The term "home scenes" is used subsequently by the American landscape designer Andrew Jackson Downing in a sense that may well correspond to Shenstone's: embodied in the beautification of such a scene are the combined forms of "trees, surfaces of the ground, buildings and walks." See Downing's text *A Treatise on the Theory and Practice of Landscape Gardening, Adapted to North America, with a View to the Improvement of Country Residences* (original ed., 1841; New York, 1859), reprinted in *America Builds: Some Documents on American Architecture and Planning*, ed. Leland W. Roth (New York, 1983), 138.

32. For gender as a category of historical analysis and as a "primary way of signifying relationships of power," see Joan Wallach Scott, *Gender and the Politics of History* (New York, 1988). Other writings that have helped me in formulating this section are Claudia Lazzaro, *The Italian Renaissance Garden* (New Haven, 1900), chap. 1, "Nature and Culture in the Garden," together with her supplementary essay, "The Visual Language of Gender in Garden Sculpture," in *Refiguring Women: Gender Studies and the Italian Renaissance*, ed. M. Migiel and J. Schiesari (Ithaca, 1990); and on the public/private distinction as it affects landscape as a genre at this period, John Barrell, *The Political Theory of Painting from Reynolds to Hazlitt: "The Body of the Public"* (New Haven, 1986), 119–20.

For literature, see also Carol Fabricant, "The Aesthetics and Politics of Landscape in the Eighteenth Century," in *Studies in Eighteenth-Century British Art and Aesthetics*, ed. Ralph Cohen (Berkeley and Los Angeles, 1985), 49–81, together with her earlier essay "Binding and Dressing Nature's Loose Tresses: The Ideology of Augustan Landscape Design," *Studies in Eighteenth-Century Culture* 8 (1979): 109–35. Ann Bermingham comparably brings out the gendering of the "prospect" in eighteenth-century British writings on landscape, in "System, Order and Abstraction: The Politics of English Landscape Drawing Around 1795," in *Landscape and Power*, ed. W. J. T. Mitchell (Chicago, 1994), 77–102.

33. There is a kindred scheme of decoration dating from the mid-sixteenth century in the Villa Giulia in Rome; later seventeenth- and eighteenth-century ceilings there in the Palazzo Rospigliosi and the Palazzo Barberini represent possible intermediaries (suggested to me by Iris Cheney).

34. Helpful to me here, in addition to the writings cited in note 32, have been Marilyn Butler's updated intro. to her *Jane Austen and the War of Ideas* (Oxford, 1975; reissued 1987), discussing developments in women's literature of the later eighteenth century, and Annette Kolodny, *The Land Before Her: Fantasy and Experience of the American Frontiers, 1630–1860* (Chapel Hill, 1984), which includes remarks on the English background for eighteenth-century women settlers, together with her earlier *The Lay of the Land: Metaphor as Experience and History in American Life and Letters* (Chapel Hill, 1975), which is more essentialist in its focus on male responses.

35. On the possible original locations that suggest

themselves for these large-scale paintings of Fragonard's, see *Fragonard*, exh. cat., Grand Palais, Paris, and Metropolitan Museum of Art, New York, September 1987–May 1988, nos. 161–63, with catalogue entries by Pierre Rosenberg.

36. Mary D. Sheriff, *Fragonard: Art and Eroticism* (Chicago, 1990), brings up the input of picturesque theory into France at this time and Condillac's concept of the natural sign, 82–85, 144–46, but she does not discuss the later landscapes specifically, or include in her scope how late paintings such as *The Lock* (c. 1776–79) show women in a more active role, which may relate to the input or collaboration of the artist's sister-in-law and protégée Marguerite Gérard.

37. The figures in the Norbury Park scheme (barely legible in photographs) consist, by comparison, of men who are more energetically posed or more actively taking possession of their environment, while women are shown in more sheltered or pensively inclined situations.

38. See on this point the very helpful discussion that is now available by Debora L. Silverman, *Art Nouveau in Fin-de-Siècle France: Politics, Psychology, and Style* (Berkeley and Los Angeles, 1989), esp. 201, 226.

CHAPTER 2

1. See C. S. Davies, *Ghirlandaio* (London, 1908), 71, and the discussion of such contracts by Michael Baxandall, *Painting and Experience in Fifteenth-Century Italy* (Oxford, 1972), 17–18.

2. See John Michael Montias, *Vermeer and His Milieu: A Web of Social History* (Princeton, 1988), 329.

3. The representation of landscape subjects in seventeenth-century Dutch households is projected in these terms in John Michael Montias, *Artists and Artisans in Delft: A Socio-Economic Study of the Seventeenth Century* (Princeton, 1982), 243, 245.

4. Letter of Owen MacSwinny to Duke of Richmond, November 1727, cited as it appears in Bernard Denvir, *The Eighteenth Century: Art, Design, and Society, 1689–1789* (London and New York, 1983), 106–8.

5. For Vernet's letter of 1765 cited, refusing the demand of a potential patron for a sketch, see Philip Conisbee, intro. to *Joseph Vernet, 1714–1789*, exh. cat. Musée de la Marine, Palais Chaillot, Paris, October 1976–January 1977, 20, and for references to "wild" subjects requested of him that Vernet made at various times, see Léon Lagrange, *Joseph Vernet, sa vie, sa famille, son siècle* (Brussels, 1858), 42, 48, 52, 133–33, 141, brought together by Daniel Mornet, *Le sentiment de la nature en France de J. J. Rousseau à Bernadin de Saint-Pierre* (Paris, 1907), 336.

6. On Poussin and the "modes," see the discussion by Jan Bialostocki, "Das Modusproblem in den bildenden Künsten," *Zeitschrift für Kunstgeschichte* 24 (1961): 128–41, repr. in his *Stil und Ikonographie: Studien zur Kunstwissenschaft* (Dresden, 1966), 9–35; Edward Lockspeiser, *Music and Painting* (London, 1973), app. B, citing in translation the remarks on the subject in Poussin's correspondence; and Thomas Puttfarken, *Roger de Piles' Theory of Art* (New Haven, 1985), chap. 1, "Félibien and the Early Academy," 29–37, for Félibien's framework of discussion.

7. Pliny the Elder, *Naturalis Historia* 35.116, trans. H. Rackham, 12 vols. (Cambridge, Mass., 1936–63), 9:347.

8. For composition and meaning in Roman landscape art in general, see the very full discussion of the materials by Bettina Bergmann, *Sacred Groves and Sunlit Shores: The Roman Art of Landscape* (Princeton, forthcoming); for the implications of the imagery in sacro-idyllic subjects, see, in addition, Susan Silberberg-Pierce, "Politics and Private Imagery: The Sacral-Idyllic Landscapes," *Art History* 5 (1980): 241–51, and for garden paintings, including the Casa del Frutteto, see Salvatore Settis, "The Deceptive Walls: Imagery and Space in Roman Garden Paintings," trans. from the Italian in International Symposium in honor of the Council of Europe Exhibition "Space in European Art," Keidanren Kaikan, Tokyo, April 1987, 55–66.

9. An overview of the categories of Dutch seventeenth-century landscape art and the mechanics of its production is provided in Wolfgang Stechow, *Dutch Landscape Painting of the Seventeenth Century* (London: Phaidon, 1966), intro., and the whole book is organized accordingly.

10. The term *pastoral* can be applied to those Roman wall paintings of groves with herdsmen or shepherds and animals that convey, through their idioms of representation, an anti-urban, escapist impulse and set up a corresponding mood. See the illuminating exposition of how a "cultural movement" is given "voice" in this way in Bettina Bergmann, "Exploring the Grove: Pastoral Space on Roman Walls," in *The Pastoral Landscape*, ed. John Dixon Hunt, National Gallery of Art, Washington, D.C., Studies in the History of Art 36 (Hanover, 1992), 1–48, which is incorporated as one of the chapters in her *Sacred Groves*. The type of window construction referred to forms part of the discussion there.

11. I adapt this term from David Carrier's book *Poussin's Paintings: A Study in Art-Historical Methodology* (University Park, Pa., 1993), esp. 104, where it serves equivalently to underwrite the structural distinctions between Poussin's art and Matisse's, and the difference of "voice" in comparison to Rubens's.

12. My discussion here draws especially, for the later Middle Ages, on Walter Cahn, "Medieval Landscape

and the Encyclopedic Tradition," in the special issue of *Yale French Studies*, ed. Daniel Poirion and Nancy F. Regolado, *Contexts: Style and Values in Medieval Art and Literature* (New Haven, 1991), 11–24. See also, for a summary of the basic types of representation, the commentary by François Boucher appended to Robert A. Koch, "The Origin of the Fleur-de-Lis and the *Lilium Candidum* in Art," in *Approaches to Nature in the Middle Ages: Papers of the Tenth Annual Conference of the Center for Medieval and Early Renaissance Studies, State University of New York at Binghamton, 1976*, ed. Lawrence C. Roberts (Binghamton, 1982), 131–36.

13. My comparison of van Eyck and Campin is indebted to the terms in which those two artists are counterpointed against one another by Craig Harbison, "Realism and Symbolism in Early Flemish Painting," *Art Bulletin* 66 (1984): 588–602; though he does not bring up landscape there, the setting of the *Rolin Madonna* is discussed more recently in related fashion in his *Jan van Eyck: The Play of Realism* (London and Seattle, 1991), 109–12.

14. Matthew Botvinick, "The Painting as Pilgrimage: Traces of a Subtext in the Work of Campin and His Contemporaries," *Art History* 15 (1992): 1–18, offers a parallel reading here (mine was formulated independently) that brings in also the left wing of the Mérode altarpiece.

15. Joel M. Upton, *Petrus Christus: His Place in Fifteenth-Century Flemish Art* (University Park, Pa., 1990), focuses on some important shifts affecting the character of sacred and narrative imagery from the mid- to later fifteenth century in the North.

16. The first unmistakably recognizable city buildings appear in the 1470s and 1480s: as in the *Virgin of the Rose Garden* by the Master of the Saint Lucy Legend (before 1483; Detroit Institute of Arts), where the belltower of Bruges is included. Possible, but not fully convincing earlier examples are discussed by Upton, in *Petrus Christus*.

17. Karl M. Birkmeyer, "The Arch Motif in Netherlandish Painting of the Fifteenth Century: A Study in Changing Religious Imagery, Part 2," *Art Bulletin* 43 (1961): 99–112 provides a model example of this kind of analysis in its discussion (108) of the settings used in the *Nativity* and *Adoration* panels of Bouts's *Infancy Altar*. Otto Pächt's remarks on the understanding of naturalism in his review of Panofsky's *Early Netherlandish Painting*, in *Burlington Magazine* 98 (1965): 267–79, are also apropos here.

18. The type of image referred to here has been independently characterized by Peter Parshall, "Imago Contrafatta: Images and Facts in the Northern Renaissance," *Art History* 16, no. 4 (December 1993): 554–76, as one that came to be designated during the sixteenth century as "bearer of visual fact," and his discussion includes a section on topography and the status of landscape, as reflected in sets of prints made for collectors.

19. Northern specialization in the production of landscape, beginning in the 1520s, is discussed in Max J. Friedlander's classic text *Essays über die Landscaftsmalerei und andere Bildgattungen* (The Hague, 1941), trans. R. F. C. Hull as *Landscape, Portrait, Still Life: Their Origin and Development* (Oxford, 1947), 50–51, 65–66.

20. Dürer's verdict on Patinir is to be found in his diary for May 5, 1521: E. Rupprich, *Dürers schriftlicher Nachlaß*, 5 vols. (Berlin, 1956–69), 1:169; trans. in *Albrecht Dürer's Diary of His Journey to the Netherlands 1520, 1521*, intro. J. A. Garis and G. Marlier (London, 1971), 89. On maps of the time incorporating into their projectional scheme specific ranges and tracts of forest in an equivalent of bird's-eye view, and especially the utilitarian form of cartographic plan of this time that came to be known in England as the "plat," see P. D. A. Harvey, *The History of Topographical Maps: Symbols, Pictures, and Surveys* (London, 1980) chaps. 4 and 9, and the discussion of British examples by Peter Barber, "King Henry VIII and Map-Making," in the exh. cat. *Henry VIII: A European Court in England*, ed. David Starkey, National Maritime Museum, Greenwich, 1991; New York, 1991, 146–47. For a Netherlandish example of a maplike view, showing the landscape around Bruges with attention to roads, waterways, and other landmarks of the area, see Ann Roberts, "The Landscape as Legal Document: Jan de Hervy's 'View of the Zwin,' " *Burlington Magazine* 133 (1991): 82–86, where the attribution of the work is linked to a date of around 1500, rather than the inscribed date of 1561, which is shown to be a later addition.

21. The brush drawings referred to are effectively placed in context in Fritz Kureny, *Albrecht Dürer and the Animal and Plant Studies of the Renaissance*, exh. cat., Sammlung Albertina, Vienna, April—June 1985 (Boston, 1985), which includes in its coverage copies, imitations, and forgeries. The travel drawings cited are reproduced and have their inscriptions translated in Walter L. Strauss, *The Complete Drawings of Albrecht Dürer*, 6 vols. (New York, 1974), 3:1519/10, 4:1520/15; the report on the King's House is translated in Dürer, *Diary*, 63.

22. The difference of orientation between this watercolor and nature studies like the *Great Piece of Turf* is framed along similar lines by Martin Kemp in his contribution "The Mean and Measure of All Things" to *Circa 1492: Art in the Age of Exploration*, ed. Jay A. Levenson, exh. cat., National Gallery of Art, Washington, D.C., October 1991–January 1992 (New Haven, 1991), 108–10.

23. Luther, *Lectures on Genesis,* as translated in *Luther's Works,* ed. Jaroslav Pelikan, 54 vols. (Saint Louis, 1955), 1:204–5.

24. The reviews of Reindert L. Falkenburg's *Joachim Patinir: Landscape as an Image of the Pilgrimage of Life* (Amsterdam, 1988) by Edwin Buijsen, *Simiolus* 19 (1989): 209–15, and by Lawrence O. Goedde, *Art Bulletin* 72 (1990): 655–57, deal with the basic terms in which the landscape imagery of this artist operates.

25. For specific developments in the scope and treatment of "world landscape" from Patinir down through Bruegel, see Walter S. Gibson, *"Mirror of the Earth": The World Landscape in Sixteenth-Century Flemish Painting* (Princeton, 1989), with a full earlier bibliography on the subject.

26. For Venetian images of Saint Jerome in the Wilderness or Desert, in which a related role is given to pastoral landscape elements from the 1520s on, see David Rosand, "Giorgione, Venice, and the Pastoral Vision," in *Places of Delight: The Pastoral Landscape,* exh. cat., Phillips Collection, Washington, D.C., in association with the National Gallery of Art, Washington, D.C., November 1988–January 1989, 66–67.

27. For the most recent discussion of Bruegel's "Months" or "Seasons" in relation to their place of destination, see Ian Buchanan, "The Collection of Niclaes Jongelinck II: The Months by Pieter Bruegel the Elder," *Burlington Magazine* 132 (1990): 541–50, and for the earlier Hercules cycle done by Floris, see Carl van de Velde, "The Labours of Hercules, A Lost Series of Paintings by Frans Floris," *Burlington Magazine* 107 (1965): 114–23, showing the various landscape settings there as they appear in the engraved version of the series by Cornelis Cort.

28. My account of the *Hunters* allies itself here to the terms of understanding that John Barrell has brought to Shakespeare's Sonnet 29, reading it in relation to the discourse of sixteenth-century patronage and its empowerment, in his *Poetry, Language, and Politics* (Manchester, 1988), chap. 1. I have profited also from reading the pages on "seeing" and "not-seeing" included in Margaret L. Sullivan, *Bruegel's Peasants* (Cambridge, 1993), chap. 3, and from discussion with her.

29. E. H. Gombrich, "Renaissance Artistic Theory and the Development of Landscape Painting," *Gazette des Beaux Arts,* 6th ser., 41 (1953): 335–60, reprinted in his *Norm and Form: Studies in the Art of the Renaissance* (London, 1966), 107–21, suggested the inspiration of the stage designs of ancient comedy, as described by Vitruvius. Even if the connection is not so crucial as he made it, the texts bearing on this subject that he brought together are all interpretatively consequential. Svetlana Alpers, in her *The Art of Describing: Dutch Art in the Seventeenth Century* (Chicago, 1983), chap. 4,

attributes to Northern/Dutch artists, in contrast, an impulse toward the "mapping" of landscape in which personal experience played a primary role. Critics of her book have found the argument here insufficiently nuanced to account for the whole development in landscape that she surveys, focusing especially on panoramic views by Ruisdael of Haarlem and its environs.

30. Fazio, *De Viris Illustribus* (Florence, 1475), trans. and discussed in Michael Baxandall, *Giotto and the Orators: Humanist Observers of Painting in Italy and the Discovery of Pictorial Composition, 1350–1450* (Oxford, 1971), 106–7. Baxandall identifies the owner named as Ottavio della Carda, nephew and counselor to Federigo da Montefeltro in Urbino; whereas Roberto Weiss, "Jan van Eyck and the Italians," two parts, *Italian Studies* 11 (1956): 3–5; 12 (1957): 10–11, had proposed that the reference was to Ottavio Cardinale of Genoa.

31. Anonimo Morelliano, *Notizia d'opere del disegno,* ed. Theodor Frimmel, Quellenschriften für Kunstgeschichte und Kunsttechnik des Mittelalters und der Renaissance, n.s., 1 (Vienna, 1888), 88, 102, 106.

32. Pliny, *Naturalis Historia* 35.101.

33. Giovio, cited and trans. by Gombrich, *Norm and Form,* 114–16.

34. The major exception surviving to these principles of construction is Benozzo Gozzoli's fresco scheme of 1459 for the Chapel of the Magi in the Palazzo Medici-Riccardi in Florence. In direct contrast to the landscape in Alessio Baldovinetti's *Nativity* fresco of 1450–62, in the atrium of the Annunziata in Florence (much damaged but still readable), Gozzoli's presents itself as an extended theater of nature through which the procession winds its way; and the act of vision as practiced on individual segments and components of the natural setting (trees, rocks, farms, and castles) has a separating force that extends also to the horses and their riders. Links that are apparent in this staging with earlier quattrocento landscape in the International Style—notably, Gentile da Fabriano's *Adoration of the Magi* altarpiece from the Strozzi Chapel of Santa Trinità, Florence (1423, Uffizi)—and with Fra Filippo Lippi's altarpiece for the Medici Chapel of the *Adoration of the Christ Child* (replaced there by a copy by Neri di Bicci) are brought out by Elena Berti Toesca in her intro. to *Benozzo Gozzoli: Gli affreschi della Cappella Medicea* (2d ed., Milan, 1958), 11–17. The taste of the patron, Piero il Gottoso, was clearly important here, as Marcia B. Hall remarks in reference to the luxuriant use of gold: *Color and Meaning: Practice and Theory in Renaissance Painting* (Cambridge, 1992), 59.

35. For the attribution to the young Titian here and for related works, see Hilliard T. Goldfarb, "An Early

Masterpiece by Titian Rediscovered, and Its Stylistic Implications," *Burlington Magazine* 126 (1984): 419–23.

36. It is well known that Walter Pater saw the entire production of the School of Giorgione in those terms, on the basis of the observation, made toward the end of his 1877 "The School of Giorgione," that "the perfect moments of music itself, the making or hearing of music, song or its accompaniment are themselves prominent as subjects"; see his *The Renaissance: Studies in Art and Poetry*, with intro. and notes by Kenneth Clark (London, 1961), 141. For the larger tradition of writing about art in such terms, see Paul Barolsky, *Walter Pater's Renaissance* (University Park, Pa., 1987), 130–31.

37. For the entire extant production, see Walter Koschatzky, *Albrecht Dürer: The Landscape Watercolors*, trans. Philippa McDermott, from the German ed. of 1971 (New York, 1973), with color plates and detailed discussion of medium, chronology, and subsequent history.

38. Helpful to me in the making of this formulation, especially as regards contingency and the "trace," was a paper by Christopher S. Wood (1991, unpublished), which he kindly allowed me to see.

39. For this body of work brought together, see Chris Fischer, *Fra Bartolommeo, Master Draughtsman of the High Renaissance: A Selection from the Rotterdam Albums and Landscape Drawings from Various Collections*, exh. cat., Museum Boymans–van Beuningen, Rotterdam, December 1990–February 1991 (Seattle, 1990), chap. 6, with identification of sites, technical information, and full details of later history.

40. Quoted in Koschatzky, *Albrecht Dürer*, 13.

41. On Altdorfer's landscape art I am much indebted to Christopher S. Wood, *Albrecht Altdorfer and the Origins of Landscape* (London and Chicago, 1993); the introduction deals with the independent landscape more generally, including Italian examples, and chapter 3 with the German treatment of forest. For other works of this artist, juxtaposed with his landscapes, see Hans Mielke, *Albrecht Altdorfer: Zeichnungen, Deckfarbenmalerei, Druckgraphik*, exh. cat., Staatliche Museen, Berlin, and Museen der Stadt Regensburg, February–July 1988 (Berlin, 1988), and for the conceptual context of the forest subjects, see Larry Silver, "Forest Primeval: Albrecht Altdorfer and the German Wilderness Landscape," *Simiolus* 13 (1983): 4–43.

42. For this correction, see S. Carezzolo et al., "Castel san Zeno di Montagnana in un disegno attribuito a Giorgione," *Antichità Viva* 17 (1978): 40–52, and Bernard Aikema and Bert W. Meijer, *Disegni veneti di collezioni olandesi*, exh. cat., Fondazione Giorgio Cini, Venice and Instituto Universitario Olandese, Florence (Vicenza, 1985), no. 15.

43. See Michael Hirst, "Salviati's Chinoiserie in Palazzo Sacchetti," *Burlington Magazine* 121 (1979): 791–92.

44. A. Richard Turner, *The Vision of Landscape in Renaissance Italy* (Princeton, 1966), chap. 7, offers a basic discussion for the sixteenth century of the impact of prints, Northern European and Venetian, on Central Italian landscape art. For the Salviati woodcut and the contributory bucolic imagery of Titian, see Rosand, "Giorgione, Venice," figs. 54, 56, and 59. A chronology for Venetian paintings and drawings inspired correspondingly by the *Eclogues* of Virgil is provided by W. R. Rearick, "From Arcady to the Barnyard," in *The Pastoral Landscape*, ed. John Dixon Hunt, 137–59.

45. I am indebted here to as yet unpublished papers by Iris Cheney and Nicola Courtwright dealing with the Brils's frescoes in the Vatican.

46. For interesting observations on Annibale Carracci's Washington landscape, which I have drawn upon, see David Reed, "Talking Pictures," interview with Stephen Ellis, in *David Reed*, exh. cat. (Los Angeles, A.R.T. Press, 1990), 28.

47. That Conti served as source for the allegorization of the story here was established by E. H. Gombrich, "The Subject of Poussin's Orion," *Burlington Magazine* 84 (1944): 37–38, 51, reprinted in his *Symbolic Images: Studies in the Art of the Renaissance* (London: Phaidon, 1972), 119–22. My further remarks about the structuring of the painting draw especially on David Carrier, "Blindness and the Representation of Desire in Poussin's Paintings," *Res* 19–20 (1990–91): 31–34, which represents a revised version of one section of his book *Poussin's Paintings* (University Park, Pa., 1993), 102–20.

48. André Félibien, *Entretiens sur les vies et les ouvrages des plus excellents peintres anciens et modernes*, 6 vols. (Trevoux, 1725), 4:160–61; English version in Oskar Bätschmann, *Nicolas Poussin: The Dialectics of Painting*, trans. Mark Daniel (London, 1990), 95, with accompanying discussion.

49. Cited in Anthony Blunt, *Nicolas Poussin*, 2 vols. (London, 1967), 1:296. For all of the statements regarding landscape in Poussin's letters and the paintings to which they apply, see 286, 292–93, 297, there, and Blunt, *The Paintings of Nicolas Poussin: A Critical Catalogue* (London, 1966), cat. nos. 209 and 217.

50. See Alain Mérot, *Nicolas Poussin*, trans. Fabia Claris (London and New York, 1990), chap. 5 and cat. nos. 289–96.

51. Quoted by Malcolm Bull in his review of recent publications, "How Smart Was Poussin?" *London Review of Books* (4 April 1991): 12–13; but Bernini may have been simply offering all-purpose praise.

52. I have drawn here on the introduction by H. Diane Russell to *Claude Lorrain, 1600–1682*, exh. cat.,

National Gallery of Art, Washington, D.C., October 1982–January 1983, 83–84, on journeying, and more generally on Margaretha Rossholm Lagerlof, *Ideal Landscape: Annibale Carracci, Nicolas Poussin, and Claude Lorrain* (New Haven, 1990), chaps. 1 and 2.

53. The locale depicted here is identified by Marcel Roethlisberger, "Claude Lorrain: Some New Perspectives," in *Claude Lorrain, 1600–1682: A Symposium*, ed. Pamela Askew, Studies in the History of Art 14, National Gallery of Art, Washington, D.C. (Washington, D.C., 1984), 47–65.

54. See here the exhibition catalogue compiled under the editorship of Cynthia P. Schneider, *Rembrandt's Landscapes, Drawings, and Prints*, National Gallery of Art, Washington, D.C. (Boston, 1990); for the role of suggestion in those prints, see the perceptive remarks of David Freedberg, *Dutch Landscape Prints of the Seventeenth Century*, British Museum Prints and Drawings Series (London, 1980), 50–55.

55. Cynthia P. Schneider, *Rembrandt's Landscapes* (New Haven, 1990) discusses issues of attribution, grouping, and chronology, with a full earlier bibliography.

56. On Dutch seventeenth-century landscape in general, see *Masters of Seventeenth-Century Dutch Landscape Painting*, exh. cat., Rijksmuseum, Amsterdam, Museum of Fine Arts, Boston, and Philadelphia Museum of Art, October 1987–July 1988, intro. Peter Sutton, which is valuable for its strong delineation of the cultural context, especially in the essay contributed by Simon Schama. See further the review of that catalogue by Ann Jensen Adams, *Art Bulletin* 74 (1992): 334–39, which uses it to assess the present state of studies in this field; and the additional material bearing on the first half of the century that is contained in *Dutch Landscape: The Early Years, Haarlem and Amsterdam, 1590–1650*, exh. cat., ed. Christopher Brown, National Gallery, London, September–November 1986, including essays by various hands.

57. Peacham (1606), quoted in Henry and Margaret Ogden, *English Taste in Landscape in the Seventeenth Century* (Ann Arbor, 1959), 5–6; Northgate, *Miniatura* (c. 1650), ed. Martin Hardie (Oxford, 1929), 41–42. Both passages are discussed in Rainer Gruenter, "Landschaft: Bemerkungen zur Wort- und Bedeutungsgeschichte," *Germanisch-romanische Monatsschrift* 34 (1953): 110–20.

58. For the placement of Ruisdael's art within a larger Dutch tradition and set of practices, see Stechow, *Dutch Landscape Painting*; and Madlin Miller Kahr, *Dutch Painting in the Seventeenth Century* (New York, 1978), chap. 10, "Landscapes and Seascapes." The exh. cat. *Jacob van Ruisdael*, by Semour Slive and H. R. Hoetink, Mauritshuis, The Hague, and Fogg Art

Museum, Harvard University, Cambridge, Mass., October 1981–April 1982 (New York, 1981), gives basic information on the major paintings, and there is now the attempt at a more conceptually and philosophically oriented reading offered by E. John Walford, *Jacob van Ruisdael: The Perception of Landscape* (New Haven, 1991), proposing that there is a specifically contemplative mode of perception at work. See also the claim for a "philosophical dimension," attaching to the Braunschweig painting especially, as made by Paul Huys Janssen in his introduction to *The Hoogsteder Exhibition of Dutch Landscapes*, exh. cat., Hoogsteder and Hoogsteder, The Hague, March–May 1991, 43.

59. Samuel van Hoogstraaten, *Inleyding tot de hooge schoole der Schilderkonst: Anders de zichtbaere werelt* (Rotterdam, 1678), 24–25.

60. "Projection" here entails the applied capacity of vision to move from what lies outside a represented world, across the divide marked by a frame into that world, and in so doing to make present spatial and sensible properties of the scene represented, in a seemingly objective fashion. For present purposes, this use of the term is to be distinguished from its psychological use—made familiar in the context of reading images by the role it plays in E. H. Gombrich's *Art and Illusion: A Study in the Psychology of Pictorial Representation* (A. W. Mellon Lectures in the Fine Arts, 1956; New York, 1960)—for the reading of configurations, such as those of landscape, into inkblots. Projection in that "subjective" sense—as with faces seen in clouds—would not answer to the pragmatic requirements, relevant for present purposes, of creating an "illusionary" environment for action and response, of the specific kind or kinds that one has in theater.

61. On Vermeer and the *camera obscura*, see Arthur K. Wheelock Jr., *Jan Vermeer* (New York, 1989), 28–39, 94–96, summarizing earlier writings of his on the subject.

62. For a general overview of this eighteenth-century genre of production, its origins and methods, see Giulio Briganti, *I vedutisti* (Milan, 1969), trans. Pamela Waley as *The View Painters of Europe* (London, 1970), and Boudewijn Bakker, *Painters of Venice: The Story of the Venetian "Veduta,"* exh. cat., with essay by Bernard Aikema, Rijksmuseum, Amsterdam, December 1990–March 1991 (The Hague, 1990).

63. For the *Eidophusikon* I have used the plates, advertisements, and descriptions of the time assembled in Richard S. Altick, *The Shows of London* (Cambridge, Mass., 1978), chap. 9.

64. Basic sources that give details for the early panoramas are Altick, *Shows of London*, chaps. 10 and 11; and Ralph Hyde, *Panoramania! The Art and Entertainment of the All-Embracing View* (London, 1988), which is interna-

tional in its scope and chronological in coverage. See also Heinz Buddemeier, *Panorama, Diorama, Photographie: Entstehung und Wirkung neuer Mediums in 19. Jahrhundert* (Munich, 1970), for related photographic materials, and the exhibition catalogue *Sehnsucht: Das Panorama als Massenunterhaltung des 19 Jahrhunderts*, organized by Marie Luise von Plessen, Kunst- und Austellungshalle der Bundesrepublik Deutschland, Bonn, May 1993–January 1994, with contributory essays pertaining to entertainment value.

65. See Altick, *Shows of London*, chap. 12, and also the comments of Nicholas Green, "Rustic Retreats: Visions of the Countryside in Mid-Nineteenth Century France," in *Reading Landscape: Country, City, Capital*, ed. Simon Pugh (Manchester, 1990), 170–71.

66. Constable, letter to Archdeacon Fisher, 30 September 1823, in *Correspondence*, ed. R. B. Beckett, 7 vols. (Ipswich, 1962–75), 6:134.

67. For fuller details of its construction and response to it, see the centenary catalogue *The Panorama Phenomenon: Mesdag Panorama, 1881–1981* (The Hague, 1981).

68. Jonathan Crary, *Techniques of the Observer: On Vision and Modernity in the Nineteenth Century* (Cambridge, Mass., 1990), chaps. 2–4, offers a conceptual background for understanding the nature of this change in psychological and philosophical terms.

69. Schopenhauer, *Die Welt als Wille und Vorstellung* (1819; 2d ed. 1844), trans. E. F. J. Payne as *The World as Will and Representation*, 2 vols. (New York, 1969), 1:179.

70. This passage from Baudelaire's "Salon de 1859" appears in his *Curiosités esthétiques* (Paris, 1868), 333: *Oeuvres complètes*, ed. Charles Pichois, 2 vols. (Paris, 1976), 2:668. The translation used is taken from Simon Pugh's introduction to his *Reading Landscape*, 4.

71. On the first of these counts, Baudelaire was responsive to settings that served as foils to contemporary society's display of itself, especially in the form of visually dazzling feminine fashions (as with Constantin Guys's drawings and watercolors, which he wrote about in 1859–60); on the second count, he was responsive to ones that amalgamated motifs and coloration to sensually evocative ends, as in Delacroix's mural of *Jacob and the Angel* for the Church of Saint-Sulpice in Paris, carried out between 1857 and 1861, in describing which Baudelaire singled out the "robust vegetation [imagined there] . . . which could be called patriarchal": "Peintures murales d'Eugène Delacroix à Saint-Sulpice," *Revue fantaisiste* (15 September 1861), reprinted in Baudelaire, *L'Art romantique* (Paris, 1885), 46; and as in the landscape incorporated much earlier into Delacroix's remarkable *Still Life with Lobsters* in the Louvre (shown at the Salon of 1827). I have profited in respect to

Baudelaire as critic from the opportunity to read a study by David Carrier (University Park, Pa., forthcoming).

72. Philippe Burty, "L'oeuvre de Charles Meryon, II," *Gazette des Beaux Arts* 14 (1863), 83, cited and translated in James D. Burke's *Charles Meryon: Prints and Drawings*, exh. cat., Toledo Museum of Art, Yale University Art Gallery, New Haven, and Saint Louis Art Museum, September 1974–April 1975, nos. 62–64.

73. This painting is the subject of a finely tuned Marxian and Baudelairean analysis in T. J. Clark, *The Painting of Modern Life: Paris in the Art of Manet and His Followers* (New York, 1985), 60–66.

CHAPTER 3

1. For general studies on this subject, see Christopher Thacker, *The Wildness Pleases: The Origins of Romanticism* (London and New York, 1983); D. C. Charlton, *New Images of the Natural in France: A Study of European Cultural History, 1750–1800* (Gifford Lectures, University of Saint Andrews, 1982–83; Cambridge, 1984); and also Keith Thomas, *Man and the Natural World: Changing Attitudes in England, 1500–1800* (London, 1983), chap. 6.

2. For the admiration for these particular artists in later eighteenth-century Britain, see *"Shock of Recognition": The Landscape of English Romanticism and the Dutch Seventeenth-Century School*, exh. cat., Mauritshuis, The Hague, and Tate Gallery, London, November 1970–January 1971 (Arts Council of Great Britain, 1971), under cat. nos. 51, 60.

3. For coverage of these developments, see Joseph Burke, *English Art, 1714–1800* (Oxford, 1976), commenting on the shaping of each genre and also the importance of engraving; Leslie Parris, *Landscape in Britain c. 1750–1850*, exh. cat. Tate Gallery, London, 1973, which remains a basic source on literary and industrial subjects, and includes a section on the literature of landscape; see also Michael Clarke, *The Tempting Prospect: A Social History of English Watercolours* (London: British Museum, 1981), for key forms of production and patronage in this medium, and John Murdoch, "Foregrounds and Focus: Changes in the Perception of Landscape ca. 1800," in *The Lake District: A Sort of National Property*, exh. cat., Cheltenham, Victoria and Albert Museum and the Countryside Commission, 1986, esp. 44, 50.

4. I have profited here from Ann Bermingham's work in progress on English drawing books. For an explanation of what is meant by the constative and performative dimensions of language usage, see the Glossary. The applicability of those terms to the operation of visual images was proposed, in a different context, by Joseph L. Koerner, "Albrecht Dürer's

Pleasures of the World and the Limits of Festival," in *Das Fest*, special no. of *Poetik und Hermeneutik*, ed. Walter Haug and Rainer Warnung, 13 (Munich, 1989): 207–8; see also Norman Bryson, *Looking at the Overlooked: Four Essays on Still Life Painting* (London, 1990), 119–20.

5. See Millard Meiss, *French Painting in the Time of Jean Berry: The Boucicaut Master* (London, 1968), 116–19, with color illustrations that include the accompanying French text.

6. See *Oxford English Dictionary*, s. v. "exotic," 2a and 2b, with citations from 1720.

7. For discussion of this artist's subjects and procedures, see Erik Larsen, *Frans Post: Interprète de Brésil* (Amsterdam and Rio de Janeiro, 1962), and Joaquim de Sousa-Leao, *Frans Post, 1612–1650* (Amsterdam, 1973).

8. See Mario Praz, *Scene di conversazione* (Rome, 1971), translated as *Conversation Pieces: A Survey of the Informal Group Portrait in Europe and America* (University Park, Pa., 1971), chap. 6, "The Family Group in an Outdoor Setting," which illustrates the seventeenth-century works referred to; Ronald Paulson, *Emblem and Expression: Meaning in English Art of the Eighteenth Century* (Cambridge, Mass., 1975), which includes a short section on the arrangement of Zoffany's conversation pieces, 154–57; John Harris, *The Artist and the Country House: A History of Country House and Garden View Painting in Britain, 1540–1870* (London and New York, 1979; rev. ed., 1985), 164–65 and 216, figs. 230, 231, for invented architecture; and Ann Bermingham, *Landscape and Ideology: The English Rustic Tradition, 1740–1860* (Berkeley and Los Angeles, 1986), 14–33, on poses and the related implications of settings.

9. See Ellen D'Oench, *The Conversation Piece: Arthur Devis and His Contemporaries*, exh. cat., Yale Center for British Art, New Haven, October–November 1980.

10. On the effects of enclosure, see Bermingham, *Landscape and Ideology*, 9–10, 13–14, and 197 n. 2 for bibliography. For basic discussions on this subject, not cited there, see W. G. Hoskins, *The Making of the English Landscape* (London, 1955), chaps. 6–8; and Raymond Williams, *The Country and the City* (London, 1973), chap. 10, "Enclosures, Commons, and Communities," esp. 96. Michael E. Turner, *Enclosures in Britain, 1750–1830* (London, 1984), gives an updated review of patterns and socioeconomic consequences. More recently, the question of who benefited and what was lost from enclosures has been freshly reexamined by Jeannette M. Neason, *Commoners: Common Rights, Enclosure, and Social Change in England, 1700–1820* (Cambridge, 1993).

11. Gainsborough's *Andrewes Family* (National Gallery, London, c. 1748–49)—rightly characterized by Bermingham, *Landscape and Ideology*, 30, as an anomaly

in the development of the genre—has been the subject of conflicting interpretations as to how the relationship of the figures to the land which they own, and to the fruits of labor there, is to be understood. Left unfinished as it was in the area of the woman's hands, it is exceptional within Gainsborough's early work in the structuring of its imagery, and without subsequent issue. In what Gainsborough goes on to do in his outdoor portraits, the governing modality is essentially the evocation of a "dream" world, in which the picturesque vocabulary of landscape is animated with a broadly poetic and mood-enhancing quality of suggestion.

12. See, for example, the portrait by Louis-Léopold Boilly from around 1800 (Musée de Lille), showing such an owner constructing a bridge on his property, with framing trees and a stretch of landscape traversed by a path.

13. I am grateful to Teri J. Edelstein for suggesting the term *expansiveness* in this connection.

14. See the Rev. Peter Chalmers, *Historical and Statistical Account of Dunfermline* (Edinburgh, 1846), 21. Mary Matthews kindly tracked down these historical details for me in the National Library of Scotland, and also consulted the Mar papers held in the Register House, Edinburgh.

15. See here Lawrence Otto Goedde, *Tempest and Shipwreck in Dutch and Flemish Art: Convention, Rhetoric, and Interpretation* (University Park, Pa., 1989), esp. 198–201.

16. This image is reproduced in *The Middle Ages: A Concise Encyclopedia*, ed. H. R. Loyn (London and New York, 1983), 128, without comment on its visual character.

17. See Roy Porter, *English Society in the Eighteenth Century* (Harmondsworth, 1982), 226–30, for a summary of the economic and social evidence here; and for a more detailed analysis, see K. D. M. Snell, *Annals of the Labouring Poor: Social Change and Agrarian England, 1550–1900* (Cambridge, 1985), chap. 6, "Enclosure and Employment."

18. Goldsmith, "The Deserted Village" (1770), lines 57–66, 275–86, cited in Parris, *Landscape in Britain*, cat. no. 158. "The Departure" illustrates lines 363–80.

19. This is the general argument of John Barrell's study *The Dark Side of the Landscape: The Rural Poor in English Painting, 1730–1840* (Cambridge, 1980), which includes stimulating discussions of Gainsborough, Morland, and also Constable.

20. See Bermingham, *Landscape and Ideology*, 76–80, and Porter, *English Society*, 110.

21. See Martin Butlin's commentary on this painting, using information on the industrial motifs supplied by N. A. Pedgen of the Leicestershire Museums, in *Aspects of British Painting, 1500–1800, From the Collec-*

tion of the Sarah Cambell Blaffer Foundation, exh. cat., Houston, Tex., 1988, 120.

22. Michael Rosenthal, Constable: The Painter and His Landscape (New Haven, 1983), offers a socially and psychologically nuanced study of how Constable treats such motifs.

23. See on this general theme John Prest, The Garden of Eden: The Botanic Garden and the Re-creation of Paradise (New Haven, 1981); and for literary manifestations combined with what are taken to be equivalent concerns on the part of artists, including Palmer, see Max F. Schulz, Paradise Preserved: Re-creations of Eden in Eighteenth- and Nineteenth-Century England (Cambridge, 1985), esp. chap. 6.

24. On the topography here, see Judy Egerton, Joseph Wright of Derby, exh. cat. Tate Gallery, London; Grand Palais, Paris; and Metropolitan Museum, New York, February–December 1990, nos. 123, 127. On the role of light in Wright's work I am indebted to a paper by one of my students, David Carroll; David Fraser, "Fields of Radiance: The Scientific and Industrial Scenes of Joseph Wright," in The Iconography of Landscape: Essays in the Symbolic Representation, Design, and Use of Past Environments, ed. Denis Cosgrove and Stephen Daniels (Cambridge, 1985), 119–41, suggested that the light in the mill windows relates to the candlelight by which its night staff worked.

25. See on this subject P. J. Marshall and Glyndwr Williams, The Great Map of Mankind: Perception of New Worlds in the Age of Enlightenment (Cambridge, Mass., 1982), part 1, esp. 57–58. Part 3, chap. 9, there deals with the later eighteenth-century exploration of the Pacific.

26. Andrew Kippis, The Life of Captain James Cook (London, 1788), cited in Marshall and Williams, Great Map of Mankind, 61.

27. Wallis, quoted in E. N. Ferdon, Early Tahiti: As the Explorers Saw It, 1767–1797 (Tuscon, 1981), 15.

28. Robertson, Journal, reprinted in The Discovery of Tahiti . . . , ed. Hugh Carrington (Hakluyt Society, 1948), 140.

29. George Forster, A Voyage Round the World . . . (London, 1777), cited in Marshall and Williams, Great Map of Mankind, 277. George's father, Johann Reinhold Forster, would translate Bougainville's narrative as A Voyage round the World . . . in the Years 1766, 1767, 1768 and 1769 (1772; repr. Amsterdam, 1967).

30. These two passages are both placed in their original contexts by Mary B. Campbell, The Witness and the Other World: Exotic European Travel Writing, 400–1600 (Ithaca, N.Y., 1988), 193, 245, with commentary on the language used.

31. Commerson, 1769, cited and trans. by Roy Porter, "The Exotic as Erotic: Captain Cook at Tahiti," in Exoticism in the Enlightenment, ed. G. S. Rousseau and Roy Porter (Manchester, 1990), 119; Forster, Voyage, 178, 216–17.

32. These features of the imagery are discussed more extensively by Harriet Guest, "The Great Distinction: Figures of the Exotic in the Work of William Hodges," Oxford Art Journal 12 (1989): 39–42.

33. Bernard Smith, European Vision and the South Pacific (Oxford, 1960; 2d ed., New Haven, 1985), 64–65, comparing Johann Reinhold Forster's 1778 description of Tahiti, suggested that these features were foregrounded so as to provide "an explanation and a unifying factor in the salubrity of the climate."

34. See the reviews cited by Guest, "Great Distinction," 40 and note 18.

35. See P. J. Marshall, "Taming the Exotic: The British and India in the Seventeenth and Eighteenth Centuries," in Rousseau and Porter, Exoticism in the Enlightenment, 46–65.

36. Hodges, Travels in India during 1780–83 (London, 1793), preface, iii–iv; cited in India Observed: India as Viewed by British Artists, 1760–1860, exh. cat., with essays by Mildred Archer and Ronald Lightbown, Victoria and Albert Museum, London, April–July 1980, 74.

37. See India Observed, 10–11, 42–45, 48, 82, for the work of the Daniells in different media; and Mildred Archer, Early Views of India: The Picturesque Journeys of Thomas and William Daniell, 1786–1794 (London, 1980), publishing the complete aquatints, with their descriptive texts and her added topographical commentary.

38. See here the related comments of Kenneth Bendiner, "Thomas and William Daniells' 'Oriental Scenery': Some Major Themes," Arts 55, no. 4 (1980): 98–103.

39. See on this subject Barbara Maria Stafford, "Towards Romantic Landscape Perception: Illustrated Travels and the Rise of 'Singularity' as an Aesthetic Category," Art Quarterly, n. s., 1 (1977): 89–124, and the corresponding sections in her book Voyage into Substance: Art, Science, Nature, and the Illustrated Travel Account, 1760–1840 (Cambridge, Mass., 1984). On German concern with geology (but without mention of Weitsch), see Timothy F. Mitchell, Art and Science in German Landscape Painting, 1770–1840 (Oxford, 1993).

40. Von Humboldt, Essai politique sur le royaume de la Nouvelle Espagne, 4 vols. (Paris, 1811), 1:103, cited and translated in Charlotte Kellner, Alexander von Humboldt (London and New York, 1963), 102.

41. Von Humboldt, Vues des Cordillères et monuments des peuples indigènes de l'Amérique, trans. Helen Maria Williams as Researches concerning the Institutions and Monuments of the Ancient Inhabitants of America, with

descriptions and views of some of the most striking scenes in the Cordilleras, 2 vols. (London, 1814), 2:94–98.

42. See, for a further representative example, the lithographs included in Johann Baptist von Spix and Carl Friedrich Philipp von Martius, *Reise in Brasilien in den Jahren 1817–1820*, 4 vols. (Munich, 1823–31), vol. 4, Tafelbild (repr., Stuttgart, 1967), esp. pl. 25 there, "Arara-Coara" from a drawing by Martius, which shows the explorer figure sketching in a boat in charge of two natives, and simple scenes of native life around, in the forest and below the waterfall. I am grateful to Valeria Salgueiro de Souza for drawing my attention to this publication.

43. For a broadly encompassing treatment of this tradition in landscape and its motifs, see Eva Borsch-Supan, *Garten-, Landschafts- und Paradiesmotive in Innenraum* (Berlin, 1967). It includes ancient and near Eastern examples, and also eighteenth- and nineteenth-century ones involving room decoration, mainly German.

44. See the exh. cat. *Hans Baldung Grien: Prints and Drawings*, organized and ed. by James H. Marrow and Alan Shestack, National Gallery of Art, Washington, D.C., and Yale University Art Gallery, New Haven, January–June 1981, cat. nos. 25–26. While Baldung did not give prime attention to landscape as a subject, the sexual resonances and associations of his settings are discussed by Charles W. Talbot in his essay there, "Baldung and the Female Nude," 19–37, and the relationship of trees to saint is phrased in corresponding terms, 143.

45. See the discussion of this in Sharon Fermor, *Piero di Cosimo: Fiction, Invention, and Fantasia* (London and Seattle, 1993), chap. 4, "Piero and the Depiction of Landscape," esp. 170–71, focusing on the *spalliera* panels and the *Incarnation* altarpiece of 1505.

46. These details of procedure draw on the introduction by Karel G. Boon to *Grafiek van Hercules Seghers*, exh. cat., Rijksprentenkabinet/Rijksmuseum Amsterdam (1967), English trans., 13–18; and on David Freedberg, *Dutch Landscape Prints of the Seventeenth Century*, British Museum Prints and Drawings Series (London, 1980), 44–50.

47. Alexander Cozens, *A New Method of Assisting the Invention in Drawing Original Compositions of Landscape* (1785), reprinted in Paul Oppé, *Alexander and John Robert Cozens* (London, 1952).

48. In the case of the frontispiece, birds, who can be taken from their expressions to be questioning collectively how they come to be there without humans—as opposed to their more comfortable individual presences in the plates that follow.

49. See Wendy Wassing Roworth, *Pictor Successor: A Study of Salvator Rosa as Satirist, Cynic, and Painter* (New York, 1978), chap. 1. This artist had written fierce and philosophical poetic satires in the 1640s already, and continued to do so for thirty years; but they were not published as a group until 1755. Except for a few early prints, from the 1640s, his etchings are all figure subjects, with landscape or outdoor settings playing a minor or secondary role. This applies especially to his *Figurine diverse* of the 1650s, which he characterized to their dedicatee as *[pignus] ludentis otii*.

50. See for this usage, which could be applied retrospectively to Salvator Rosa (cf. note 49) and comparably to the graphic art of Jacques Callot and Stefano della Bella, David Rosand's introduction to "*Capriccio*: Goya and a Graphic Tradition," in Janis A. Tomlinson, *Graphic Evolutions: The Print Series of Francesco Goya*, published as exh. cat. for Columbia University Art Gallery (New York, 1989), 3–9.

51. Links in the choice of specific motifs between Goya's imagery and that of Bosch were brilliantly adduced by Francis Klingender—to lay the groundwork for an understanding of the tradition in question that can be extended to settings—in his *Goya and the Democratic Tradition* (London, 1948; 2d ed. 1968), 168–69.

52. For a reading of the landscape in those terms, in conjunction with the form of the signature, *Solo Goya*, cut into rock at the Duchess's feet and her pose pointing to it, see Mark Roskill and David Carrier, *Truth and Falsehood in Visual Images* (Amherst, Mass., 1983), 53–55, and also 86 there for the kind of "as if" representation that would apply in this case. Whereas Baldung and Seghers as described earlier show what *might* be, if one suspends disbelief, in Goya what *could* be is metamorphosed into what could hardly be, so that the processes of doing this constitute transformation in a transgressive sense.

53. The red chalk drawing for this print that survives (Prado no. 191) shows a viaduct crossing the left part of the scene, while the drawing for its pendant has sexually suggestive rock shapes in the foreground, which equally seem like creatures talking to one another. For these studies and basic information on the prints, see Pierre Gassier and Juliet Wilson, *The Life and Complete Work of Francesco Goya*, 2 vols. (French ed., 1970; New York, 1971), 216 and cat. nos. 749, 750, 751.

54. I am indebted to a lecture by Susan Kuretsky, given at Smith College in February 1992, for drawing my attention to these features of the print.

55. See Roskill and Carrier, *Truth and Falsehood*, 60 and 132 n. 28, for the larger sense in which change on such lines may be said to occur in both art and literature in the course of the eighteenth century.

56. Blake, *A Descriptive Catalogue* (1809), III, reprinted in *The Complete Writings of William Blake*, ed.

Geoffrey Keynes (London and New York, 1957), 567, 575.

57. For a full discussion of what is known and surmisable about these works of Géricault's, see Gary Tinterow, "Géricault's Heroic Landscapes: The Times of Day," *Metropolitan Museum of Art Bulletin* 48, no. 3 (1991), entire issue, with earlier bibliography, and also the perceptive remarks of Régis Michel in *Géricault*, exh. cat., Grand Palais, Paris, October 1991–January 1992, p. 122, where reference is appropriately made to the artist's Deluge subject of February 1818—a very free variation on Poussin's *Deluge* in the Louvre, stressing violence and irrationality to the point of parody—and 370–72, cat. no. 162.

58. The source is [Constant Bourgeois], *Recueil de vues et fabriques pittoresques d'Italie, dessinées d'après nature* (Paris, 1804); see Tinterow, "Géricault's Heroic Landscapes," for the relevant plates compared, and also for the example of Vernet.

59. See in this connection the *Trumpeter* paintings from c. 1814 (Clark Art Institute, Williamstown, Mass., and Glasgow Art Gallery), along with the various studies for the *Wounded Cuirassier,* which was shown at the 1814 Salon.

60. The leading studies of nineteenth-century Orientalism, though much to the point in comparative terms, give little attention to the role played there by landscape settings, except for bringing up what so appealed to Delacroix in North Africa in 1832: the vision-enhancing and imagination-stirring agencies of light and color. The latter, it may be said—reversing what took place with Tahiti—transpose the will to command and the desire for release from social constraints back into the realm of the visual.

CHAPTER 4

1. Dean MacCannell, *The Tourist: A New Theory of the Leisure Class* (New York, 1976; rev. ed., 1989), chap. 6, uses the term *markers* to refer to information or inscriptions made available to tourists. In my application of the term to pictorial representations, with or without accompanying text, elements that are singled out in their significatory role or treated in such a way that a privileged status of authenticity can be accorded to them are ones that the viewer seeks to find on returning to the originatory site, on the comparable basis of their being concretized for identificatory purposes and made visually attractive.

2. The contribution of this impulse to nineteenth-century American landscape art is put forward as a key argument in Barbara Novak, *Nature and Culture: American Landscape and Painting, 1825–1875* (London and New York, 1980), esp. 266–72.

3. See Hayden White, *Metahistory: The Historical Imagination in Nineteenth-Century Europe* (Baltimore, 1973), intro., for a basic categorization of how the tropologies apply there; and for art history of more recent date, Mark Roskill, *The Interpretation of Pictures* (Amherst, Mass., 1989), 29–35.

4. I have adapted here an argument of Richard Shiff's regarding the advent of photography developed in his "Phototropism (Figuring the Proper)," which appears in the symposium publication *Retaining the Original: Multiple Originals, Copies, and Reproductions,* National Gallery of Art, Washington, D.C., *Studies in the History of Art* 20 (Hanover, 1989), 161–79.

5. On the sketching practices of Claude Lorrain—entailing, according to Joachim von Sandraart in his *Teutsche Akademie* (1675–79), preliminary color sketches or wash drawings made outdoors, and a move from this to painted studies from nature, as being inherently superior to drawings in their degree of truthfulness—see Michael Kitson, "The Relationship Between Claude and Poussin in Landscape," *Zeitschrift für Kunstgeschichte* 14 (1961): 142–62, and the further discussion by Lawrence Gowing, "Nature and the Ideal in the Art of Claude," *Art Quarterly* 37, no. 1 (spring 1974): 91–96. While no such studies survive, a pointer to their character is provided by the landscapes of the German Gottfried Wals, who collaborated with Claude for some years in Naples and went on to do small-scale studies of outdoor subjects, such as the *Landscape* in the Fitzwilliam Museum, Cambridge, which are essentially concerned with the fall of sunlight and what it does to physical forms such as trees and stones. For the situation in Dutch landscape practice, as it centered upon the advantages of working "nae t'leven," see the comments of Walter Melion and Susanne Kuechler, in their introduction to *Images of Memory: On Remembering and Representation,* ed. Melion and Kuechler (Washington, D.C., 1991), 16.

6. Roger de Piles, *Abrégé de la vie des peintres* (Paris, 1699), translated as *The Art of Painting, with the lives and character of above 300 of the most eminent painters* (London, 1706), 32, 259; *Cours de peinture par principes, avec un balance des peintres* (Paris, 1708), translated "by a painter" as *The Principles of Painting* (London, 1743), 124–25. The much earlier publication of De Piles's referred to, *Conversation sur la connoissance de la peinture et sur le jugement qu'on doit faire des tableaux* (Paris, 1677; repr., Geneva, 1970), had discussed in its section devoted to landscape, 146–55, five paintings of Rubens's in the same *cabinet,* three with rural (*champêtre*) and the other two with heroic subjects. For the differentiations of subject and mood that apply in those and other like cases, the fullest recent study is that of Luisa Vergara, *Rubens and the Poetics of Landscape* (New Haven, 1982).

7. See Emilio Sereni, *Storia del paesaggio agrario italiano* (Bari, 1961), trans. Louise Gross as *Histoire du paysage rural italien* (Paris, 1964), 167, 172, for the carrying of this "degradation" of landscape as subject back, in the case of Italy, to the second half of the sixteenth century. In the early seventeenth-century landscape drawings of Guercino, figures in a position of vantage consistently seem to direct their attention *through* the landscape, rather than *at* its contents: a feature that could be put into relation to that historical development.

8. For the larger context of this development and the increasing attention paid over the last quarter-century to filling out its ramifications, see *French Landscape Drawings and Sketches of the Eighteenth Century*, exh. cat., intro. Rosaline Bacou, British Museum, London, 1977; Philip Conisbee, "Pre-Romantic *Plein Air* Painting," *Art History* 2 (1979): 413–28; Werner Busch, "Die autonome Ölskizze in der Landschaftsmalerei: Der wahr- und für wahr genommene Auschnitt aus Zeit und Raum," *Pantheon* 41, no. 2 (May–June 1983): 126–33 with English summary, which synoptically covers a range of individual practices; *Painting from Nature: The Tradition of Open-Air Oil Sketching from the Seventeenth to the Nineteenth Centuries*, exh. cat., curated by Philip Conisbee, John Gere, and Lawrence Gowing, Fitzwilliam Museum, Cambridge, and Royal Academy, London, 1980–81; and the exhibition of the same title mounted by the Arts Council of Great Britain, 1980, exh. cat. by Conisbee, intro. by Gowing; and most recently Peter Galassi, *Corot in Italy: Open-Air Painting and the Classical-Landscape Tradition* (New Haven, 1991), chap. 1, "Painting from Nature."

For the development as it bears on British art, see further John Gage, *A Decade of English Naturalism, 1810–1820*, exh. cat., Norwich Castle Museum and Victoria and Albert Museum, London, 1969, which brought in Continental work also; Lawrence Gowing, *The Originality of Thomas Jones*, Walter Neurath Memorial Lecture (London, 1985); and *From Gainsborough to Constable: The Emergence of Naturalism in British Landscape Painting, 1750–1810*, exh. cat., Gainsborough's House, Sudbury, and Leger Galleries, London, August–December 1991, with essays by Michael Kitson and Felicity Owen pertaining to the background to Constable's art.

9. Pierre-Henri de Valenciennes, *Elemens de perspective pratique . . . suivis de réflexions et conseils à un élève sur la peinture et particulièrement sur le genre de paysage* (Paris, 1799–1800; 2d enl. ed., 1820). For discussion of the contents and influence of this treatise, see Albert Boime, *The Academy and French Painting in the Nineteenth Century* (London: Phaidon, 1971; 2d ed., New Haven, 1986), 138–44, and Galassi, *Corot in Italy*, 28–

30, and for the artist's Italian studies as a group, see further Robert Mesuret, *Pierre-Henri de Valenciennes*, exh. cat., Musée Paul-Dupuy, Toulouse, 1956; the redatings given in Geneviève Lacambre, *Les paysages de Pierre-Henri de Valenciennes, 1750–1819*, exh. cat., Musée du Louvre, Paris, Dossier du département de peintures no. 11, 1976; and Paula Rea Radisich, "Eighteenth-Century *Plein-Air* Painting and the Sketches of Pierre-Henri de Valenciennes," *Art Bulletin* 64 (1982): 98–104.

10. Jean-Baptiste Deperthes, *Théorie de paysage, ou considérations générales sur les beautés de la nature que l'art peut imiter et sur les moyens qu'il doit employer pour réussir dans cette imitation* (Paris, 1818); the quoted phrases are from 144, 210, 312, as translated by Boime, *The Academy and French Painting*, 140–41.

11. Andrew Hemingway, *Landscape Imagery and Urban Culture in Early Nineteenth-Century Britain* (Cambridge, 1992), 76–78, cites two texts of the period pertaining to this viewpoint and its background in association theory, which he lays out in detail: one from John Varley's *A Treatise on the Principles of Landscape Design* (London, 1816–17), the other from Richard Ramsay Reinagle's letterpress to Turner's *Views in Sussex*, engraved by W. B. Cooke (London, 1819).

12. A paradigm case for the application to landscape of a claim of this order was established by Reynolds's Discourse 14 (1788) on Gainsborough, defending him against the imputation of negligence.

13. See Hemingway, *Landscape Imagery*, 115, for the comment from the *Morning Post*, 7 March 1816, and 252, 275, 295 for the "pastoral" implications of this work, which are discussed also—in comparison with Constable's newly rediscovered *Wheatfield* of 1815–16 (private collection), reexhibited at the British Institution in 1817 as *A Harvest; Reapers, Gleaners*, and George Robert Lewis's *Harvest Scene, Afternoon* of 1816 (Tate Gallery)—by Michael Rosenthal in his exhibition review "Constable at the Tate; The Bright Side of the Landscape," *Apollo* 134 (August 1991): 77–84, and by Christiana Payne, "Boundless Harvest: Representations of Open Fields and Gleaning in Early Nineteenth-Century England," *Turner Studies* 11, no. 1 (summer 1991): 7–15, suggesting an implied looking back in these cases to preenclosed agriculture and the values associated with it.

14. See Mark W. Roskill, "On Realism in Nineteenth-Century Art," *New Mexico Studies in the Fine Arts* 3 (1978): 5–12, esp. 6, for the contrast of realism and naturalism in landscape understood in this light for the first part of the century.

15. Auguste Jal, *Esquisess, croquis, pochades ou tout ce qu'on voudrait, sur le salon de 1827* (Paris, 1828), 237, and anonymous review, *The Literary Gazette* (London),

9 February 1828, p. 90; both cited by Patrick Noon in his introduction to *Richard Parks Bonington: "On the Pleasure of Painting,"* exh. cat., Yale Center for British Art, New Haven, and Petit Palais, Paris, March–May 1992, 72, 74.

16. *The Examiner,* 27 June 1819, 413, and 13 May 1822, 301, reviews signed "R. H.," reprinted in Judy Crosby Ivy, *Constable and the Critics, 1802–1837* (Woodbridge, Suffolk Records Society, 1991), 82, 95. The terminology adopted in the three preceding paragraphs is one derived equally from reviews of the time. See further in this connection Ann Bermingham, "Reading Constable," *Art History* 10, no. 1 (March 1987): 38–58, which amounts to a critique of the assumptions and procedures of definition invested in Graham Reynolds's book *Constable: The Natural Painter* (London, 1965).

17. *The European Magazine* 81 (June 1822): 563, author unidentified, reprinted in Ivy, *Constable and the Critics,* 96.

18. See the checklist of titles for exhibited works provided by Ivy, *Constable and the Critics,* 238–40.

19. Again reviews of the time are apropos, particularly those in *The Sun,* 30 June 1817 and 26 May 1818 (presumably by the same author), linking "truth" and "spirit"; reprinted in Ivy, *Constable and the Critics,* 73, 77. See also Hemingway, *Landscape Imagery,* esp. 191–92, on the understanding of Constable's work in such terms. He contrasts the "poetic" type of landscape, as exemplified in Turner's early Thames series (252) and cites from a lecture of J. B. Crome on poetry and painting on the making of external nature "more elegant than reality" for such purposes (342 n. 173).

20. *The London Magazine* 7 (June 1822): 701–2, 703, 704, and *The Sun,* 5 February 1824; reprinted in Ivy, *Constable and the Critics,* 100, 104.

21. For the historical developments that brought this about, see Alain Corbin, *The Lure of the Sea, the Discovery of the Seaside in the Western World, 1750–1840,* trans. Joycelyn Phelps (Berkeley and Los Angeles, 1994); and for a schematic account of the visual consequences, see Dominique Rouillard, *Le site balnéaire* (Liège, 1984), esp. chap. 4, "Ville-paysage." Links between France and Britain through Dieppe are discussed by John Willett, "Rendez-vous à Dieppe," in *The Dieppe Connection: The Town and Its Artists from Turner to Braque,* exh. cat., Brighton Museum and Art Gallery, May–June 1992, pp. 9–16.

22. See Hemingway, *Landscape Imagery,* chap. 8, "The Imagery of Seaside Resorts and Modern Leisure," which includes an extended consideration of Constable's *The Beach at Brighton, the Chain Pier in the Distance* (Tate Gallery, London), shown at the Royal Academy in 1827 and the British Institution the year following,

and his versions of *Yarmouth Jetty* (or *Pier*), exhibited in 1823 and 1831. He also discusses views of the same places by George Vincent, a Norwich artist who, along with James Stark, figures prominently in chap. 9 of the book, on the imagery of rivers.

23. See most recently *Boudin at Trouville,* exh. cat., Burrell Collection, Glasgow, and Courtauld Institute Galleries, London, November 1992–May 1993, with text by Vivien Hamilton. The typology of North Coast painting that Bonington had established during his brief career, spent mainly in France, had been extended by Eugène Isabey in the second quarter of the century; Isabey sketched mainly at Etretat, and it was he who recommended that Boudin paint the Trouville beach.

24. See here Robert L. Herbert, "Industry in the Changing Landscape from Daubigny to Monet," in *French Cities in the Nineteenth Century,* ed. J. M. Merriman (New York, 1981), chap. 6, esp. 142, and also Bonnie Grad and Timothy Riggs, *Visions of City and Country: Prints and Photographs of Nineteenth-Century France,* exh. cat., Worcester Art Museum, Worcester, and the National Gallery of Art, Washington, D.C., 1982; and Fred Inglis, "Landscape as Popular Culture," in *Reading Landscape: Country, City, Capital,* ed. Simon Pugh (Manchester, 1990), chap. 12, esp. 211.

25. Stendhal [Henri Beyle], "Salon de 1824," part 10, *Journal de Paris,* 27 October 1824, reprinted in his *Mélanges d'art,* ed. Henri Martineau (Paris, 1932), 89–97; translated in *Stendhal and the Arts,* ed. David Wakefield (London, 1973), 109–11.

26. *The Works of John Ruskin,* ed. E. T. Cook and Alexander Wedderburn, 34 vols. (London, 1903–10), 3:191.

27. See Kenneth Bendiner, "John Brett's 'The Glacier of Rosenau,'" *Art Journal* 44, no. 3 (fall 1984): 241–48, which discusses this work also. For the problems posed for other Pre-Raphaelite artists by this type of exactness in the treatment of landscape subjects, see further Allan Staley, *The Pre-Raphaelite Landscape* (London, 1973), 100–103 (on Holman Hunt and Seddon), and 128–35 (on Brett's work); the essays brought together as "redefinitions" in *Nature and the Victorian Imagination,* ed. U. C. Knoepflmacher and G. B. Tennyson (Berkeley and Los Angeles, 1977), chaps. 16–18; George Landow, *William Holman Hunt and Typological Symbolism* (New Haven, 1979), 15–17 (on Seddon); and Ann Bermingham, *Landscape and Ideology: The English Rustic Tradition, 1740–1850* (Berkeley and Los Angeles, 1986), chap. 4, which deals with the Victorian suburban landscape, esp. the work of Ford Madox Brown.

28. Ruskin, *Academy Notes,* 1859; *Works,* 14: 234–37. I am indebted to Robert L. Herbert for drawing my attention to this passage, which appears in shortened

form in his edition of *The Art Criticism of John Ruskin* (New York, 1964), 410–13.

29. See Castagnary, *Salons (1859–1870)*, 2 vols. (Paris, 1892), 1:105–6, Salon of 1863, from which the phrase quoted comes.

30. See Gabriel P. Weisberg, *Beyond Impressionism: The Naturalist Impulse* (New York, 1992), for a presentation bringing together earlier articles of his on individual artists, and focusing particularly on the use of photographs.

31. See for these overtones the account of the environment and the sites that the artist chose given by Richard R. Brettell, *Pissarro and Pontoise: The Painter in a Landscape* (New Haven, 1990), chap. 1. The industrial subjects of 1873 and 1876 are taken up in chap. 4 there.

32. Thoré-Bürger, *Salon de 1844 precédé d'une lettre à Théodore Rousseau* (Paris, 1844), 106–8. The idea of a "poetry" generated by the artist in reflection of what nature offers is found again in the accompanying discussion there.

33. The attribution of "musicality" to Giorgionesque landscape painting (see Chapter 2) is, in Walter Pater's reading of it (see Chapter 2, note 36), overlaid with the aestheticizing conception of "life itself . . . as a form of listening."

34. See the article on this subject by George J. Buelow, "Rhetoric and Music," in *New Grove Dictionary of Music and Musicians*, ed. Stanley Sadie, 20 vols. (London, 1980), 15:793–803. In accordance with that theory, so-called *musica pathetica* in the Baroque period was taken as empowering an equivalent to an impassioned form of verbal delivery.

35. Charles Batteux, *Les Beaux Arts reduit à un même principe* (Paris, 1747), 283, 288–89, as cited and translated by James Neubauer, *The Emancipation of Music from Language: Departures from Mimesis in Eighteenth-Century Aesthetics* (New Haven, 1986), 73.

36. Christian Gottfried Krause, *Von der musikalischen Poesie* (Berlin, 1753; facsimile repr., Leipzig, 1970), as cited and translated in Neubauer, *Emancipation of Music*, 73.

37. See Neubauer, *Emancipation of Music*, 50, citing René Descartes, *Musicae Compendium* (Trajecti ad Rhenum, 1650), 4; and Andrew Kagan, "Ut pictura musica, I: to 1860," *Arts* 60, no. 9 (May 1986): 86–91, for the tradition of comparison and its classical background.

38. Denis Diderot, "Lettre sur les sourds et les muets" (1751), in Diderot, *Oeuvres*, 20 vols. (Paris, 1875–77), 1:406, 408–9, cited and translated by Neubauer, *Emancipation of Music*, 112–13.

39. Jean-Jacques Rousseau, *Essai sur l'origine des langues*, chap. 16, in Rousseau, *Oeuvres*, 22 vols. (Paris,

1819–20), 13:225–27; ed. Charles Porset (Paris, 1968), 173–77. This passage is discussed by Neubauer, *Emancipation of Music*, 175.

40. For surveys of earlier and later interest in this theme bringing together pictorial and literary aspects, see Hans Vogel, *Die Ruine in der Darstellung der abendländischen Kunst* (Kassel, 1948), and Roland Mortier, *La poétique des ruines en France: Ses origines, ses variations de la Renaissance à Victor Hugo* (Geneva, 1974).

41. Denis Diderot, *Salons*, ed. Jean Seznec and Jean Adhémar, 4 vols. (Oxford, 1957–67), 3:225–37; the passage referred to and quoted from comes at 228–29.

42. See for these sources A. Richard Turner, *The Vision of Landscape in Renaissance Italy* (Princeton, 1966), 205–12, and also Konrad Oberhuber, "H. Cock, Battista Pittoni und Paolo Veronese in Villa Maser," in *Munuscula Discipulorum: Festschrift für Hans Kauffmann zum 70 Geburtstag* (Berlin, 1968), 207–17.

43. Friedrich Schlegel, *Kritische Schriften*, ed. Wolfdietrich Rasch (Munich, 1956), 83–84: from *Athenaeum* 1, no. 2 (Berlin, 1798; repr., Stuttgart, 1960), 321.

44. For Runge's developing ideas on landscape art as they relate to the *Tageszeiten* project, see Otto Georg von Simson, "Philipp Otto Runge and the Mythology of Landscape," *Art Bulletin* 24 (1942): 335–50; William Vaughan, *German Romantic Art* (New Haven, 1980), 51–52, 59–63; and Frances S. Connelly, "Poetic Monsters and Nature Hieroglyphs: The Precocious Primitivism of Philipp Otto Runge," *Art Journal* 52, no. 2 (summer 1993): 31–39. For exposition of the artist's theory in general, including his remarks on music, see Rudolf M. Bisanz, *German Romanticism and Philipp Otto Runge: A Study in Nineteenth-Century Art Theory and Iconography* (DeKalb, Ill., 1970), with earlier bibliography; and for documentation of the *Tageszeiten* as they can be reconstructed from surviving studies, see Jorg Traeger, *Philipp Otto Runge und sein Werk* (Munich, 1975), chap. 9, with critical catalogue, and *Runge in seiner Zeit*, exh. cat., Kunsthalle, Hamburg, 1978, 188–219.

45. Review of Spohr's *Overture in C Minor* (publ. 1808) and also his *Violin Concerto* op. 10 and *Quartet* op. 11, *Allgemeine Musikalische Zeitung* 11 (Leipzig, 1808–9): 185; cited and translated in Clive Brown, *Louis Spohr: A Critical Biography* (Cambridge, 1984), 46.

46. Johanna Schopenhauer, in *Journal des Luxus und der Moden* 25 (Weimer, 1810), 690–93; excerpted in Helmut Borsch-Supan and Karl Wilhelm Jahnig, *Caspar David Friedrich: Gemälde, Druckgraphik und bildmäßige Zeichnungen* (Munich, 1973), 78.

47. This terminology for the understanding of Beethoven's musical achievement is adapted from Charles

Rosen, *The Classical Style: Haydn, Mozart, Beethoven* (New York, 1971) 444–47. The review of Spohr's music cited is one that anticipated by two years, in respect to the invocation of Romanticism, Hoffmann's celebrated discussion of Beethoven's instrumental music, one part of which first appeared anonymously in the same periodical in July 1810. That discussion (taken up already by Willi Wolfradt, *Caspar David Friedrich und die Landschaft der Romantik* [Berlin, 1924], 80–82, in connection with the musicality of this artist's landscapes and the conception of music at the time) is similarly conceived overall, but more dogmatic in its application of the term "romantic" to such music and also more verbally effusive in its movement back and forth between musical structure and qualities of feeling conveyed. See Ernst Theodor Amadeus Hoffmann, *Sämtliche Werke*, ed. C. G. von Maassen (Munich, 1905, incomplete) 1:55–58, 60–61, 62–64, translated in *Some Readings in Music History from Classic Antiquity Through the Romantic Era*, selected and annotated by Oliver Strunk (New York, 1950), 775–81, and the remarks of Robert Wallace, *Beethoven's Critics: Aesthetic Dilemmas and Resolutions During the Composer's Lifetime* (Cambridge, 1986), 21–26.

48. This reading of Friedrich's painting is indebted particularly to the interpretations of his earlier art, including this work, that are offered by Vaughan, *German Romantic Art*, chap. 4; and by Joseph Leo Koerner, *Caspar David Friedrich and the Subject of Landscape* (London and Cambridge, Mass., 1990), chap. 2. It uses, however, a terminology different in key respects from theirs and, one hopes, resistant to the implication, which they contravert in the course of their discussion, that one can talk here of a vocabulary of religious and personal symbols, transposable in direct and clear-cut fashion into words.

49. A particularly meaningful comparison to be made here is with Adrian Ludwig Richter's *The Watzmann* of 1824 (Neue Pinakotek, Munich). For ways of developing the contrast, see Vaughan, *German Romantic Art*, 110, 208, and Timothy F. Mitchell, "Caspar David Friedrich's *The Watzmann*: German Romantic Landscape Painting and Historical Geology," *Art Bulletin* 63, no. 3 (1984): 452–62, and also, for the different kinds of mood that such paintings carry, Gabriele Hammel-Heider, "Über den Begriff 'Stimmung' anhand einiger Landschaftsbilder," *Weiner Jahrbuch für Kunstgeschichte* 41 (1988): 139–48.

50. See on this subject Joseph Leo Koerner, "Borrowed Sight: The Halted Traveller in Caspar David Friedrich and William Wordsworth," *Word and Image* 1, no. 3 (1985): 149–63; Richard Wollheim, *Painting as an Art* (A. W. Mellon Lectures, National Gallery of Art, Washington, D.C., 1984; Princeton, 1987), 135–39;

and the fuller analysis of the paintings with such figures in Koerner, *Caspar David Friedrich*, part 3, "The Halted Traveller." A convenient survey of earlier images with such figures in them, categorized according to how they are presented and the role they play, is provided by Bruno Weber, "Die Figur des Zeichners in der Landschaft," *Zeitschrift für Schweizerische Archäologie und Kunstgeschichte* 34, no. 1 (1977): 44–82.

51. For a discussion of Schubert's song-settings in those terms, especially his *Die Winterreise* of 1828, see Rosen, *The Classical Style*, 454–55.

52. The studies of Friedrich in question are illustrated in Koerner, *Caspar David Friedrich*, pls. 108–9. Representative examples of what was done in this way by Delacroix, Boudin, and Whistler appear in color in Peter Greenaway, *Le bruit des nuages: Flying Out of This World*, exh. cat., Musée du Louvre, Paris, Département des Arts graphiques, November 1992–February 1993, pls. 32–41, with an early eighteenth-century study of sky by François Desportes and a watercolor of clouds by Constable conveniently included, to bring out distinctions apparent in their two cases. For Blechen, see especially his oil *Sea at Evening* (c. 1828; Oskar Reinhart collection, Winterthur); for Daumier, the drawings *Landscape by Moonlight* and *Landscape with a Large Tree* reproduced in *Daumier Drawings*, exh. cat., Städtisches Galerie, Frankfurt, and Metropolitan Museum, New York, November 1992–May 1993, cat. nos. 66–67.

53. On the vignette form as inaugurated in wood engraving by Thomas Bewick at the end of the eighteenth century and its role in book illustration thereafter, see Charles Rosen and Henri Zerner, *Romanticism and Realism: The Mythology of Nineteenth-Century Art* (New York, 1984), chap. 3.

54. See Kermit S. Champa, "The Rise of Landscape Painting in France," in *The Rise of Landscape Painting in France, Corot to Monet*, exh. cat., originating at Currier Art Gallery, Manchester, N.H., January–April 1991, 36–37, citing Alfred Robaut and Etienne Moreau-Nélaton, *Histoire de Corot et de ses oeuvres*, 4 vols. (Paris, 1905), 1:196; and Alfred Sensier, *Souvenirs sur Théodore Rousseau* (Paris, 1872), 362. Champa's essay discusses quite broadly how the relationship of painting and music should be given critical application to a range of works chosen for the exhibition in that light.

55. See Norma Broude, *Impressionism, A Feminist Reading: The Gendering of Art, Science, and Nature in the Nineteenth Century* (New York, 1991), 30–31, for a discussion of the term *effect*, which make reference to Jacques Nicolas Paillot de Montabert, *Traité complet de la peinture*, 9 vols. (Paris, 1829–51), 1:153. The term was equally applied to early paper photography, as by Philippe Burty, and my account of it follows directly that of André Jammes and Eugenia P. Janis, *The Art of the*

French Calotype: with a Critical Dictionary of Photographers, 1845–1870 (Princeton, 1983), 98, 124 n. 206, using sources of that time. A convenient reference for the earlier, more general usage of the term, keyed to the structural character of the natural elements chosen for depiction and their coloring is David Cox's *A Treatise on Landscape Painting and Effect in Watercolour* (London, 1813–14; ed. A. L. Baldry, London, 1922).

56. For Corot, see "Paroles de Corot" (ascribed to 1869) in Félix Fénéon, *Oeuvres plus que complètes*, ed. Joan U. Halperin, 2 vols. (Paris, 1970), 1:190–91, and for the later history of this text, *Georges Seurat, 1859–1891*, exh. cat., Grand Palais, Paris, and Metropolitan Museum, New York, April 1991–January 1992, with text by Robert L. Herbert, app. M. Whistler's *Ten O'Clock Lecture* of 1885, referring as it did to landscapes of his with figures absent, or absorbed completely into the mood of the whole, equally played a part in extending the relevant notion of harmony, particularly in light of the way that Whistler brought in music. See further Ron Johnson, "Whistler's Musical Modes: Numinous Nocturnes," *Arts* 55, no. 8 (April 1981): 169–76. On response to Monet's art using the term *ensemble* and especially Etienne Bricon's 1898 article "L'art impressionniste au Musée du Luxembourg" (*La Nouvelle Revue*, 15 September 1898, 298–99), see Steven Z. Levine, *Monet and His Critics* (New York, 1976), 83, 112–13, 142–43, 224–27.

57. A. Meyer, "Monticelli," *La Provence artistique et pittoresque*, 25 August 1881, 82–86, cited and translated by Aaron Sheon in *Monticelli, His Contemporaries, His Influence*, exh. cat., originating at Museum of Art, Carnegie Institute, Pittsburgh, October 1978–January 1979, 66–67.

58. M. H. Dixon, "Monticelli," *Art Journal* 47 (July 1895): 211–15, and André Gouirand, *Monticelli* (Paris, 1900), 16–17, reprinted in his *Les peintres provençaux* (Paris, 1901), 100–104; cited and translated by Sheon, *Monticelli*, 8, 92, 94. See also Arthur Symons, "The Painting of the Nineteenth Century" (review of D. S. MacColl, *Nineteenth Century Art*), *Fortnightly Review* 79 (March 1903): 520–34: "doubtless [he] is content with the arabesque of the intention, with a voluptuous delight in daring harmonies of color, as a musician might be content to weave dissonances into fantastic progressions, in . . . a sadism of sound" (Sheon, *Monticelli*, 95).

59. Paul Mantz, "L'exposition des peintures impressionnistes," *Le Temps*, 22 April 1877, as cited and translated in Kathleen Adler and Tamar Garb, *Berthe Morisot* (Oxford: Phaidon, 1987), 72.

60. For the part played by such innuendo in the consideration of Morisot's art from 1877 on, see Tamar Garb, "Berthe Morisot and the Feminizing of Impression-

ism," in *Perspectives on Morisot*, ed. and intro. T. J. Edelstein (New York, 1990), 57–63; and also her larger overview on the subject, "*L'art féminin*: The Formation of a Critical Category in Late Nineteenth-Century France," *Art History* 12 (1989): 39–65.

61. On this subject, see Margaret A. Sullivan, "Bruegel's Proverbs: Art and Audience in the Northern Renaissance," *Art Bulletin* 73, no. 3 (1991): 431–66, where the 1570 engraving is discussed (without noting the faces in the trees) at 461–62.

62. See *I Bamboccianti: Niederländische Malerrebellen im Rom des Barock*, exh. cat., Wallraf-Richartz Museum, Cologne, and Centraal Museum, Utrecht, August 1991–February 1992, especially the work of Jan Asselijn and Johannes Lingelbach, cat. nos. 1.2 and 21.8, 21.11. The introductory essay by Giulio Briganti, which brings up irony, 23–28 with literary comparisons, limits itself in that section to travesty and burlesque in figure motifs.

63. For the social interpretation of Wilson's landscapes referred to, see David Solkin, intro. to exh. cat., *Richard Wilson*, Tate Gallery, London, 1982, esp. 82, on the views of the Thames near Twickenham, and 130–31 on the landscapes for Sir Watkin Williams-Wynn; and also, for the critical implications of this interpretation and the furor that it aroused, see Neil McWilliam and Alex Potts, "The Landscape of Reaction: Richard Wilson (1713?–1782) and His Critics," in *The New Art History*, ed. A. L. Rees and F. Borzello (London, 1986), 106–19. I am indebted to Claire Renkin for offering a spirited argument against the idea that Wilson's devotion to the classical ideal was simply and invariably slavish.

64. For a skeletal introductory bibliography on the subject of this change, see Mark Roskill and David Carrier, *Truth and Falsehood in Visual Images* (Amherst, Mass., 1983), 132–33 n. 28.

65. William Beckford, *The Grand Tour of William Beckford*, ed. Elizabeth Mavor (Harmondsworth, 1986), 30–31. The text by Gessner was presumably his *New Idylles*, trans. W. Hooper, together with his *Letter on Landscape Painting* of 1770 (London, 1776).

66. Georg Kaspar Nagler, *Neues Allgemeines Kunstler-Lexikon*, 22 vols. (Berlin, 1835–52), 1:307; cited and translated by Vaughan, *German Romantic Art*, 154, where the *Park* painting is also discussed. The corresponding section in Vaughan's related article, "Landscape and the 'Irony of Nature,' " *Art History* 2, no. 4 (December 1979): 457–74, offers a variant translation.

67. See Martin Butlin and Evelyn Joll, *The Paintings of J. M. W. Turner*, 2 vols. (London, 1977; rev. ed., New Haven, 1986), cat. nos. 477–78, *Wreckers on the Coast: Sunrise Through Mist* and *Morning After the Wreck*, and nos. 480–81, *The Storm* and *The Day After the Storm*, for notable examples. The first two are assigned there to c.

1835–40, the second two (pendants, both now in National Museum of Wales, Cardiff) to c. 1840–45. Two late watercolors of the artist's, one inscribed "Wreck on the Goodwin Sands" (a shoreline famous at the time for such disasters) followed by lines of poetry of Turner's, the other with lines beginning "Lost to all Hope" (in both cases incompletely readable), on which my phrasing draws, are discussed by Andrew Wilton in *Turner and the Sublime*, exh. cat., Art Gallery of Ontario, Toronto, Yale Center for British Art, New Haven, and British Museum, London, November 1980–September 1981, cat. no. 68.

68. For the genesis and development of this work, see T. J. Clark, *The Absolute Bourgeois: Artists and Politics in Nineteenth-Century France* (London and New York, 1973), 76–78, 97–98, with apt comments.

69. See Robert L. Herbert, intro. to *Jean Francois Millet*, exh. cat., Grand Palais, Paris, and Hayward Gallery, London, October 1975–March 1976, p. 13 (English version) and cat. no. 112, and Bruce Laughton, *The Drawings of Daumier and Millet* (New Haven, 1991), 124–25.

70. Fritz Novotny, "Die Bilder Van Goghs nach fremden Vorbildern," in *Festschrift Kurt Badt* (Berlin, 1961), 213–30; reference on 224–225; J. -B. Delafaille, *The Works of Vincent van Gogh: His Paintings and Drawings* (rev. ed., New York, 1970), 254, cat. no. F652.

71. Rural labor and its setting may be more subtly ironized in Eastman Johnson's *The Cranberry Pickers* of 1879. In the series of thirteen oil studies for this project brought together with the final version in *Eastman Johnson, The Cranberry Pickers, Island of Nantucket*, exh. cat., Timkin Art Gallery, San Diego, Fine Arts Museum of San Francisco, and Yale University Art Gallery, New Haven, April–December 1990, with essays by Marc Simpson, Sally Mills, and Patricia Hills, women and children are prominently featured, including a possible black figure; but the final version has a posted notice on display in the foreground, "No pass over this Cranberry Lot," suggesting that the landscape represents a reserved territory to which the pickers admitted at this season are given entry only on sufferance.

72. As the landscape settings of spectacular paintings by Sebastiano del Piombo, especially his *Raising of Lazarus* (1516–19; National Gallery, London), and by Giulio Romano, in his frescoes done for the Palazzo del Té at Mantua (1528–30; Sala di Psiche, with landscape extending across two walls) already did, by the use of controlled coloring and chiaroscuro in what amounts to a highly theatrical fashion, within one section or particular sections of the work. See Marcia B. Hall, *Color and Meaning: Practice and Theory in Renaissance Art* (Cambridge, 1992), 131–36, 154, for discussion of those examples.

73. See Arthur R. Blumenthal, *Theater Art of the Medici*, exh. cat., Dartmouth College Museum and Galleries, October–December 1980 (Hanover, N.H., 1980), cat. nos. 4–5, 18, and for a fuller account of the performance in each case, see A. M. Nagler, *Theater Festivals of the Medici, 1539–1637* (New Haven, 1964), chaps. 6, 8, and pls. 52 (engraving by Agostino Carracci) and 64 (etching by Cantagallina).

74. To match this description, the copy or variant of the scene-setting by John Webb includes trees. See Stephen Orgel and Roy Strong, *Inigo Jones: The Theatre of the Stuart Court*, 2 vols. (Berkeley and Los Angeles, 1973), 2:662, 670–71.

75. Batteux, *Beaux Arts*, 274, referring to "divine actions," as cited and translated in Neubauer, *Emancipation of Music*, 139–40. Batteux argued for the merger of this with emotion produced "in the head" by the expression of passions, to create what he termed "lyrical" spectacle.

76. For theater as specific model for the workings of visual illusion in those terms, see Marian Hobson, *The Object of Art: The Theory of Illusion in Eighteenth-Century France* (Cambridge, 1982), 142, 171.

77. Anon., "Observations sur les Tableaux exposés au Louvre," *Mercure de France* 2 (October 1757): 164–65, cited by Hobson, *The Object of Art*, 48–49. See also Ian J. Lochhead, *The Spectator and the Landscape in the Art Criticism of Diderot and His Contemporaries* (Ann Arbor, Mich., 1982), 7–9 and 48 (where the same review is cited in shorter form) for earlier critical responses to Vernet's seascapes along such lines, beginning with La Font de Saint-Yenne in 1747, and the background to this in French aesthetic argument of the first half of the century. Robert L. Montogomery, *Terms of Response: Language and Audience in Seventeenth- and Eighteenth-Century Theory* (University Park, Pa., 1992), offers a parallel discussion; see esp. 162–63, 200.

78. See *Claude-Joseph Vernet, 1714–1789*, exh. cat., Iveagh Bequest, Kenwood, June–September 1976, with text by Philip Conisbee, cat. no. 33, where the name of the commissioner (a M. Poulhariez) is given and the close relationship to the Wallace Collection painting is noted.

79. Shown at the Salon of 1757 and described in the Marigny sale cat. of March–April 1782; see John Ingamells, *Wallace Collection, London, Catalogue of Pictures*, 4 vols. (London, 1985–92), 3:338–39.

80. See Michael Fried, *Absorption and Theatricality: Painting and the Beholder in the Age of Diderot* (Berkeley and Los Angeles, 1980), chap. 3, where the works in question by De Loutherbourg and Le Prince are illustrated and a lengthy commentary on the notion of reverie is provided.

81. Diderot, *Salons*, 3:165–66. For the specific

passages reflecting Burke's contribution, see Edmund Burke, *A Philosophical Enquiry into the Origin of our Ideas of the Sublime and the Beautiful* (London, 1757), ed. J. T. Boulton (London, 1958), editor's intro. cxxi–cxxii, and Lochhead, *The Spectator and the Landscape*, 12–13; and for the interrelationship more generally, see Gita May, "Diderot and Burke: A Study in Aesthetic Affinity," *Proceedings of the Modern Language Association of America* 45 (1960): 527–39.

82. On the precedent availability and understanding of Longinus's text, see Burke, *Philosophical Enquiry*, xliv–lx, noting (xlvii) the importance for eighteenth-century debate of one passage in Longinus where reference is made to admiration for the sheer size of ocean and great rivers (chap. 35); and also T. A. Laman, *Le sublime en France, 1660–1714* (Paris, 1971), and Thomas Puttfarken, *Roger de Piles' Theory of Art* (New Haven, 1985), chap. 5, part 2, 115–24.

83. John Baillie, *An Essay on Taste* (London, 1747; repr. with intro. by Samuel Holt Monk, Los Angeles, 1953), 3. He refers briefly to the painting of mountains on 38.

84. Burke, *Philosophical Enquiry*, 57, 136; the specific phrases quoted subsequently are at 43, 71. Burke adds at the close a separate section (part 5) on the impact of words.

85. Basic studies of the taste for the sublime and the texts that instigated or reflect it are Samuel H. Monk, *The Sublime; A Study of Critical Theories in Eighteenth-Century England* (New York, 1935; repr. with a new preface, Ann Arbor, Mich., 1960), and Marjorie Hope Nicolson, *Mountain Gloom and Mountain Glory: The Development of the Aesthetics of the Infinite* (New York, 1963), both of which include visual imagery in their purview as well as literary impact. See further Peter Bicknell, *Beauty, Horror, and Immensity: The Picturesque Landscape in Britain, 1750–1850*, exh. cat., Fitzwilliam Museum, Cambridge, July–August 1981 (including adjunct textual materials), and Louis Hawes, intro. to *Presences of Nature*, exh. cat., Yale Center for British Art, New Haven, 1982, chap. 1, "Mountain Landscapes." Andrew Wilton's intro. to *Turner and the Sublime*, exh. cat., Art Gallery of Ontario, Toronto; Yale Center for British Art, New Haven; and British Museum, London, November 1980–September 1981, chaps. 1–2, covers some of the same conceptual territory; but this presentation is somewhat confusing, in that Wilton's main categories for the eighteenth century of the "classical" and the "landscape" sublime are not given a historical specificity such as belongs to his subcategories of the picturesque, historical, and architectural sublime, as they apply to the work of Turner and his contemporaries.

86. Jean François de Saint-Lambert, preface to *Les*

saisons, poésies (Paris, 1826), 11; cited and translated in D. C. Charlton, *New Images of the Natural in France: A Study of European Cultural History, 1750–1800* (Gifford Lectures, University of Saint Andrews, 1982–83; Cambridge, 1984), 58.

87. For Volaire's treatments of this subject after he settled in Naples in 1769, see Jacques Foucart, *French Painting 1774–1830: The Age of Revolution*, exh. cat., Grand Palais, Paris; Detroit Institute of Arts; and Metropolitan Museum, New York, November 1974–September 1975, 674–77, cat. no. 203 (linking what is entailed, somewhat prematurely, to the Kantian sublime), and for the larger popularity of the site and subject, see Alexandra R. Murphy, intro. to *Visions of Vesuvius*, exh. cat., Museum of Fine Arts, Boston, April–July 1978.

88. Nicolas Boileau-Despréaux, *Traité du sublime, ou du merveilleux dans le discours* (Paris, 1674), reprinted in Boileau-Despreaux, *Oeuvres*, 3 vols. (Paris, 1768), 3:ii, with frontispiece illus.; and discussed by Margaretha Rossholm Langerlof, *Ideal Landscape: Annibale Carracci, Nicolas Poussin, and Claude Lorrain* (New Haven, 1990), 39.

89. Immanuel Kant, *Kritik der Urteilschaft* (Berlin, 1790), part 1, trans. J. C. Meredith as *Kant's Critique of Aesthetic Judgement* (Oxford, 1911), book 2, "Analytic of the Sublime," sects. 23–28. See 111, 130 (where Burke is referred to), and for the phrases subsequently quoted, 109, 113–114, 120–21, and 124–25, for the critique of the effect of astonishment on which Burke focused; the passage in Burke on the perception of the Deity referred to and quoted from is to be found in Burke, *Philosophical Enquiry*, 68–70.

90. The fullest study of the implications of Kant's argument here is to be found in Thomas Weiskel, *The Romantic Sublime: Studies in the Structure and Psychology of Transcendence* (Baltimore, 1976).

91. Henry Fuseli, *Lectures on Painting, delivered at the Royal Academy* (London, 1801–20), lecture iv, part 2; *The Life and Writings of Henry Fuseli Esq.*, ed. John Knowles, 3 vols. (London, 1831; repr., Millwood, N.Y., 1982), 2:217–18.

92. For the documented details of the careers of these two artists, see Thomas Balston, *John Martin, 1789–1854: His Life and Works* (London, 1947); and Eric Adams, *Francis Danby: Varieties of Poetic Landscape* (New Haven, 1973), showing this Bristol painter working earlier on the fringes of the sublime, with literary or moodily evocative subjects.

93. See Richard S. Altick, *The Shows of London* (Cambridge, Mass., 1978), chap. 16, 211–13, for these details. He notes how the Cosmorama was sometimes called the Panoramic and Dioramic exhibition, as if it brought together aspects of one and the other presenta-

tionally, and that copies on glass of Martin's *Fall of Nineveh* and his *Joshua* would be shown in its rooms in 1837. William Feaver's *The Art of John Martin* (Oxford, 1975), while it does not bring up the Cosmorama, makes reference throughout to other types of spectacle current at the time; but it does so in broad terms only, which appear to exclude any strain of direct competition.

94. Richard Ray, *An Address Delivered before the American Academy* (New York, 1825), 30–31, quoted by William H. Gerdts, "American Landscape Painting: Critical Judgements 1730–1845," *American Art Journal* 17, no. 1 (winter 1985): 28–59; reference on 44.

95. This is especially evident in the case of James Hall, an upper-class Philadelphian and author of *Letters from the West* (London, 1828), who would write of the Ohio Valley in 1838 that "the forest is seen in its majesty; the pomp and pride of the wilderness is here. Here is nature unspoiled, and silence undisturbed"; *Notes on the Western States* (Philadelphia, 1838), 54, cited in Roderick Nash, *Wilderness and the American Mind* (New Haven, 1967; rev. ed., 1973), 59. When Cole visited Schroon Mountain in the Adirondacks in 1837, he wrote in his account of the trip, using terms that similarly recall and transpose Burke's categories, of "the sublimity of untamed wildness, and the majesty of the eternal mountains" and of "a wild sort of beauty that approaches [grandeur]: quietness—solitude—the untamed—the unchanged aspect of nature"; Louis L. Noble, *The Course of Empire, Voyage of Life and Other Pictures of Thomas Cole N.A. . . .* (New York, 1853; reissued as *The Life and Works of Thomas Cole*, intro. Elliott S. Vessell, Cambridge, Mass., 1964), 239, 241.

96. All of the subjects enumerated are ones discussed by Cole in his 1835 lecture, published as "Essay on American Scenery," *American Monthly Magazine*, n.s., 1 (January 1836): 1–12, reprinted in John W. McCoubrey, *American Art, 1700–1960: Sources and Documents* (Englewood Cliffs, N.J., 1965), 98–110. For the contribution of Gilmor here, see especially his letter to Cole of 1 August 1826, commissioning a pair of landscapes, published by Howard S. Merritt in *Studies on Thomas Cole, An American Romanticist*, Baltimore Museum of Art, *Annual 2* (1967), app. 1, 43–44, and the discussion of this letter and others by Oswald Rodriguez Roque in *American Paradise: The World of the Hudson River School*, exh. cat., Metropolitan Museum of Art, New York, October 1987–January 1988, pp. 120–22.

97. For Cole's comments on Turner, see Ellwood C. Parry III, *The Art of Thomas Cole: Ambition and Imagination* (Newark, N.J., 1988), 96–98, citing Noble, *Course of Empire*, 81–82, and also Earl A. Powell, *Thomas Cole* (New York, 1990), 52–53.

98. Cole, letter of 29 January 1832, published in Baltimore Museum *Annual* (1967) 72.

99. Cole, letter of end of January 1832, in Noble, *Course of Empire*, 99–100.

100. See Noble, *Course of Empire*, 42–43, for the journal entries, titled there "A Trip to Windham," and 39–41, for the poem. Bryan J. Wolf in his *Romantic Re-Vision: Culture and Consciousness in Nineteenth-Century American Painting and Literature* (Chicago, 1982), chap. 5, "Thomas Cole and the Creation of an American Sublime," 214–28, offers, along with an intense psychological commentary, a more complete set of transcriptions from the notebooks in question.

101. See Powell, *Thomas Cole*, app., "Cole's List," 131, no. 10, and for a fuller discussion of the nature of Cole's borrowings from Martin, which brings in the availability in New York, by the end of 1828, of published prints of *Joshua Commanding the Sun to Stand Still* and *The Deluge*, see Ellwood C. Parry III, "When a Cole Is Not a Cole: Henry Cheever Pratt's *Moses on the Mount*," *American Art Journal* 16, no. 1 (winter 1984): 34–45; Christopher Kent Wilson, "Rediscovered Thomas Cole Letter: New Light on the *Expulsion from the Garden of Eden*," *American Art Journal* 18, no. 1 (1986): 73–74 (letter answering to the charge of plagiarism); and Parry, *Art of Thomas Cole*, 73–77, 86–89.

102. See Parry, *Art of Thomas Cole*, 149, quoting Henry William Herbert in *American Monthly Magazine* (2 October 1853), 137, on the "sublimity of conception" to be found there. While there is no direct documentary evidence that Cole had seen in London any of the popular spectacles that were on view at the time, there is a considerable likelihood that he would have taken the opportunity to do so. Such a presumption was brought up already by Wolfgang Born in his *American Landscape Painting: An Interpretation* (New Haven, 1948; repr., Westport, Conn., 1970), 81, but he made reference only to panoramas, Robert Burford's in particular.

103. See especially *West Rock, New Haven* of 1849, as discussed by John K. Howat in *American Paradise*, exh. cat., 240–41. This site was famous because in 1661 the regicide judges who had taken flight after the fall of Cromwell found refuge in a cave there from the royal troops sent to search for them; see Christopher Kent Wilson, "The Landscape of Democracy: Frederic Church's *West Rock, New Haven*," *American Art Journal* 18, no. 3 (1986): 20–39.

104. See especially the publication of the German Johann Moritz Rugendas, who knew Humboldt personally: *Voyage pittoresque dans le Brésil* (Paris, 1827–35), with 70 lithographs; Portuguese ed., *Viagem Pitoresca através do Brasil* (São Paulo, 1989). For the travels in question and their background, see Gertrud Richert, *Johnn Moritz Rugendas: Ein deutscher Maler in Ibero-Amerika* (Munich, 1952).

105. Von Humboldt, *Ansichten der Natur, mit wissenschaftlichen Erläuterungen,* 2 vols. (Stuttgart, 1826), trans. E. C. Otté and Henry G. Born as *Views of Nature: or Contemplation of the Sublime Phenomena of Creation; with scientific illustrations* (London, 1850), xi–xii. A recent discussion of the political and social implications of this advice, as it affected perception of the southern continent more generally, is to be found in Mary Louise Pratt, *Imperial Eyes: Travel Writing and Transculturation* (London, 1992), chap. 6, "Alexander von Humboldt and His Reinvention of America."

106. Von Humboldt, *Kosmos: Entwurf einer physischen Weltschreibung,* 5 vols. (Stuttgart, 1845–62), vols. 1 and 2 trans. E. G. Otté as *Cosmos: A Sketch of a Physical Description of the Universe,* 4 vols. (London, 1850–52; New York, 1855), 2:93–95.

107. *The Home Book of the Picturesque . . .* (New York, 1851; repr., with intro. by Motley F. Deakin, Gainesville, Fla., 1967), 3. Magoon's essay is quoted from and paraphrased by J. M. Coetzee in his *White Writing: On the Culture of Letters in South Africa* (New Haven, 1988), chap. 2, "The Picturesque, the Sublime, and the South African Landscape," which very interestingly compares Britain and America in the eighteenth and nineteenth centuries. The exhibition catalogue *All Seasons and Every Light: Nineteenth-Century American Landscapes from the Collection of Elias Lyman Magoon,* originating at Vassar College Art Gallery, Poughkeepsie, October–December 1983, with texts by Ella M. Foshay and Sally Mills, brings out Magoon's developing taste for landscape subjects in the 1850s.

108. George W. Curtis, *Lotus-Eating: A Summer Book* (New York, 1852), 135–39; partially quoted in Hans Huth, *Nature and the American: Three Centuries of Changing Attitudes* (Berkeley and Los Angeles, 1957), 52. There are chapters also on the Catskills, Lake George (from which the quotations come), Nahant, Newport, Niagara, Saratoga, and Trenton. On Church's motivations in painting Niagara, see further David C. Huntington, "Frederic Church's *Niagara:* Nature and the Nation's Type," *Texas Studies in Language and Literature* 25, no. 1 (spring 1983): 110–38, and Howat, *American Paradise,* 243–245.

109. Von Humboldt, *Cosmos,* trans. Otté, 93–94. Church's awareness of this text was first brought out by Born, *American Landscape Painting,* 109, 113. See further Katherine Manthorne, "Views of Cotopaxi by Frederic Edwin Church," in *Creation and Renewal: Views of Cotopaxi by Frederic Edwin Church,* National Museum of American Art, Smithsonian Institution, Washington, D.C., March–July 1985, 9; and Franklin Kelly, *Frederick Edwin Church and the National Landscape* (Washington, D.C., 1988), 74–75.

110. See Kevin J. Avery, "The Heart of the Andes Exhibited: Frederic E. Church's Window on the Equatorial World," *American Art Journal* 18, no. 1 (1986): 52–72. Both the London Cosmorama and a version to be seen in New York in the early 1850s are brought up there; and see also Avery, intro. to *Church's Great Picture: The Heart of the Andes,* exh. cat., Metropolitan Museum, New York, October 1993–January 1994, 20, for comparison with John Martin.

111. Von Humboldt, *Vues des Cordillères et monuments des peuples indigènes de l'Amérique,* trans. Helen Maria Williams as *Researches concerning the Institutions and Monuments of the Ancient Inhabitants of America, with descriptions and views of some of the most striking scenes in the Cordilleras,* 2 vols. (London, 1814), 1:120–21; cited by Manthorne, "Views of Cotopaxi," 7, 16.

112. See Manthorne, "Views of Cotopaxi," 26–27, citing *The (New York) Albion,* 21 March 1861, 141.

113. "Church's *Cotopaxi,*" *New York Times,* 17 March 1863, 4; cited by Manthorne, "Views of Cotopaxi," 44.

114. *The Crayon* 8 (1861): 133, quoted by Katherine Manthorne in *The Thyssen-Bornemisza Collection: Nineteenth-Century American Painting,* ed. Barbara Novak (New York, 1986), cat. entry for this painting, 96–98. On Arctic views of the 1860s, see further John Wilmerding, "William Bradford: Artist of the Arctic," in his *American Views: Essays on American Art* (Princeton, 1991), chap. 7.

115. Auguste Comte, *Cours de philosophie positive: Discours sur l'ensemble* (Paris, 1848), serving as intro. to his previous 4 vols. of writing (1830–42), chap. 5; trans. J. H. Bridges as *General Theory of Positivism,* ed. Frederic Harrison (London, 1908), 313–19, 330–33.

116. See the valuable discussion of this point by Richard Shiff, *Cézanne and the End of Impressionism: A Study of the Theory, Technique, and Critical Evaluation of Modern Art* (Chicago, 1984), chap. 3, esp. 24–25.

117. Hippolyte Taine, *Philosophie d'art. Leçons professés a l'Ecole des beaux arts* (Paris, 1865), chap. 1, "De la nature de l'oeuvre d' art," part 5; trans. and revised by the author as *The Philosophy of Art* (London, 1865), 60–64. Kermit Swiler Champa, *Studies in Early Impressionism* (New Haven, 1973), 72–73, suggests that such words of Taine's would, at the time of his lectures, have been encouraging to the young Pissarro.

118. Hippolyte Taine, *Voyage en Italie* (Paris, 1871), trans. as *Italy,* 2 vols. (London, 1871), 1:iv–v; quoted and discussed by Sholum J. Kahn, *Science and Aesthetic Judgement: A Study in Taine's Critical Method* (London, 1953), 80.

119. Arthur Schopenhauer, *Die Welt als Wille under Vorstellung* (1819; 2d ed. 1844 with added supplements), trans. E. F. J. Payne as *The World as Will and Representation,* 2 vols. (New York, 1969), 1:260–67. A

helpful exposition of Schopenhauer's aesthetic premises is provided by Lucian Krukowski, *Aesthetic Legacies* (Philadelphia, 1992), chaps. 2 and 5.

120. For landscape painting as it corresponds to an "important grade of the will's objectification," and for the "objective side of aesthetic pleasure" that it can bring to the fore accordingly, see Schopenhauer, *The World as Will and Representation*, 1:218–19. The inference from Schopenhauer that such an "abstraction" and harmonization on the model of music could occur in painting was, it could be argued, a key factor that would impel Kandinsky's move into abstraction, and particularly so in the domain of landscape. A parallel is to be found also, in this respect, in Larionov's "pneumorayist" work of 1913, *Sea, Beach, and Woman*, a landscape including what appear to be musical notes in the form of black dots and attached bars. See Anthony Parton, *Mikhail Larionov and the Russian Avant-Garde* (Princeton, 1993), 63–65, 117.

121. Hegel, *Die Philosophie der Geschichte*, in G. W. F. Hegel's *Werke*, 19 vols. (Berlin, 1832–87), vol. 9, ed. Edward Gans (1837), rev. ed. by Karl Hegel (1840); trans. H. B. Nisbet as *Lectures on the Philosophy of World History*, intro. Duncan Forbes (Cambridge, 1975). Quotations are taken from "The Geographical Basis of World History," 154–55; the additions of 1826–27, 215; and "The Course of World History," 127.

122. See on this subject Leonard P. Wessell Jr., *Karl Marx, Romantic Irony, and the Proletariat: The Mythopoetic Origins of Marxism* (Baton Rouge, 1979), esp. 143–83.

123. Nietzsche, *Götzendämmerung* (Leipzig, 1889), 9:8–9, trans. Anthony M. Ludovici as *Twilight of the Idols* (*Complete Works of Friedrich Nietzsche, vol. 16*) (London, 1911), 16:65–67.

124. For these underlinings in *R. W. Emerson's Essays* (or *Versuche*), trans. G. Fabricus (Leipzig, 1858), see *Nietzsches Werke. Grossoctavausgabe*, 2d ed., 19 vols. (Leipzig, 1901–13), 13:64, 231; cited by George J. Stack, *Nietzsche and Emerson: An Elective Affinity* (Athens, Ohio, 1992), 72, 169, with a full review of the context of ideas and earlier bibliography on the subject.

125. On the appeal of such subjects and their treatment, see Andrew Hemingway, "Meaning in Cotman's Norfolk Subjects," *Art History* 7, no. 1 (1984): 57–77, together with two articles by Adele M. Holcomb: "John Sell Cotman's *Dismasted Brig* and the Motif of the Drifting Boat," *Studies in Romanticism* 14, no. 1 (winter 1975): 29–40, and "The Bridge in the Middle Distance: Symbolic Elements in Romantic Landscape," *Art Quarterly* 37, no. 1 (1974): 31–58, where the term *metaphor* is introduced.

126. See for this suggestion regarding metaphor William T. Oedel's review of *Paintings by Fitz Hugh Lane*, exh. cat., organized by John Wilmerding, with essays by various hands, National Gallery of Art, Washington, D.C., 1988, in *Essex Institute Historical Collections* (Salem, Mass.), 126, no. 1 (January 1990): 52–55; it includes an adroit critical discussion of problems of interpretation posed, in Lane's case and more generally, by the concept of Luminism. A similar point is made independently by David C. Miller, "The Iconology of Wrecked or Stranded Boats in Mid- to Late Nineteenth-Century American Culture," in *American Iconology: New Approaches to Nineteenth-Century Art and Literature*, ed. Miller (New Haven, 1993), chap. 9, 192, 196–97.

127. After his trip to Europe in the same year 1873, which included visits to Germany, Austria, and Switzerland as well as France, Kuinji appears to move toward an ironic implication in his *Deserted Village* of 1874 (making reference to political oppression and entirely devoid of figures); and his later subjects of snow and moonlight, such as the *Ukrainian Night*, which he showed at the Paris World's Fair in 1878, are more uplifting, in the vein of synecdoche.

128. In the clothed version (Walters Art Gallery, Baltimore), which may have come first, the flowers grow out of the stone blocks of a broken wall on which the figure sits: see exh. cat. *Puvis de Chavannes, 1824–1896*, Grand Palais, Paris, and National Gallery of Canada, Ottawa, November 1976–May 1977, cat. nos. 90–91, with entries by Jacques Foucart.

129. Irony in Turner's art is most commonly associated with the depiction of historical or legendary events, dramatized in extended landscape settings of which one is given an overview. In the very extensive body of recent literature on Turner, the most exploratory discussion of the images and motifs in question is that of Eric Shanes, *Turner's Human Landscape* (London, 1990).

130. Champfleury, "Du rôle important des paysagistes à notre époque," *Le Courrier Artistique*, 15 February 1862, 65–66, cited and commented on by Anne M. Wagner, "Courbet's Landscapes and Their Market," *Art History* 4, no. 4 (1981): 424–25.

131. These observations on Courbet's landscape art draw directly on the following discussions and the overlap between them: Petra Ten-Doesschate Chou, "It Took Millions of Years to Compose That Picture," in *Courbet Reconsidered*, exh. cat., Brooklyn Museum, New York, and Minneapolis Institute of Arts, November 1988–April 1989, 55–68; Klaus Herding "Egalität und Autorität in Courbets Landschaftsmalerei," *Städel Jahrbuch*, n.s., 5 (1975): 158–99; and "Farbe und Weltbild: Thesen zu Courbets Malerei," in *Courbet und Deutschland*, exh. cat., Kunsthalle, Hamburg, and Städelsches Kunstinstitut, Frankfurt, 1978–79, 478–91, brought together in English versions in Herding,

Courbet: To Venture Independence, trans. John William Gabriel (New Haven, 1991), as chap. 4 "Equality and Authority in Courbet's Landscape Painting," and chap. 6, "Color and Worldview"; Wagner, "Courbet's Landscapes" (as in note 130), 410–33, esp. 426–27; Ann Dumas, Sarah Faunce, and Linda Nochlin, in *Courbet Reconsidered,* cat. nos. 11, 52.

132. A valuable discussion of the philosophical and aesthetic considerations at work here is to be found in Shiff, *Cézanne,* chap. 3, and in his contribution "The End of Impressionism" in *The New Painting: Impressionism, 1874–1886,* exh. cat., coordinated by Charles S. Moffett, National Gallery of Art, Washington, D.C., and M. H. de Young Memorial Museum, San Francisco, January–July 1986, 41–79.

133. Armand Silvestre, intro. to vol. 1 of *Galerie Durand-Ruel: Recueil des estampes* (Paris, 1873), cited and trans. in *The Impressionists at First Hand,* ed. Bernard Denvir (London, 1987), 78–79. For the musical analogy introduced here, as appropriate to the technical practices in question, see the comments of Kermit Swiler Champa, *Studies in Early Impressionism* (New Haven, 1973), 78.

134. Jules-Antoine Castagnary, "Exposition du boulevard des Capucines: Les impressionnistes," *Le Siècle,* 29 April 1874, partially cited and translated in John Rewald, *The History of Impressionism* (New York, 1946; rev. ed., 1961), 329–30.

135. Emile Blémont [Petitdidier], "Les impressionnistes," *Le Rappel,* 9 April 1876, cited and translated in Denvir, *The Impressionists,* 101–2.

136. Louis Emile Edmond Duranty, *La Nouvelle Peinture* (Paris, 1876), reprinted in *The New Painting,* 477–84. The passages quoted on landscape (481, 483) are translated in Denvir, *The Impressionists,* 103, 107.

137. Théodore Duret, "Les peintres impressionnistes," brochure of May 1878, reprinted in his *Critique d'avant-garde* (Paris, 1885), 57–89; the passages cited are translated in Denvir, *The Impressionists,* 111.

138. Frédéric Chevalier, "Les impressionnistes," *L'Artiste* (1 May 1877): 329–33; the translation used comes from a wall label by John House for the thematic exhibition "Impressionism and Its Context," mounted at the Courtauld Galleries, London, in 1990, and for the further phrases quoted, from Virginia Spate, *Claude Monet: Life and Work* (London and New York, 1992), 124. Chevalier also wrote on "L'impressionisme au Salon," *L'Artiste,* 1 July 1877, 32–36, including under the umbrella-term artists who showed there, as if they made up a broad trend with almost no reference to the independent group.

139. The critics cited here are Duret, "Les peintres impressionistes," 75–80, and Armand Silvestre, "Le monde des arts: Exposition de la rue des Pyramides," *La Vie Moderne,* 24 April 1880, 262 (echoing Castagnary, "Exposition," on Pissarro's "synthesizing eye," and Phillippe Burty, "Exposition de la Société anonyme des artistes," *La République Française,* 25 April 1874, on the recalling of Millet); Leon de Lora [Louis de Fourcaud], "L'exposition des impressionnistes," *Le Gaulois,* 10 April 1877; Emile Zola, "Nouvelles artistiques et littéraires," *Le Messager d'Europe* (Saint Petersburg, in Russian), July 1979. Translations are taken from *The New Painting,* 139, 232, 288, 330.

140. The critics cited in this case are Georges Rivière, "L'exposition des impressionnistes," *L'Impressionniste* 1–2, 6 April 1877, 2–6, and 14 April, 1–4; Duret, *Les peintres impressionistes,* 82–83; H[enri] Mornand, "Les impressionnistes," *Revue Littéraire et Artistique,* 1 May 1880, 67–68; Paul Mantz, "Exposition des oeuvres des artistes indépendants," *Le Temps,* 14 April 1880; Eugène Veron, "Cinquième exposition des independants," *L'Art* 21 (1880): 92–94; and Gustave Geffroy, "L'exposition des artistes indépendants," *La Justice,* 19 April 1881. The last four phrases are ones translated in *The New Painting,* 328, 366.

141. Mallarmé, "The Impressionists and Edouard Manet," *Art Monthly Review and Photographic Portfolio* 1, no. 9 (30 September 1876): 117–22; reprinted in *The New Painting,* 27–35, with earlier bibliography on the subject.

142. Jean Rousseau, *Le Figaro,* 2 May 1875, cited in *Manet, 1831–1883,* exh. cat., Grand Palais, Paris, and Metropolitan Museum, New York, April–November 1983, ed. Françoise Cachin et al., 355. Rousseau was a painter, satirist, and critic of Belgian origin; see George Heard Hamilton, *Manet and His Critics* (New Haven, 1954), 189, from which I take the translation given. For the caricature, see Hadol, "Le Salon comique," *L'Eclipse,* 30 May 1875, reproduced in T. J. Clark, *The Painting of Modern Life: Paris in the Art of Manet and His Followers* (New York, 1985), 169, with comments of Clark on this painting, 164–71, which direct attention to the sail/factory conjunction.

143. See, for this recognition, Jules Clarétie, *L'art et les artistes français contemporains* (Paris, 1876), 337. Degas, who was of the same older generation as Manet and did landscape only occasionally from about 1869 on, in pastel over monotype, is reported to have had an ironic motivation of this sort, directed at the success of the plein-air painters, for showing very roughly sketched landscapes, created from memory and imagination in his studio, at Durand-Ruel's gallery in October 1892. According to Valéry, he did his "rare landscapes only as a flourish [*de chic*] . . . not without a certain sly enjoyment [*malice*] at the expense of the open-air fanatics. There was something oddly arbitrary about them"; Paul Valéry, *Degas, Danse, Dessin* (Paris,

1936; 1946 ed., 69), trans. David Paul in Paul Valéry, *Degas, Manet, Morisot* (New York, 1960), 43. For the exhibition in question and its contents, see further Richard Kendall, *Degas Landscapes* (New Haven, 1993), chap. 7.

144. The critics quoted here are Gustave Geffroy, "Dix tableaux de Claude Monet," *La Justice*, 17 June 1888; Marcel Fouquier, "L'exposition Claude Monet, le triomphe d'un maître—la série des meules," *Le dix-neuvième siècle*, 7 May 1891; Charles Saunier, "Petite gazette d'art: Claude Monet," *La revue blanche* 23, no. 181 (15 December 1900): 624. Their comments are cited and translated by Paul Tucker in *Monet in the 90s: The Series Paintings*, exh. cat., Museum of Fine Arts, Boston, 1989, 31, 40, 105.

While the 1891–92 canvases of Rouen Cathedral were not landscapes, they raised the question, in their degree of concern with light and atmosphere, of whether Monet might be ironizing this subject, as no longer representing for the artist a Catholic or a national monument. For Camille Mauclair, these paintings contained "no intellectual emotion" responsive to the architecture and "the very idea that the Gothic, the *cerebral* art par excellence, serves as a theme for this superbly sensual a pagan, is somewhat disconcerting"; Mauclair, "Choses d'art," *Mercure de France*, June 1895, 357, cited by Spate, *Claude Monet*, 271, with comments also on admirers who defended these paintings in secular, pantheist, or anticlerical terms.

CHAPTER 5

1. Their role already in the descriptions by Philostratus the Elder of imaginary landscape paintings was noted in Chapter 1.

2. See in particular the review of Gustave Kahn, "Exposition Puvis de Chavannes," *Revue Indépendante* 6, no. 15 (January 1888): 142–46, cited and translated in the intro. by Richard Wattenmaker to *Puvis de Chavannes and the Modern Tradition*, exh. cat., Art Gallery of Ontario, Toronto, October–November 1975 (rev. ed., 1976), 18, with surrounding citations of other texts on Puvis of the 1880s.

3. For a leading testimony of such appreciation and the terms in which it was couched now, see Théodore Duret, "L'art japonais" (1884), reprinted in his *Critique d'avant-garde* (Paris, 1885), 164–67, referring to the treatment of nature; and Mark Roskill, *Van Gogh, Gauguin and the Impressionist Circle* (London and Greenwich, Conn., 1970), 60, 77, and app. B for remarks on the pattern of response in this decade.

4. Only one entry into the critical and theoretical vocabulary of art that achieved currency in the 1880s can lay claim to an overarching applicability to the structural features referred to; and it is actually a set of variations on a term (*synthesis*; in French, *synthèse*) that comes to include *synthetic* and its derivative *synthetically*, the verb *synthetize* and, more programmatically, *synthetism*. See Roskill, *Van Gogh, Gauguin*, 95–96; and for *synthetism* the clarifying discussion of Robert Goldwater, *Symbolism* (New York, 1979), 75–79. The critic Felix Fénéon used the verb for landscapes by Seurat and Signac, treated in a "definite aspect" so as to "preserve the sensation implicit in them": "Le néo-impressionnisme: 3e exposition des artistes indépendants," *L'Art Moderne* (Brussels), 1 May 1887, reprinted in Félix Fénéon, *Oeuvres plus que complètes*, ed. Joan U. Halperin, 2 vols. (Geneva, 1970), 1:74.

5. Most particularly, in 1890–91, by the short-lived Symbolist critic Albert Aurier, who wrote successively on van Gogh's art early in 1890, with some attention to his landscape settings, and on Gauguin's a year later, concluding with a summarizing definition of the Symbolist work of art from which the discussion of operative concepts that follows in my text (without the specificisms that Aurier invoked) is adapted. See "Le Symbolisme en peinture—Paul Gauguin," *Mercure de France* 2, no. 15 (March 1891): 155–65, ending with the passage in question, cited and translated in Goldwater, *Symbolism*, 183–84. Aurier's later writings of 1892 on Symbolist art, which add little more on the topic of landscape but bring in the Nabis, Sérusier, and Redon, all of whom worked with imaginative and/or decorative landscape subjects in the 1890s, are reprinted along with the two earlier pieces in his *Oeuvres posthumes* (Paris, 1893).

Maurice Denis's writings of the first half of the 1890s also serve to support the account following, and they develop the part played from 1888 on by Gauguin's example, and also the contribution made by a rekindling of interest in fresco painting. But they do this without specific comments on landscape subjects and settings, albeit Denis devoted much attention to them in his art of those years. See the articles of 1890 and 1895, reprinted in Denis, *Théories (1890–1910): Du symbolisme et de Gauguin vers un nouvel ordre classique* (Paris, 1912), 1–30. On Edouard Vuillard's parallel contribution as a Nabi, see now Gloria Lynn Groom, *Vuillard, Painter-Decorator: Patrons and Projects, 1892–1912* (New Haven, 1993), esp. chap. 6, "Landscape as Decoration—Transformations of Place," and the comparison with Denis in respect to park and garden subjects, 49–53.

6. See J.-B. Delafaille, *The Works of Vincent van Gogh: His Paintings and Drawings* (rev. ed., New York, 1970; hereafter abbreviated F), cat. nos. 2, 4, 7 of August 1882 and the related watercolors F938, 940 of May–June and F980, 982 of October 1882. Van Gogh's key statement documenting his admiration for this kind

of subject as treated by the artists of the Hague School is to be found in *Verzamelde Brieven van Vincent van Gogh*, 4 vols. in 2, vols. 1–3, ed. J. van Gogh-Bonger, vol. 4, ed. V. W. van Gogh (Amsterdam, 1955), translated as *The Complete Letters of Vincent van Gogh*, 3 vols. (London and Greenwich, Conn., 1958; hereafter abbreviated CL), letter 144, Etten, 1 May 1881 (with special mention of a beach scene by H. W. Mesdag, seen on exhibition in Brussels); and see further Ann Murray, "Strange and Subtle Perspective . . . Van Gogh, the Hague School, and the Dutch Landscape Tradition," *Art History* 3, no. 4 (December 1980): 410–24.

7. See esp. F426–27, 465, 545 from the summer.

8. The phrase quoted is from letter 593 of early June 1889, CL3:177, where it refers to landscapes that van Gogh knew by Daubigny and Rousseau. For relevant works by Daubigny and their relation to the Auvers canvases of wheatfields, see Mark Roskill, "Van Gogh's 'Blue Cart' and His Creative Process," *Oud Holland* 81, no. 1 (1966): 3–19, app., 18.

9. Letter 74 of 26 August 1876 and sermon of 31 October, CL 1:66, 90–91; see also the mention in letter 82 of 25 November of a "sketch" for the picture seen at Obach's.

10. For the argument that van Gogh was in fact describing Boughton's painting *God Speed! Pilgrims setting out for Canterbury: Time of Chaucer* (acquired after its reidentification in 1985 by the Rijksmuseum Vincent van Gogh, Amsterdam), which was shown at the Royal Academy in London in 1874, so that van Gogh would have been able to see it there, see the most recent reiteration on the subject—despite contrary arguments that had been advanced—offered by Debora Silverman, "Pilgrim's Progress and Van Gogh's Metier," in *Van Gogh in England: Portrait of the Artist as a Young Man*, exh. cat., Barbican Gallery, London, February–May 1992, 95–113 (reference is to 102), and cat. no. 59, with earlier bibliography. Judy Sund in her book *True to Temperament: Van Gogh and French Naturalist Literature* (Cambridge, 1992), 30–31 and 259 n. 77, had in the meantime suggested that the reference might more probably be to Boughton's *Bearers of the Burden*, which van Gogh would equally have seen at the Royal Academy a year later (an engraving from it appears in *Van Gogh in England*, cat. no. 60, illus., 134); and I am much indebted to her for the thorough review of the problem she kindly provided for me.

11. See letters 492 from the end of May 1888 and 477a to John Russell of late April (on Delacroix and Monticelli, CL 2:583, 547); 539 of mid-September (on Puvis; CL 3:43); and 595–96 of the following June, written after he had received notice of newly produced religious subjects by Gauguin and Emile Bernard, to which he took strong objection. For landscapes by

Monticelli he recalled, see letters 474, 488, 610, and for the *Poet's Garden* series, see Ron Johnson, "Vincent van Gogh and the Vernacular: The Poet's Garden," *Arts* 53, no. 6 (February 1979): 98–104, and John House, "Van Gogh's The Poet's Garden, Arles," *Portfolio* 2, no. 4 (September 1980): 28–33.

12. The letter cited is 614a (wrongly dated in CL); for the identification of the November–December 1889 *Olive Pickers* as F654–656 and in addition F 587, see Jan Hulsker, *The Complete Van Gogh: Paintings, Drawings, Sketches* (New York, 1980), 485 n. 11, and for an extended discussion of van Gogh's involvement with the subjects in question, Vojtěch Jirat-Wasiutýnski, "Vincent van Gogh's Paintings of Olive-Trees and Cypresses from St-Rémy," *Art Bulletin* 75, no. 4 (December 1993): 647–76.

13. The paintings referred to are F620, 683, 604 (the last convincingly redated by Hulsker, *Complete Van Gogh*; for a fuller discussion of the imagery of F683, see Mark Roskill, " 'Public' and 'Private' Meanings: The Paintings of Van Gogh," *Journal of Communication* 29, no. 4 (autumn 1979): 157–69.

14. Gauguin, letter to Schuffenecker of 14 August 1888, in *Lettres de Gauguin à sa femme et ses amis*, ed. Maurice Malingue (Paris, 1946), no. 67, p. 134, cited and translated in John Rewald, *Post-Impressionism from van Gogh to Gauguin* (New York, 1956; 2d ed., 1962), 196. Gauguin went on to speak of his "researches" reflected here, going back a few years, into "the *synthesis* of form and color derived from the observation of the dominant element only" (see note 4 above).

15. Gauguin, letter to Vincent van Gogh of c. 22 September 1888 (with drawing of *Vision* enclosed), in Paul Gauguin, *45 lettres à Vincent, Théo et Jo van Gogh*, ed. Douglas Cooper (The Hague, 1983), no. 32, cited and translated in *The Art of Paul Gauguin*, exh. cat., National Gallery of Art, Washington, D.C., and Art Institute of Chicago, May–December 1988, cat. no. 50, p. 103 (entry by Claire Frèches-Thory). The emphasis here is Gauguin's.

16. See on this subject Merete Bodelsen, *Gauguin's Ceramics: A Study in the Development of His Art* (London, 1964), 178, and the repetition of the same comparison with a print by Hokusai in *The Art of Paul Gauguin*, cat. no. 32.

17. See *The Art of Paul Gauguin*, cat. no. 48 (entry by Claire Frèches-Thory), 100. The works by Puvis in question appeared in *Exposition de tableaux, pastels, dessins de Puvis de Chavannes*, Galerie Durand-Ruel, Paris, November–December 1887, as nos. 17, 83.

18. See Roskill, *Van Gogh, Gauguin*, 134–35, 137–38, 147, for an explicit discussion of Gauguin's method of composing landscapes at Arles, based on the little sketches relating to two of those landscapes found in the

extant notebook that he used there. The question of whether he ever did, or began, any of his landscapes working directly in paint on the spot remains a moot one in the literature; see, for instance, the site comparisons invoked in the case of a Martinique landscape in *The Art of Paul Gauguin*, cat. no. 31; and the investigative discussion of Wayne Andersen, "Gauguin's Motifs at Le Pouldu—Preliminary Report," *Burlington Magazine* 112 (September 1970): 615–20. But whatever the relationship to the site in distinct and individualized respects, none of the Martinique, Arlesian, or Breton landscapes appears incompatible, as a composite, with improvisation based on quick graphic annotations, memory, and/or (as in the fan designs) existing images from which motifs could be taken for reuse.

19. See especially here *The Art of Paul Gauguin*, cat. no. 15 (entry by Charles F. Stuckey, with earlier refs.), and the fan that appears in the *Still Life* with pot with rats' heads on it, cat. no. 41 there, dated c. 1888.

20. Jules Huret, "Paul Gauguin devant ses tableaux," *L'Echo de Paris*, 23 February 1891, 2, trans. Eleanor Levieux (with cuts) as "Paul Gauguin Discussing His Paintings," in *The Writings of a Savage: Paul Gauguin*, ed. Daniel Guérin (New York, 1978), 49–50.

21. Octave Mirbeau, "Paul Gauguin," *L'Echo de Paris*, 16 February 1891, 1, also published as the preface to *Catalogue d'une vente de 30 tableaux de Paul Gauguin* (Paris, Hôtel Drouot, 1891), 3–12; reprinted in Mirbeau, *Des artistes* (Paris, 1922), 119–29. The passages cited are given as translated in Rewald, *Post-Impressionism*, 473–74.

22. This understanding of *bricolage* in its synthesizing capacity draws on Marshall Sahlins, *Culture and Practical Reason* (Chicago, 1976), 217. For the surviving decoration on glass (rescued by Somerset Maugham in 1916) that is datable to this period, see *The Art of Paul Gauguin*, cat. no. 134, including in its imagery a white flowering tree, a white rabbit, and a segment of blue water with white sails on it.

23. Gauguin, "Exposition de la Libre Esthétique," *Essais d'Art Libre* 5 (February–April 1894): 32, referring to the *Prodigal Son* (probably the large version now in the National Gallery, Washington, D.C.) as a key work in the exhibition; and Julien Leclerq, "Choses d'art: Paul Gauguin," *Mercure de France* 13 (January 1895): 121–22, for the inclusion of photographs of works by Puvis in the exhibition mounted in Gauguin's Rue Vercingétorix studio at the end of that year. Aurier had already in his articles of 1891–92 (see note 5) acclaimed Gauguin as a fundamentally decorative artist, whose works could be taken as "fragments of immense frescoes" (1891, 165) and who should be given walls to paint.

24. See on the subject of this exhibition the review by Thadée Natanson, "Petite gazette d'art: M. Paul Gauguin," *Revue Blanche* 17 (December 1898): 544–46, which allows the reconstruction of its content and character made by Richard Brettell in *The Art of Paul Gauguin*, 392 and cat. no. 277. Gustave Geffroy is quoted there as remarking, much like Natanson, on the "grand decorative style" expressed in the "series of canvases" shown: "L'art d'aujourd'hui: Falguière—Chauval—Gauguin," *Le Journal*, 20 November 1898, 1–2.

25. For an overview of subjects and technique, see Robert L. Herbert, *Seurat's Drawings* (London, 1962), added to and updated in his sections of text in *Georges Seurat, 1859–1891*, exh. cat., Metropolitan Museum, New York, September 1991–January 1992 (French version, Grand Palais, Paris, April–August 1991).

26. See in this regard Paul Smith, "Seurat and the Port of Honfleur," *Burlington Magazine* 126 (September 1984): 562–69; Eric Darragon, "Seurat, Honfleur et la Maria en 1886," *Bulletin de la société de l'histoire de l'art français* (1984): 263–80; and on the imagery chosen for the marines, see Richard Thomson, *Seurat* (Oxford, 1985), chap. 8, esp. 181.

27. Along with framing borders of dots that were given to them, the seascapes were originally shown in frames decorated with a related scheme of dots by Seurat himself; one of these, from 1889 (on *Le Crotoy from Upstream*, Detroit Institute of Arts), has survived subsequent replacement.

28. For parallels here with Symbolist poetry inspired by the ocean, especially the work of Henri de Régnier, whom Seurat knew, see Thomson, *Seurat*, 177–81.

29. Joris-Karl Huysmans, "Chronique d'art: Les indépendants," *Revue Indépendante* 3 (April 1887): 51–57 (on *The Hospice and the Lighthouse, Honfleur* of 1886, compared to *La Grande Jatte*); cited and translated in John Rewald, *Seurat* (New York, 1990), 170. See also 189–90 there for Félix Fénéon's view that, in the 1889 paintings of *Le Crotoy Downstream* and *Upstream*, the cloud shapes were too directly suggestive *and* the figures too stiff: "5e exposition des artistes indépendants," *La Vogue*, September 1889, reprinted in Fénéon, *Oeuvres*, 164–65.

30. Emile Verhaeren, "Chronique artistique: Les XX," *La Société Nouvelle* 7 (February 1891): 249–51; cited and translated by Ellen W. Lee in her essay in *Seurat at Gravelines: The Last Landscapes*, exh. cat., Indianapolis Museum of Art, October–November 1990, 29, 55.

31. Georges Rivière, *L'Impressionniste* 2 (14 April 1877), reprinted in Lionello Venturi, *Les archives de l'impressionnisme*, 2 vols. (Paris and New York, 1939), 2:315–17.

32. For Cézanne's effective anticipation in this way of the Symbolist notion of style that would be put forward by Aurier in 1890–91 (as in note 5), see Richard Shiff, *Cézanne and the End of Impressionism: A Study of the Theory, Technique, and Critical Evaluation of Modern Art* (Chicago, 1984), part 1, esp. 30.

33. See in this connection the respectful but wittily detached comments on Cézanne that Gauguin communicated to Emile Schuffenecker in a letter of 14 January 1885: *Lettres*, ed. Malingue, no. 11—with some errors of transcription—pp. 45–46, translated in *Writings*, ed. Guerin, 4.

34. On the connotations of the word "sincere" as it was used in this connection at the time, see George Heard Hamilton, "Cézanne and His Critics," in *Cézanne: The Late Work*, exh. cat., Museum of Modern Art, New York, 1977, 139–49, with citations from three voices of the 1890s at 144–45.

35. Georges Lecomte, "Paul Cézanne: Catalogue des tableaux composant la collection de M. E. Blot," Hôtel Drouot, Paris, 9–10 May 1900, 25, cited and translated by John Rewald, *Cézanne and America: Dealers, Collectors, Artists, and Critics* (A. W. Mellon Lectures in the Fine Arts, 1979; Princeton, 1989), 37–39. On subsequent and belated propagation of the term *decorative* in Cézanne's case, see Hamilton, "Cézanne and His Critics," 147.

36. The landscapes of Odilon Redon in particular, especially those done in oils after 1900, enlarge the scope of the tradition with their preciousness of technique and coloring and their fairy-tale-like atmosphere: a quality that also comes into landscape in book illustrations for children from this period.

37. On considerations affecting the expansion of purpose and practice that comes into being on this front about 1905, see the extended discussion of Roger Benjamin, "The Decorative Landscape, Fauvism, and the Arabesque of Observation," *Art Bulletin* 75, no. 2 (June 1993): 295–316.

38. See the marine subjects illustrated and discussed in *Neo-Impressionism*, exh. cat., Guggenheim Museum, New York, 1964, with text by Robert L. Herbert; especially those of Henri Edmond Cross and Paul Signac, which proved important for Matisse in respect to technique in 1904–5; the Belgians Albert Finch, Georges Leman, Theo van Rysselberghe, and Henry van de Velde, and the Dutchman Jan Toorop.

39. See Frank Whitford, *Klimt* (London, 1990), chap. 10, "The Pattern of Landscape," for discussion on these lines.

40. Lhote, letter of 8 December 1907, in André Lhote, Alain-Fournier, and Jacques Rivière, *La peinture, le coeur et l'esprit: Correspondance inédite (1907–1924)*, ed. A. Rivière et al., 2 vols. (Bordeaux, 1986), 1:29–

30; cited and translated in Benjamin, "Decorative Landscape," 312.

41. Both Edvard Munch's snow landscapes and Ferdinand Hodler's mountain subjects of the same period (after 1900) can be taken—in their own geographic regions and post-Symbolist frameworks of expression—as doing something similar. Wassily Kandinsky and Gabriele Münter, who were aware of Fauve landscape art through their extended stay in Sèvres, close to Paris, in 1906–7, engage in a related kind of practice in their Murnau landscapes of 1908–9.

42. Suggestive here for the way in which the postcard operated are some of the introductory comments of James Buzard in his *The Beaten Track: European Tourism, Literature, and the Ways to Culture, 1800–1918* (Oxford, 1993), esp. 12, on the growing impulses early in this century affecting what he terms the "anti-tourist." For the related situation of Fauve landscape, there are helpful remarks in Judi Freeman's essay "Surveying the Terrain: The Fauves and the Landscape," in *The Fauve Landscape*, exh. cat., Los Angeles County Museum of Art, Metropolitan Museum, New York, and Royal Academy, London, October 1990–September 1991, 13–58 (with bibliography of earlier literature); and see also the suggestive terms of discussion brought in by John Elderfield, "The Garden and the City; Allegorical Painting and Early Modernism," *Bulletin of the Museum of Fine Arts, Houston* 7, no. 1 (summer 1979): 3–21.

43. Claude Roger-Marx, "Les Nymphéas de M. Claude Monet" (review of exhibition at the Galerie Durand-Ruel), *Gazette des Beaux Arts*, 4th ser., 1 (June 1909): 523–32, translated in *Monet: A Retrospective*, ed. Charles F. Stuckey (New York, 1985), 255, 268.

44. "Cosmos" [Ernest Govett], *The Position of Landscape in Art* (London, 1912); the key passages cited are from 7, 61, 67–68, 123–24.

45. See Joan Grundy, *Hardy and the Sister Arts* (London and New York, 1977), chap. 2, "Pictorial Arts," citing a passage from the 1878 *Return of the Native* (New Wessex ed., London, 1975, 132) using the specific terms in question, and also the poem "At the Royal Academy."

46. Florence Emily Hardy, *The Life of Thomas Hardy, 1848–1920* (first published 1928–30), ed. Michael Millgate (Athens, Ga., 1985), 192, 225.

47. See *The Return of the Native* (1878), bk. 1, chap. 1, as cited by Grundy, *Hardy and the Sister Acts*, 54; and for the reading in question, see Edmund Burke, *A Philosophical Enquiry into the Origin of our Ideas of the Sublime and the Beautiful* (London, 1757), ed. J. T. Boulton (London, 1958), editor's intro., cxviii–cxix.

48. This formulation of a change afoot after 1900, linking together space and time for both artist and sub-

ject, draws in part on Bernard Harrison's "Rhetoric and the Self," in his *Inconvenient Fictions: Literature and the Limits of Theory* (New Haven, 1992), chap. 7, esp. 193–94, bringing in Wittgenstein, Nietzsche, and Merleau-Ponty. For Monet's linking of the term *enveloppe* with "instantaneity" in a letter to Gustave Geffroy of 7 October 1890, written when his *Grainstacks* were in progress, see Geffroy, *Claude Monet, sa vie, son temps, son oeuvre* (Paris 1922), 189, and the thoughtful discussion by George Heard Hamilton, *Claude Monet's Paintings of Rouen Cathedral* (Charlton Lecture on Art, 1959; Oxford, 1960, repr. Williamstown, Mass., 1969), 18–19.

49. For the importance for subsequent practice of the late nineteenth-century idea of the series—embracing what Monet and Cézanne contribute on this front—see Mark Roskill, *The Interpretation of Cubism* (Philadelphia, 1985), 37–38; Proust is brought in there, 61–62, 165; the paintings by the fictitious artist Elstir described in *A l'ombre des jeunes filles en fleur* (1918) are equally relevant in their general character.

50. See William Rubin, "Picasso and Braque: An Introduction," in *Picasso and Braque: Pioneering Cubism*, exh. cat., Museum of Modern Art, New York, 1989, 16–17 (photo), 54 n. 3 (facsimile of the documentary passage in question) and app., 63–68, for the suggestion that this exceptionally large work (evidently destroyed) was undertaken to form part of a "decoration" that Picasso had agreed to do in 1909 for the library of a New York painter and critic, Hamilton Field. The decipherment of the word that precedes "swimming" in the letter in question, dated 25 July 1911, as *filles* (young women) is uncertain owing to the difficulties posed by Picasso's handwriting and command of French at this date; but if this reading is right (and there may be bathing figures to be made out to the left in the photograph), the imagery puts into a pleasantly seasonal setting a subject that Picasso had taken over from Cézanne and placed in a generalized context of landscape in a number of compositions of his from 1907–8 on. For Céret as it motivated Picasso and Braque in other works of the time, see Roskill, *Interpretation of Cubism*, 42.

51. This summary account draws on Keith Alldritt's study, *The Visual Imagination of D. H. Lawrence* (London, 1971), esp. 5–15, 131–32 for the treatment of landscape, and also 61–64, drawing on the "Study of Thomas Hardy," which was in progress in December 1914, contemporary with the final rewriting of *The Rainbow*.

In E. M. Forster's *Howards End* (1910), descriptions of the countryside put in an intense but more occasional appearance, involving characteristically the sense of place as ongoing habitat. While the tie-in of the rural community with a rooted quality of belonging is in this way articulated, land is treated as a form of property that can be inherited spiritually, rather than merely possessed and handed on.

52. R. M. Rilke, *Worpswede Monographie* (Bielefeld, 1903), 54, cited and translated in *Post-Impressionism: Cross-Currents in European Painting*, exh. cat., ed. John House and Mary-Anne Stevens, Royal Academy of Arts, London, November 1979–March 1980, 170, cat. no. 260 (entry by Gillian Perry).

53. William Henry Hudson, *Green Mansions . . .* (London, 1935 ed.), 307; cited by David Miller, *W. H. Hudson and the Elusive Paradise* (New York, 1990), 163. This is the most recent study of the subject, dealing with the landscape descriptions in chap. 15, esp. 136–39. See also 113–14 for a comparable excerpt from *The Purple Land*; and 88 for the way in which other books of Hudson's, such as *A Shepherd's Life* (1910), situate themselves in the tradition of English nature writing descending into this period (as with his friend Edward Thomas) from Gilbert White and Richard Jefferies.

54. The "sign" operates here as in the Symbolist scheme of thought (see Glossary), pointing back to an originating mind and its capacity to "exaggerate, attenuate and deform" (in Aurier, "Le Symbolisme") so as to empower imaginative response; only it does so more elliptically.

Matisse in his "Notes of a Painter" of December 1908 ("Notes d'un peintre," *La Grande Revue*, 25 December 1908, 731–45; translated in Alfred H. Barr Jr., *Matisse, His Art and His Public*, Museum of Modern Art, New York, 1951, 119–23) used the term "sign" to refer simply to marks in paint and their interlinkage, and he played down the importance of landscape for conveying ideas and feelings, as compared to the figure—because, as the context makes clear, the terms of discussion there made it crucial for him to define his practice in opposition to the Impressionist rendering of appearances, as exemplified by Monet and Sisley.

55. For a fuller elaboration on these lines, see Mark Roskill, "Matisse on His Art and What He Did Not Say," *Arts* 49, no. 9 (May 1975): 62–63.

56. See *Matisse in Morocco: The Paintings and Drawings, 1912–1913*, exh. cat., National Gallery of Art, Washington, D.C., and Museum of Modern Art, New York, March–September 1990, with documentation and chronology for the works referred to, and accompanying essays by Pierre Schneider and John Elderfield, which contain relevant comments. Postcards of Tangier sent by Matisse while there and ones that he kept are reproduced in that publication as figs. 6, 47, 54, 73, 85, 131, and 135.

57. Nash, notes on reverse of photograph cited by Sue Malvern, " 'War as it is': The Art of Muirhead Bone, C. R. W. Nevinson, and Paul Nash, 1916–17,"

Art History 9, no. 4 (December 1986): 487–511; reference is to 502.

58. The comprehensive discussion of this change of outlook provided by Samuel Hynes, *A War Imagined: The First World War and English Culture* (New York, 1991), chap. 9, "The Death of Landscape," serves as a basic source for what follows.

59. Ford, "Arms and the Mind," first published in *Esquire* 94 (December 1980): 78–80; cited by Hynes, *A War Imagined,* 106.

60. Wilfred Owen, letter to his mother of 17 January 1917; in *Collected Letters,* ed. Harold Owen and John Bell (London, 1967), 429; cited by Hynes, *A War Imagined,* 160–61, with explanatory comment on the Bone series.

61. Arnold Bennett, "Introductory Note" for *Paul Nash,* exh. cat., Leicester Galleries, London, May 1918; cited by Hynes, *A War Imagined,* 199–200, with comparison, 201, of the language in another 1917 letter of Owen's.

62. The drawing is reproduced with these details of the context of its creation in Meirion and Susie Harries, *The War Artists: British Official War Art of the Twentieth Century* (London, 1983), 55.

63. The terms of discussion applied here to the *Battle of Issus,* which was done for the duke of Bavaria as one of a series of large-size works depicting famous battles of antiquity, draw in some key respects on Christopher S. Wood, *Albrect Altdorfer and the Origins of Landscape* (Chicago, 1993), 165. Italian Mannerist use of *bizarrerie,* in landscape and more generally, seems to entail by comparison a motivating awareness of the ancient literary tradition specifying that fantasy can be a source of beauty: see John Shearman, *Mannerism* (Harmondsworth and New York, 1967), 156.

64. Paul Klee in landscapes of the 1920s and early 1930s and Paul Nash in his of 1929–36 equally use suspension in space and a seemingly irrational congeries of shapes; but to gentler effect in their cases, because of the sense of control and containment induced by a consistent atmosphericity.

65. See in this connection the reproduction of all three versions in color in *Henri Matisse: The Early Years in Nice, 1918–1930,* exh. cat., National Gallery of Art, Washington, D.C., November 1986–March 1987, 157–59, along with the introductory essay by Jack Cowart, which refers to them at 20.

66. John Cornall's review essay "Christopher Wood and Localism," *London Magazine* 30, nos. 5–6 (August–September 1990): 102–6, brings out how Wood's Breton subjects are to be regarded in this connection.

67. It is interesting that a comparable notion of "picturing," analogizing the philosophical enterprise as practiced from "different directions and [ever] new sketches" to the look of a landscape album, was put forward by Ludwig Wittgenstein in explanation of the form taken by his *Philosophical Investigations.* See his preface of January 1945 to that book, ed. G. H. von Wright and G. E. M. Anscombe, translated from the German by Anscombe (London, 1953; 3d ed., New York, 1968), v–vi.

68. See the perceptive remarks on this subject of William J. Keith, *The Poetry of Nature: Rural Perspectives in Poetry from Wordsworth to the Present* (Toronto, 1980), bringing in Hardy's poetry, which frequently pays direct tribute to Wordsworth and the "revivalist tone" (170) of the first two volumes of the *Georgian Poetry* series, which appeared in 1913 and 1915 (with subsequent volumes following in 1918, 1920, and 1922).

69. See on this subject the overlapping discussions, leading up to the 1920s, of Martin J. Wiener, *English Culture and the Decline of the Industrial Spirit* (Cambridge, 1981), chap. 4, "The English Way of Life"; Jan Marsh, *Back to the Land: The Pastoral Impulse in England from 1880 to 1914* (London, 1982); and Alan Howkins, "The Discovery of Rural England," in *Englishness: Politics and Culture, 1880–1920,* ed. Robert Colls and Philip Dodd (London and Dover, N.H., 1986), 62–88. A particularly revealing text for the interwar period is that of Edmund Blunden, who was both a Georgian poet and a war survivor: "The Preservation of England," reviewing G. M. Trevelyan's address "Must England's Beauty Perish?" reprinted (undated) in Blunden, *Votive Tablets* (London, 1931), 352–62.

For successive stages in the assimilation of Constable's art to the national cultural image of rural England, see Elizabeth Helsinger, "Constable: The Making of a Natural Painter," *Critical Inquiry* 15, no. 2 (winter 1989): 253–79 (on the ongoing influence of the ideas expressed in the 1833 publication *English Landscape Scenery*); Alex Potts, " 'Constable Country' Between the Wars," in *Patriotism: The Making and Unmaking of British National Identity,* ed. Raphael Samuel, 3 vols. (London and New York, 1989), vol. 3, *National Fictions,* 160–88; and Stephen Daniels, "John Constable and the Making of Constable Country," in his *Fields of Vision: Landscape Imagery and National Identity in England and the United States* (Princeton, 1993), chap. 7, 200–242. On the artists associated with the emergence in the 1920s and 1930s of a distinctive "home counties" landscape, see the coverage of this in Ian Jeffrey, *The British Landscape, 1920–1950* (London and New York, 1984).

70. Wallace Stevens, *Collected Poems* (New York, 1954), 96; first published in *New Republic* 20, no. 554 (14 September 1921).

71. Stevens, *Collected Poems,* 57; from his first collection also, *Harmonium* of 1923.

72. For the two paintings in question, see *The Louise*

and Walter Arensberg Collection, 2 vols., Philadelphia Museum of Art, 1954, vol. 1, *Twentieth-Century Section,* cat. by Marianne W. Martin, nos. 98, 194, and for Stevens's opportunity to study works in the collection, Joan Richardson, *Wallace Stevens: The Early Years, 1879–1923* (New York, 1986), 468–71, where the relevance of the Villon is brought up in related terms.

73. T. S. Eliot, "Little Gidding" (written 1941–42, first published December 1942), ii: *Four Quartets* (London, 1944), 37.

74. See on this subject Kenneth Maddox, "Thomas Cole and the Railroad: Gentle Maledictions," *Archives of American Art Journal* 26, no. 1 (1986): 2–10; Nicolai Cikovsky Jr., " 'The Ravages of the Axe': The Meaning of the Tree Stump in Nineteenth-Century American Art," *Art Bulletin* 61 (December 1979): 611–26; Maddox, "The Railroad in the Eastern Landscape; 1850–1900," in *The Railroad in the American Landscape; 1850–1950,* exh. cat., ed. Susan Danly Walther, Wellesley College Museum, April 1981; and *The Railroad in American Art: Representations of Technological Change,* ed. Susan Danly and Leo Marx (Cambridge, Mass., 1988; based on a symposium held for the 1981 exhibition) with essays by Maddox, on Durand's *Progress* of 1853, and Cikovsky, on Inness's *The Lackawanna Valley* of 1856–57 (revising his earlier interpretation), an "iconological" overview by Leo Marx and studies by Susan Fillin-Yeh of Sheeler's *Rolling Power* and Gail Levin of Hopper's railroad imagery. The more recent publication entitled *Denatured Visions: Landscape and Culture in the Twentieth Century,* ed. Stuart Wrede and William Howard Adams (New York, Museum of Modern Art, 1991), includes an essay by Robert Rosenblum entitled "The Withering Green Belt: Aspects of Landscape in Twentieth-Century Painting"; however, the terms of discussion introduced there seem not particularly germane to the major American artists of the interwar period and their concerns.

75. John Wyndham, *The Chrysalids* (London, 1955), 59; I am indebted to Gretchen Fox for drawing my attention to this passage.

76. Hans Vaihinger's *Die Philosophie des Als Ob* (Berlin, 1911), trans. C. K. Ogden as *The Philosophy of As If* (London, 1924), lays out a rich twentieth-century development of that imaginative principle, entailing now a more systematic exploitation of possible fictions.

77. The best introduction to the character of these landscapes (with photographic comparisons) remains the essay by Maurice Tuchman in *Chaim Soutine, 1893–1943,* exh. cat., Los Angeles County Museum of Art, 1968, 21–29.

78. Isak Dinesen, "Snow-Acre," in her *Winter Tales* (New York, 1942), 29–30. I am grateful to Claire Daigle for showing me this passage.

79. Ferdinand de Saussure's use in his *Cours de linguistique générale* (Geneva, 1916) of the term "sound image" for the *signifier* is glossed in this way—as representing the "mental imprint of a sensorial perception," as opposed to the sound itself—by Ora Avni, *The Resistance of Reference: Linguistics, Philosophy, and the Literary Text* (Baltimore, 1990), 47–53; she aptly reviews in this connection the three differing versions of the course given between 1906 and 1911. For the part played by context in the inferential processing of verbal and/or sensorial data, see further the account of this given by Dan Sperber and Deirdre Wilson, *Relevance: Communication and Cognition* (Cambridge, Mass., 1986), chap. 3.

80. The terms used here are ones that were introduced into the discussion of German literature by Clemens Lugowski, *Die Form der Individualität im Roman* (Göttingen, 1932; repr. Frankfurt, 1976), now made available in English as *Form, Individuality, and the Novel: An Analysis of Narrative Structure in Early German Prose,* trans. John Dixon Halliday (Cambridge and Norman, Okla., 1990); see esp. the introduction by Heinz Schaffler, xii.

For mountain landscapes done by David Bomberg in Spain in 1934–35 (in and around Ronda) that for analogous reasons have a quality of *anima* attributable to them, see David Sylvester, ed., "Selected Criticism," in *Bomberg, Paintings/Drawings/Watercolours and Lithographs,* exh. cat., Fischer Fine Art, London, March–April 1973, quoting from his own and John Berger's reviews of the Arts Council of Great Britain memorial exhibition of 1958, with introduction by Andrew Forge. For British artists who devoted themselves to mythical imagery harking back to Romantic precedents in the two decades following, see *A Paradise Lost: The Neo-Romantic Imagination in Britain, 1935–55,* exh. cat., ed. David Mellor, with text by him and essays by four other contributors, Barbican Art Gallery, London, May–July 1987.

81. See the catalogue for this exhibition, with introduction by Baur, 5–14, and 69, 71, 75, 82 there for the statements paraphrased, which are those of Philip Guston, Angelo Ippolito, Joan Mitchell, and Hyde Solomon; also the opening commentary of Thomas B. Hess in his review of the exhibition, "Inside Nature," *Art News* 56, no. 10 (February 1958): 40–43, 59–65.

82. For Pollock's statements see *Jackson Pollock,* exh. cat., Museum of Modern Art, New York, 1967, with chronology by Francis V. O'Connor, 31–33, 40, 51–52, and cat. no. 77 for the painting in question; paradoxically, the 1944 statement comparing the feeling imparted by the Atlantic to Pollock's formative experience of the West could have been used, insofar as it fitted an "ocean" subject. For De Kooning, see his 1963 interview with David Sylvester for the British Broadcasting Corporation, which first appeared under the title

"Content is a Glimpse . . ." in *Location* 1, no. 1 (spring 1963); reprinted in *Willem de Kooning*, exh. cat., Museum of Modern Art, New York, 1968, 146–50. The works in question are referred to on 149 there; see also the accompanying text by Thomas B. Hess, 103, 122–23, for the shift to this kind of imagery and its context.

83. Barr, intro. to *The New American Painting*, exh. cat., Tate Gallery, London, Arts Council of Great Britain, February–March 1959 (repr., with added color plates and a selection of critical responses that had appeared in European publications, for the New York showing, May–September 1959), 9–13. Works were selected for the exhibition by Dorothy C. Miller of the Museum of Modern Art, which simultaneously, under the same auspices, sent on tour to London, Paris, and six other European cities a retrospective exhibition of the work of Pollock: *Jackson Pollock, 1912–1956*, March 1958–February 1959, based on the exhibition sent to the São Paulo Bienal in September–December 1957 and accompanied as there by a text by Sam Hunter, adapted from the museum's catalogue for its Pollock exhibition of December 1956–February 1957. Also in 1959 Pollock and De Kooning had volumes devoted to them in the Great American Artists series published by Braziller, New York: a series in which Winslow Homer and Albert Pinkham Ryder appeared as major American landscape painters.

84. Barr, intro. to *New American Painting*, mentioned the contributory criticism of Clement Greenberg in particular. For Greenberg's progressive formulation of the way in which Pollock had assimilated and then moved beyond those named sources of inspiration, see O'Connor, *Jackson Pollock*, 31, 38–39, 41, reprinting comments of 1943, 1946, and 1947. Sam Hunter's *New York Times* review of 30 January 1949 (O'Connor, *Jackson Pollock*, 46) is also relevant.

85. Both were represented in the 1958 Whitney exhibition: Hofmann in the second subdivision, with his *Radiant Space* of 1955 (which was only indirectly a landscape); Frankenthaler in the first with a painting of 1957 titled *Lorelei*. See Sam Hunter, *Hans Hofmann* (New York, 1963), which includes information on Hofman's European background and working methods; and the intro. by E. C. Goossen to *Helen Frankenthaler*, exh. cat., Whitney Museum of American Art, February–April 1969, 8–9, where the text, written in consultation with the artist, specifies all of the admirations mentioned.

86. See especially in this connection Greenberg's comment on the late Monet, noting the relevance of what he saw there to Clyfford Still's work, in his "American-Type Painting," *Partisan Review* 22, no. 2 (spring 1955): 179–91; reprinted in Clement Greenberg, *The Collected Essays and Criticism*, 4 vols., ed.

Justin O'Brien (Chicago, vols. 1–2, 1986; vols. 3–4, 1993), 3:217–36 (reference is on 230, with a related comment about a Pollock of 1950, 233). The view of Pollock here as going beyond "late Cubism" toward the end of his career can be conveniently compared with Greenberg's comment five years earlier on the "effort to impose Cubist order" and "[extend] the Cubist and post-Cubist past . . . in an unforeseen way" that he had felt then to be the major link among Pollock, De Kooning, and Gorky; see his essay "The European View of American Art" (review of European criticism of the Biennale that year), *The Nation*, 171 (25 November 1950): 490–92, reprinted in Greenberg, *Collected Essays*, 3:59–62.

87. See especially in this connection the observations of Louis Finkelstein that appeared under the title "New Look: Abstract-Impressionism," *Art News* 55, no. 1 (March 1956): 36–37, 66.

88. See Baur, intro. (as in note 81), 13, calling the "sub-movement" in question "a somewhat amorphous trend within the general boundaries of abstract expressionism." The latter term was one that had been first introduced by Robert Coates in 1946, for Hofmann, and it was also used in the United States, from c. 1929, for Kandinsky's work of c. 1910 on, so that it designated in general abstraction *on*, or *from*, an Expressionist ground; Harold Rosenberg, in a dialogue of 1958 with Thomas B. Hess, argued for dropping it because of its overpersonal associations; see his *The Tradition of the New* (New York, 1959), 28n, dealing with his preferred use of his own coinage of 1952, "Action Painting." The phrases drawn from Barr's 1959 essay (as in note 83), which opted for none of those terms, appear at 11 there.

In Baur's exhibition, Philip Guston, Joan Mitchell, and Paul Jenkins were featured, along with Hyde Solomon and Angelo Ippolito, among the painters who, it was stated, had been associated with Abstract Impressionism. In the *New American Painting* catalogue, Guston's statement written for Baur was quoted, affirming that he thought of painting "more in terms of the drama of . . . process than . . . of 'natural' forces" (36). Bradley Walker Tomlin and Jack Tworkov, who have been seen as contributing to Abstract Impressionism on the basis of their work of the early 1950s, were also in the 1959 exhibition, but their statements published there said nothing about nature, while that of James Brooks, made for Baur but not used by him, denied looking "at natural growth of forms more often than . . . at man-made things" (18). Baur represented Mark Tobey with a work of his from 1942, *Drift of Summer*; Barr mentioned Hofmann as teacher, but the exhibition for which he wrote his text did not include either Hofmann or Tobey. And if it had taken into account early works by Mark Rothko, Clyfford Still, and

Theodore Stamos, who were included (and only the last of whom was shown at the Whitney, with a work of 1957), it would have been apparent that a lyrical, fluid improvisation upon forces and sensations deriving from nature did not always or necessarily go—following Greenberg's line of argument, as it extended to those artists—with a "post-Cubist" exploration of relations between ground and surface, or outlying shape and edge; see in this connection the essay by Robert Carleton Hobbs prefacing *Abstract Expressionism: The Formative Years*, exh. cat., Herbert F. Johnson Museum of Art, Cornell University, March–May 1978, and the contrary cases brought together there.

The drawing of too outright a boundary between "expressionistic or abstract painting" and the "symbolistic overtone[s]" that may be carried by landscape is also apparent in William C. Seitz's conclusion on the very late paintings of Monet (after he organized the 1960 Museum of Modern Art exhibition "Claude Monet: Seasons and Moments," which prominently featured the museum's newly acquired triptych, replacing its destroyed waterlily canvas referred to with a comparable late work): *Claude Monet* (New York, 1960), 43.

89. Ossorio, intro. to *Jackson Pollock, 1951*, exh. cat., Betty Parsons Gallery, New York; reprinted in *New American Painting*, 60.

90. As by the Venetian critic Bruno Alfieri in *L'Arte moderna*, 1950, followed by *Time*, 20 November 1950; see O'Connor, *Jackson Pollock*, 54–56.

91. Pollock's own address here to what he was engaged in doing is the subject of a number of informal statements of his, the most important of which may be the journal or notebook entry of c. 1955–56, which reads, "my concern is with the rhythms of nature . . . the way the ocean moves . . . the ocean is what the expanse of the West is for me [cf. his 1944 statement referred to in note 82 above]. . . . I work from the inside out, like nature"; quoted in Bernard H. Friedman, *Jackson Pollock: Energy Made Visible* (New York, 1972), 228. See also the statement reported by Lee Krasner Pollock: "I saw a landscape, the like of which no human being could have seen"; Friedman, interview with her published in *Jackson Pollock: Black and White Paintings*, exh. cat., Marlborough-Greene Gallery, New York, 1969. The implications of this in respect to color and handling are taken up by Timothy J. Clark, "Jackson Pollock's Abstraction," in *Reconstructing Modernism: Art in New York, Paris, and Montreal, 1945–1964* (proceedings of symposium held under that title at the University of British Columbia, 1986), ed. Serge Gilbaut (Cambridge, 1990), 172–244.

92. Ørsted, "Betragtninger over den danske Character, pt. i" *Dansk Ugeskrift* 2, no. 85 (24 November 1843), 105–20 (reference is to 105–6); cited in Kasper

Monrad, *Hverdagsbilleder: Dansk Gulalder—kunstnerne og deres vilkår* (Copenhagen, 1989), 146–47; I am indebted to Peter Nisbet for this reference and the use of his translation.

93. Kermit Swiler Champa, *Mondrian Studies* (Chicago, 1985), chap. 1, "Holland and 'Dutchness,' " 5–6, argues for a relationship of response in kindred terms.

94. For Mondrian's importance for De Kooning, see the statement written for a symposium at the Museum of Modern Art, New York, 5 February 1951, reprinted in *Willem de Kooning*, 145. For Soutine's contribution, see Diane Waldman, *Willem de Kooning* (New York, 1988), 132, 136, citing De Kooning's admiration for this artist, and the fuller argument on the subject by Judith Zilczer, "De Kooning and Urban Expressionism," in *Willem de Kooning: From the Hirshhorn Museum Collection*, exh. cat., Smithsonian Institution, Washington, D.C., October 1993–January 1994, 47–50, 56 (also 17 on Mondrian).

95. See Zilczer, "De Kooning," 38–39, reproducing a Marin watercolor of 1922 that was in the 1936 exhibition. Pollock, contrastingly, had expressed interest in his 1944 statement in Ryder only among earlier American artists; see O'Connor, *Jackson Pollock*, 32.

96. De Kooning, 1963 statement (as in note 82), 148 ("content is a glimpse of something, an encounter like a flash. . . . I still have it now from fleeting things, like when one passes something and it makes an impression") and 149, from which the remaining phrases come.

97. The frequent comparison of them to Franz Kline's landscapes of the time brings up qualities shared in this regard.

98. *The Bridge* was published in Paris in January 1930 and in New York the following October. The critical comments quoted are taken from Louis Untermeyer, "Prophetic Rhapsody," *Saturday Review of Literature* 6 (14 January 1930): 1125; Allen Tate, "Hart Crane" (combining texts of his from 1932 and 1937), in his *Essays of Four Decades* (Chicago, 1968), 310–23; and Karl Shapiro, "Study of *Cape Hatteras* by Hart Crane," in *Poets at Work*, ed. Charles D. Abbott (New York, 1948), 111–18. All three essays are reprinted in *The Merrill Studies in the Bridge*, compiled by David R. Clark (Columbus, Ohio, 1970), where the quoted phrases are to be found at 10, 26, 35, 37, 40.

99. The phrases quoted, explicating *The Bridge* as a poem conceived in Symbolist terms, are taken from Stanley K. Coffmann Jr., "Symbolism in *The Bridge*," *Proceedings of Modern Language Association of America* 66 (March 1951): 65–77, reprinted in Clark, *Merrill Studies*, 52–66. The recent study by W. T. Lhamon Jr., *Deliberate Speed: The Origins of a Cultural Style in the American 1950s* (Washington, D.C., 1990), which

brings in the literature, jazz, and photography of this decade as well as painting and art criticism, has a suggestive passage in its chap. 4, "Congeniality," about the importance now of making "difficult but accessible" art for a "newly emergent public" (123).

The difference between De Kooning and Pollock, in respect to aims and forms of imaging deriving their ultimate authority from Symbolism, might be amplified by an alignment in Pollock's case with van Gogh's *Starry Night* of 1889; for its indebtedness to the imagery of Whitman, see the summary of Hope Werness, "Whitman and Van Gogh: Starry Nights and Other Similarities," *Walt Whitman Quarterly Review* 2, no. 4 (spring 1985): 35–41; and in De Kooning's case with Munch's *Starry Night* of 1893 (J. Paul Getty Museum, Malibu; version of c. 1895–97, Von der Heydt-Museum, Wuppertal), both discussed by Louise Lippincott, *Edvard Munch: Starry Might* (Malibu, 1988), especially in terms of the effect of the spatial and atmospheric merger there of each element with its neighbors.

100. On the records of process as they register in Diebenkorn's work, see Arthur Danto's essay of 1988 on the artist, reprinted in his *Encounters and Reflections: Art in the Historical Present* (New York, 1990), 193–96. On the tribute paid to Matisse's example, accessible especially through the Museum of Modern Art's exhibition of seventy-four paintings in 1952 and Alfred H. Barr's text of 1951, *Matisse, His Art and His Public*, written to accompany that exhibition—while Clement Greenberg wrote with particular critical admiration of Matisse's 1913–16 period in articles from 1946 on, culminating in his small booklet of 1953 on the artist—see Richard T. Buck Jr., "The Ocean Park Paintings," in *Richard Diebenkorn, Paintings and Drawings, 1943–1980*, exh. cat., Albright-Knox Art Gallery, Buffalo, and other locations, November 1976–November 1977; rev. ed. (New York, 1980), 42–49. On Gary Snyder's poetry dealing with the landscape of the American West—as in his volume of poems *Turtle Island* (New York, 1974), from the same decade as the Diebenkorn illustrated—in a fashion that combines "the coolness of Imagism and Objectivism with the traditions of Chinese poetry," see Martin Green, *Prophets of a New Age: The Politics of Hope from the Eighteenth Through the Twenty-First Centuries* (New York, 1992), 261, drawing on Alan Williamson's contribution to *Gary Snyder: Dimensions of a Life*, ed. Jon Halper (San Francisco, 1991).

101. The details given here and in what follows draw directly on the reading of the painting provided by Tom Sherman, "Jack's Eye Was a Camera," *Arts Magazine* 65, no. 6 (February 1991): 44–47.

102. An offering of surety of a related order can be taken as informing the work of artists who deal with actual landscape, such as Robert Smithson, Richard Long, and Mary Miss. For definitional purposes pertaining to the present study, their work does not entail languages *of* landscape, but rather an architectural/sculptural vocabulary and syntax applied *to* landscape, as site and source of materials. See for their work and the principles and practices underlying it, Alan Sonfit, *Art in the Land: A Critical Anthology of Environmental Art* (New York, 1983); Lucy Lippard, *Overlay: Contemporary Art and the Art of Prehistory* (New York, 1983); and Stephanie Ross, "Gardens, Earthworks, and Environmental Art," in *Landscape, Natural Beauty, and the Arts*, ed. Salim Kemal and Ivan Gaskell (Cambridge, 1993), 158–82. Interest in the philosophical phenomenology of Maurice Merleau-Ponty represents one factor here held in common with Chambers.

103. On the uses of "hyperrealism" in connection with the marketing of consumer products, see now Jean Baudrillard's sociophilosophical essay *Simulacres et simulations* (Paris, 1981), trans. Paul Foss, Paul Patton, and Philip Beitchman as *Simulations* (New York, 1983), esp. 141.

That photography of landscape subjects can equally have a subversive role today, vis-à-vis conventional or superficial expectations of what the camera produces in dealing with nature, is brought out by Paul Graham's recent photographs of Ireland in which subjects that are at first glance appealing in a quite straightforward and traditional way turn out to reveal, on closer inspection, flags, posters, bits of color, and other signs, such as graffiti having to do with the political activities of the IRA. See Jerry Saltz, "The Scene of the Crime: Paul Graham's *Republican Parade, Stabane*, 1986," *Arts Magazine* 63, no. 5 (January 1989): 13–14. Landscape as pleasant spectacle thereby becomes, one may say, "masquerade."

104. See *Kimura: Paintings and Works on Paper, 1968–1984*, exh. cat., Phillips Gallery, Washington, D.C., January–March 1985, and *Chuta Kimura (1917–1987)*, exh. cat., Takamatsu City Museum of Art and Shuto Museum of Art, 1989, with texts by Denys Sutton and Arthur C. Danto, the latter including photographs of the artist painting in nature.

105. See *The Painters of Barbizon and Japan*, exh. cat., Fukushima, Chiba, and Yamanashi Prefectural Museums of Art, 1993, 19–20, and cat. nos. 100–117. I am indebted to Robert L. Herbert, who contributed prefatory remarks to it, for making available a copy of this catalogue.

106. I owe information on the subject of these visitors to Paul H. Tucker.

107. See, for these details, *Georgia O'Keeffe: Art and Letters*, letters selected and annotated by Sarah Greenough (serving as catalogue for the exhibition "Georgia O'Keeffe: 1887–1986," originating at the

National Gallery of Art, Washington, D.C., November 1987; New York and Boston, 1987), 287, note to letter 3.

108. See Mary Burke, "Twisted Pine Branches: Recollections of a Collector," *Apollo* 121 (February 1985): 77–83 (the phrases quoted are from 79). I am grateful to the curator of the Burke Collection, Gratia Williams, for supplying this reference.

109. I am indebted to Barbara Westheim and Lorna J. Ritz for discussing Kimura's work with me.

CONCLUSION

1. The terms used here and the larger framework of discussion, transposed from the study of verbal communication, draw especially upon Dan Sperber and Deirdre Wilson, *Relevance: Communication and Cognition* (Cambridge, Mass., 1986).

2. The terms used in this section draw directly upon Ronald W. Langacker, *Concept, Image, and Symbol: The Cognitive Basis of Grammar* (Berlin and New York, 1990): I am also indebted to Robert Kemp for suggestions as to how transposition to the domains of the visual should be made, and the specifics of application there.

3. See Franklin Kelly, in *Frederic Edwin Church and the National Landscape*, exh. cat., Smithsonian Institution, (Washington, D.C., 1988), 9–10 and 140 n. 37, where comparable associations attaching to historic oaks painted by George Harvey (1840) and Asher B. Durand (1860) are brought in.

4. On the subject of this painting, see Klaus Herding, "Egalität und Autorität in Courbets Landschaftsmalerei," *Städel Jahrbuch*, n.s., 5 (1975): 158–99, trans. John William Gabriel, in Herding, *Courbet: To Venture Independence* (New Haven, 1991), as chap. 4 (83–84 there refer); and *Courbet Reconsidered*, exh. cat., Brooklyn Museum, New York, and Minneapolis Institute of Arts, November 1988–April 1989, cat. no. 44, with text by Linda Nochlin. When shown in Courbet's one-man exhibition of 1867, the painting carried an extended title referring to the dispute of the time as to whether the camp of Caesar's general Vercingetorix—whose name correspondingly had become attached to the tree—was located in Franche-Comté, in the ancient Gallic capital of Alesia.

5. Sir Ernst Gombrich in the well-known account of Constable's *Wivenhoe Park* given in his *Art and Illusion: A Study in the Psychology of Pictorial Representation* (A. W. Mellon Lectures in the Fine Arts, 1956; New York, 1960), 33–38, 386–88, deals with that painting in a fashion that seems to me in conformity with my formulation in this paragraph, as against the version of the "transparency" thesis attributed to him by

Norman Bryson, *Vision and Painting: The Logic of the Gaze* (New Haven, 1983), 43–45, 53, under the name of Perceptualism.

6. Augustine of Hippo, *De magistro* 39, 44; translated as *The Teacher*, in *Augustine: Earlier Writings*, selected and trans. with intro. by John H. S. Burleigh (Library of Christian Classics 6; London, 1953), 66–69 and 96, from which the phrases quoted are taken. The Greek word for truth, *aletheia*, was originally charged with the meaning of "not forgetting."

7. On the social framework of memory, see the classic discussion of Frederick C. Bartlett, *Remembering: A Study in Experimental and Social Psychology* (Cambridge, 1932, repr. 1967), chap. 11, "Images and Their Function," esp. 312; and for the operation of nostalgia as it attaches to place, see Edmund S. Casey, *Remembering: A Phenomenological Study* (Bloomington, 1967), part 3, "Pursuing Memory Beyond Mind," esp. 198, 201. See also Susanna Koechler and Walter Melion, eds., *Images of Memory: On Remembering and Representation* (Washington, D.C., 1991), esp. 7 of their introduction.

8. A lecture given by the novelist Paul Theroux on memory and creation (May 1991) and a question posed to him lie behind the analogy drawn here.

9. Constable, as cited from an unexplained source—as if the passage commenting on the London Diorama (written to Archdeacon Fisher in September 1823) that was brought up in Chapter 2 continued this way—in C. R. Leslie, *Memoirs of the Life of John Constable, composed chiefly of his Letters* (first published 1843), ed. Jonathan Mayne (London, 1951), 106.

10. Cole, letter of 4 January 1838 to Durand, cited in Ellwood C. Parry III, *The Art of Thomas Cole: Ambition and Imagination* (Newark, 1988), 201. Dorinda Evans, reviewing that book in *Art Bulletin* 73, no. 3 (September 1991): 496, noted antecedence in Reynolds and Washington Allston in this respect; in effect, what had always been at issue in landscape art was now being brought to the fore and made increasingly self-conscious.

11. Delacroix, *Journal*, ed. André Joubin, 3 vols. (Paris 1932; rev. ed., 1960), 1:488; see Lee Johnson, *The Paintings of Eugène Delacroix: A Critical Catalogue*, 6 vols. (Oxford, 1981–89), 3:no.489, for an endorsement of the view first put forward by Etienne Moreau-Nélaton, *Delacroix raconté par lui-même*, 2 vols. (Paris, 1916), 2:107, that the so-called *Sea from the Heights of Dieppe* in the Louvre could well be the work referred to here. See also *Journal* 2:469, 471, for mention in October 1856 of his having done from memory, together with drawings, two views that month of his cousin's estate near Ante; these are discussed by Johnson, 3:nos. 485 and L202, and also by Maurice Serullaz, *Eugène Delacroix: Album de croquis* (Paris, 1961), fols. 21–22, and *Mémorial de l'exposition Eugène*

Delacroix, Musée du Louvre, Paris, 1963, cat. nos. 484–85.

12. Key points about the framing of those questions, in other pictorial contexts, and the contrasting contribution of words are made by David Carrier, *Principles of Art History Writing* (University Park, Pa., 1991), chaps. 8 and 9, esp. 190–91.

13. Ruskin, *Modern Painters*, vol. 4 (1856), part 5, "Of Mountain Scenery," chap. 2, "Of Turnerian Topography"; *The Works of John Ruskin*, ed. E. T. Cook and Alexander Wedderburn, 34 vols. (London, 1903–10), 4:33–43 and pls. 20–21. Ruskin's estimate of the watercolor realized for him is to be found in his *Catalogue of Turner Sketches in the National Gallery*, part 1 (1851), cat. no. 40; *Works* 13:206. The "sample study" in question is reproduced in Robert Upstone, *Turner: The Final Years, Watercolors, 1840–1851*, exh. cat., Tate Gallery, London, February–May 1993, no. 30.

14. A classic text affirming this dual source of fascination as it was purveyed by the original garden is the report of François Thiébault-Sisson, "Un nouveau musée parisien: Les *Nymphéas* de Claude Monet à l'Orangerie des Tuileries," *Revue de l'art ancien et moderne* 52 (June 1927): 40–52; translated as "Claude Monet's Water Lilies," in *Monet: A Retrospective*, ed. Charles F. Stuckey (New York, 1985), 279–92. It records a visit of February 1918 and brings up the problematic effect on the work of Monet's by then deteriorating eyesight.

The most extensive photo-documentation bearing on the relation of garden to paintings is to be found in Robert Gordon and Andrew Forge, *Monet* (New York, 1983), chaps. 7–9. See also the earlier publication, *Monet at Giverny*, with text by Claire Joyes (London and New York, 1975), to which they contributed on the same lines.

15. On the form taken by the sharing here, see Anne Scott-James, *Sissinghurst: The Making of a Garden* (London, 1975).

Glossary of Linguistic and Semiotic Terms

Catachresis In language, a perverted or improper use of words. Insofar as a movement is characteristically entailed from the literal toward or into the figurative, it can be taken to entail the inappropriate use of a term of description of a characterizing order for evocative purposes (as in "a mule shod with silver shoes").

In the case of visual imagery and the account that is given of it, to call a photograph a "living image [of actuality]" represents a slippage of a corresponding sort, impelled by the way in which, in that particular medium, the availability of the subject to presenting itself and being seen in the way that it is seen belongs specifically to another time and place than the here and now. More generally, pictorial images can be characterized in a figurative way that is accepted and understood as such, while at the same time—as with "an unbounded scene of nature" or "a spatially frozen mountain"—retaining the form or appearance of a literal description.

Constative Use of Language *See* Performative/ Constative Uses of Language

Diachronic Analysis *See* Synchronic/Diachronic Analysis

Etymology This form of linguistic study deals with the origin and history of words, tracing them back to their bases in earlier language-groups. Traditionally the term has been used to cover regularities of occurrence pertaining to both form and content. With pictorial imagery, the tracing back that occurs can be taken to depend analogously on repetition and parallelism: without, that is, the presence of any necessary causal connection to be used as explanation for the link, or without a motivation being specified that is extrinsic to the evolution itself.

Intertextuality This term was introduced into French critical theory by Julia Kristeva (1966–67), drawing for her understanding on the later writings of Mikhail Bakhtin. Since then it has come to mean for others (as for Michael Riffaterre) a complex dialogic process, provoked in the act of reading, between readers and the memory of earlier texts.

In the application of the term to visual images, it is important in principle that any artifact that can be "read" may count as "text," with or without writing being included or attached to it. There are then two ways in which the concept can inform interpretative practice. It may be taken to imply a layered quality of textuality present in the work, through which references to other, earlier texts are inferred as being relevant to the construction of meaning. Or it may designate the responsiveness of a "text" to being read in the light of other texts, that it recalls or brings to mind. The term "reading" itself needs to be adapted here, to fit the nonlinear type of exploration and response that a visual image invites.

Lexicon This term refers in linguistics to the listing that a speaker's mental dictionary contains of all the items in his or her vocabulary, together with a set of rules for word formation mapping the usage of those items. In the domain of pictorial representations it can be used to refer comparably to the individual components that are taken as adding up together to a thematic vocabulary, and to the syntactic principles understood as governing their arrangement.

Metonymy As a figure of speech, metonymy designates in its grammatical form the naming of a part or attribute in place of the whole (crown for royal authority, blue-collar for worker), or of an instrument of cause in place of its effect (key for prison). For its amplified figurative usage, contrasting with metaphor, and its application to visual imagery, see Tropology.

Performative/Constative Uses of Language　Following the lead of the language philosopher J. L. Austin, a distinction has been mapped out for language usage between "performative" and "constative" classes of expression. The type of phrasing that is "performative" in its scope serves to express that the speaker is doing something declaratively (as in saying "I hereby give up smoking"), in contrast to a "constative" phrasing, which has the function of describing or evidencing what is the case (as in saying "to smoke constantly is damaging to one's health").

In the way in which pictorial representations signify, a similar distinction can be taken to apply, here to the material counterpart to a particular communicative message. The issue of a warning against smoking may entail presentationally a display of smokers disposed to indulge their appetite, and it may register because of the way in which such indulgence declares itself, as distinct from having its implications and consequences brought out by their being specified. Similarly richness and sensual splendor may have attention ostensively drawn to them in an image that asserts a saint's or hermit's renunciation of the world. One might say that a difference of *force* applies in such cases, in respect to what is shown and what is affirmed.

Pragmatics　This term was applied by Charles Morris (1946) to the study of signs (q.v.) in terms of their origin, use, and effect, as distinct from their material relations or the signification attached to them. Now it has come to designate in linguistics the way in which attitudes and beliefs entertained by speaker and hearer and their basic knowledge of language usage and understanding of its applications bear on what takes place communicatively in a particular context of utterance.

With visual images, the idea of a context within which communication and response occur widens out beyond the wishes and expectations of particular patrons or individual purchasers for works of art, and beyond the belief- or attitude-governed patterns of receptivity of viewers, to include the part played by exhibitions, or public venues for display and discussion. Beyond that in turn lie a whole series of factors that could be taken as contributing to the climate of understanding, or as having a relaying role in gaining attention for the image. In practice, the forms of presentation and the mechanisms of distribution that are particular to works of art make for differences from works of literature at the pragmatic level: ones that bear on communicational affect in the same sort of applied way as comes up for consideration in rhetoric.

Within the present study, pragmatics designates accordingly aspects of the creative process that require reference to the uses made of visual imagery; to the assumptions or attitudes of viewers, amounting to a *disposition* on their part; and to the larger context in which participatory understanding takes place. Taken in this way, the term corresponds more to *Wirkung* (customarily translated as "response theory"; q.v.) than it does to *Rezeption,* as those two terms are currently used in German theorizing.

Reference　The epistemologist and formal logician Charles Sanders Peirce made a founding contribution to the modern discipline of semiotics when, in his discussion of the communicative functioning of signs, he effectively triangulated sign, user, and referent. What the visual sign refers to—not necessarily an object in reality or concrete entity, though such is most often the case—is "made present" processually in the mind of the viewer by virtue of an interpretative understanding in thought, which Peirce termed the *interpretant:* an understanding that might, as Peirce posited, substitute for the original sign another that it evoked. Charles Morris (1938) used the same term for the effect of the sign on its interpreter, as distinct from the sign's vehicle or its referent.

New Marxist theory of language intersects with this territory of discussion in its emphasis on the production and circulation of meanings, independent of any authorial responsibility for the determination of how reference is to be apprehended. It postulates accordingly that, rather than serving as a neutral and transparent medium of communication, language engages in actively building patterns of usage. In that process of building reference is sustained and amplified by expanding, mutually reinforcing patterns of understanding.

This in turn entails that associated implications, and resonances that are based on applied patterns of comprehension, will be fluctuant in changing contexts. There will be, in effect, a continual process of slippage at work: as if each new accrual of meaning were compensating thereby for the inherent nonexplicitness of communication itself. In this material property and ability of language as a instrument, an expanding chain of linked significations brings into being a shifting of reference from one "frame" to another, and a constant seeking of further and freer play for itself.

Among the numerous subdivisions of the sign that Peirce introduced, one triad only has proved its importance since for understanding the workings of reference in practice: that of icon, index, and symbol. The icon as he explained it is linked to its object of reference in virtue of resemblance, or likeness to it; the index is "factually" related to its object of reference in virtue of being "really affected" by it (as in his example of the pointing finger); the symbol, by

virtue of conventions entailing familiar patterns of association.

Since *icon* and *symbol* are effectively preempted for the visual arts by their prior usages there, which by no means completely conform, Peirce's account of the functioning of these three basic, and not necessarily mutually exclusive, sign-types can benefit from rewriting so that it ties in also more closely with Marxist thought about language. The iconic type of sign, then, refers by virtue of perceived resemblance, as determined by prior or existing patterns of representation that are acknowledged. The indexical or "deictic" type of sign embodies a concretely present "trace" (as Peirce called it, using the examples of photographs and bullet-holes) of what brought it into being, which refers in the case of visual imagery in virtue of serving as a record of the creator's presence at the site of the image's coming into being; or more generally as a physically embedded record of process. And the symbolic type of sign sets up reference and puts it to work by drawing to itself an expanding, potentially unlimited chain of associations.

This account of reference does not by any means cover all of the ways in which images achieve signification, but it elucidates the basic empowering mechanisms (see also Signs).

Response Theory A branch of interpretative study in which the endeavor is to reconstruct (as a form of historicism) the way in which contemporary or near-contemporary audiences responded to the work, their modes of engagement with it and the forms of active awareness or attentiveness that were entailed. Such terms of response may be conceived of as a force shaping the character of the work, while it is in gestation and before its reception on the part of a larger public begins: in which case evidence will be from within the work, as it outwardly comes to present itself, including all of the accompanying elements or factors that *frame* an image for the viewer, in the extended sense of that verb.

Semiotics Conceived of by Saussure as a "science" of signs (q.v.). If what he further called the "life of signs in society" is to be studied in the case of visual images, this needs to be done in a heuristic fashion, paying attention both to the terms of operation to which those images conform as a matter of principle, and to the particular ways in which individual images invite being viewed and read. The purpose will be not so much to discover underlying "laws," regulating representational practices and their understanding on the part of viewers. It will be rather to investigate, in particular categories or groupings of imagery—including mental representations—how ongoing adaptation occurs, and the types of interpretative move that are possible in accordance with such adaptation.

Signs The term *sign* has been used in so many different and alternative ways that the subject calls for a broad review, both historical and conceptual. Signs in antiquity were taken as standing in for particular things or entities that are not present to the senses, or exist only in consciousness. Mental faculties enable and set on foot the cognitive act of interpreting the sign (*semeion*) in terms of what it designates or exemplifies. Words, taken as signs, communicate according to an underlying scheme of substitution or symbolization. Images, including mental and pictorial ones, need not be conventionalized in that way, but rather can do their "standing in" in an unmediated fashion.

Medieval uses of the Latin *signum* extend the term to symptoms, imprints, and tokens, which have in common their being signals of something else, or markings inscribed on a surface. They operate, essentially without human volition, by a form of reference (q.v.) to what is latent or implied (rash/infection; presage/coming event; scar/damage; ruin/decay; lying or obfuscation/guilt), from which inferences can be drawn. For Saint Augustine, when words are used to signify objects, they can be learned and deployed to "express [one's] desires," as in a simple, performative (q.v.) language of instruction. The issue raised here of how signification is recognized, in an expressive process of communication that translates into actions, can be extended to the use of purely visual signals, gestures or marks, and to the way in which a form of mnemonic recovery is entailed in their being understood. While for Saint Augustine images derived from things that are no longer present to the senses are stored for private contemplation and are not directly accessible to cognition as the things themselves once were, the shift made here in considering recovery, from the standpoint of the knowing producer to that of the recipient, brings up how one's own memory comes into use with images, and is relied on for recognizing purposes. Focus on the recovery process then extends itself in the later Middle Ages, via consideration of sequence and order, to accumulations of images and diagrammatic arrangements of them (typified in stained-glass windows with themes such as the Tree of Life); and the way in which a system of visual presentation differs from a sequence brings in the question of transposability, rather than item-by-item translatability, from the textual source or model to a visual equivalence and back again into words. In their empowering of contemplative thought, signs depend on an encoding of concepts and abstractions and an assumed capacity for their decipherment, in which, depending on the medium and the message, the visual may supplement, parallel, or actively displace the verbal.

The coming of printing and multiple reproduction in graphic form opens up how different, complex signs can

be combined on the same ground—especially (as in maps) emblematic images, formulaic labels, arrangements of lettering—and the competing forms of response they can promote and manipulate. Such amalgamations of sign-system call for acceptance and appreciation based on what they contribute to the reading as a whole; and the separation of the roles of denotation and connotation from one another becomes more intricately interwoven with the workings of those systems, individually and together.

In the eighteenth century, interest shifts to aspects of reality that are controlled by consciousness, so that they embody meaning as part and parcel of a living cultural ambience. A complex, evolving language in which ideas can be expressed is itself a sign of civilization and of the workings of privileged minds within it. The counterpart in the visual sphere to this idealization of the properties and potentials of language is that the sign on which consciousness operates is distinguished from the *natural* sign, which by virtue of transparent resemblance has an immediately intelligible relationship of correspondence to what it signifies. Schemata as a means of cognitive apprehension consist by comparison of "abstract" signs that, in a given context of appearance, stand in for what they denote in reality; while creative orderings of reality (such as garden schemes) need to be elucidated in their social and intellectual terms of operation, as if grasp in those terms was inherently needed to give access to what signs so constituted are organized to express.

In the late nineteenth-century Symbolist theory of signs, emphasis is placed primarily on the originating creator and his or her order of imagination. The exercise of an idiosyncratic sensibility (like van Gogh's), guiding the power of invention and showing its individuality and openness to change, enables the sign, poetic or pictorial, to designate or refer to different kinds of entity—not just material ones—in a seemingly arbitrary or flexibly allusive fashion. This conceptualization, in its focus on controlling artistic intelligence, the manipulations introduced, and the divergence of connotations invoked is like an updated version of the Renaissance notion of the artist as bringing to sight what is absent, by just such signifying means as finally defeat material constraints. The sign in art can then appear, emergently or for those disposed to take it that way, as a reification of the spiritual.

The argument of Ferdinand de Saussure's *Course in General Linguistics* (given as lectures in 1907–11 and promulgated by students after his death in 1913, to become a foundational text for modern semiotics) is that language (*langue*) is to be conceived of for the purpose of understanding its framework as a rule-governed *system* of signs. Relations within that system and between its ultimate acoustic units (referred to by Saussure as

"sound-images") are to be seen as forming the basis for particular permutations and combinations, as in a code—as opposed to the modes of utterance and inflections of individual language use (*parole*), which are to be kept separate as a subject of investigation. Saussure's preponderant emphasizing of *langue* over *parole* implied that there was in effect a two-part, divided framework for the production of meaning, corresponding on the one hand to a differentially structured scheme of mutually related values; and on the other to contingencies of adaptation and choice, which are studied in the form of particularized applications of the scheme.

Within the verbal sign Saussure posited a constitutive relationship, that of material *signifier* standing for the hearer receiving its mental imprint in place of an absent *signified*. This is a form of relationship that can be transposed to the visual. A sign within a pictorial representation has meaning assigned to it by virtue of there being comparably a material signifier, such as marks on the page, and of its being inseparable from its signified, which may consist of a concept or movement of thought, or an ideal held in the mind. There are, however, two stipulations or qualifications to this correspondence to consider. Signs as components of a visual language bring up in practice other signs, to which they relate and which they evoke, so as to constitute, both in combination and incrementally, an association that the image carries: which is in turn a form of reference (q.v.). And personal adaptation and choice in the "intonation" of what is offered—a term chosen on the analogy of the roles of tone and gesture in speech—affect how the material signifier (such as paint) carries signification, which corresponds to the "performative" dimension of language usage (q.v.).

Pictorial signs are devised, deployed, and distributed within a structure that is thereby animated; as with the masks studied by Claude Lévi-Strauss and the fashion and advertising images analyzed by Roland Barthes. It may be more helpful accordingly to speak of sign-formations—especially in modern art, where there is no necessary iconographic linkage between signifier and signified—rather than of individual meaning-carrying signs, to be identified as such. There will also be variations in signification—what is communicated—according to the context of occurrence of a sign in relation to other signs; typically the use made of a sign may be abstract (in the older sense of the word, as it applies to the art of Ingres), or gestural, or selective or condensatory in its articulation. I have limited the interpretative use of the term in my text, (paralleling the premises of Leo Steinberg and T. J. Clark when they use it) to cases where the signification becomes, in a

given context, an ideologically loaded one—as if independent of any personal or individual choice to this effect.

Synchronic/Diachronic Analysis As introduced by Saussure (see under Signs) and as taken up within Structuralism, these terms counterpoint two inherently different ways of examining language. The study of its operations as it exists as a whole at a particular (theoretically, single) point in time is placed in opposition to the study of its historical evolution, focusing upon change over time. Diagrammatically, the available alternatives and the rationale for choices made among them can be taken as being mapped in the one case along a horizontal axis, while in the other case the consideration of continuity and alteration proceeds on a vertical track.

In the case of visual imagery, structural analysis within a practice such as portraiture allows for the framing of similarity and difference at a given period in time, which may be narrowed to a few years only; but with the important difference from language that complementary and contrasting pairs of terms have to be brought in to account for distinct versions existing of the basic alternatives posited. On the diachronic axis, the way in which visual motifs enter into new or different configurations can be charted in terms of their being authorized individually by larger cultural changes; but the anchorage of those motifs to preexisting concepts that secure meaning will tend to show itself more strongly or readily than is the case with linguistic developments.

Synecdoche Synecdoche—which is often confused with metonymy (q.v.) or taken as a subdivision of it—is a figure of speech singling out some larger aspect of the entity that is in question, with a particular strategy of emphasis on its representativeness for the purpose of expressively characterizing the whole (as in the avowal "he is all heart"). Understood in that way, it forms one of the four basic tropologies (q.v.), and can be transposed to the domain of visual imagery on that basis.

Tropology Tropology deals basically with figurative language, studying it in terms of how it works in individual contexts of communication, and the role that it plays in speech and writing more generally. The term derives from the analysis of tropes, or conventionalized and individually identifiable figures of speech, and their contribution to persuasion. So understood, it goes back to what is set out in detail in antique and again in Renaissance treatises on rhetoric, with many varieties of possibility identified. But the way in which figurative language is put to work can also be thought of as expressing a shaping attitude or disposition on the part of a writer, and the philosophical viewpoint and cultural background underlying this.

Here, in accord with a categorization set up in the sixteenth century for rhetorical effects in general, the presentation that the writer makes can be taken as deploying in its governing patterns one of four available modalities, which correspond to the most basic or pervasive of the tropes themselves: metaphor, irony, metonymy (q.v.) and synecdoche (q.v.). Such has been the suggestion recently (following Hayden White) for nonscientific discourse and different kinds of historical writing. Two of the same tropes, metaphor and metonymy, have also been taken (following Roman Jakobson) to represent fundamental aspects or key dimensions of figurative discourse that expose themselves in the poetic and imaginative construction of texts, corresponding to the selective and combinative "axes" of language usage.

To apply corresponding terms of analysis to visual imagery has the great value of highlighting there the role of those mechanisms that, following Freud's analysis of dreams, have come to be known by the names of condensation and displacement, and of exposing further those considerations of transposition, between the visual and the verbal, that underwrite the possibility of communicative exchange here (as in the telling and interpreting of dreams). The mechanism of condensation entails basically the creation of a composite of two images, which partakes selectively of the meaning attaching to each. That of displacement entails the transfer of an image from a context where its appearance is normatively expected, to another where it takes on a resonance deriving from its unfamiliarity there.

To the "selective" and "combinative" dimensions of language usage, so understood, there correspond specific capabilities in the deployment of visual imagery: ones in which attention is displaced from a literal reading of the representation, toward a play with analogy between component elements on the one hand, and reciprocity between them on the other. In either case this makes for an imaginative conceptual linkage between different features or things. It may be that, as with metaphor, a larger aspect of nature is thereby expressed: one that can only be grasped progressively in the unfolding of consciousness over time or in space. Or, as with metonymy, the relationship may center upon an element standing in place of a complete or fuller entity, of which it forms part or to which it is causally linked. Visual irony may equally be treated in a broad way, relating it to those creations of forced and paradoxical effect that go under the name of catachresis (q.v.). The practices of personification and the concatenation between elements that are deployed in the case of allegory can be put into relation to synecdoche. And suggestive visual equivalents to other tropes, such as simile, which involves displacement, can also be brought in.

Index

Millet, Jean François, 152–54, 171, 178
Milton, John, 83, 157, 160, 164
Minoan art, 12
Mirbeau, Octave, 189
Miró, Joan, 201–3, 213–14
modalities, 122. See also *modes, concept of*
Modersohn, Otto, 197
Modersohn-Becker, Paula, 197
modes, concept of, 39, 73–74, 89
Mola, Pier Francesco, 159
Mondrian, Piet, 197, 217
Monet, Claude, 144, 176, 179–81, 194–95, 196, 204, 214, 219, 223–24, 237
Monticelli, Adolphe, 144–45, 187
Morisot, Berthe, 145–47, 179, 219
Morland, George, 100–102, 104, 121
Mornand, Henri, 179
Morosov, Ivan, 199
Morris, Charles, 278
Morse, Samuel F. B., 243 n. 29
Morton, J. L., 162
Munch, Edvard, 268 n. 41, 274 n. 99
Münter, Gabriele, 268 n. 41
musicality in landscape art, 135–40, 142–47, 170, 184
Muziano, Girolamo, 54
mythologization of landscape, 206, 208, 210–12

Nagler, Georg Kaspar, 152
narrative elements in landscape art, 13, 16, 17, 58–59, 68, 70, 125–26, 139, 183, 186–87, 236. *See also* narratology
narratology, 9
Nash, Paul, 199–201, 202, 270 n. 64
naturalism, 47–48, 124, 126–35, 169–70, 177
nature poetry, 205–6
Neo-Impressionism, 193
Niccolo dell'Abbate, 54
Nicolson, Harold, 238
Nietzsche, Friedrich Wilhelm, 171–72
Norbury Park, 29–33
Norgate, Edward, 80
Norwich School, 172
nostalgia in landscape art, 206, 232
notation, 62, 146
Novalis (Friedrich von Hardenberg), 43

Odyssey Landscapes, 17–19, 32, 228
O'Keeffe, Georgia, 211–12, 219, 225
Orientalism, 120, 193, 253 n. 60
Orley, Bernaert van, 56
Ørsted, Hans Christian, 217
Ossorio, Alfonso, 216–17
Ovid, 19
Owen, Wilfred, 200

paese, concept of, 19, 64
pageant. *See* masques; spectacle
Palazzo Pubblico, Siena, 93
Palazzo Sacchetti, Rome, 68
Palmer, Samuel, 102
panorama, 82–86, 89, 222. See also *Cosmorama*
parerga, 59
Parigi, Giulio, 165
Parmigianino, Francesco, 32
Parsons, Betty, 216
Passert, Michel, 71
pastoral subject-matter, 20–21, 25, 59, 66, 99, 124, 148, 150, 195, 208, 244 n. 10
pastoralism. *See* pastoral subject-matter
Pastorini, Benedict, 31
Pater, Walter, 247 n. 36, 256 n. 33
Patinir, Joachim, 49–50, 52, 54, 55, 59, 202
Pausanias, 14
Peacham, Henry, 80
Peirce, Charles Sanders, 278–79
performative/constative dimensions to language use, 92, 278
periaktoi, 14
perspective, use of, 80, 229
Perugino, Pietro, 6
Peruzzi, Baldassare, 68
Petrarch (Francesco Petrarca), 20
Philip II, King of Spain, 115
Philostratus the Elder, 15–17, 19
photography of landscape, 123, 168, 193
Photo-Realism, 222, 223
Picasso, Pablo, 196–97, 205, 213–14, 269 n. 50
pictorialism, 195–96
picturesque, theory of, 23–29, 107–8, 109, 162, 165–66. *See also* Gilpin, William
Piero della Francesca, 60, 93
Piero di Cosimo, 112–13
Piranesi, Giovanni Battista, 114–15, 116
Pissarro, Camille, 133–34, 176, 178, 179, 189
Pittoni, Battista, 138
Plato, 39
plein air practices, 124–26
Pleydenwurff, Hans, 50
Pliny the Elder, 39, 51, 59
Po-Chui, 6
Pointel, Jacques, 73, 74
Pollock, Jackson, 213–17, 218
Polo, Marco, 93, 104
Polygnotus, 14
Pompeian painting, 19, 40–42
Porcellis, Jan, 78
Porta, Giuseppe, 69
Post, Frans, 93
postcards, availability and use of, 193–94, 199